For centuries, the performance horse has inspired wonder, exhilaration and devotion in their human companions. Their majestic beauty and powerful grace are truly unequalled. Bayer Animal Health has long been committed to the health of all animals, and to the well-being of equine athletes in particular. We pay tribute to these remarkable animals and the owners, trainers and riders who work closely and tirelessly beside them. As you will see on the following pages, this faithful partnership between man and horse is at the very heart of greatness.

FOR CENTURIES, THE PERFORMANCE HORSE HAS INSPIRED WONDER, EXHILARATION AND DEVOTION IN THEIR HUMAN COMPANIONS. THEIR MAJESTIC BEAUTY AND POWERFUL GRACE ARE TRULY UNEQUALLED. BAYER ANIMAL HEALTH HAS LONG BEEN COMMITTED TO THE HEALTH OF ALL ANIMALS, AND TO THE WELL-BEING OF EQUINE ATHLETES IN PARTICULAR. WE PAY TRIBUTE TO THESE REMARKABLE ANIMALS AND THE OWNERS, TRAINERS AND RIDERS WHO WORK CLOSELY AND TIRELESSLY BESIDE THEM. AS YOU WILL SEE ON THE FOLLOWING PAGES, THIS FAITHFUL PARTNERSHIP BETWEEN MAN AND HORSE IS AT THE VERY HEART OF GREATNESS.

THE PERFORMANCE HORSE

A PHOTOGRAPHIC TRIBUTE

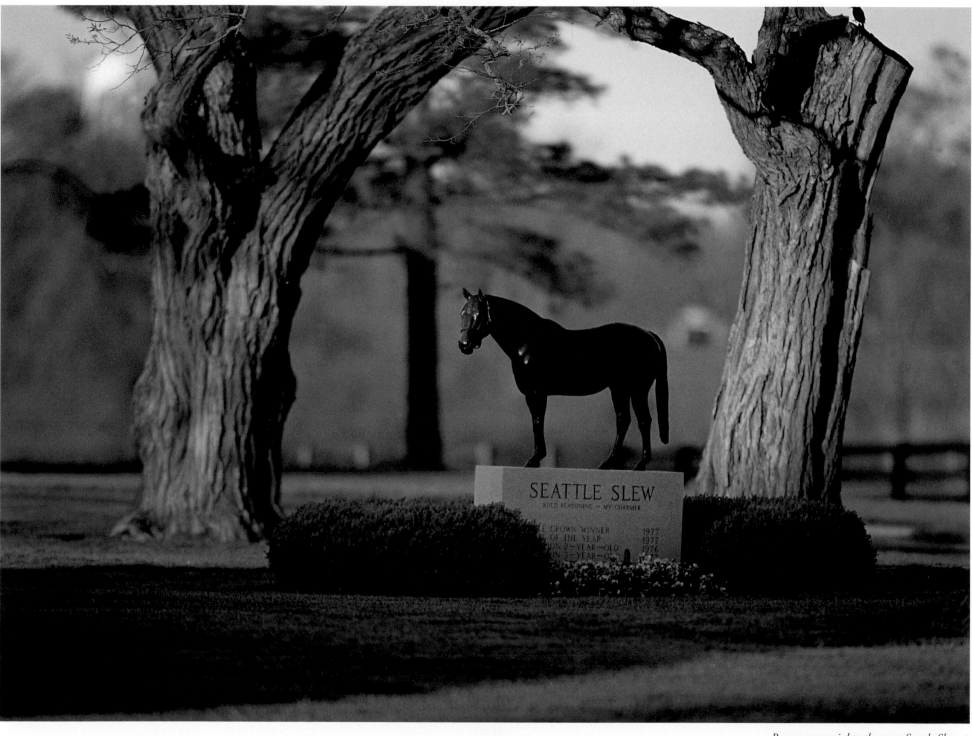

SEATTLE SLEW
BOLD REASONING — MY CHARMER

E CROWN WINNER	1977
OF THE YEAR	1977
N 2—YEAR—OLD	1976
N 3—YEAR—O	

Bronze memorial to the great Seattle Slew at
Three Chimneys Farm, Lexington, Kentucky

S

STOECKLEIN
PUBLISHING & PHOTOGRAPHY

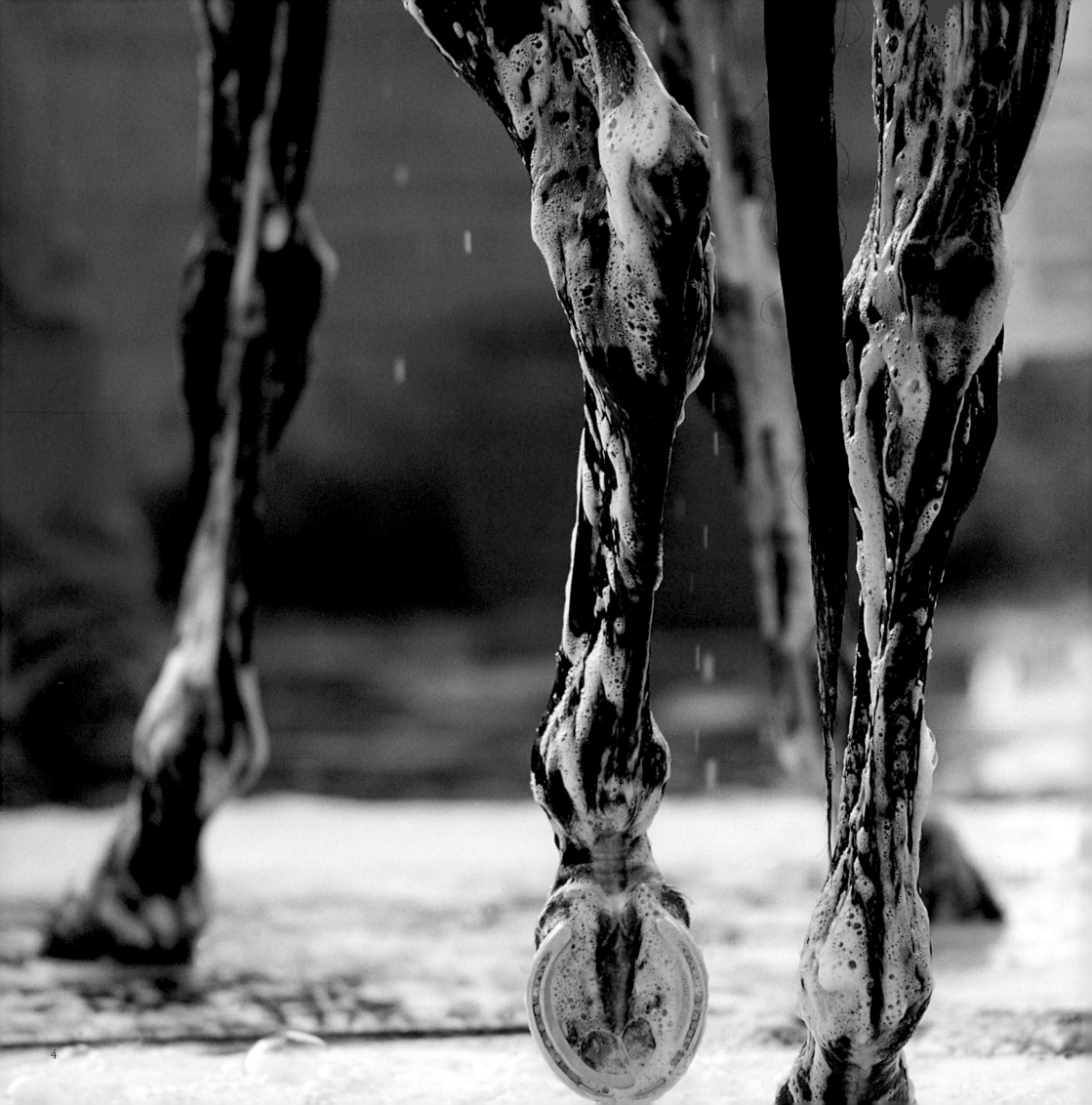

DEDICATION

For Mary, Thanks for being there.

Love, Dave

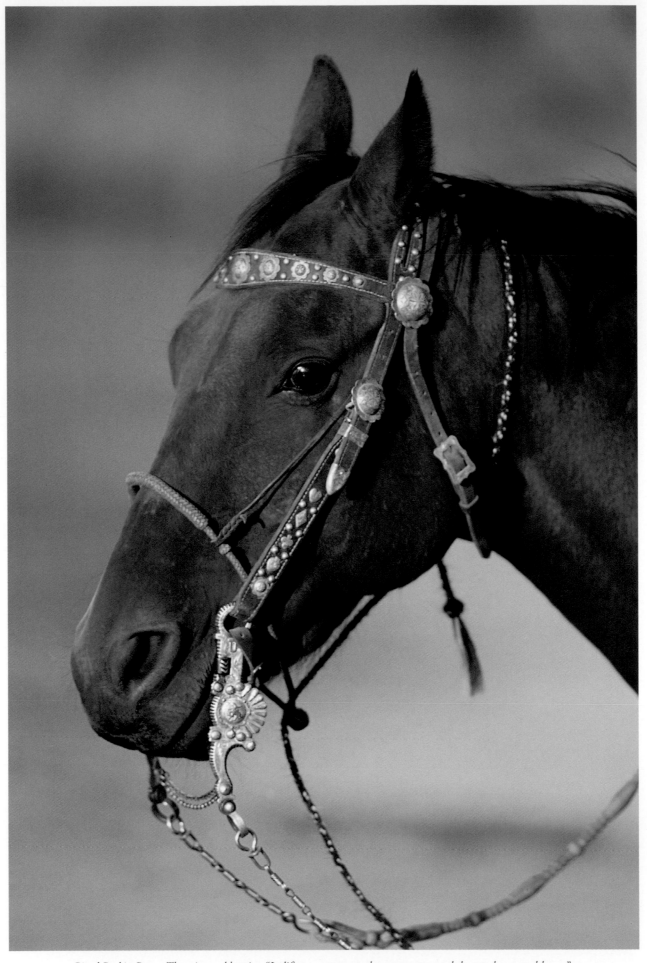

Pistol Packin Pete – There is an old saying "In life you get one good woman, one good dog, and one good horse."
I am lucky enough to have all three; this is my horse. –DRS

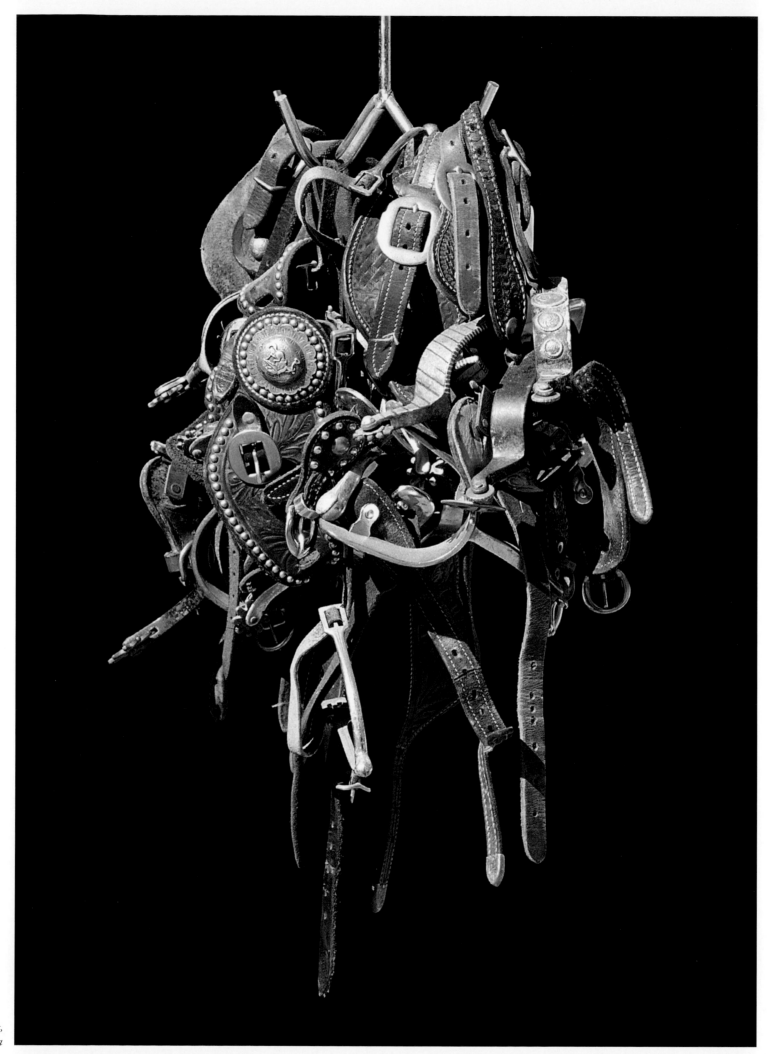

*Spur collection, Perry Farms,
Ocala, Florida*

Thanks

I would like to take this opportunity to thank the
horse for thousands of years of devotion and dedication to man.

Sincerely,
David R. Stoecklein

THE PERFORMANCE HORSE

A PHOTOGRAPHIC TRIBUTE

Photography David R. Stoecklein
Art Direction & Design Gary Custer & Kelley Custer
Writer Jennifer Forsberg Meyer
Editor & Producer Carrie R. James

The Performance Horse: A Photographic Tribute

PHOTOGRAPHER & CREATIVE DIRECTOR	David R. Stoecklein
ART DIRECTION & DESIGN	Gary Custer, Kelley Custer
WRITER	Jennifer Forsberg Meyer
EDITOR & PRODUCER	Carrie R. James

All images in this book or any of David's other publications are available as fine art gallery prints or for stock photography use. Please call Stoecklein Photography at 208.726.5191 for more information.

Dave is also available for assignment photography. Some of his clients include Canon USA, Bayer Corporation, US Tobacco, Marlboro, Chevrolet, Pontiac, and Jeep. His work has also been published in many major U.S. magazines.

To see more of Dave's work or to order additional products, please log on to our Web site at **www.stoeckleinphotography.com**.

DESIGNED BY:
STEPHENS & ASSOCIATES ADVERTISING
7300 W. 110th St., Suite 530
Overland Park, KS 66210-2332
913.661.0910 tel
http://www.stephensad.com

PUBLISHED BY:
STOECKLEIN PUBLISHING, LLC
PO Box 856
Tenth Street Center, Suite A1
Ketchum, ID 83340
208.726.5191 tel
208.726.9752 fax

PRINTED IN CHINA
ISBN 1-931153-22-1
Library of Congress Catalog Number 2002091149

Cover photo- War Chant, sunrise,
Three Chimneys Farm,
Lexington, Kentucky

STOECKLEIN
PUBLISHING & PHOTOGRAPHY

FOREWORD

I was sitting in my booth at the World Championship Snaffle Bit Futurity in Reno, Nevada, in October of 2001 with my good friends Butch Morgan of the *Western Horseman* magazine and Joel Gleason from Bob Avila's Pro Shop. We were talking about horses, of course, and one of the guys asked me what my next book project was going to be. I told them that I was not sure. Then a few minutes later, out of nowhere, I came up with the idea of performance horses. They thought it sounded great and wanted to know more. At that point I did not have any specific thoughts since I had just dreamed it up on the spot. The next thing I know, I am talking to Bob Avila and Todd Bergen, thinking that this could be a fantastic endeavor.

From Reno, I traveled back to Idaho and then to New York City and Texas. All of a sudden it was Thanksgiving and time to go to the AAEP show in San Diego. Throughout my many travels last fall, I kept thinking about the project and I started to get more and more excited about it. My first horse book, *The Western Horse,* was selling pretty well and my newest book on the American Paint Horse was exceeding all our sales expectations. So why not? I love horses and I love taking photographs of them. I thought that this could be a great excuse to learn about all types of horses and to visit with horse people all over the United States.

So at dinner one night during the AAEP show, I asked my friend Allyn Mann, marketing manager for equine products at Bayer Corporation, what he thought of my latest idea. He was enthusiastic and even said he would love such a book to give to the veterinarians he works with. He wanted to support the project, but said that he would need the finished product to give out by November of 2002.

My fate was sealed. I said I would do it while I had a month and a half of work already booked. That meant I could not start on the photographs for the book until the middle of January 2002. That would leave only about five months to finish the design and the text. To start, I called Gary Custer at Stephens & Associates Advertising. He was the one who introduced me to Allyn and has been the art director for all the Bayer projects we have worked on over the past four years. He signed on to help and his daughter Kelley also volunteered to assist the old man with the computer design. Then I called Jenny Meyer who had just finished working with me on *The American Paint Horse* book and done such an amazing job. She completed the team as our writer. Jenny and I hashed out a rough outline of the chapters we needed to cover, as well as the timing for each one. And away we went!

To start, I went first to Santa Ynez, California, to photograph jumping, dressage, reining, and cutting horses. I called on my old Rancheros sidekick and local celebrity, Joe Olla for help. He put me in touch with Kristin Ferguson and Charlotte Bredahl. From there, we went on to Florida where Brooke Berg introduced me to the horse country in Ocala. Then we were off to Wellington near Palm Beach, where Linda Wirtz was my able host and organizer. Allyn Mann also called around and introduced me to David and Karen O'Connor who then put me in touch with the folks at Orange County Hunt in Virginia. Next on our itinerary was Kentucky, where my old high school friend, Nelson Clements, introduced me to Tom Van Berg and Churchill Downs and we then went on to Keeneland. Kimberly Graetz of *The Horse* magazine was a great help in Lexington as a guide to the horse park and stallion farms. Allyn Mann also joined us there and gave us all new jackets to keep us dry on what was one of the wettest weekends I have ever endured.

We traveled back to California and met up with Brett Black, an Idaho transplant who is now the coach of the Cal Poly Rodeo team. He set me up with team ropers, calf ropers, and barrel racers. In Utah, Lewis Fields trains the Utah Valley College Rodeo team where his sons, Chad and Casey, team roped. I also caught up with Danyelle Campbell in California where Pete Craig set up his arena for some outstanding barrel racing shots. While we were in California we stayed at the Tucalota Creek Ranch and had a great time with Bob Avila. We also continued on to the northern part of the state to hook up with Bob Ingersoll, who is a true reinsman, and with Fritz and Phyllis Grupe for incredible photos of combined driving.

At this point, I was getting pretty tired out, but I saved the best for last and visited Leon Harrel who is one of the world's greatest cutters down in Kerrville, Texas. I completed the whole journey back in Idaho with one of the best horsewomen in the country, Anne Reynolds Jones, as well as the cutting horse champion, a genuine cowboy from Bellevue, Idaho, Gregg Smith.

Well, my Delta Airlines mileage account went through the roof with 45,000 new miles and my pickup logged at least 8,000 new miles, but we did it. Here is the finished product in all its glory. I hope you enjoy it as much as I enjoyed putting it together. It was fun.

All the best,

David R. Stoecklein

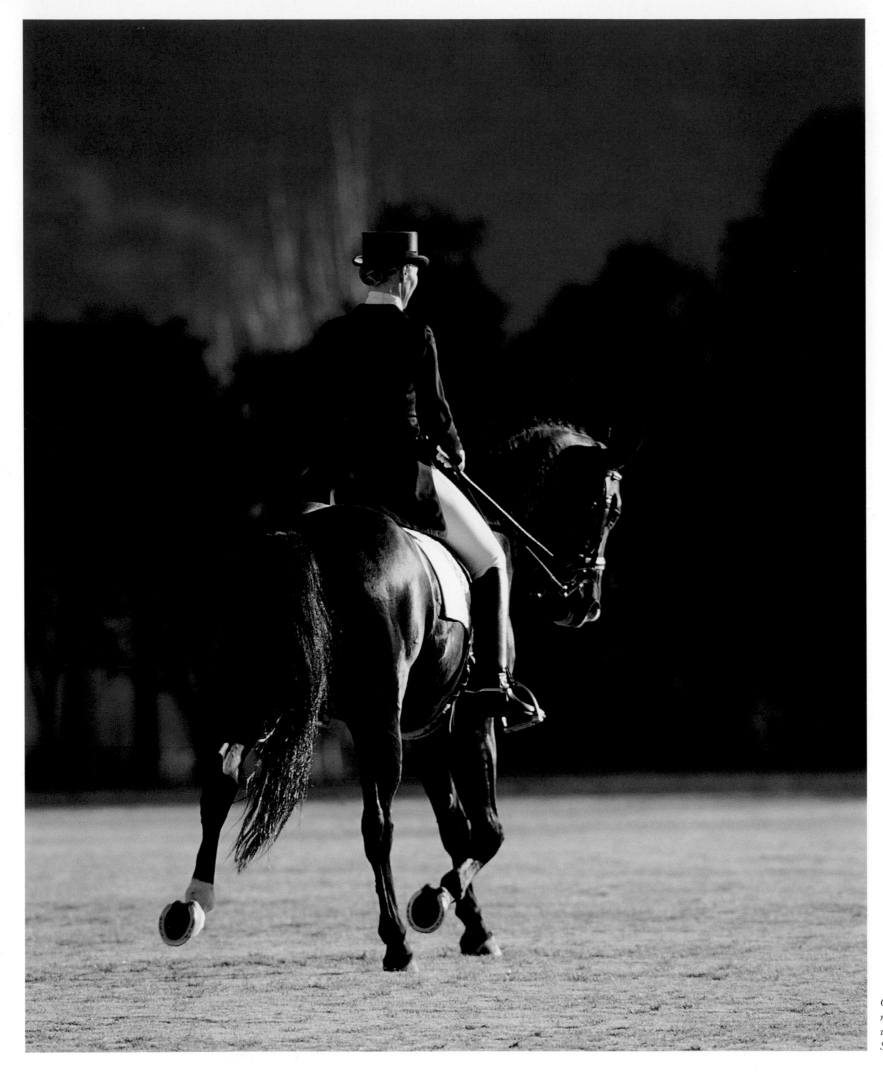

Charlotte Bredahl,
morning exercise
with Windfall,
Santa Ynez, California

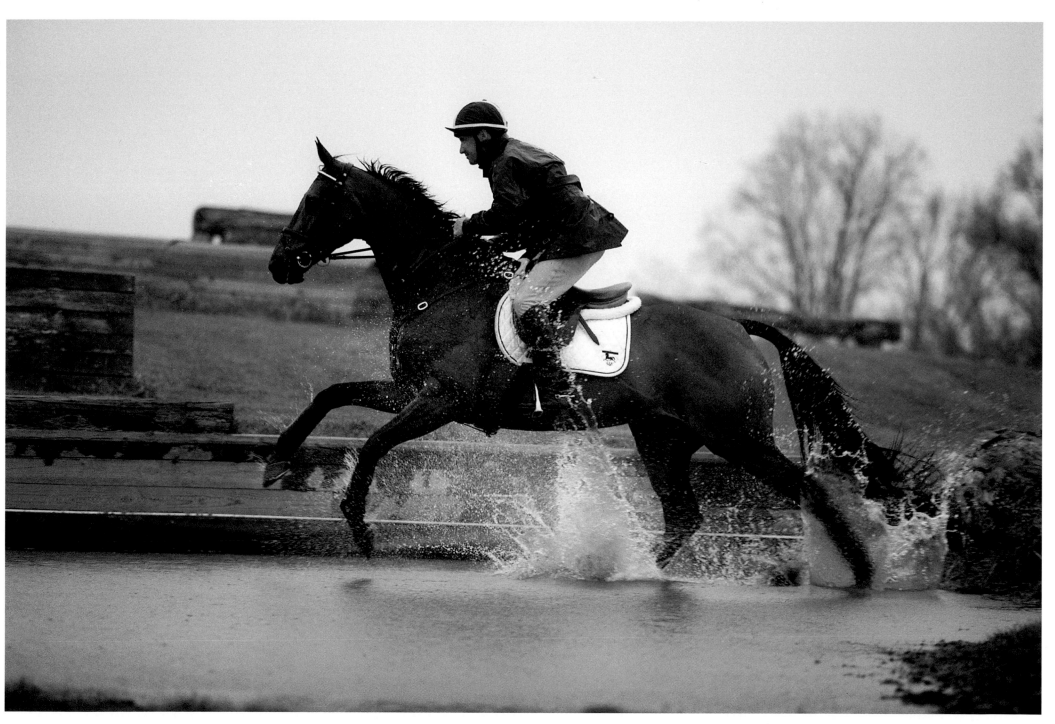

David O'Connor working out at his training facility, The Plains, Virginia

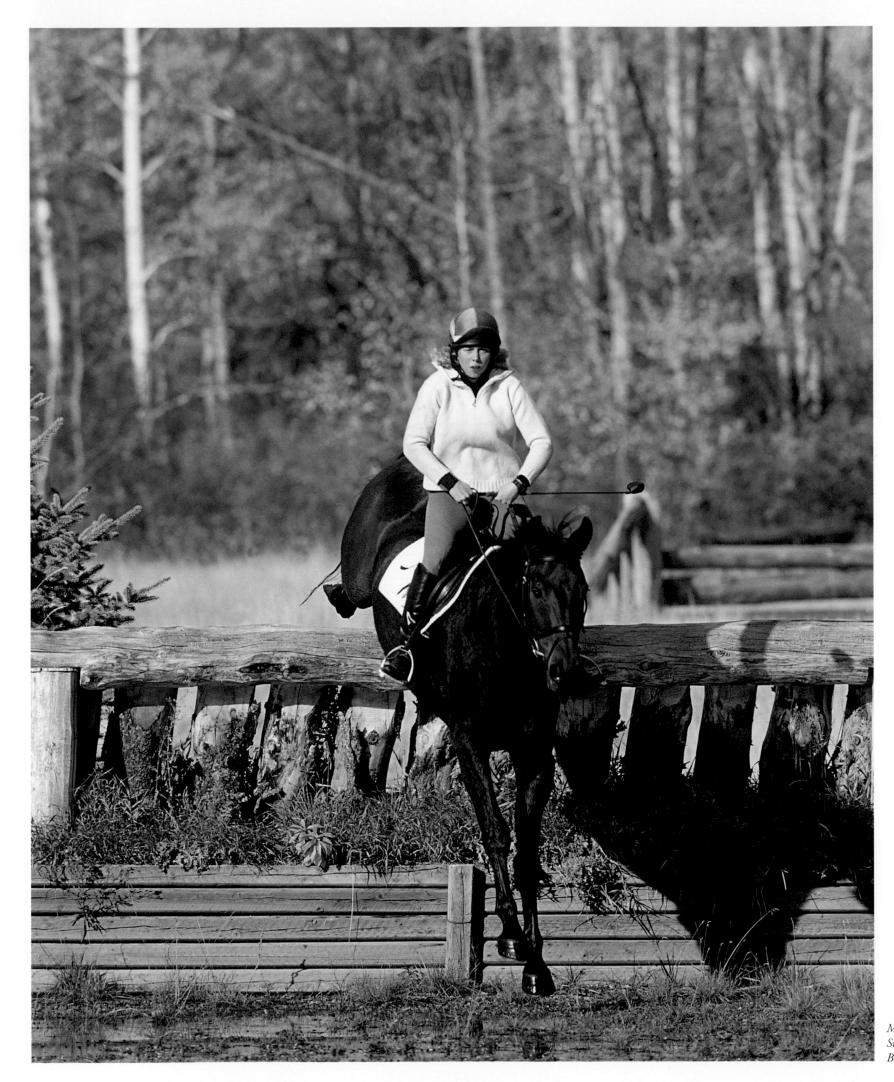

Meaghan Stamper,
Swiftsure Ranch,
Bellevue, Idaho

Table Of Contents

Kristin Ferguson's boot,
Santa Ynez, California

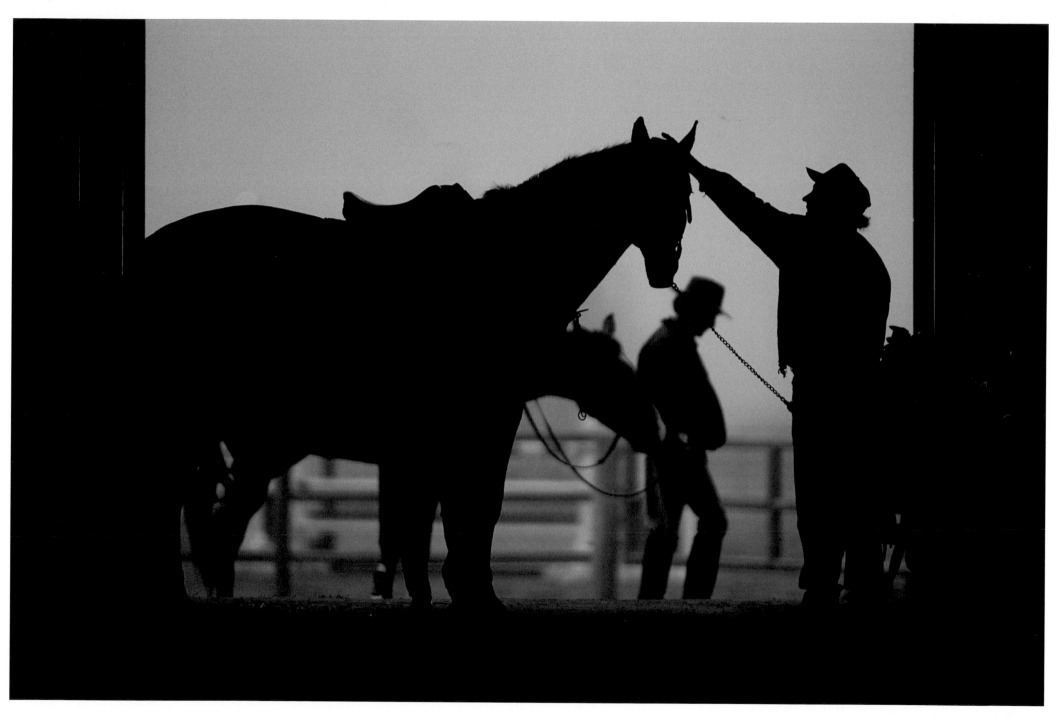

Gregg Hind and Paul McEnroe,
Rancho La Purisma,
Santa Ynez, California

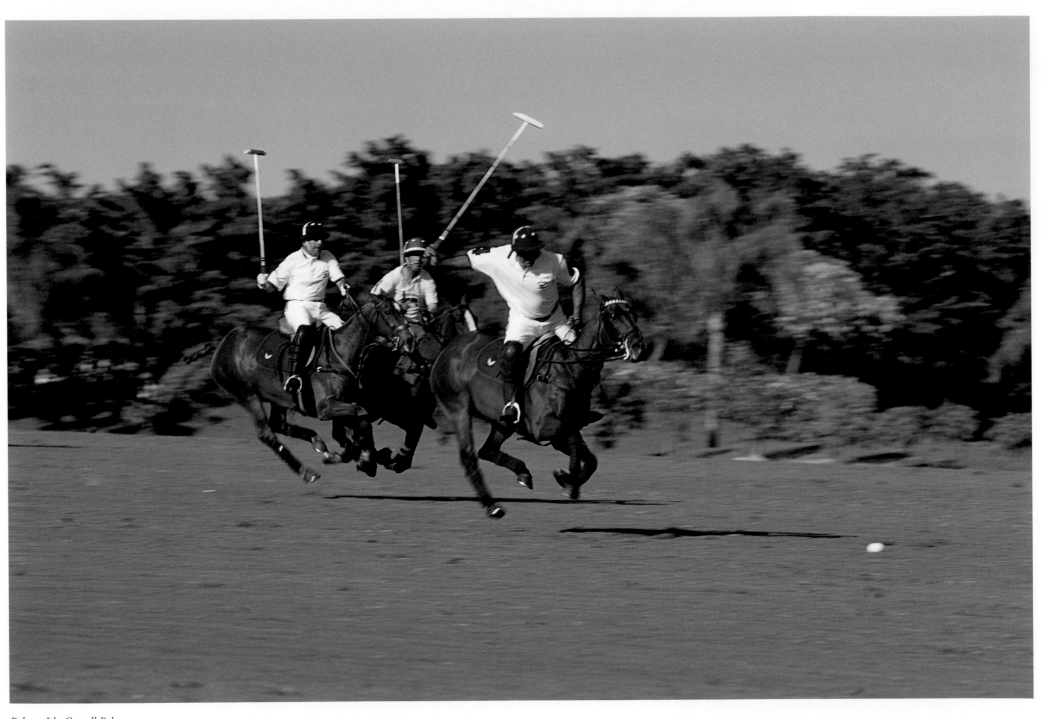

Polo at Isla Carroll Polo,
Wellington, Florida

PARTNERS IN PERFORMANCE: A RETROSPECTIVE

For seven millennia, the horse has been our faithful companion. More than any other animal on earth, he has helped to speed the advance of civilization, providing us transport, toiling on our farms and ranches, doing all the grunt work. Today, his high-profile role is that of our partner in a host of equestrian sports. Watching him in action, we are awed by his magnificent blend of power, grace, spirit, and willingness.

His unique suitability for us is another source of wonder. Observe any well-matched horse-and-rider pair, and the two seem made for each other. Look more closely, and it is not hard to imagine that *Equus caballus* was intelligently designed specifically for humans to ride and drive. How else to explain this extraordinary creature, so perfectly tailored for friendship and service?

Compare the horse to other animals. Unlike the deer or the antelope, the horse has a large frame, strong back, sturdy legs, and solid hooves, all of which allow him to support and transport our weight. The rounded contours of his back, as contrasted with the bony backs of cattle or oxen, make him comfortable to ride for hours at a time, even without a saddle. And no other animal has the horse's combination of speed, endurance, and sheer beauty. He can carry us in fleet bursts or over long treks, and we are proud to be seen on his back.

Even some of the horse's finer attributes seem engineered for our benefit. Consider the interdental space, that odd little gap between a horse's front incisors and rear molars, which makes the wearing of a bit possible. Or the withers, which help position and stabilize a rider on his back. Or the mane, which provides a convenient hand-hold. Or the absence of horns and antlers, an oddity among hoofed mammals, which makes handling him less hazardous. Or his coat colors – every natural hue plus dazzling patterns of white – that render the horse utterly irresistible to us.

As convenient as these physical characteristics are, though, none of them would matter if the horse were untamable. Happily, the opposite is true. The horse is among the most easily trained creatures on earth, with a phenomenal memory and a disposition that makes him willing, often eager, to bear us and do our bidding. Even the horse's very nature, it seems, is tailored to meet our needs.

And yet, for the first forty thousand to forty-five thousand years of our association with the horse, he was neither a servant nor a companion. He was a food source. Like other wild beasts, he was hunted, killed, and devoured, his bones tossed aside to be found in ancient cave dwellings by modern-day archeologists. We find further evidence of humans' hunger for horses in late Ice Age cave paintings in southern France and northern Spain. These prehistoric works of art depict stylized images of horses, along with drawings of mammoths, reindeer, bison, aurochs (predecessor of the cow), and other hunted species. Still vibrant after more than fifteen thousand years, the paintings are astonishingly beautiful and evocative of Cro-Magnon man's reverence for his splendid prey.

Horses of this era were small and looked somewhat like the Przewalski horse, the lone surviving wild horse of today. Speed and natural wariness would have made prehistoric horses an elusive and frustrating quarry. Early hunters may have driven them into natural traps made of stone walls and impenetrable foliage in order to spear or club them to death. An archeological site in Solutre, France, contains the remains of up to one hundred thousand horses killed by early humans over a period of about twenty thousand years.

FROM SUSTENANCE TO SERVANT

The flighty restlessness that made prehistoric horses difficult to hunt may also account for a curious fact: The horse, now one of the most successful and popular of earth's tamed creatures, was the last animal to be domesticated. Indeed, today we take our loyal servant for granted, but as science writer and naturalist Stephen Budiansky points out, of four thousand species of mammals to exist on the earth in the last ten thousand years, the horse is one of fewer than a dozen to have been so widely embraced by humans as domesticated animals.

The first animal to be domesticated was the wolf, which became a part of the human family about fourteen thousand years ago. As a predator, the wolf – and his descendant, the dog – may have aided humans in hunting. Next tamed was the sheep, and soon after, goats, pigs, and chickens joined the communal dwellings that spread as humans began to relinquish their nomadic ways, settle down, and cultivate crops.

No one knows exactly when the horse was domesticated, but it may well have saved him from extinction. Fifteen thousand years ago, as the Ice Age was ending and climates were warming, the tundras favored by horses began to disappear. They were replaced by thick forests, which did not suit a horse's need for grazing. At the same time, vigorous hunting was also affecting the horse population. In North America, where equids had evolved for over 55 million years, these same pressures led to the horse's extinction about ten thousand years ago. Other large mammals that relied on open grasslands, notably mammoths, mastodons, and giant elk, also died out.

LOOK BACK ON OUR STRUGGLE FOR FREEDOM, TRACE OUR PRESENT DAY STRENGTH TO ITS SOURCE, AND YOU'LL FIND THAT MAN'S PATHWAY TO GLORY, IS STREWN WITH THE BONES OF A HORSE.

...Anonymous

A similar fate was about to befall the horse in Europe and Asia when domestication intervened, approximately sixty-five hundred years ago. It may have come about when horses – like mice or starlings – discovered the advantages to lingering near human developments. They risked being killed for food, but they also gained incidental protection from other predators, and could pilfer food from human crops.

Gradually, early humans began to treat horses differently. During this period of mutual adaptation, the horse's natural inclination to bond may have furthered the domestication process. Because horses as a species are migratory rather than territorial, they must bond in order to remain cohesive as a unit. A particular piece of ground does not hold them in one place, so a natural affinity for each other must serve to unify them instead. This tendency to bond, which horses also exhibit with other species, ultimately made it possible for humans to tame them. It is also what fosters the close relationships that form between top performance horses and their handlers today.

One of the first peoples to tame horses were the nomadic Aryan tribes living on the Ukrainian steppes that bordered the Caspian and Black Seas northeast of the Mediterranean. These nomads already knew how to herd animals – probably sheep, goats, cattle, and reindeer. Domestication of the horse may also have been occurring at roughly the same time in other parts of the world, notably China and Mesopotamia (modern Iraq).

As an animal herded for meat and milk, horses offered the tribes at least one advantage over other species: easier feeding. This is because horses, unlike other herd animals, will paw through snow to find forage in the wintertime. To keep things manageable, it is likely that early horse herders kept only mares, tying them out when they were in season to be covered by wild stallions. Colts born into the herd may have been eaten; fillies grew up to join the mare band.

Archeologists disagree about whether we first rode or drove the horse after we tamed him. For a long time, it was thought that horses were first used to carry packs or pull sleds, wheeled carts, and chariots. More recently, however, researchers have pointed to the likelihood that herdsmen would have been mounted in order to manage large numbers of horses. This theory puts our first horseback rides at about the same time as the horse's domestication.

As best we can tell, there were no differences between the bits used for riding and driving in ancient times. The earliest evidence of bitted horses comes from archeological sites at Dereivka in southern Ukraine and Botai in northcentral Kazakhstan. These digs have yielded fifty-five hundred- to six thousand-year-old horse remains with toothwear suggesting contact with a bit. The mouthpiece of these early bits was likely made of rope or sinew, with cheek pieces carved from deer antlers. Later mouthpieces were made of hardwood, bone, or horn; metal bits made of bronze did not appear until somewhere between 1300 and 1200 B.C. Horses were also controlled during those times with nose rings, a method humans had already been using on oxen, donkeys, and perhaps onagers (Asiatic wild asses).

Even without the type of gear we now take for granted, by about 3000 B.C., humans were riding and driving horses in many parts of Asia, Europe, and North Africa. The Chinese, in particular, became accomplished horsemen who bred several types of horses for different purposes. By 1000 B.C., horseback riding had become commonplace throughout the ancient world.

This new use of the horse – as transportation rather than as meat – dramatically and permanently changed the face of civilization. Man was now mobile, in ways that the already domesticated ass and ox could not provide. But it would be a long time before the horse would come to be used as he is today – as a partner in many of our most popular sport and leisure activities.

His role in the meantime was fundamental to our very existence, and helped to drive and define emerging human cultures around the world.

A WEAPON OF WAR

One of the earliest horse cultures was that of the Scythians. These were fierce mounted nomads who flourished near the Black Sea for about three thousand years, up until the time of Christ. Tattooed and illiterate, they drank fermented mare's milk and practically lived on horseback, using gear decorated with gold and colorful felt – and the occasional human scalp. Horses, especially gold-colored ones, were their most treasured possession, and as such were regularly sacrificed in gruesome burial rituals. Scythians rode without saddles, using balance and leg grip, and are credited with inventing what must have been a necessity to them: trousers.

Skillful archers, the Scythians and other early horse cultures helped to spread a use of the horse that persisted for thousands of years, right up until the mechanization of the nineteenth century. They used the horse as an instrument of war. The value of the horse in this role is incalculable. Warriors on horseback or in chariots had a psychological as well as physical advantage over their adversaries. Seen for the first time, mounted warriors were terrifying, their speed and power devastating. Foot soldiers were decimated by mounted troops, and peoples thus vanquished quickly developed cavalries of their own. In this way, the use of horses as a vehicle of human conquest spread rapidly around the known world in a sort of early arms race.

The Assyrians of northern Mesopotamia were the first to amass large cavalry squadrons. With the advantages provided by mounted warriors and war chariots (which had become light and maneuverable with the addition of spikes to wheels in 2000 B.C.), the Assyrians dominated much of the civilized world between 1200 and 612 B.C.

The Parthians, an offshoot of the Scythians, are considered by many to have been the most expert horsemen of the ancient world. They ruled Persia (modern Iran) around the third century B.C., and their most famous military maneuver – shooting over their horses' rumps during retreat – gave us the term "Parthian shot" (now "parting shot"). The strong, swift Parthian horses were highly valued by other cultures, and eventually influenced the development of the Andalusian, Lusitano, and Lippizaner breeds.

It is hard for us now to imagine, but for the first several millennia that humans rode horses – in war or otherwise, right up until about A.D. 300 – they did it without the benefit of stirrups. Today, saddles with stirrups are a necessity when riding performance horses. Consider the variety: tiny, short-stirrup racing models; deep-seated, long-stirrup dressage models; slender-horned, workmanlike cutting models; elaborately tooled, silver-laden western pleasure models. The one thing all saddles have in common today, apart from a girth, is a pair of stirrups, which aid the rider's balance and greatly extend his or her mounted endurance. Stirrups make possible most of the equine sports we enjoy today. How then could early man have gone so long without them? Archeologists cannot say. Stirrups seem obvious to us now; clearly they were not to early riders.

The lack of stirrups during early times created difficulties. Mounting, especially in battle gear, was especially awkward. Another problem was controlling a galloping horse and maintaining one's balance while shooting an arrow in the midst of a melee. Early Assyrian archers had two ways of solving this dilemma. In one, they rode next to a mounted partner, who held the reins for them while they shot. In the other, they attached weighted tassels to the reins to maintain a steady pressure on the horse's mouth while they used both hands for archery.

A precursor to the stirrup appeared in India around 100 B.C. It was a mounting aid consisting of a small loop of rope – a sort of "toe stirrup" on the near, or left, side of the saddle only. Indeed, the word "stirrup" stems from the Old English "stige-rap" or roughly, "mounting rope." The first real stirrups were probably developed in China sometime around the fourth century A.D. and spread westward; they became more common in Europe sometime after the fall of the Roman Empire late in the fifth century.

A saddle with genuine stirrups made possible the Age of Chivalry (from the French *chevalerie,* or 'horseman') that lasted in Europe from about A.D. 1000 to 1600. With the stability that stirrups provided, feudal knights could wreak even deadlier havoc with sword and lance without toppling from their horses. Sturdy *destriers,* or 'war mounts' – a smaller version of today's draft horses – were bred to carry the heavy armor that protected both horse and rider in combat. The extra equine bulk was also useful for adding to the power of a lance-thrust, and for trampling unmounted adversaries underfoot.

Eventually, the invention of firearms made the heavy warhorse obsolete. Musket balls pierced armor and far outdistanced the range of the lance. At this point, lighter, more agile horses became desirable once again. Heavy English horses were crossed with the finer-boned, swifter Arabians, Barbs, and Turks that armies had come into contact with during the Crusades in the Middle East and North Africa. The offspring of these matches became the predecessors of the Thoroughbred, the breed with the greatest influence on virtually every type of competitive performance horse today.

Meanwhile, in North America, the cradle of the horse's evolution, horses had been extinct for ten thousand years when the Spanish explorers reintroduced them to their ancestral home in the early sixteenth century. Once again the horse proved a formidable war tool. Just as the ancients in Europe had quailed at their first sight of mounted warriors, so too did Native Americans recoil in terror when they first beheld mounted Spanish explorers. Pressing their advantage, the conquistadors were able to vanquish large numbers of Indians with a relative handful of men. "Next to God," reported the expedition of Francisco Coronado to what is now New Mexico, "we owe our victory to the horses."

The Indians eventually overcame their fear and acquired horses of their own, gathering strays or stealing from the white man's bands. They called their mounts *mesteno,* Spanish for 'without an owner,' and quickly became superlative bareback riders. Astride a galloping mustang, they could wield spears or shoot arrows in rapid succession, even while dropping to one side of the mount to use the animal's body as a shield.

Horses continued to be used in warfare all over the world, at a horrible price to the animals themselves, until mechanization finally made them obsolete. The last full-scale military action involving horses was a massacre in 1941, during the German advance on Moscow. A Russian cavalry division charged a German infantry division and was mowed down by machine-gun fire and heavy artillery. The United States horse cavalry – which was created during the Revolutionary War, served in the Civil War, and helped settle the West – was abolished in 1948.

Today, thankfully, the use of horses in combat is relatively rare. Americans were astonished to see images of mounted Afghan warriors in the fighting that ensued after the September 11, 2001, attacks on New York and the Pentagon. Over the ages, however, the horse's role as an indispensable battle companion led to some of the most famous pairings in history. Think of Alexander the Great and Bucephalus, the noble black warhorse for whom an ancient Greek city was named. Or Napoleon and Marengo, the courageous gray Arabian that endured eight battle wounds in the course of his career. Or Wellington and Copenhagen, the chestnut Thoroughbred who carried his master for fifteen hours on the day the duke defeated Napoleon at Waterloo. The staunch

relationships that existed between warhorse and warrior are a source of wonder and a clear precursor to the bonding that takes place between great performance horses and their human partners today.

At about the time that jeeps and armored tanks were replacing warhorses, motor vehicles were taking the place of saddle and coach horses, and tractors were phasing out farm horses. Our loyal servant who had worked in cities, on farms, and in mines and who had made possible our agriculture, industry, trade, and transportation, was finally getting a break. Some sixty centuries after his domestication, the horse was at last beginning to assume the role for which he is celebrated today, that of our teammate in performance events.

OUR SPORTING PARTNER

Of course, humans had been using the horse in sporting events right from the time of his domestication. Informal horse racing probably began as soon as two or more humans were mounted, and we know bareback racing occurred in Greece in about the fifth century B.C. Chariot racing, the precursor of harness racing and carriage driving, was popular in the ancient Olympics from about 700 B.C. until A.D. 400. Polo, the oldest stick-and-ball game in the world, dates to 500 B.C. in Asia and Asia Minor. Wealthy Persians enjoyed foxhunting in 300 B.C., and jousting tournaments were a popular spectator sport in medieval Europe. Dressage, the methodical refinement of the horse's natural gaits, began to gain recognition as an art form during the late Renaissance period of 1500 to 1600, when it was cultivated at elegant riding schools across Europe.

In America, horse sports were popular from the beginning of colonization. In particular, the first settlers brought from England a passion for horse racing. The sport took a slightly different form in the New World, however, and resulted in a new breed of horse. With few large racetracks (clearing the dense woodlands of the colonies was difficult, and most cleared land was needed for crops), early Americans match-raced their horses over shorter distances than those popular in England. They raced imported English Thoroughbreds, and also bred their own stock, crossing fine-blooded English imports with the hardy Spanish breeds brought to America by the conquistadors. (Of Andalusian and perhaps Barb and Arabian blood, the explorers' horses had become the seed stock for the great herds of mustangs that eventually spread across the American West.)

The result was a tough horse with quick speed and native cow sense – the American Quarter Horse, named for his fleetness at a quarter mile. Like the Thoroughbred, which became influential in the development of many performance breeds, the Quarter Horse helped refine many western performance breeds, notably the Paint (the Quarter Horse's white-splashed brother) and the Appaloosa (the spotted horse bred by the Nez Perce Indians of the Northwest).

In addition to racing, the Quarter Horse and other western breeds teamed up with the cowboy to work the vast cattle ranches that spread over the American Southwest in the 1800s. That union led to the birth of the first uniquely American horse sports, which grew out of the impromptu riding and roping contests that took place during cattle roundups. (The word *rodeo* is Spanish for 'roundup.') Other sports based on a western style of riding – including cutting, reining, and cow horse events – evolved in the mid-1900s to preserve and highlight the talents of painstakingly trained ranch horses.

In America today, the performance horse, in all his incarnations, has reached his zenith. As our multi-talented sporting partner, he brings exhilaration not only to those who ride and drive him, but also to the enthusiasts who come to watch. Horse racing and rodeo events, in particular, are significant spectator sports in many parts of the country.

The performance horse also supports a considerable portion of our economy. According to American Horse Council figures, there are over three million performance horses in the United States today, and the various sports they participate in have an economic impact of more than $70 billion.

As a species, the horse has always been a versatile animal. Now, with the specialization that selective breeding has produced, horses excel at a mind-numbing variety of competitive activities. We will examine each of these in turn in the chapters to come. For the moment, though, consider the range:

• Racehorses are speed demons over short and long distances. Harness racers reach racing speeds in "second gear," overriding their urge to gallop. Steeplechasers hurtle over fences, combining speed with jumping ability. Show jumpers are the Michael Jordans of the horse world; they leap to eye-popping heights – with a rider onboard.
• Show hunters jump stylishly; foxhunters jump fearlessly, in the heat of the chase. Event horses are triathletes: jumping in an arena, racing across country, and performing dressage. Dressage horses are the ice dancers of the horse world, displaying grace and athleticism in intricate patterns.
• Carriage horses combine strength, endurance, and precision; polo ponies combine the boldness and agility of hockey players. Cutting horses are like defensive basketball players – crouching, sprinting, and anticipating an adversary's every move. Reiners take dressage and ramp up the speed, spinning and sliding with dexterity.
• Reined cow horses are triathletes in western gear – cutting, reining, and sprinting after a single cow. Western pleasure mounts excel at smooth, easy gaits and pushbutton control; rodeo horses excel at speed and athleticism.

There is nothing, it seems, that the modern-day performance horse cannot do. For a single species to have become so proficient in so many disciplines takes more than selective breeding. It takes a creature with an enormous capacity to learn, an elephantine memory, and an endless willingness to please. Yet for a horse to reach the highest levels of his sport, it also takes one other essential characteristic. One that horsemen simply call heart.

THE ROOTS OF GREATNESS

Heart is, in fact, the essential quality of a great performance horse. When horsemen say they have a superb racehorse or reiner or jumper, they are not referring to that animal's conformation or athletic ability, although both of those attributes are doubtless exceptional. They are talking about courage, the willingness of that horse to find just a tiny bit "more" when it counts – in the big race or the championship event. And because running faster or stopping harder or jumping higher is not something a horse chooses to do on his own, he must do it because he is asked to do so. And indeed the great ones do just that – out of an uncommon kind of generosity. Or, to put it another way, a horse with heart will give you his heart when you ask for it.

Performance horse trainer Ted Robinson, six-time winner of the World Championship Snaffle Bit Futurity – the reined cow horse "triathlon"– says you learn about a horse's heart in the show ring.

"You walk into the arena, and if the bleachers are full, a great horse just comes alive," he observes. "You move into the herd to make your cut, and if you pick a Brahma-cross instead of, say, a Hereford, that horse knows the difference. The Brahmas give more eye contact and challenge a horse more. The horse knows it, and he responds even before the work begins. His heart goes to beating – you can feel it in your legs.

"You start working that cow, and it goes well. When the crowd starts hollering, that horse gets even quicker, works even harder, all on his own. But he's doing it for you, because what's in it for him? Great horses win for their riders. And a lot of times, it seems they try even harder than their riders do."

Karen O'Connor, who, along with her husband David, helped lead the United States to three medals in eventing at the 2000 Sydney Olympics, sees the same kind of heart in the best horses of her three-phase sport.

"If you've built the proper foundation with a horse, he'll come through for you, no matter what," she says. "You might even break a stirrup leather or a rein on your way to a big fence, and he'll get out the safety net and say, 'I gotcha.'"

To offer this kind of trustworthiness, a horse must regard his rider as a partner, not a predator – no mean feat for an animal that we hunted for more than forty thousand years. That is something to keep in mind, O'Connor says.

"When you approach a horse in a field and he puts his tail up and runs, he's just behaving like the prey species he is," she explains. "Then, when he stops, turns, looks at you and snorts, he's deciding whether you're friend or foe. That's just how a horse thinks, and we must honor that in order to communicate with him in a way that fosters a partnership. When you have that partnership, you can ask a well-trained horse to do about anything – even if it's outside his comfort zone – and he'll try his heart out for you."

Try his heart out. This is what the horse has been doing since domestication, sixty-five hundred years ago. It is what has led to his status as a cultural icon around the world. And it is what thrills us most about the top performance horses we ride, drive, and thoroughly enjoy today.

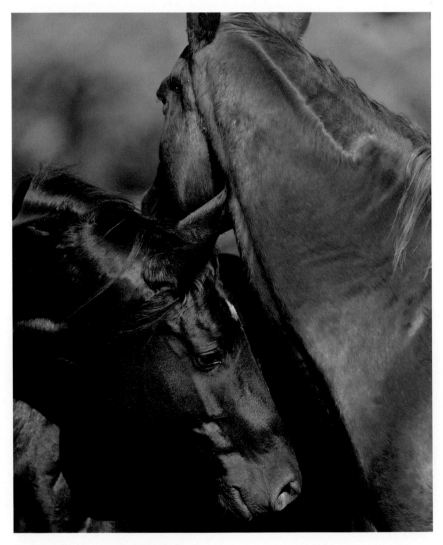

Quarter Horse mares, King Ranch, Texas

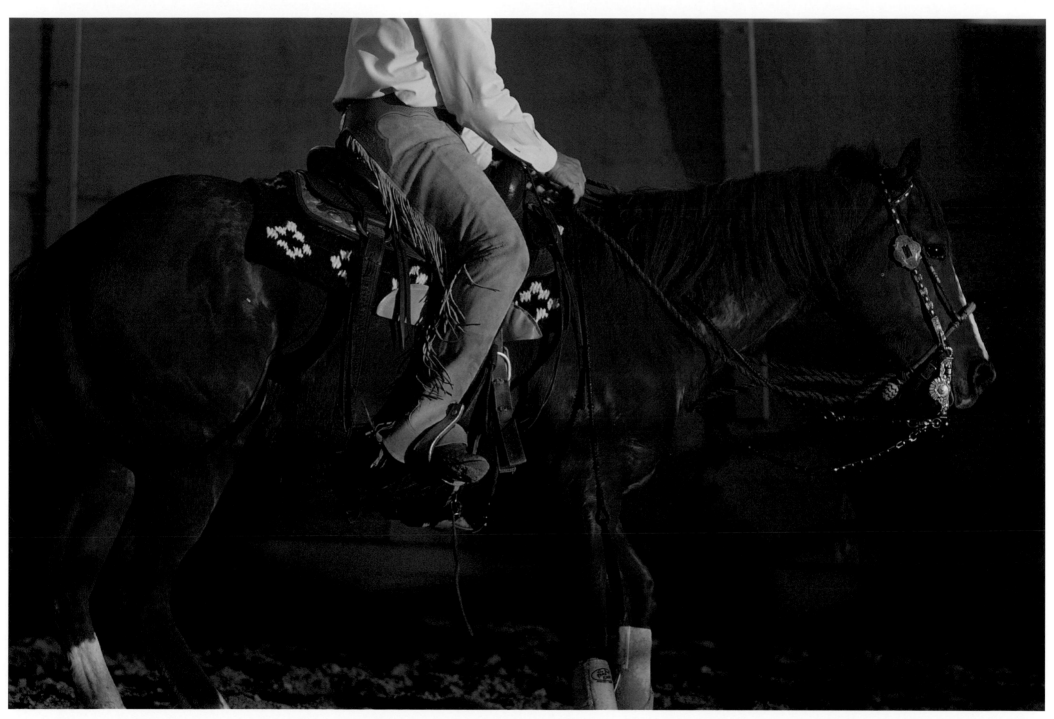

Les Vogt riding Danny, Santa Maria, California

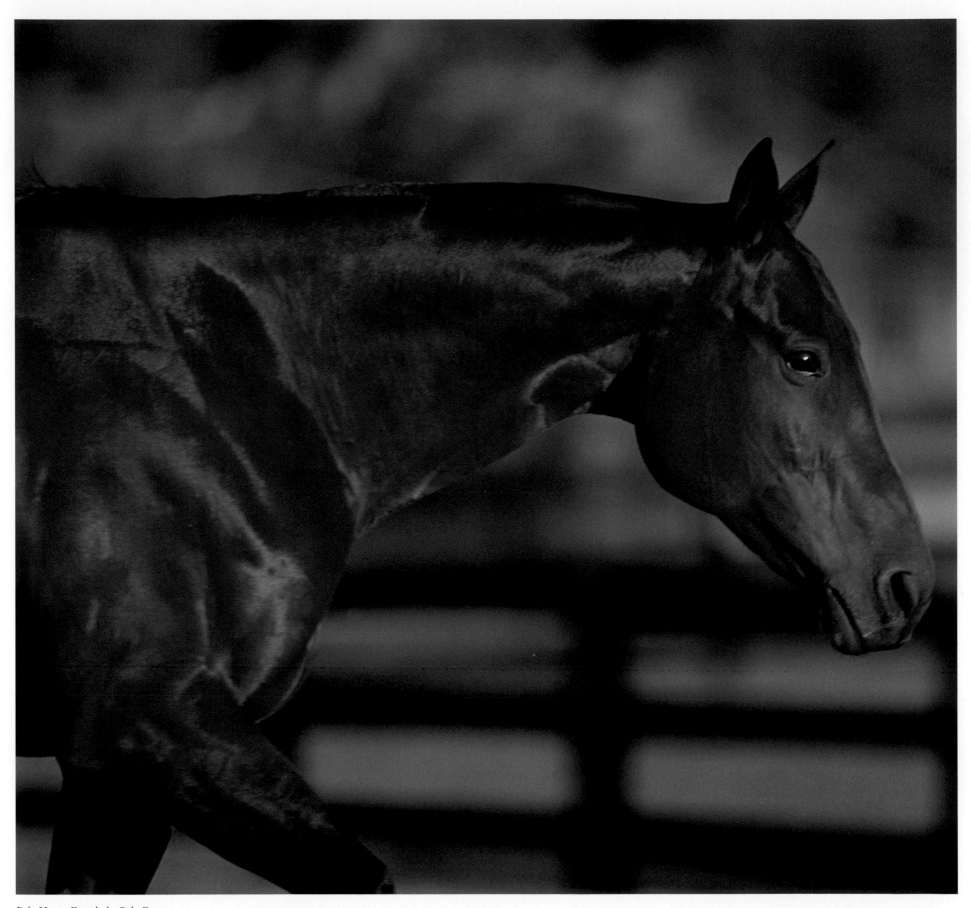

Polo Horse, Everglades Polo Farm,
Wellington, Florida

THE POLO PONY

*I*s the polo pony the horse world's hardest working athlete?

"Think of it this way," suggests Sunny Hale, the first woman to play on a winning polo team in a United States Open Championship, which she did in 2000. "It's like telling your trail horse, 'We're going to run as fast as we can for three miles nonstop, and we're going to turn at every tree.' Polo is exhausting – unbelievably hard work."

Indeed it is. Next to ice hockey, polo is the fastest game in the world, reaching speeds of up to thirty miles per hour. It is frenetic, with constant pressure and ever-changing rhythms. A polo pony must sprint, stop, turn, and sprint again for the duration of a seven-minute period; in a fast game, he might well cover up to three miles. He works mostly in high gear, enduring jostling, rough riding, and flailing mallets. Like his forebears, he carries a "warrior" into a battle – overcoming his natural urge to flee, pressing bravely into the fray, obeying his rider's commands.

"Polo is the ultimate sport," says Joel Baker, who has been a professional for thirty years. In the seventies and eighties, Baker played on the winning team of every major tournament in the United States. "You have to be a ball-playing athlete, but you also must become one with the horse, so that you're not even thinking about your riding – just as a soccer player never thinks about his running."

Polo (which takes its name from *pulu,* the Tibetan word for 'ball') may well be the oldest team game in the world. It has been around at least since 500 B.C., when its earliest form was played in Persia, Tibet, and Mongolia. Darius, King of Persia, is said to have sent a polo stick and ball to Alexander the Great at the time of the young Greek's succession to power; his implication was that a game, rather than warfare, was more in keeping with Alexander's age and inexperience. The young ruler responded that the ball was the earth and he the stick, and proved his point by crushing Darius in battle in 331 B.C.

Rough and furious, polo is euphoric in a way that players claim is addictive. The urge to pursue the ball is almost primal, requiring the nerve and daring of both player and pony. A timid player, in fact, can be as much of a safety hazard as a slow driver on the freeway. Scoring goals takes precedence over equitation in polo, and the horsemanship is not always pretty.

The game is similar to hockey except the horse serves as a player's legs. Matches take place on grass grounds approximately the size of ten football fields. Two teams of four players each attempt to score goals by striking a three-and-a-half-inch ball with a mallet made of wood and bamboo. Unlike croquet, players use the side, rather than the end, of the mallet head to hit the ball. There are four to six periods, called "chukkers," per game, depending on the level of play. Players change horses after each chukker, and the action is so intense that each horse plays no more than two chukkers per match. Like chess, polo has a three-dimensional quality to it, as players must size up not only their own and their teammates' horses, but also those of the opposing team – a task that must be repeated at the start of each chukker.

Polo ponies are not really ponies, though they were when the modern game originated. Polo was played on twelve-hand Manipur ponies in nineteenth-century India, where the game had migrated from Mongolia centuries earlier. British tea planters and cavalry officers in India at the time were delighted with the sport and brought it to England in 1869, whereupon it spread to America in 1878. A 14.2-hand height limit for polo ponies was abolished in 1919; today the average size for polo mounts is fifteen-one.

At the lower levels, any type of horse can serve admirably as a polo pony, as long as it is trained to neck rein and turn off a rider's leg. At the upper levels, however, many of the best mounts are Thoroughbreds from the racetrack. Top polo ponies also come from Argentina, where Thoroughbreds crossed with native Criollo horses produce ideal mounts. Polo is practically a national sport in Argentina; top players there are revered the way sports heroes are in America, and children grow up riding horses the way American youngsters play baseball or soccer.

Polo's unique handicapping system provides for matches to be played between teams of similar ability, avoiding disparities by crediting goals in advance to the weaker team. The United States Polo Association ranks players from minus two to ten; a team's handicap is the sum of its four members' handicaps. Since the inception of the ranking system in 1890, fewer than fifty players have been awarded a perfect handicap of ten goals. In recent years, there are generally about a dozen active ten-goal players registered with the USPA at any given time, and more than three-quarters of them are Argentinean.

Polo was popular in the modern Olympics until 1936, when too few countries were capable of fielding competitive teams. For the last twenty years, the Federation of International Polo, headquartered in Beverly Hills, California, has been working to reinstate the game as an Olympic event.

The best players will tell you that the polo pony accounts for up to seventy-five percent of the game. "The team with the best horses usually wins," says Phil

SHE'S A WONDER AT GETTING AWAY, AND GIVE HER A LENGTH ON THE GRASS, THEY CAN BID A GOOD-DAY TO THE SWIFT LITTLE BAY, FOR THERE'S NOTHING CAN CATCH HER OR PASS; SHE FIGHTS FOR HER HEAD TO THE BALL, FOR THE PONIES ARE FOND OF THE FUN, AND OH! BUT SHE LOVES TO BE LEADING THEM ALL, DOES WITCHERY – FOURTEEN-ONE.

...Anonymous (New Zealand)

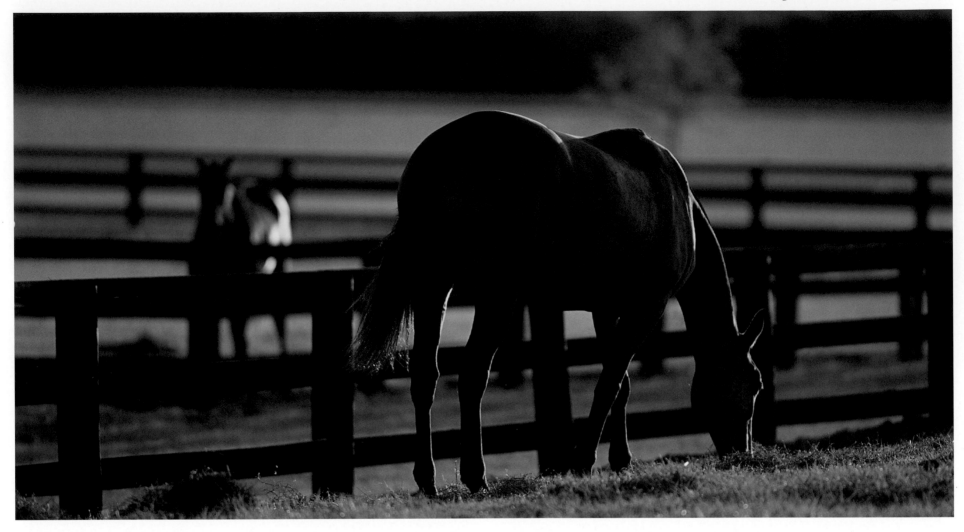

Heatley, manager of the highly successful Outback Steak House Polo Team based in West Palm Beach, Florida. "It's a game of split seconds, where the horse fastest off the mark from a turn gives a player the edge. At the upper levels, the horses have to have power – what we call 'a big motor.' Our players generally use nine horses each per match, but for the very biggest matches, such as the semi-finals or finals of the U.S. Open, they'll narrow it down to their best four horses. That's how important the horses are."

Explosive speed and catlike agility are essential for a polo pony. Horses must also be quiet enough to stay calm in the midst of a melee, yet bold enough to "ride off" another horse – that is, muscle him off the line of the ball at a gallop. It would seem that the game is tailor-made for the Quarter Horse, and indeed this quick, handy breed is often used at the lower levels.

"But in high-goal polo," notes Heatley, "the classic Quarter Horse has too much muscle mass to oxygenate during a seven-minute chukker. The ideal polo pony is a Thoroughbred that's built like a Quarter Horse, with a well-developed chest and hindquarters and a deep heartgirth. We do use some racing-bred Quarter Horses that carry a lot of Thoroughbred blood and show it in their conformation. They have the greater lung capacity we need for the game."

Heatley also notes that, in high-goal polo, mares are the preferred competition horse. "We keep over a hundred head of horses in training for our team, and of those, six are geldings," he says. "When you have to 'go to the bottom' of your horse, mares have the heart to give their all. They'll go until they drop. A gelding knows how to protect himself better. It's harder to get him to give everything."

There are exceptions, of course. Sunny Hale points to Cognac, a twelve-year-old black Thoroughbred gelding off the track. "He has tremendous heart, he's consistent, and he's *fast*," she says of her favorite mount. "I can miss a shot, and he'll turn and get off the mark so quickly he'll actually catch the player with the ball, who has a jump on him. When I need a clutch play, I can go to Cognac and know exactly how he'll respond. Like any great horse, he'll get you there – and then some."

Joel Baker, who instituted one of the first major polo clinics in the United States (in California in 1981), says the best polo ponies are competitive by nature, and will even resist being "ridden off" the ball by another player.

"When another horse is pressing into you, and your horse digs in and pushes back – that's an exceptional mount," he says, adding that a good horse sometimes takes care of his rider as well. "The ball isn't always where you want it to be. I've lunged out in space for a shot, and had my horse run right under me. That's how it is with a really good one – he'll try to figure out what you want or need, and then respond accordingly."

"The great ones do amazing things," he says simply.

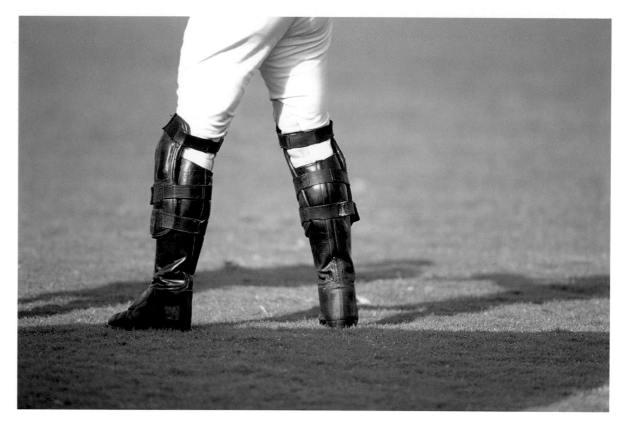

Polo player with legs wrapped and ready

Polo saddle, Wellington, Florida

Polo pony, wrapped and ready

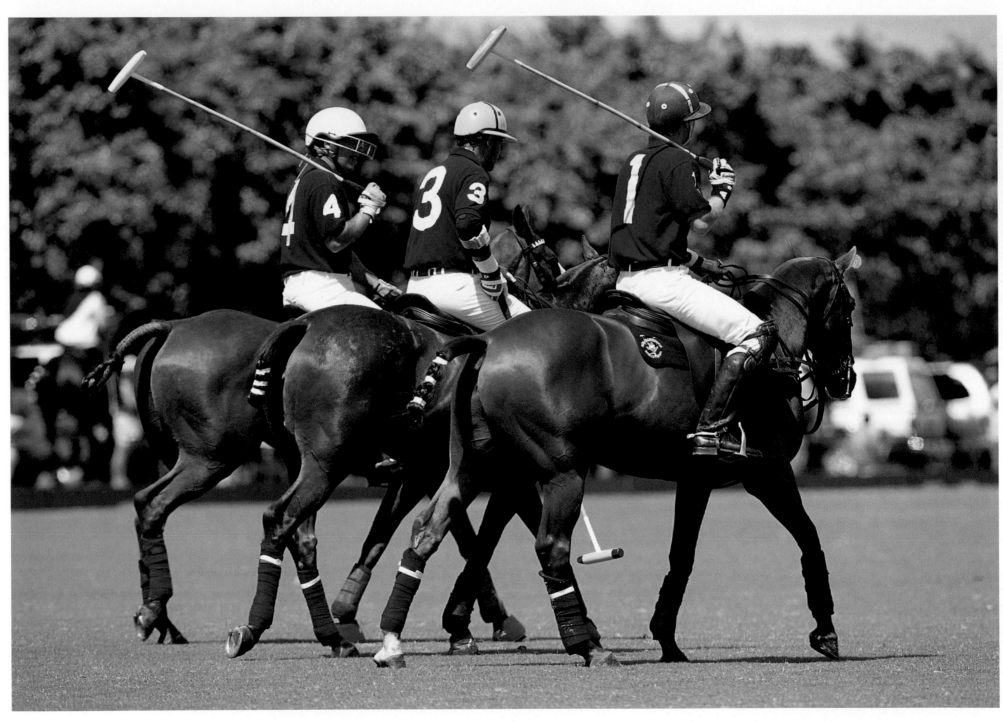

Polo players going to battle,
Revlon Polo Fields,
Wellington, Florida

Polo at Revlon Polo Fields, Wellington, Florida
following pages 30-31

Isla Carroll Polo Fields
following page 31, lower right hand corner

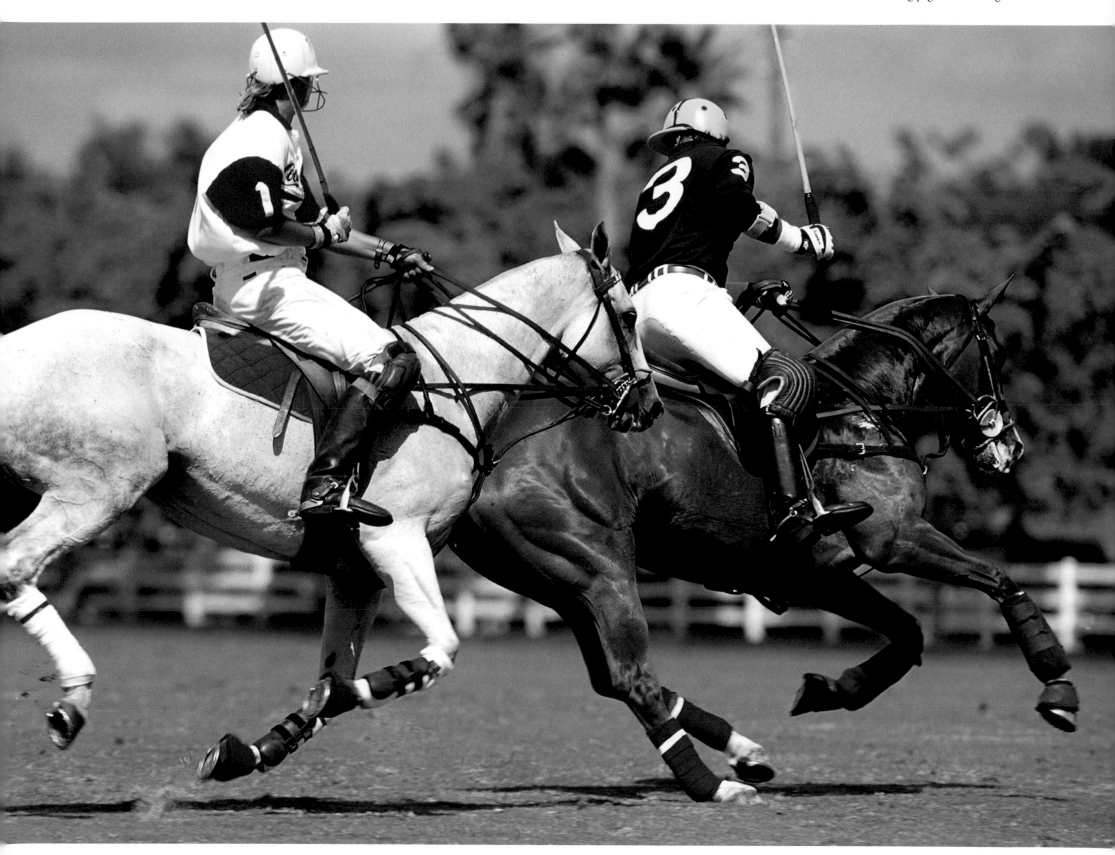

Revlon Polo Fields, Wellington, Florida

Revlon Polo Fields, Wellington, Florida
following pages 32-33

29

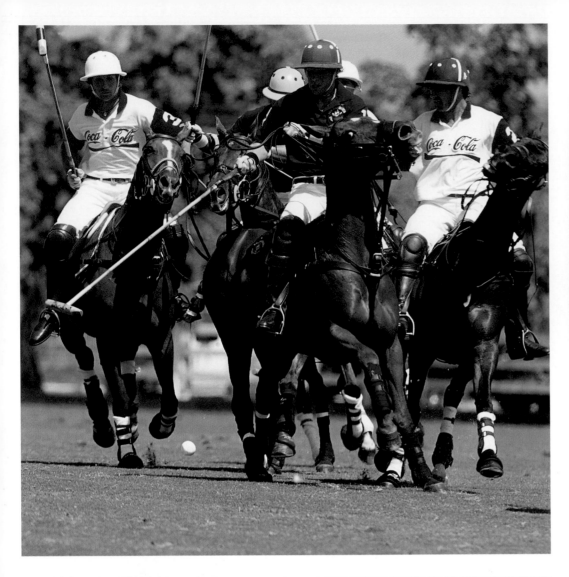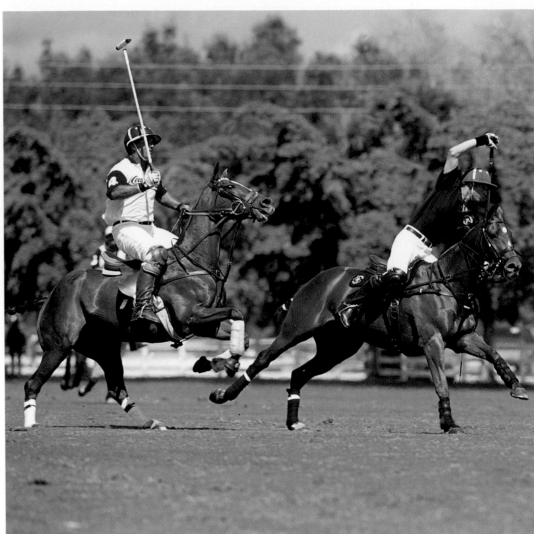
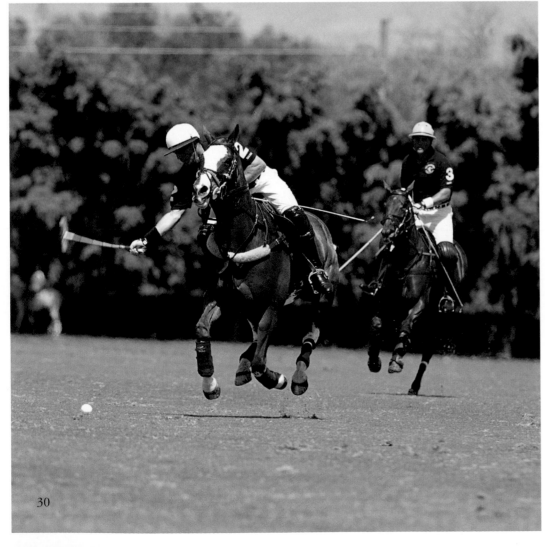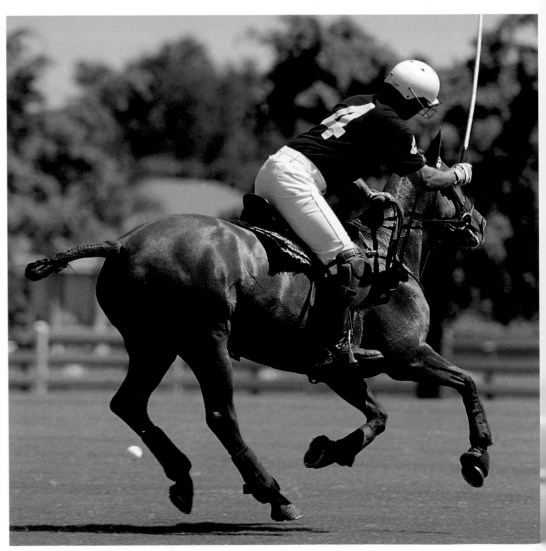

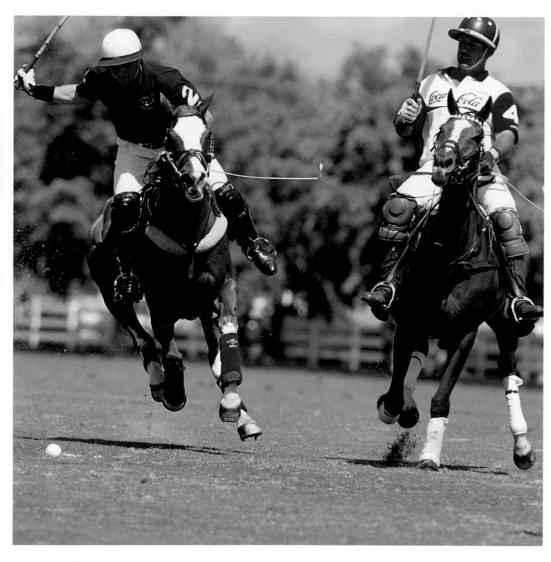
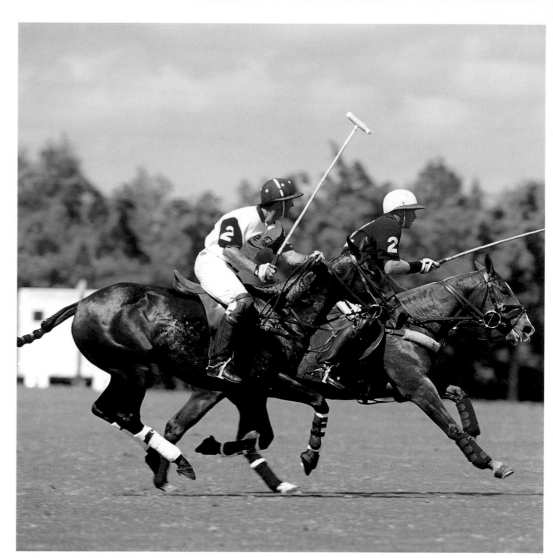
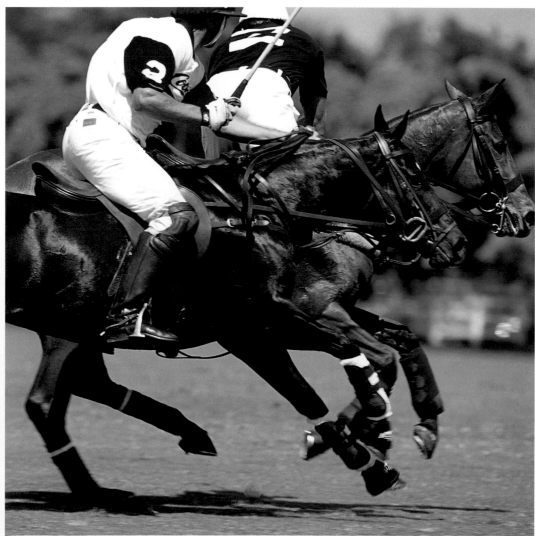
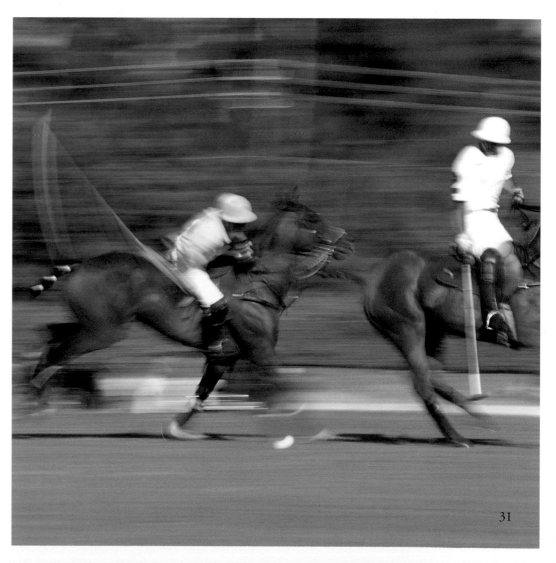

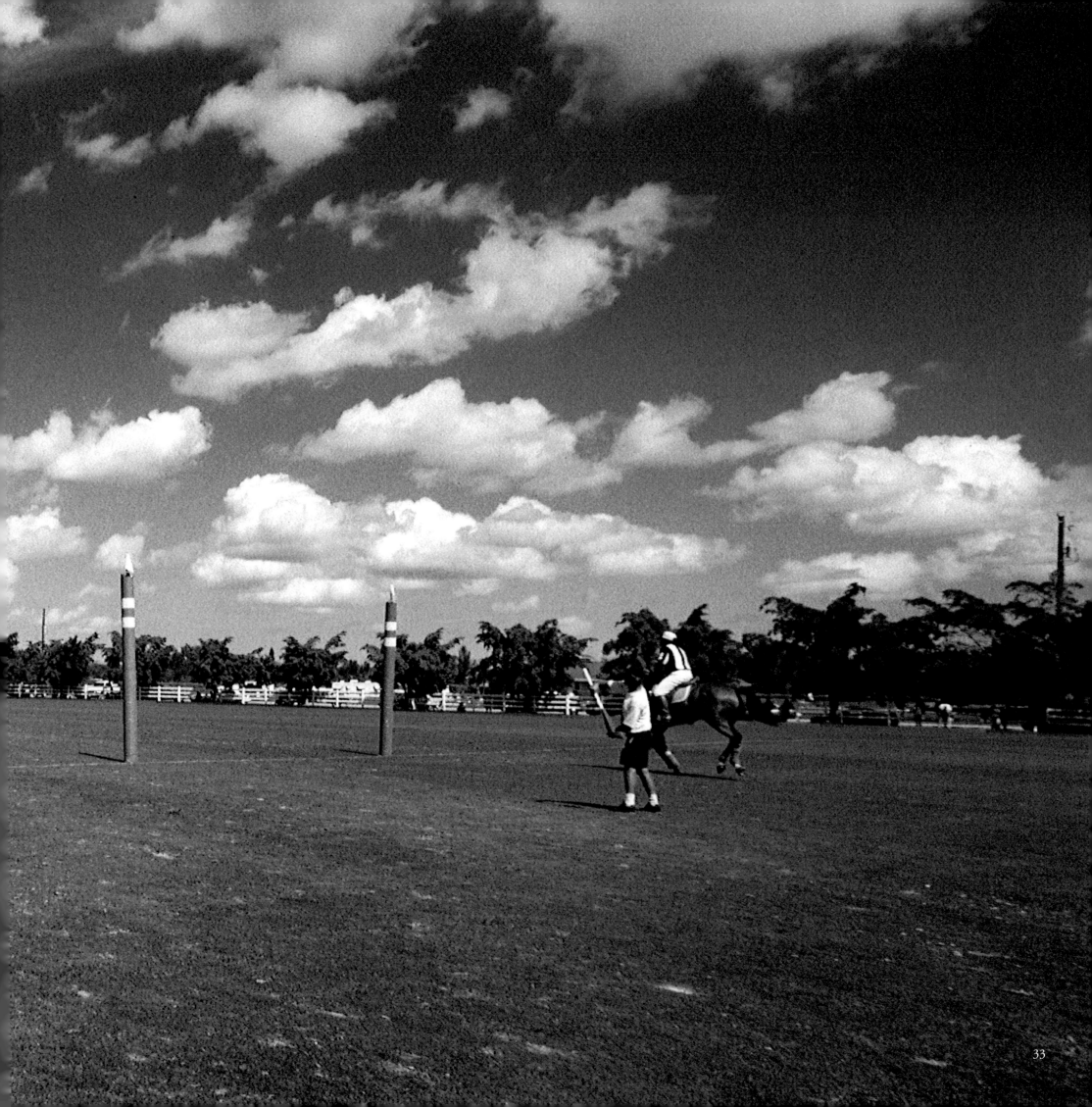

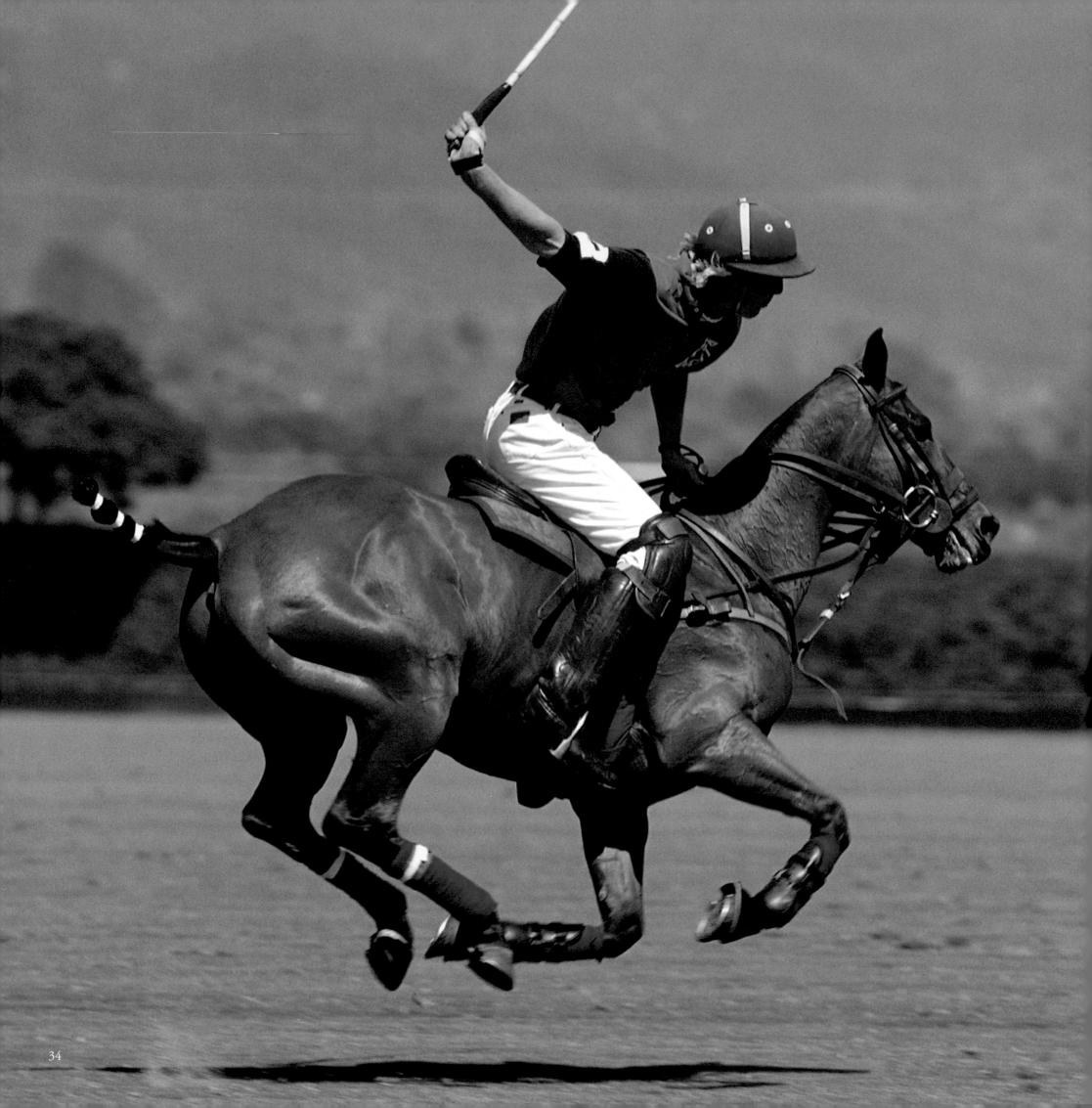

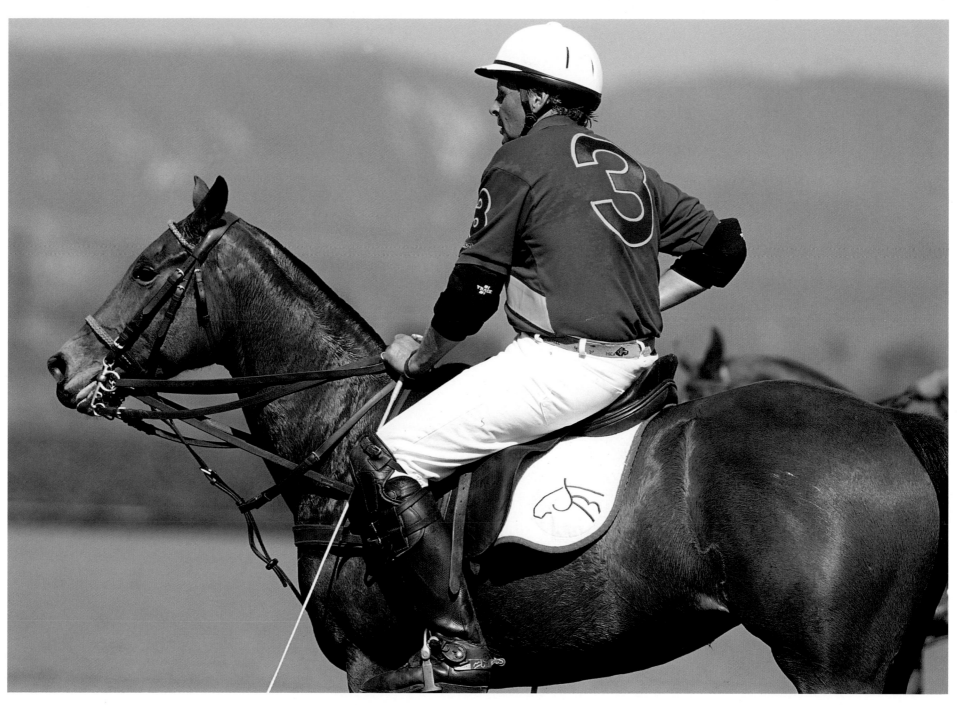

Joel Baker ready to play, Santa Barbara Polo,
Santa Barbara, California

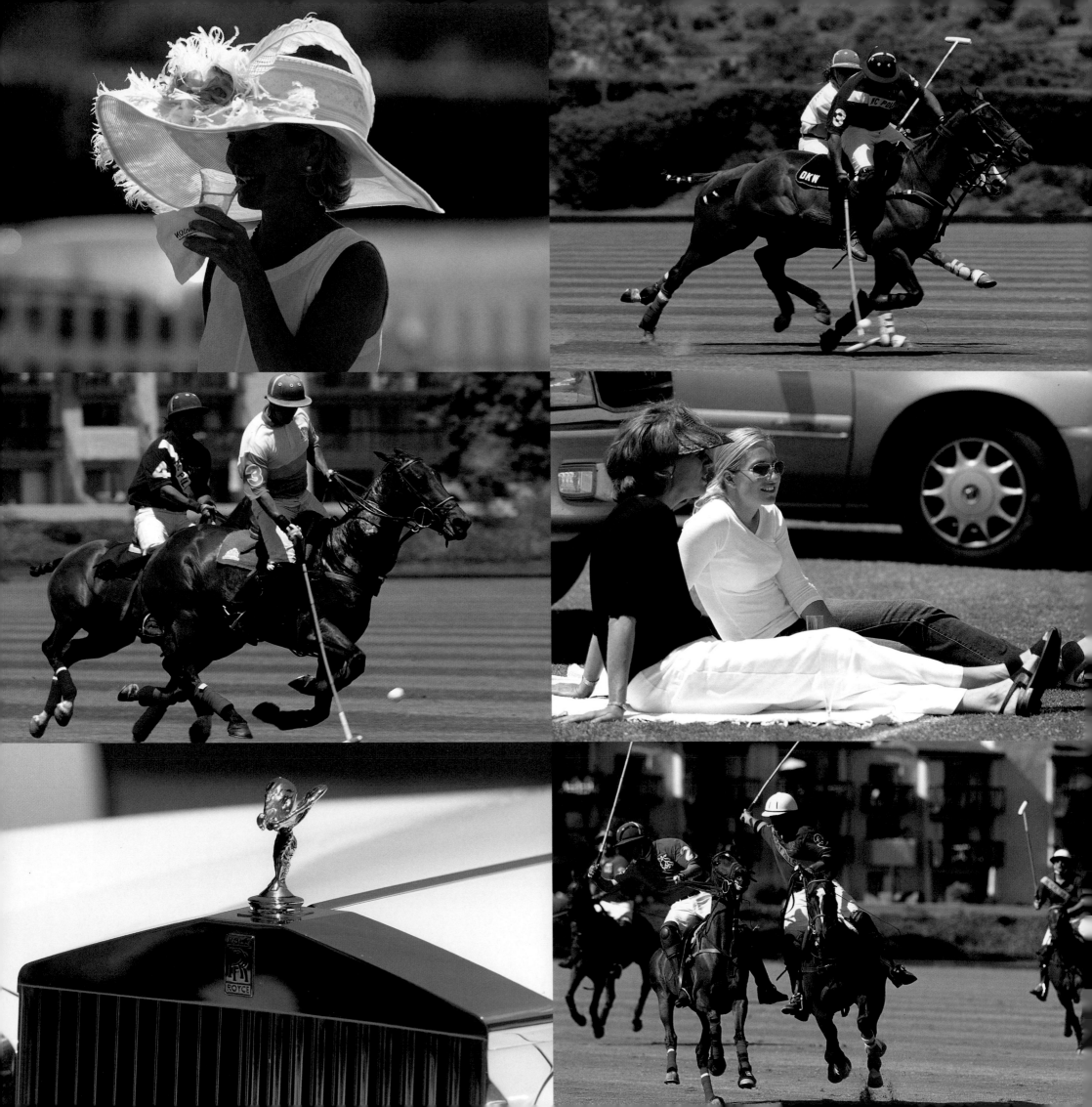

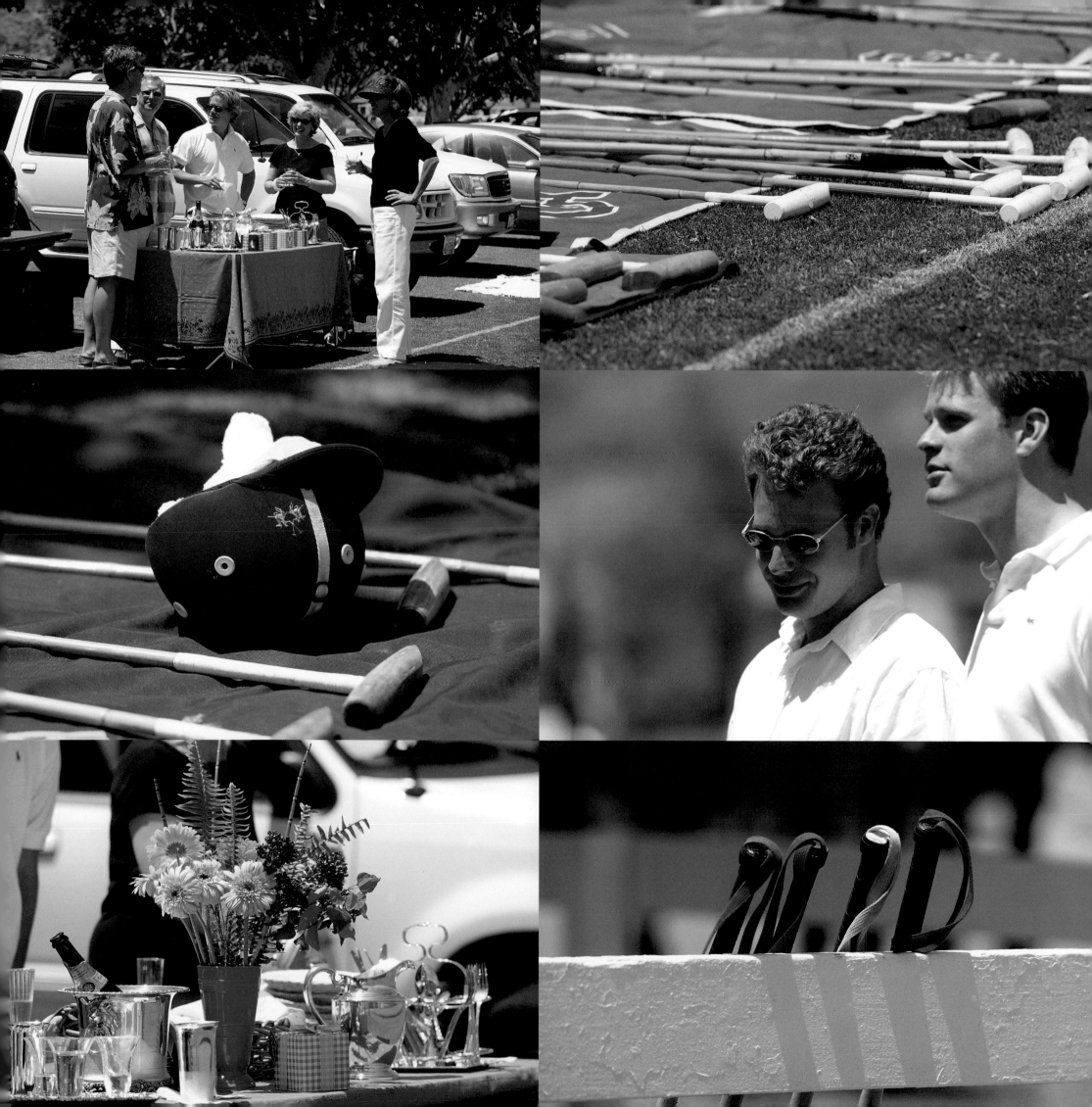

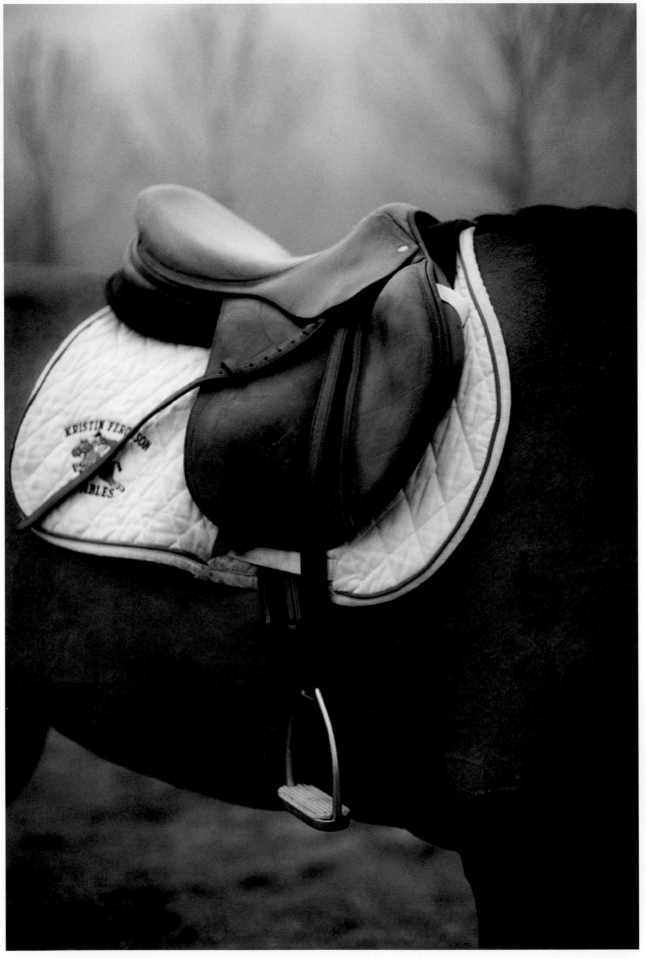

Kristin Ferguson's jumping saddle

THE ENGLISH HORSE

*T*he English horse, refined and stylish, is the sophisticated older sister of the performance horse family. Many of the so-called sport horse disciplines, notably dressage, foxhunting, and combined driving, retain the traditional flavor of their genteel roots. Braided manes, tasteful gear, and formal attire are de rigueur.

At the same time, the English horse is no sissy. Consider the demands of jumping, eventing, and grand prix dressage, and it is clear the opposite is true. To do what he does with the requisite flair, the English horse must be a superb athlete with an undauntable spirit.

Perfect embodiments of these characteristics are the show jumper, the dressage horse, the event horse, the field hunter, and the combined driving horse.

THE SHOW JUMPER

This bold individual boasts the highest profile of all the English horses – literally and figuratively. His mighty haunches propel him over fences as high as his head, and his event, of all the sport horse disciplines, holds the greatest popular appeal.

Though riding has been around for many centuries, asking horses to jump over obstacles has not. Show jumping began only about a century ago, as an outgrowth of foxhunting – the origin of the grand prix jumper rider's traditional red coat. The first jumping contests occurred in Paris in 1866, and the new sport was featured in New York's Madison Square Garden at the first National Horse Show, in 1883. Jumping contests debuted in the Olympics at the 1900 Paris Games, and the Federation Equestre Internationale (FEI) was established in 1921 to standardize show jumping rules.

The popularity of show jumping began to soar in the 1950s with the advent of television coverage of the Olympics. Grand prix (from the French, meaning 'richest or greatest prize') show jumping debuted in America in 1965, in Cleveland, Ohio. When American jumpers met with success in the Olympics in the eighties and nineties by winning a total of six medals, two of them gold, the sport's popularity in the United States skyrocketed.

Show jumping is a perfect spectator sport – fast, thrilling, and easy to understand. Contestants must negotiate fifteen to twenty obstacles, up to five and one-half feet in height and seven feet or more in width. Knockdowns, refusals, falls, and exceeding the time limit bring faults. Though a jumper's mandate is straightforward, helping him achieve it is not.

"Riding a show jumper is an art," observes Kristin Ferguson, who develops winning hunters and jumpers at her facility in Santa Ynez, California. "You have to know when to help your horse, and when to stay out of the way and let him do his thing. If you interfere, you can cause him to make mistakes."

In show jumping's early days, even nondescript horses could become champions. Snowman, a gray farm gelding of unknown breeding, was saved from the slaughterhouse to become one of the top American show jumpers of the late fifties and early sixties. He became so popular with the American public that a book was written about him, and he was even featured on the pages of *Life* magazine with another fifties icon, Marilyn Monroe. Nautical, a palomino half-Quarter Horse, who was an international-caliber competitor along with Snowman, was immortalized in the Walt Disney movie, "The Horse With The Flying Tail."

Today, now that courses have become more difficult and technical, and timed jump-offs are commonplace, agility and speed are paramount. For this reason, Thoroughbreds and European warmbloods – especially those with plenty of Thoroughbred blood – prevail. In addition to being fabulous athletes, jumpers must be intrepid, sometimes to the point of roguery.

"I had a mount that came to me as a bad actor," recounts Ferguson. "He would rear and refuse to go forward. But once I channeled his energies into the sport, he never had a rail down in competition. His attitude was, 'I am *not* going to hit that,' and he'd leap as high as he could at every jump. It felt as if we were in the air forever. I'd actually have time to think, 'Wow...this is incredible.'"

The best jumpers are also self-confident and they inspire confidence in their riders. Lauren Hough, who placed sixth in team competition at the 2000 Sydney Olympics, says her Holsteiner gelding Windy City is a perfect example.

"He's small, and not really built to be a grand prix jumper, but he's a fighter— he wants to win," says the Floridian. "He's sort of the opposite of Clasiko [her Olympic mount, also a Holsteiner], who really looks the part. But he's got a lot of 'try,' and I trust him completely." That trust was tested at the Nations Cup in Calgary in 2001, when Windy City spooked at a gimmicky fence known as the bicycle jump.

"It consisted of a real bicycle, and didn't even look like a jump," Hough recalls. "He went to leave the ground, then changed his mind and put his feet back down." Hough flipped over his head and was knocked unconscious. When she came to, she insisted on going back into the arena.

O ELEGANT CREATURE, OF ALL, MOST PREFERRED, THAT MOVES LIKE A DANCER AND SOARS LIKE A BIRD. ALL CADENCE AND BRILLIANCE AND VIGOR AND FORCE: O ELEGANT CREATURE, MAGNIFICENT HORSE.

...Anonymous

"I knew his spooking was a freak thing, and I had total faith in him," she says. "I knew he wouldn't make the same mistake twice. And he didn't – he soared over it the second time." The Canadians, impressed by both horse and rider, made a promotional film of the incident, titling it "American Courage."

In a sport that demands it, courage is the hallmark of a great show jumper.

THE DRESSAGE HORSE

With grace and elegance, the dressage horse excels in a discipline that is to some esoteric, to others the pinnacle of equestrian endeavor. It is a marriage of art and sport, calling for the athleticism of gymnastics, the precision of figure skating, and the subtlety of ballet. More than one world-class rider has maintained that the goal of dressage is to make the horse more beautiful – physically, mentally, and in motion. It renders him supple, responsive, and obedient, so that he moves freely and energetically, with pure gaits and to the utmost of his athletic ability.

The word dressage (which rhymes with massage) comes from the French verb *dresser,* meaning 'to train.' Dressage horses do not jump, but they execute exacting patterns, sometimes to music, with impulsion and brilliance. Like a dancer, they maintain cadence and rhythm as they flow in straight lines and graceful curves, collecting and extending their steps, sometimes gliding laterally across the arena. At the upper levels of dressage competition (the highest of which is grand prix), they perform challenging movements including repeated changes of lead, trotting in place, and pirouettes at the canter. Piloting an animal thus engaged can be an almost transcendental experience.

"On the best horses," says Debbie McDonald, the 2001 National Grand Prix champion with Brentina, "you can just *think* something, and have it happen underneath you. It's as if they're reading your mind."

The roots of dressage are in classical horsemanship. Xenophon, the Greek historian and equestrian instructor, wrote manuals on training warhorses circa 380 B.C. Many of his principles – which stress attending to the horse's mind as well as his body, and using patience and positive reinforcement over punishment – are still in use today.

Medieval knights used many dressage principles to train their warhorses. During the late Renaissance period, the type of riding known today as dressage was recognized as an art in its own right, the equal of music, painting, and literature. Elegant riding academies, the most notable being the Spanish Riding School of Vienna, sprang up across Europe, and riding instruction was an essential part of every young nobleman's education.

Dressage became a competitive activity in the early 1900s, debuting in the Olympics at the 1912 Stockholm Games. Though Germany currently dominates dressage competition worldwide, the United States has earned four Olympic team bronze medals in recent years: 1976, 1992, 1996, and 2000.

Dressage tests are scored on individual movements. Competitors receive a written record of their test that enables them, like golfers, to compete against themselves in a never-ending quest for perfection. Because it stresses precision and finesse over risk-taking, dressage appeals to middle-aged baby-boomer equestrians, particularly women.

At the lower levels, any horse with decent movement and a good mind can compete in dressage – and be made better by it. At the highest levels, where a competitive mount must have three superior gaits and a good work ethic, the European Warmblood, long bred for precisely these attributes, excels.

McDonald's Brentina, a 16.2-hand German Hanoverian, has everything a top rider looks for. "Her cadence and rhythm are incredible," says the Idaho horsewoman. "The feeling when I'm riding her is of floating. It's as if her feet aren't even touching the ground." McDonald also praises Brentina's willingness to give her all in competition – even under adverse conditions. She points to the mare's performance at the selection trials in Gladstone, New Jersey, for the 2002 World Equestrian Games.

"An allergy caused her to break out in huge hives less than an hour before our test," she relates. "Two vets were working on her, giving her fluids. I'd about given up hope, but we decided to let her make the call on whether or not to compete. In the warm-up, she told me she could do it. Then she gave me one of the best tests we've ever had – in spite of the hives, and the extra difficulty she had breathing in that East Coast humidity."

The paradox of dressage is the need for both brilliance and precision. For a horse to move extravagantly, yet remain responsive to his rider's bidding, requires both exuberance and submission – contradictory impulses. The necessary mental gymnastics mean top mounts are often sensitive to the point of volatility.

Charlotte Bredahl, who with her gelding Monsieur was part of the bronze medal U.S. team at the 1992 Barcelona Olympics, says the imported Danish Warmblood was an anxious, insecure horse who bucked her off the first time she rode him at home.

"He was scared of everything," says the Californian, adding that the gelding had to be hand-walked around showgrounds for hours before he felt comfortable enough to compete. At the Olympic selection trial in Orlando, Florida, in early 1992, a noisy group of schoolchildren distracted the gelding, ruining his score. The next day, however, the horse performed brilliantly, putting the pair back into contention for an Olympic berth.

"It was as if he was guided by a larger-than-life force, and knew how important this competition was," marvels Bredahl. "I was crying when I came out of the arena – I'd never felt so at one with my horse."

This feeling of partnership, arguably stronger between dressage riders and their horses than between any other competitive team, is the dressage horse's greatest gift.

THE EVENT HORSE

Take show jumping and dressage, and add a third element – one in which horses must prove their mettle by sliding down steep embankments. Plunging into unfathomable water. Tackling banks so huge that some horses opt to land on them momentarily as they power over.

This is the mission of the event horse, the "iron man" of the horse world. His sport – combining dressage, stadium jumping, cross-country jumping, and more – is the most demanding of all the equestrian disciplines, an extreme test of vigor, valor, and inventiveness.

"Cross-country fences pose tremendous challenges," says David O'Connor, winner of the United States' first-ever individual gold medal in eventing at the 2000 Sydney Olympics. "They are puzzles that must be solved. Champion event horses all have the ability to solve hard puzzles and meet that challenge."

Created at cavalry schools in the early twentieth century, eventing was intended to test the fitness, training, and versatility of army horses. Originally called "The Military," the sport has since gone by other names, including combined training and three-day eventing. The latter denotes the length of

time typically needed to complete the event's three separate phases. Dressage takes place on the first day, endurance (the cross-country course, preceded by six to twelve miles of trotting and cantering, plus a low-hurdle steeplechase) is held on the second day, and the horses compete in stadium jumping on the third day. The cross-country segment – in which horses brave obstacles with names like The Coffin, The Trout Hatchery, and The Elephant Trap – is the sport's signature phase, and weighted accordingly in the scoring.

The first *Militaire,* as it was called then, took place in 1902. Eventing joined the Olympics at the 1912 Stockholm Games and involved only cavalry officers; military horsemen continued to rule the sport for decades. Eventually eventing became an amateur-dominated sport; today, it offers many levels to accommodate riders of all abilities.

The sport is not without risk, and falls do occur. Women were excluded from competing until 1964, and the sport's current rules place a heavy emphasis on safety for both horse and rider. Precautions such as special helmets, protective vests, and equine leg wraps are now quite common on cross-country courses.

Thoroughbreds, with their unequalled speed and endurance, dominate the top levels of eventing, although horses of all breeds compete at lower levels. An event horse must be robustly athletic, structurally correct, and mentally stable to withstand the rigors of the sport. Karen O'Connor, an Olympic medalist and second half of the Virginia-based O'Connor Event Team, says the best event mounts have a zest for competition. "A great horse will fight to be excellent," she says. "He may not be competitive in the same sense we are, but he does enjoy working once he's fit. Event horses are very purposeful animals."

Furthermore, notes David O'Connor, they do seem to know the difference between competition and practice. "They're often withdrawn right before it's their turn to go on course," he says. "Then, afterwards, their personality changes. They're much more sociable and outgoing – they want to 'talk' to everyone. It's as though they realize they've done something important."

O'Connor's Irish Thoroughbred Giltedge did something extremely important in the team competition at the 2000 Olympics, along the way substantiating his puzzle-solving prowess. "He hit the fence with his hind legs going into the water," O'Connor explains, "and it threw me up onto his neck. At that point, it could have gone either way. But he got quick and smart with his feet, and pulled it out. He solved the problem on his own, something he does for me consistently."

Eventing's extreme demands require both horse and rider to be in superior physical shape. "The conditioning of an event horse is like that for a marathon runner," says O'Connor. "The level of fitness he needs is not far from that of a racehorse at the track. And although the event horse must be *that* fit, he must still be cool and calm enough to perform reliably in the dressage. That takes an incredibly flexible mind."

Flexibility, versatility, athleticism, and courage – all are hallmarks of the high-level event horse.

THE FIELD HUNTER

Another grand galloper of the countryside is the foxhunting horse, or field hunter. His job is to carry his rider on adventures that combine the thrill of the chase, the exhilaration of jumping, and the fascination of watching hounds across ever-changing natural terrain. Traditional foxhunting is a bit of a spectacle, with its dogs, horns, and colorful hunt coats. Small wonder that the sport has been the subject of art and literature for centuries.

Although mounted hunting dates back to antiquity, modern-day foxhunting was born in eighteenth-century Britain, when the Enclosure Acts added walls and hedgerows to the British countryside. With these barriers in place, jumping became a necessary part of foxhunting, a sport whose aim was to control populations of red fox, considered vermin by British farmers and shepherds.

American colonists brought the sport with them from England and were devotees; George Washington even had his own pack of hounds. The first organized hunt took place in Virginia, still the leading foxhunting state today, followed by Pennsylvania and Maryland. American foxhunting differs from that of the British Isles in that the emphasis is on the chase, rather than the kill. If the hunted animal "goes to ground" (that is, enters a hole in the earth), the hunt ends and is deemed successful. Also, in the United States, the quarry is as likely to be coyote as it is red fox or grey fox, especially in the West. Bobcats are even sometimes chased in the Southeast.

Mounts for foxhunting are chosen on the basis of individual merits, rather than breed, and all types of horses appear in the field. A good hunter is a reliable jumper with a mind that enables him to withstand the commotion of the sport – galloping comrades, baying hounds, the hazards of foliage and footing. He also has an uncanny instinct for survival.

"He looks out for himself and his rider," says Cindy Martin, a member of the venerable Los Altos Hunt near San Francisco. "You might come upon a fence you haven't used in some time, and discover it now has groundhog holes on the takeoff and swampy footing on the landing. Or, particularly in the West, you might meet a fence flanked with barbed wire past the wings on both sides. At times like that, you need to know your horse is going to pick his way carefully, clear the obstacle, and be handy on the landing. And that's exactly what the good ones do."

Experienced horses also seem to appreciate the sport as much as their riders do. "I've seen horses come out of their trailers quivering with anticipation on hunt days," says Martin. "During the hunt, your horse's ears swivel, following the hounds' every move.

"Then, as you're trailing the pack at a quiet trot, one of the hounds suddenly 'speaks' – the baying that indicates he's discovered a scent line. Your horse's head pops up, and his whole demeanor changes. A moment later, the hounds go into 'full cry,' and your horse's body language says, 'Oh, boy! Now we get to *go!*'"

In addition to relishing the chase, the best field hunters possess a certain forbearance that endears them to their riders. "At rest stops," says Martin, "it's not unusual to see a horse standing, hip cocked, and a dozen or more hounds packed under and around him, panting in the shade of his body. The horse's attitude seems to say, 'Yep, this is my job. These are my hounds.' It's something to see."

It is this kind of companionship that makes a good field hunter the very best element of foxhunting.

THE COMBINED DRIVING HORSE

The term "horse-drawn carriage" brings stately coaches and elegant four-in-hands to mind. The event known as combined driving does indeed boast such images, but the true nature of this relatively new equestrian sport is something altogether different. A more apt image for the marathon phase of this event might be that of a stagecoach pursued by Indian warriors, or a chariot in battle at close quarters.

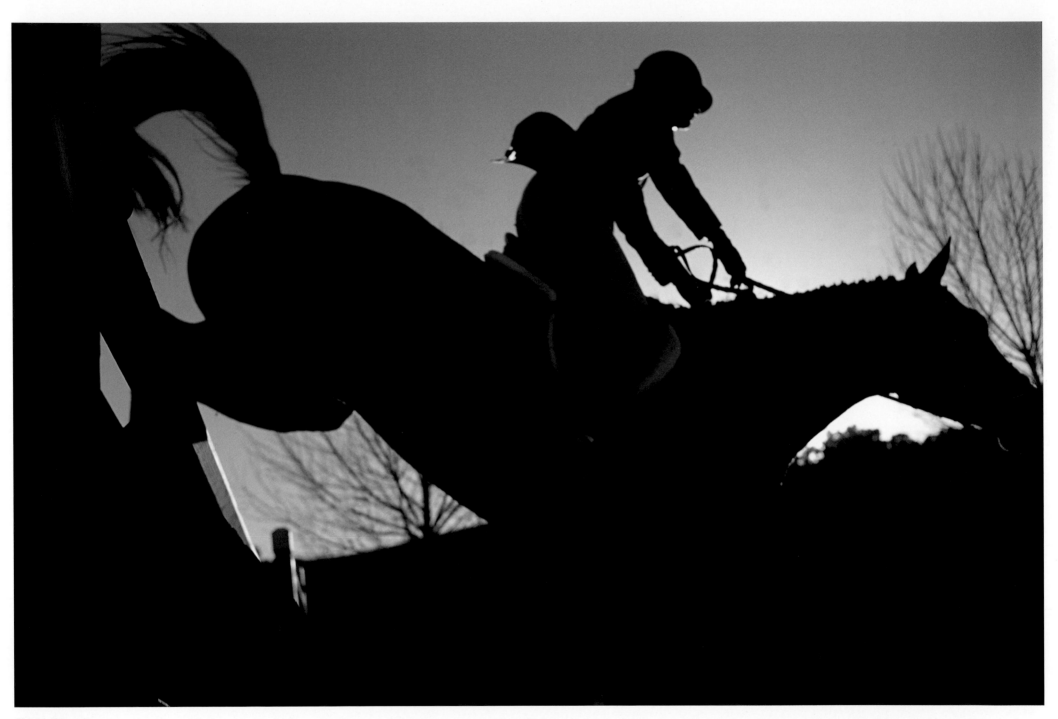

Kristin Ferguson,
Santa Ynez, California

42

"It's definitely the marathon phase that attracts people to this sport," says Fritz Grupe, an experienced driver who hosts combined driving events at his Shady Oaks farm in Lodi, California. "Discovering what harnessed horses are capable of is exhilarating."

The concept of horses in harness is an ancient one; some experts believe the tamed horse was driven even before he was ridden. Images from antiquity depict the harnessed horse at work in war, hunting, and in ceremonial processions. The driven horse continued to be humankind's preferred mode of transportation up until about 100 years ago with the advent of the internal combustion engine. Even when automobiles took over the roadways, enthusiasts continued to drive horses in harness as a leisure activity. Competitions for teams and pairs of horses had become well established in Europe as of the late nineteenth century.

The sport of combined driving, however, did not appear until the middle of the twentieth century. It was the brainchild of Britain's Prince Philip, who devised a competition based upon the challenges of three-day eventing. Like the ridden event, the combined driving event consists of three phases contested over three days. Divisions are for one, two, or four horses or ponies in harness; the carriage, with its whip (driver) and horses is known as a turnout.

On the first day, the presentation and dressage phase shows off the beauty and correct training of the horses through a series of compulsory figures driven in an arena at a walk and trot. The best horses demonstrate cadence, fluidity, and accuracy as they work the patterns.

On the second day, the elegance of the previous day's competition is replaced by breakneck daring. The marathon tests horses' fitness, responsiveness, and courage over a cross-country course covering five to ten miles. The timed course includes a half-dozen obstacles, usually man-made, called "hazards." These are devilish, maze-like contraptions involving fences, trees, water, and all manner of decorations. They require the turnout to make what would seem to be impossibly tight turns and double-backs. Often the "navigator," who rides in back of the vehicle, must leap into the air to lift and reposition the cart to enable a particularly tight turn. Drivers receive penalty points for every second they are inside a hazard, making for frenzied action within the mazes and galloping departures away from them.

On the third day, the cones course, driven at a smart trot, tests a horse's willingness, agility, and soundness after marathon day. The timed course consists of pairs of cones spaced mere inches wider than a carriage's wheels. A ball balances on the top of each cone; the merest touch will cause it to fall, creating penalty points.

Combined driving horses must be supple, obedient, fast, even-tempered, and brave. Any breed of horse or pony is eligible to compete, and in international competitions, breeds often vary by country. Germans favor the Holsteiner; the Dutch prefer their Dutch Carriage Horses; the British like their Welsh Cobs.

In the United States, various breeds are used, including Morgans, Quarter Horses, Standardbreds, Norwegian Fjords, Haflinger and Welsh ponies, and even the occasional mule; Miniature Horses have their own separate divisions. Because of the unique demands of the marathon and cones phases, combined driving is one equestrian sport where hot-bloods are not preferred.

"Horses get worked up and excited in the marathon," observes Grupe, who has driven his Haflinger ponies to several North American championships. "It can be difficult to bring them back 'down' for the precision of the cones the next day. Breeds that are already high-strung by nature, such as the Thoroughbred, are not generally a wise choice for this sport."

The water hazards of the marathon call for extraordinary equine courage. "Going into water is intimidating for a horse," Grupe explains. "He doesn't know how deep it's going to be or what the traction will be like, or even what he's supposed to do when he gets in there. But any slowdown on the approach will hurt your time. To keep their pace up, horses must have total trust in their drivers, and vice versa."

Other types of hazards can be equally challenging. Grupe points to one at his facility known as the Fort of Last Appeals, a stockade with walls positioned to create a maze. To enter it, contestants must approach one of the walls head-on at top speed, and then whip around at the last minute to negotiate a ninety-degree turn.

"To the horses," he notes, "it seems as if they're headed straight into a wall. They don't know if they're going to hit it, or if they're going to go left or right to avoid it. Again, it calls for one hundred-percent trust in their driver."

Still, he adds, "My best pony, Movin Car, seems to love it. He's like a good hunting dog – he can't wait to get out there and go like crazy."

Going like crazy is just another day's work for the skilled combined driving horse.

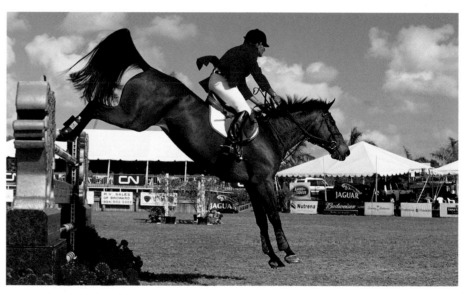

Martin Mallo riding Lady Belle,
Grand Prix jumping,
Wellington, Florida

ENGLISH HORSE

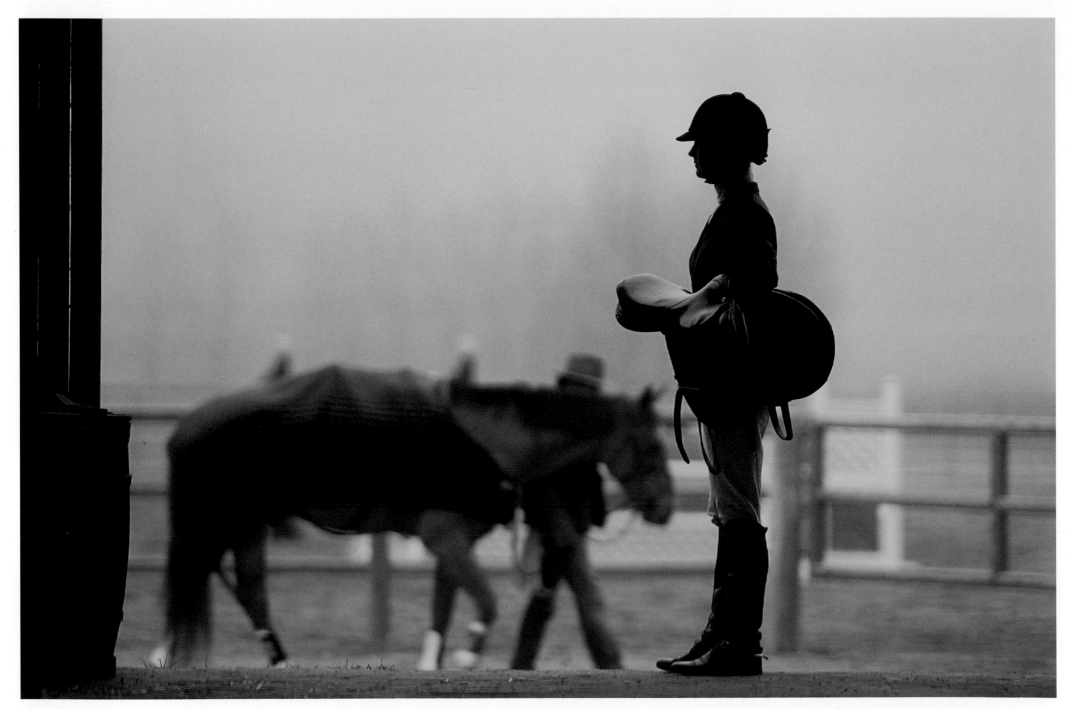

Kristin Ferguson,
Santa Ynez, California

Grand Prix jumping,
Wellington, Florida

Kristin Ferguson,
Santa Ynez, California
following page

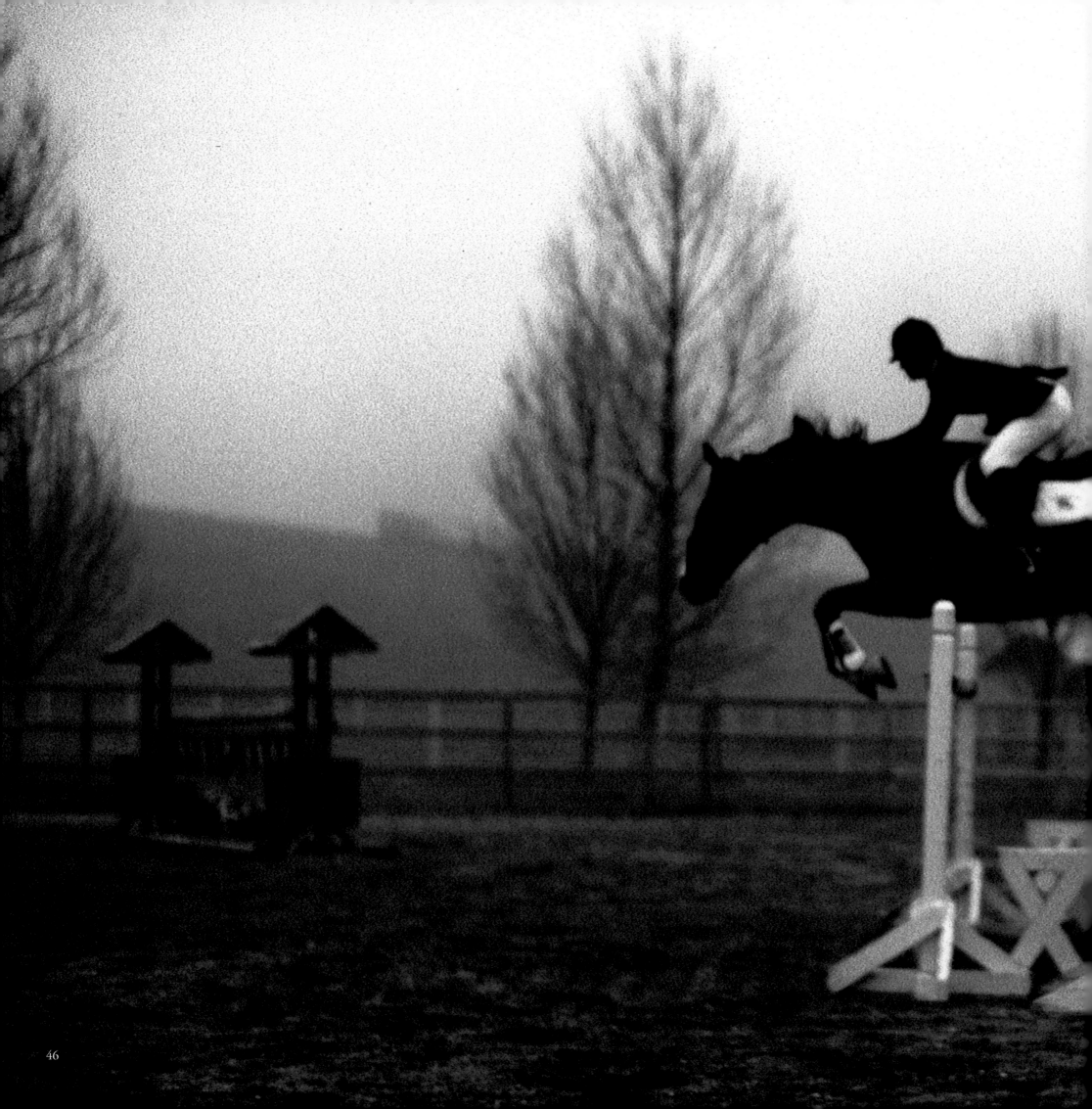

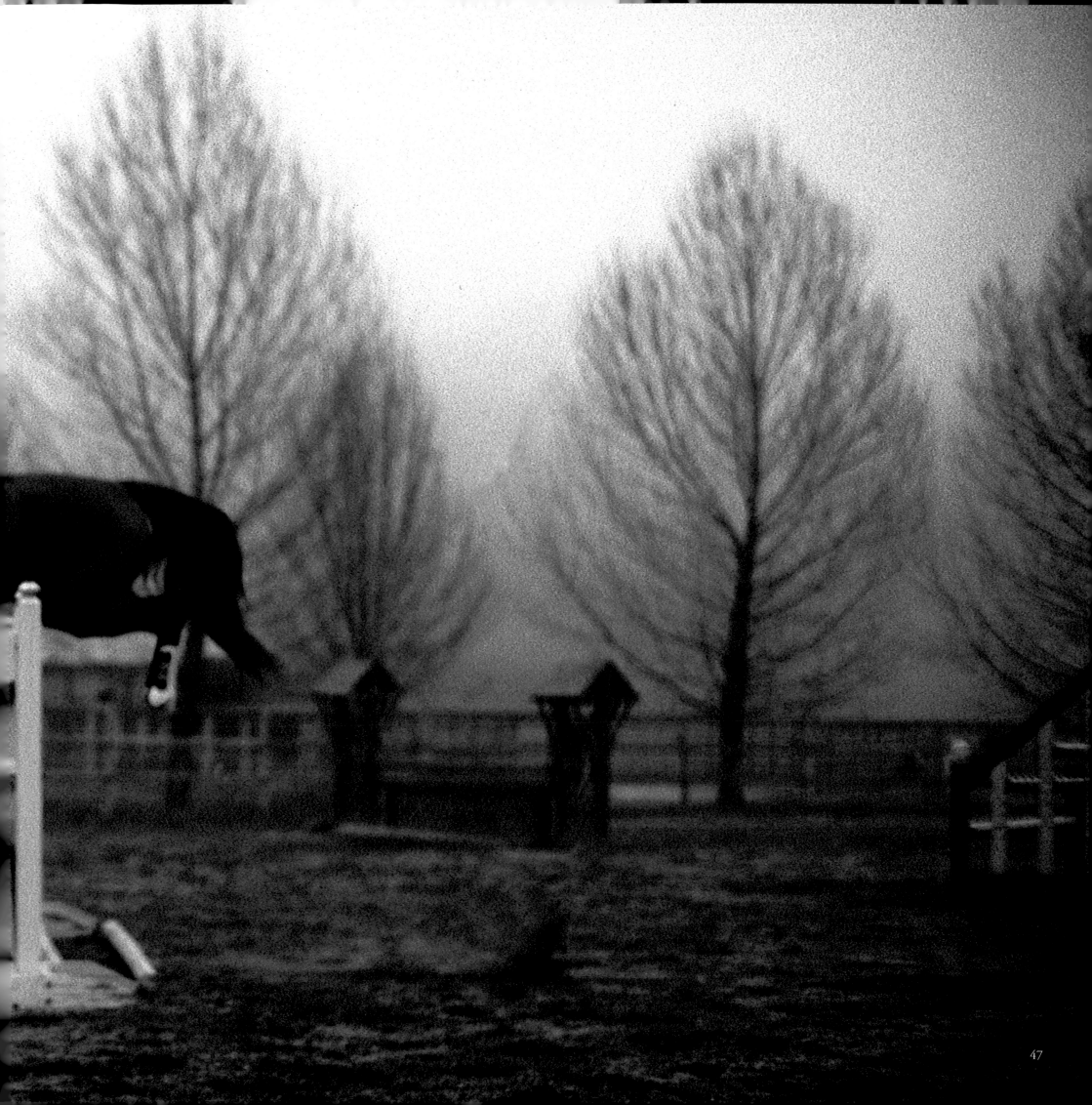

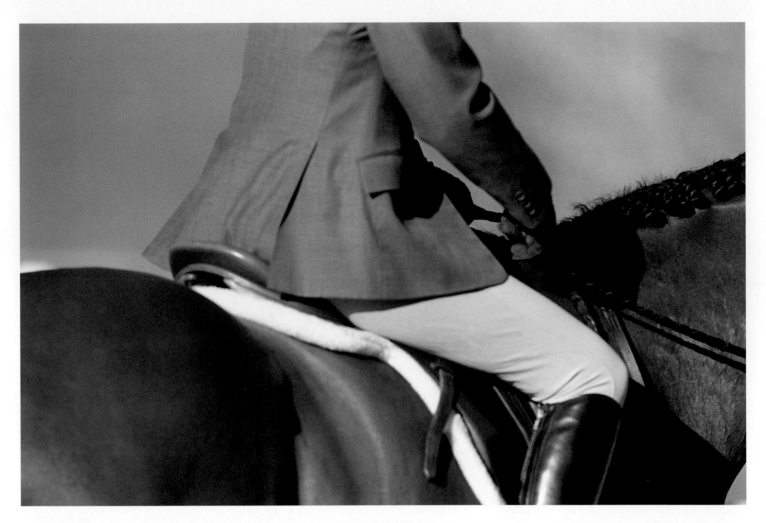

Kristin Ferguson,
Santa Ynez, California

48

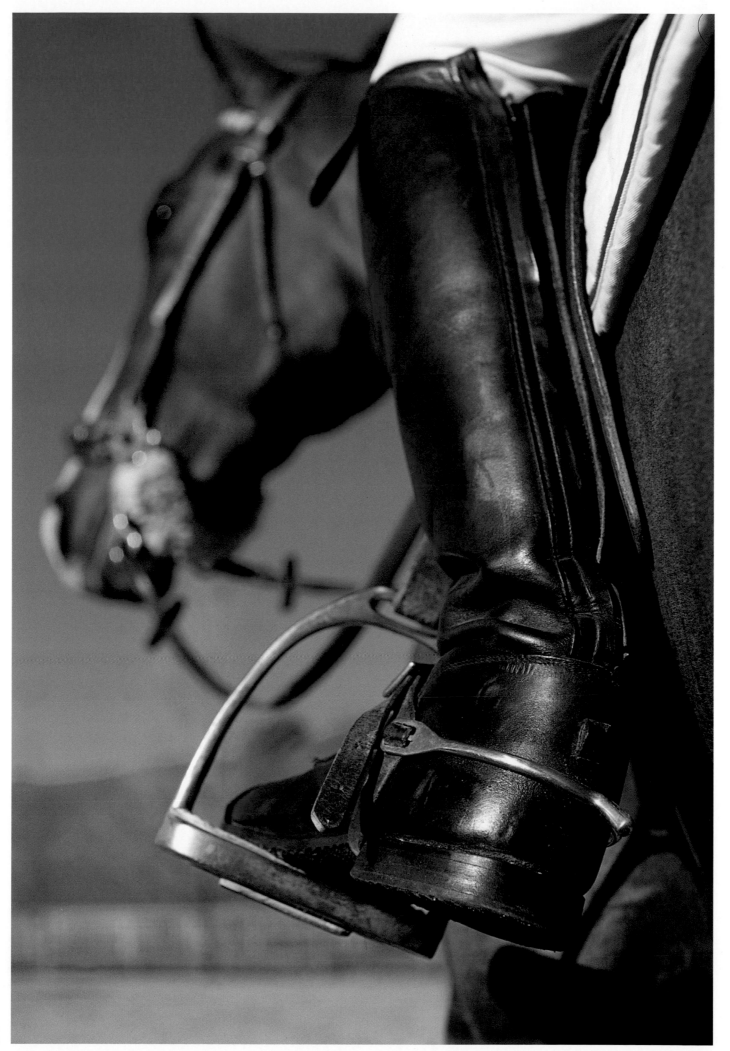

Boot and spur, Kristin Ferguson,
Santa Ynez, California

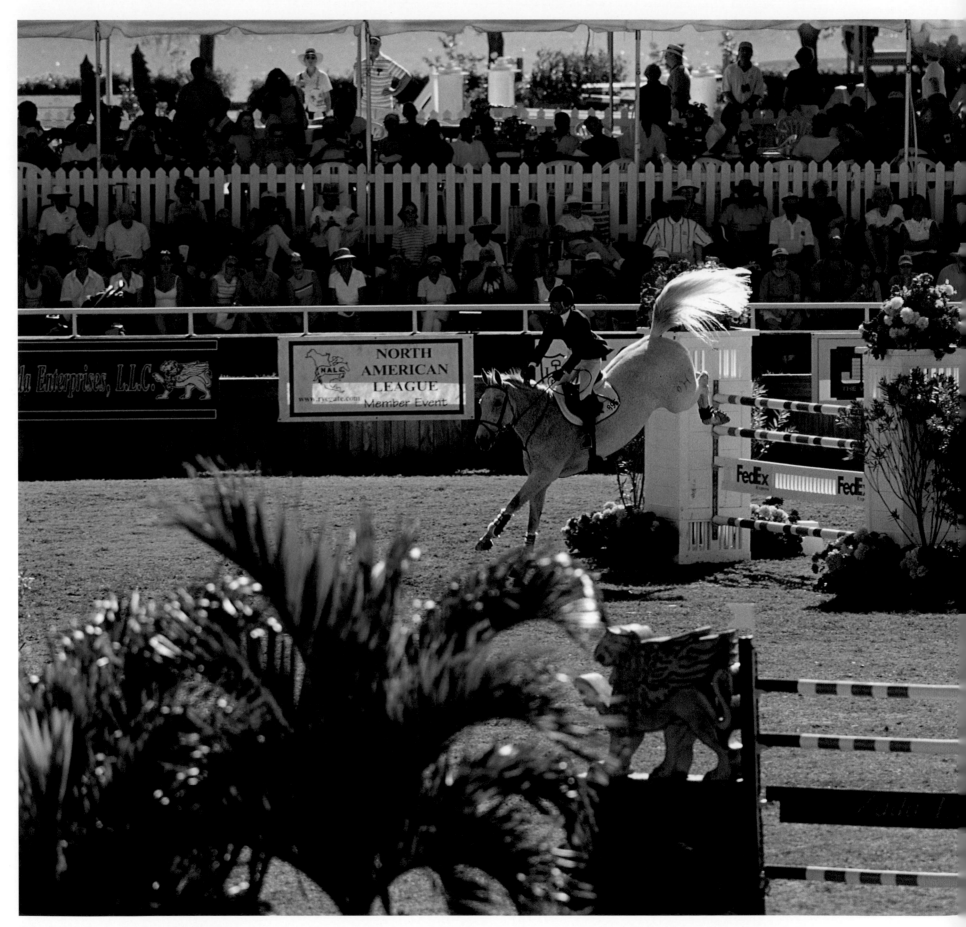

Gabriella Salick riding Sandstone Pelot De Goma,
Grand Prix jumping, Wellington, Florida

Lauren Hough riding Clasiko, Grand Prix jumping, Wellington, Florida

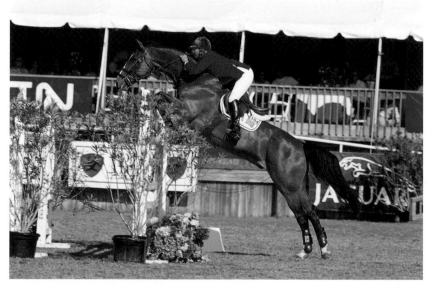

Laura Kraut riding Anthem, Grand Prix jumping, Wellington, Florida

Margie Goldstein Engle riding Hidden Creek's Perin, Grand Prix jumping, Wellington, Florida

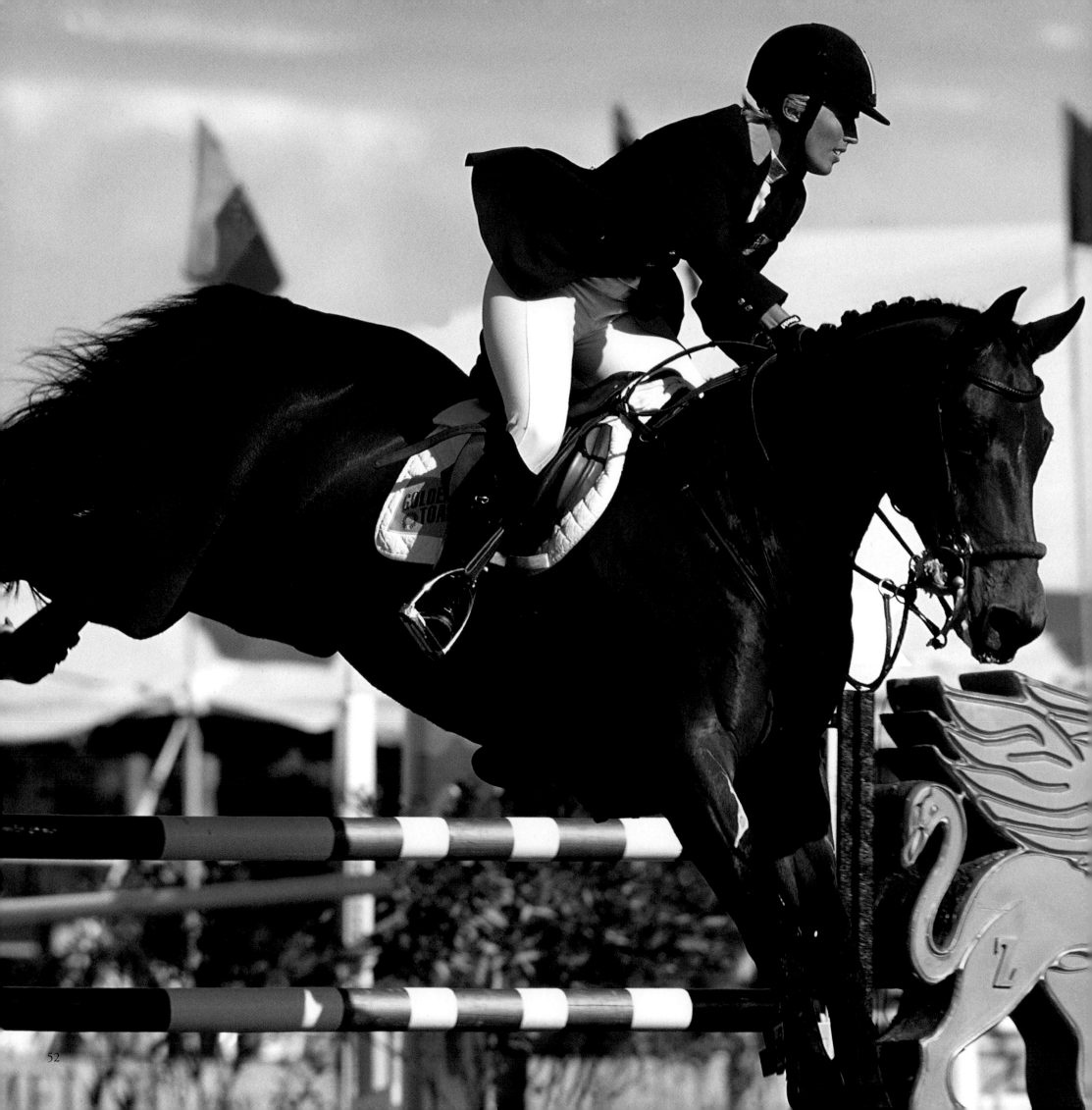

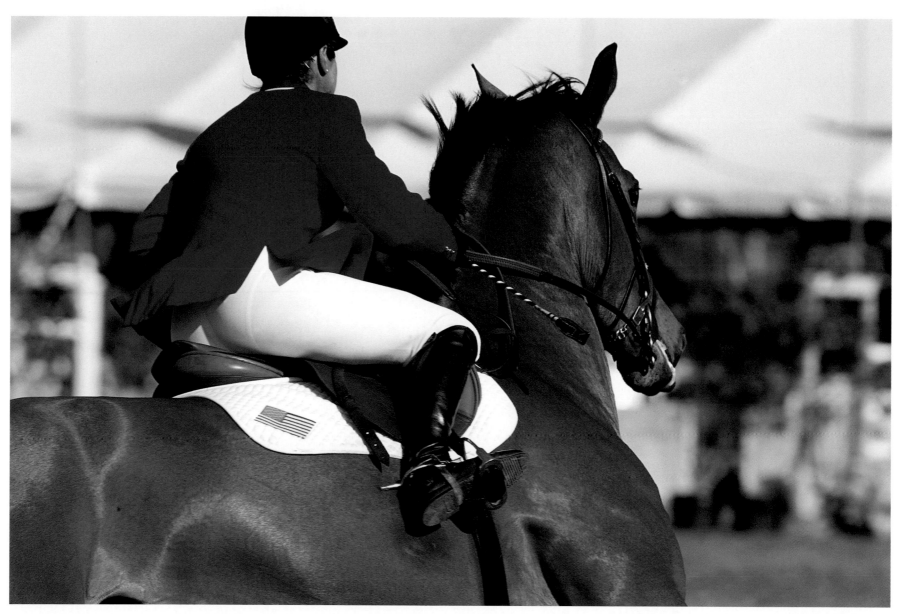

Margie Goldstein Engle
riding Hidden Creek's Perin,
Grand Prix jumping,
Wellington, Florida

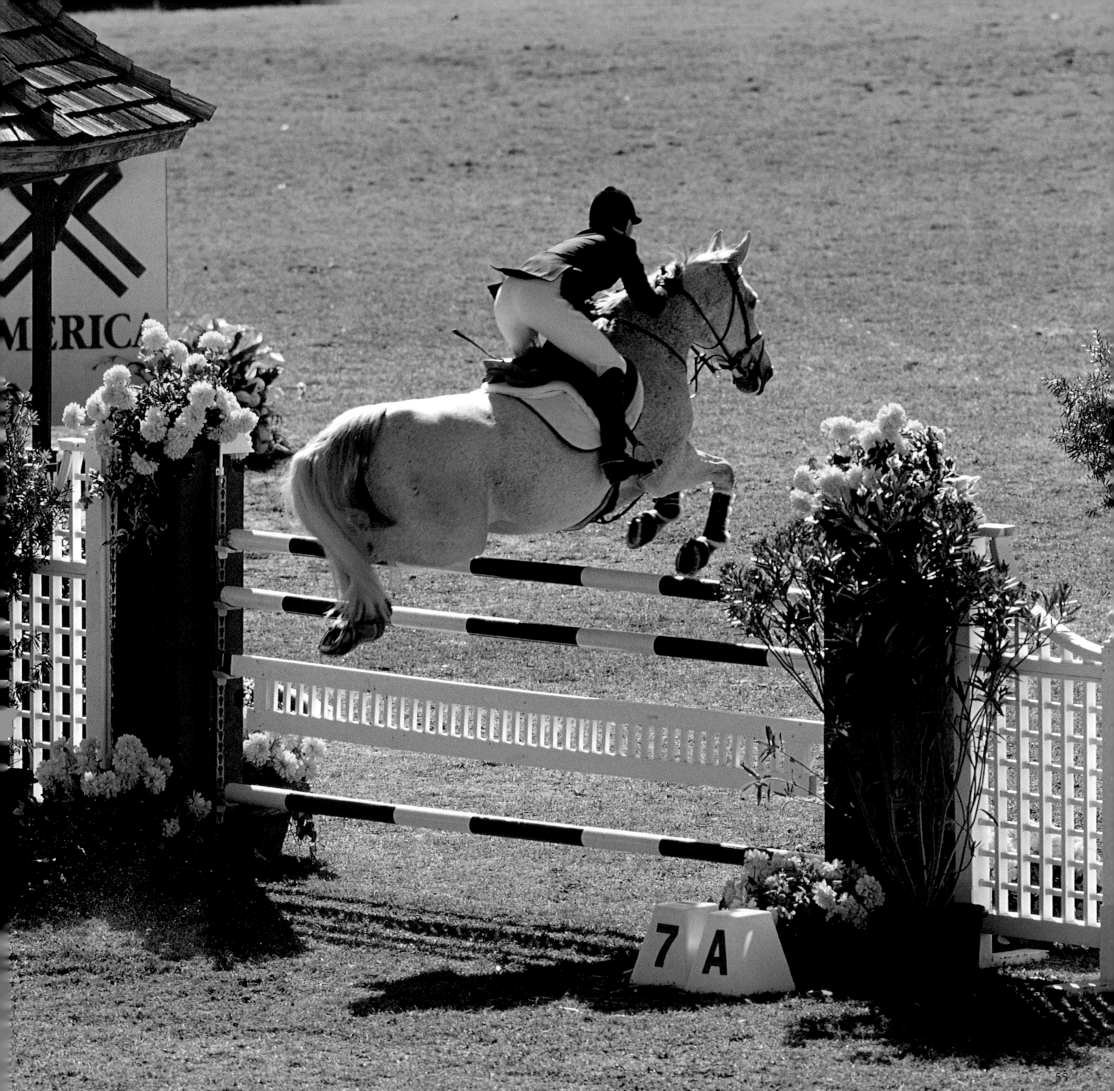

Gabriella Salick riding
Sandstone Pelota De Goma,
Grand Prix jumping,
Wellington, Florida
previous page

EVENTING

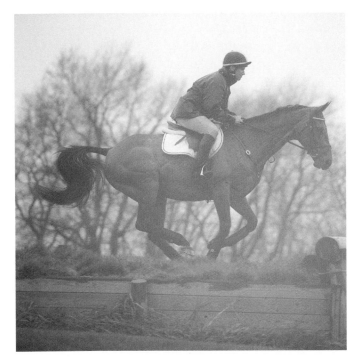
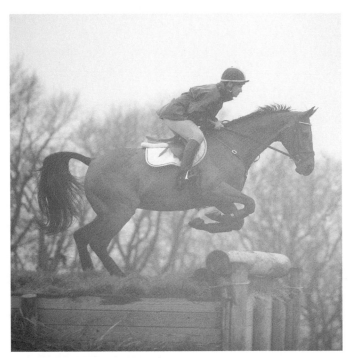
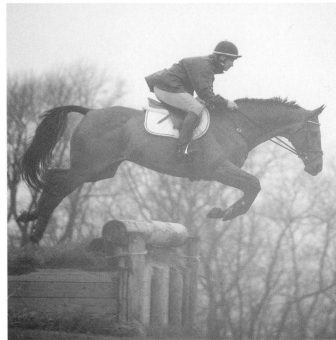

David O'Connor training, The Plains, Virginia

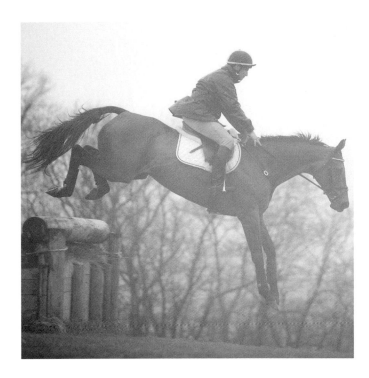

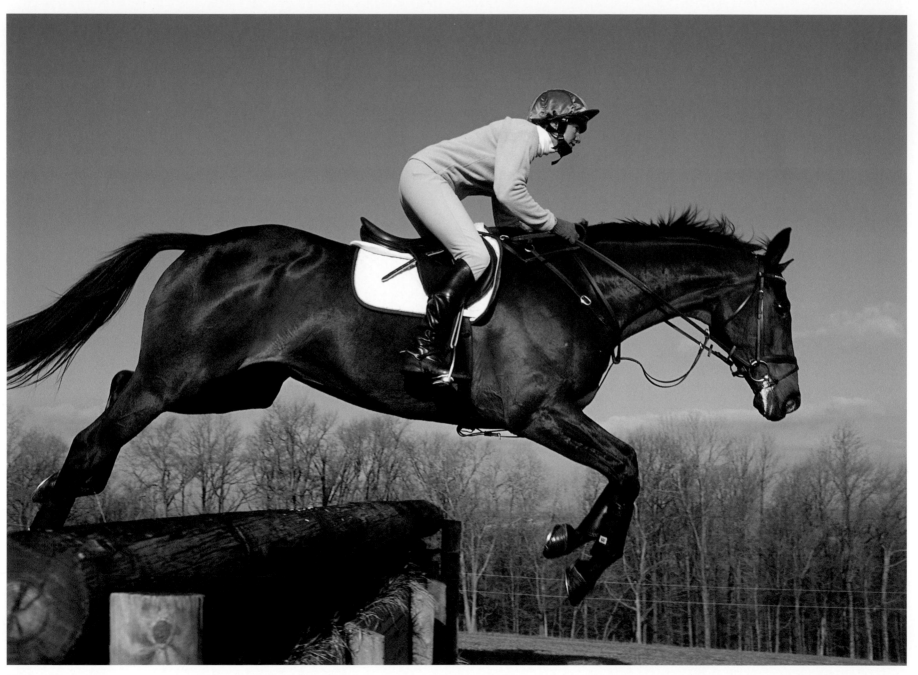

Karen O'Connor training,
The Plains, Virginia

Karen O'Connor training,
The Plains, Virginia
following page

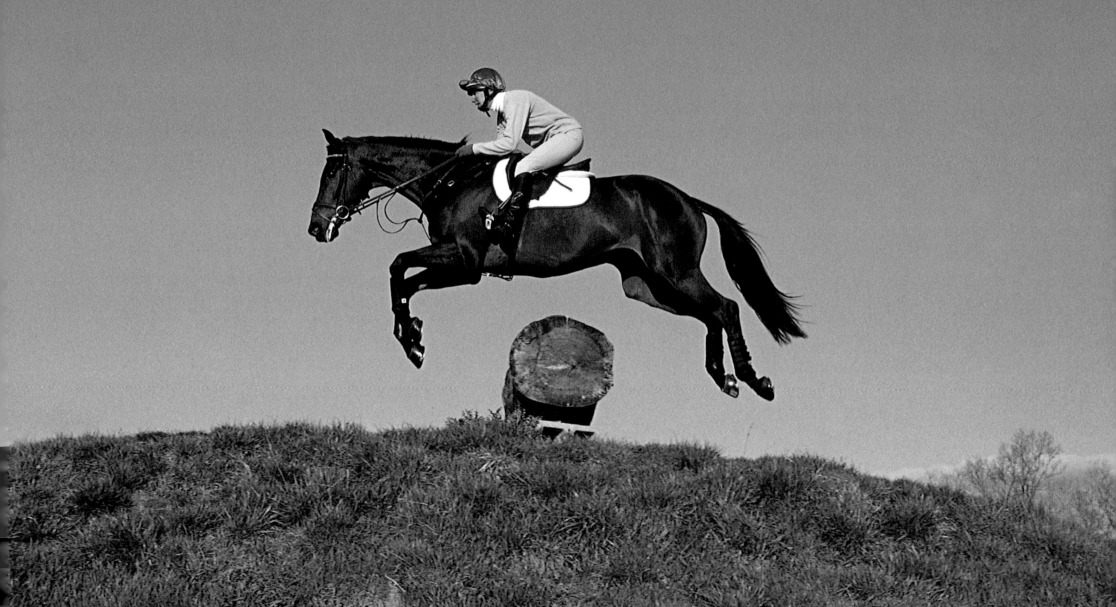

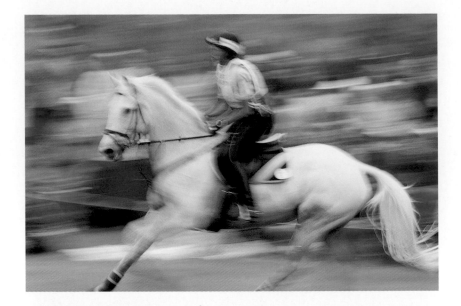

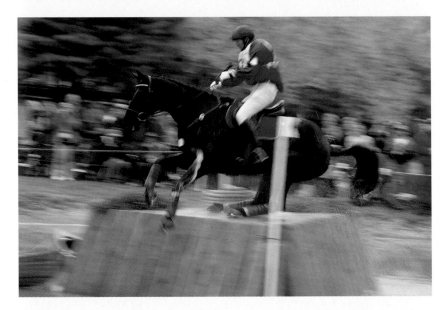

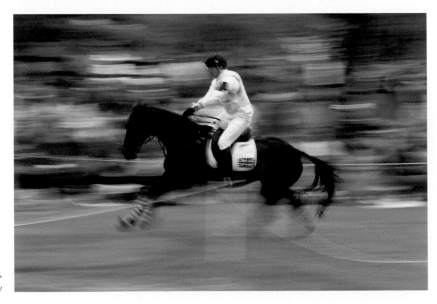

The Rolex three-day event,
Lexington, Kentucky

The Rolex three-day event,
Lexington, Kentucky

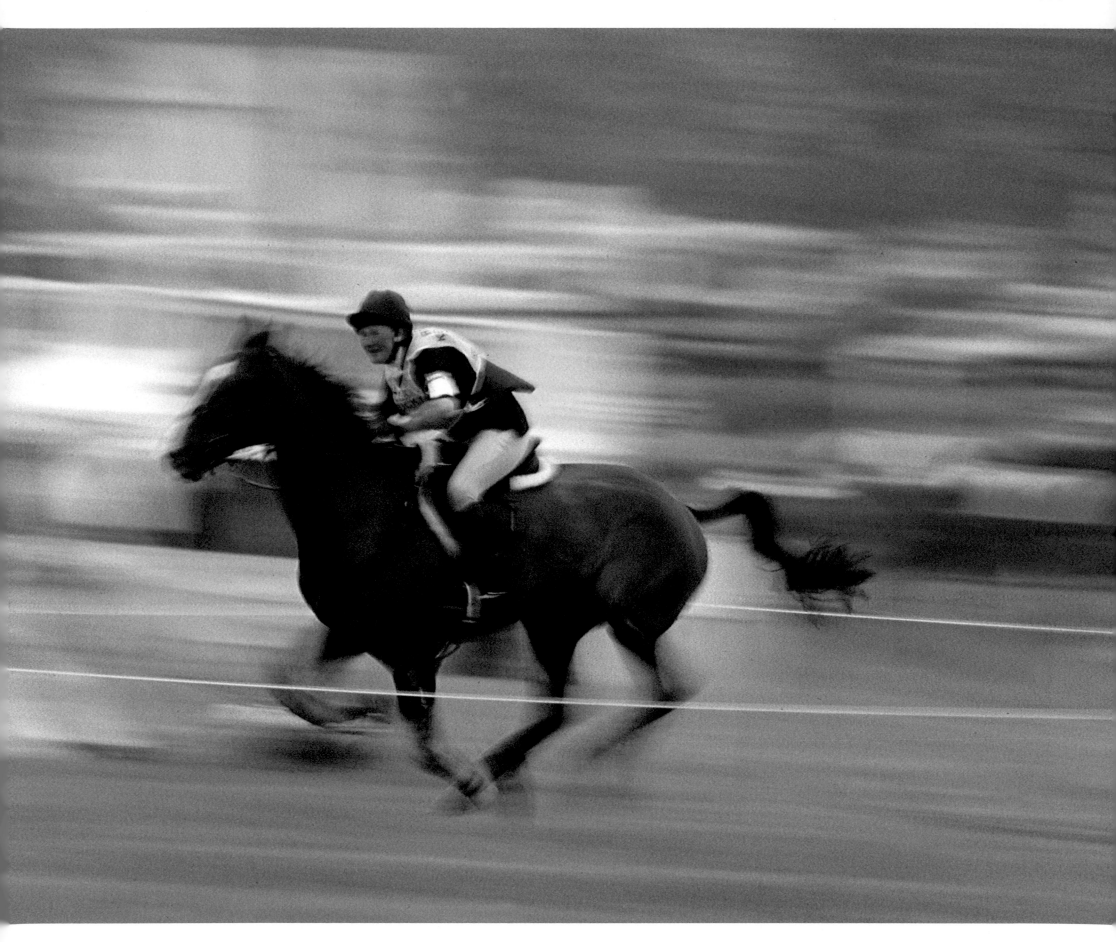

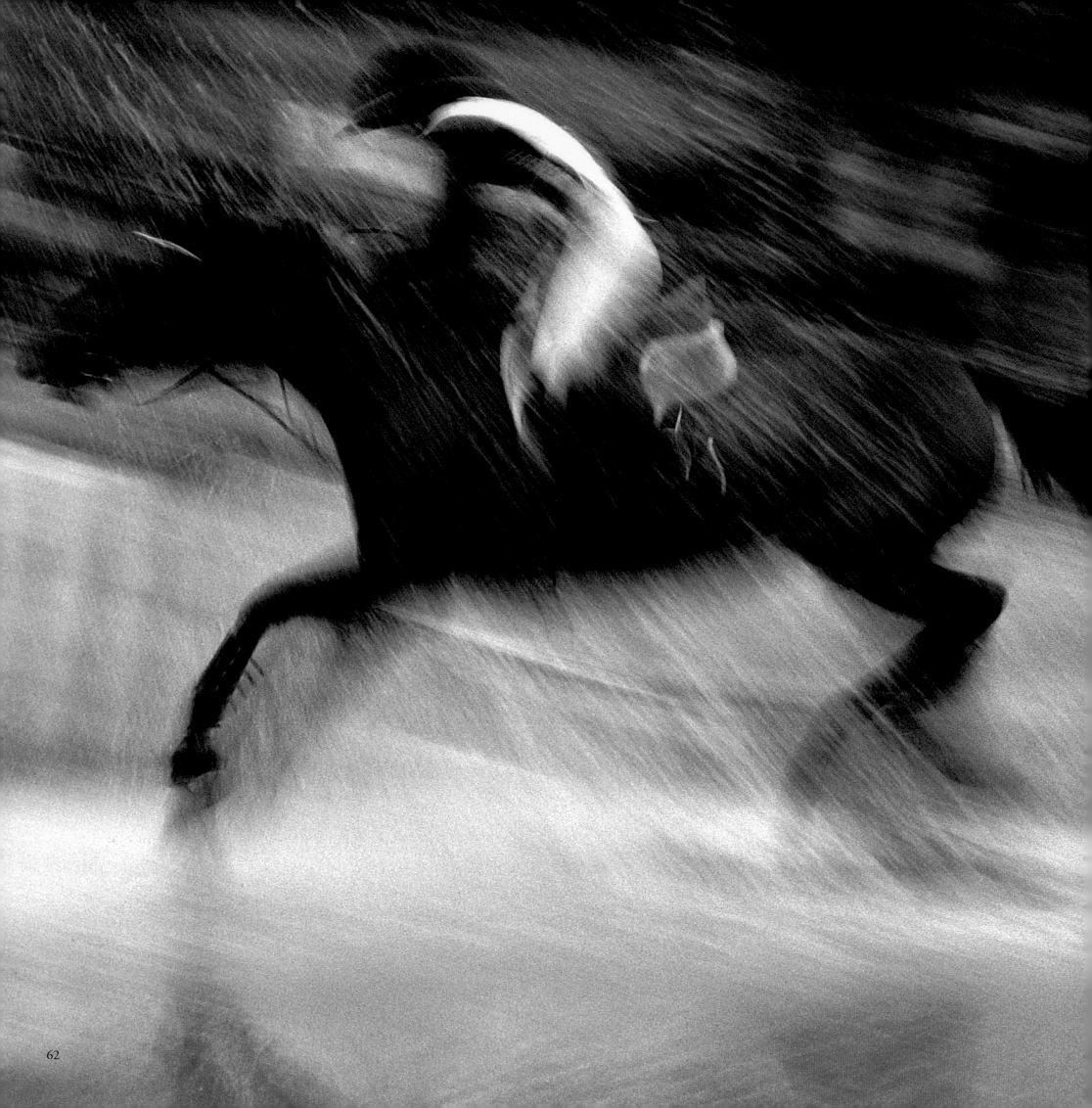

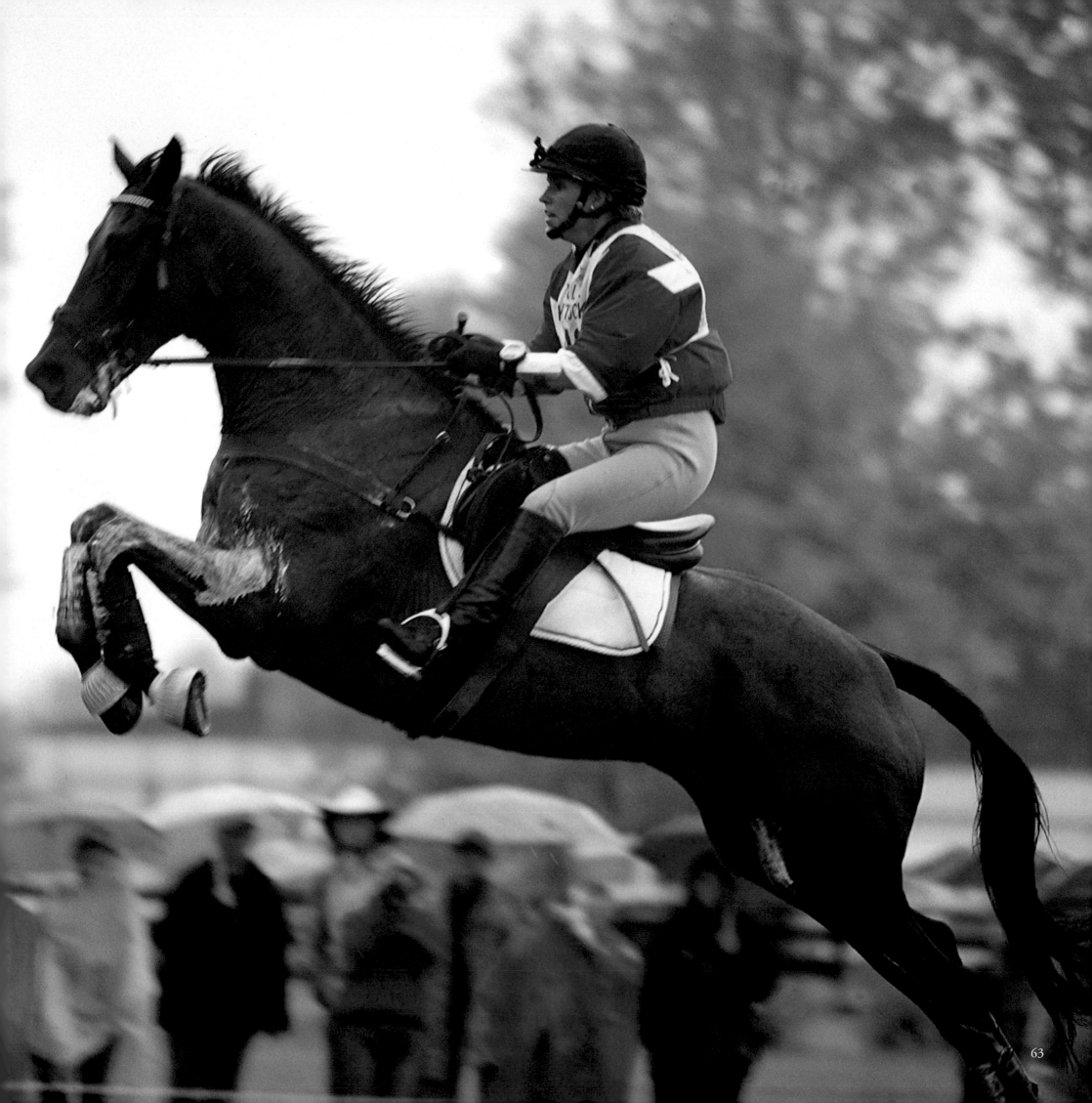

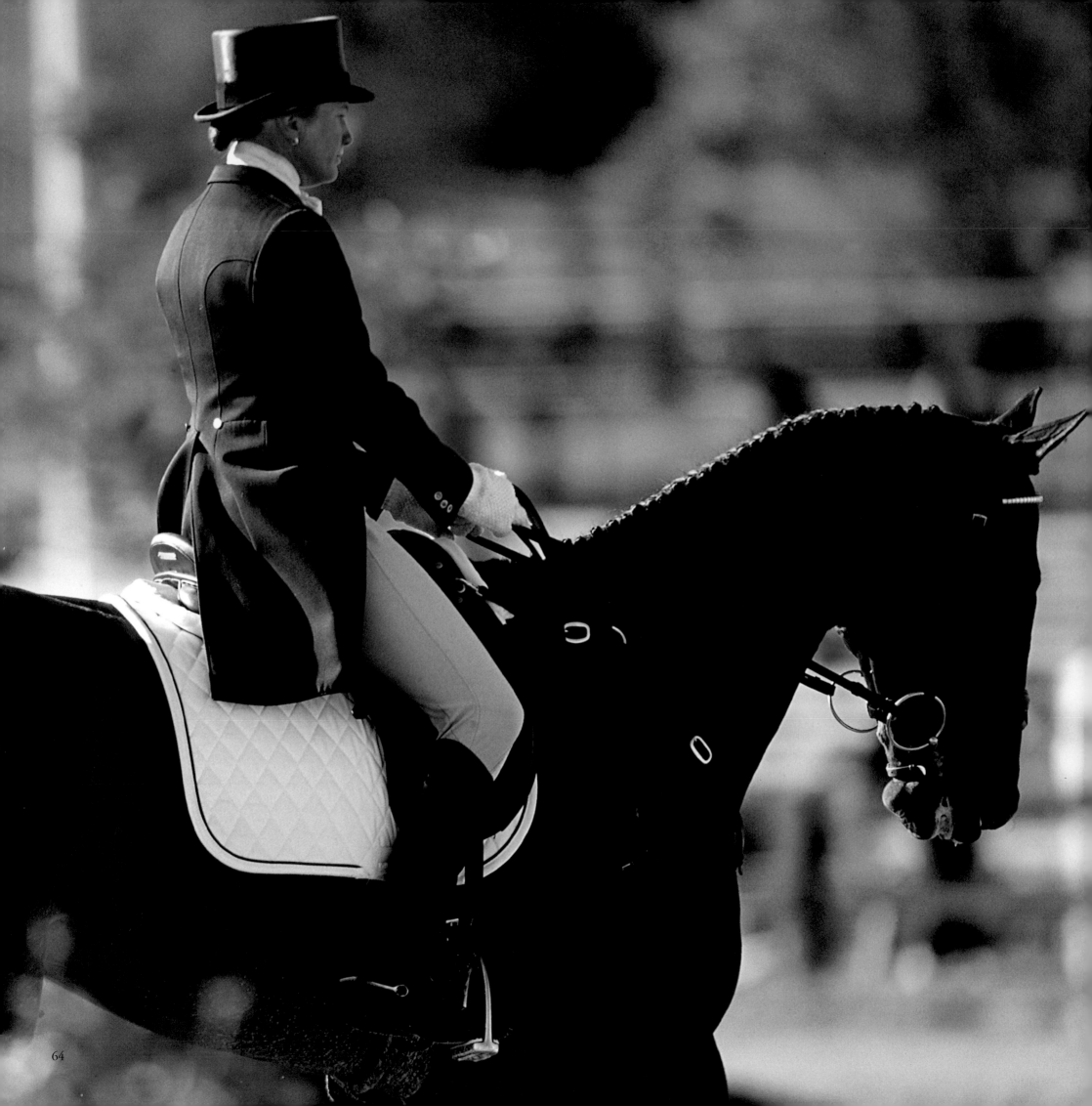

Karen O'Connor,
The Rolex three-day event,
Lexington, Kentucky
opposite page

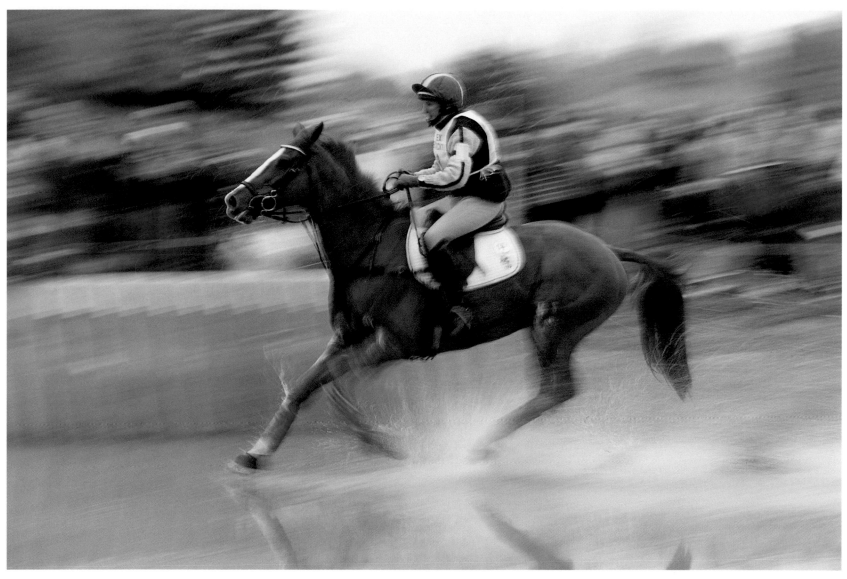

Karen O'Connor,
The Rolex three-day event,
Lexington, Kentucky

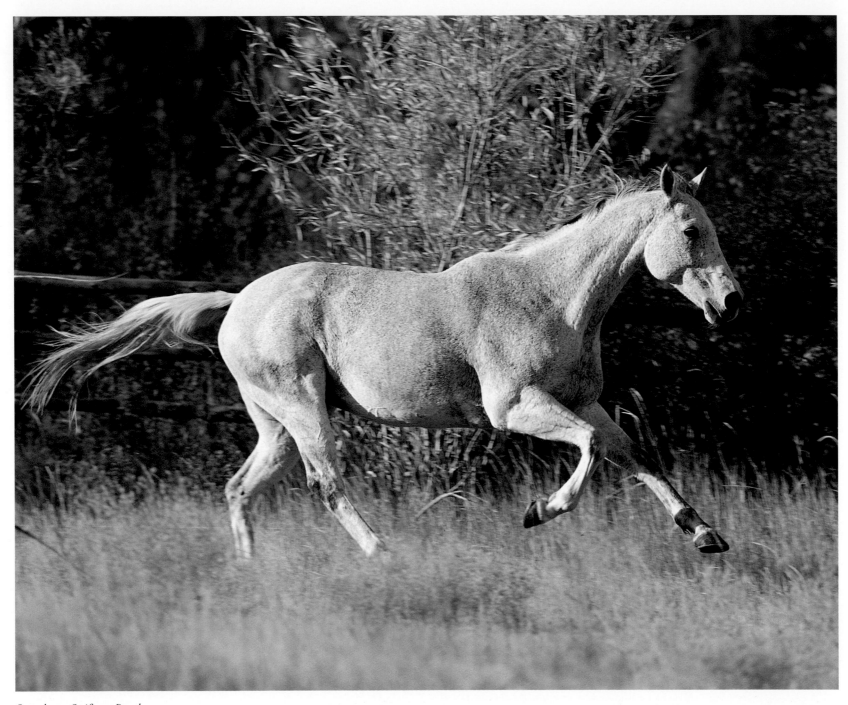

Sport horse, Swiftsure Ranch,
Bellevue, Idaho

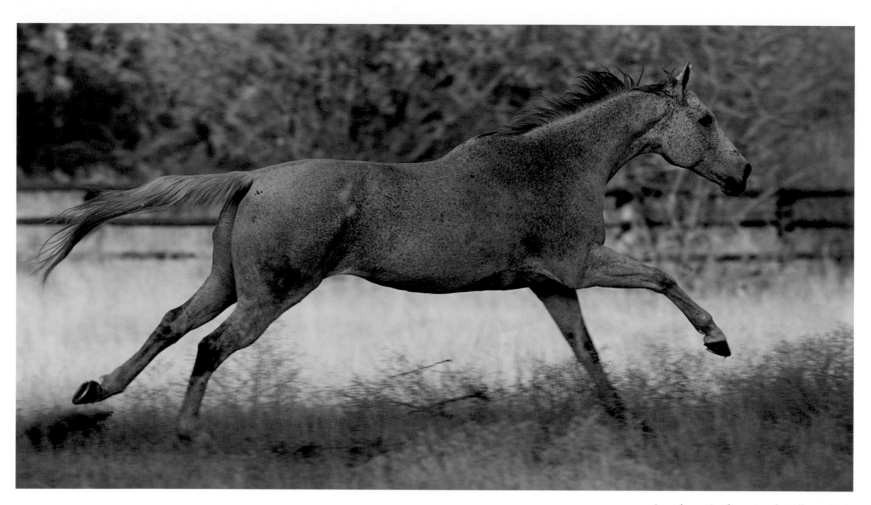

Sport horse, Swiftsure Ranch, Bellevue, Idaho

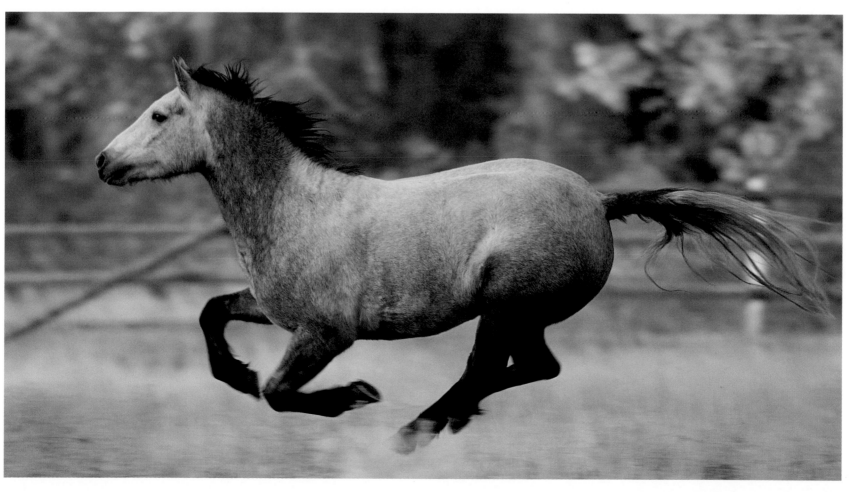

Sport horse, Swiftsure Ranch, Bellevue, Idaho

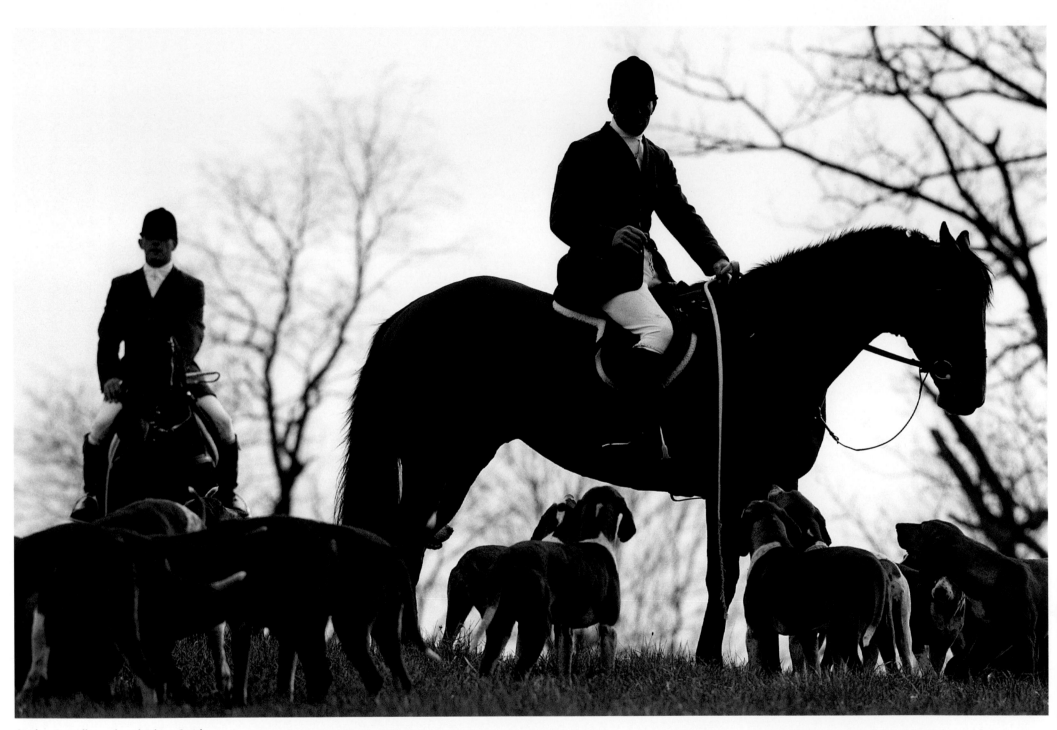

Stephen Spreadborough and Adrian Smith,
Orange County Hunt, The Plains, Virginia

Fox Hunting

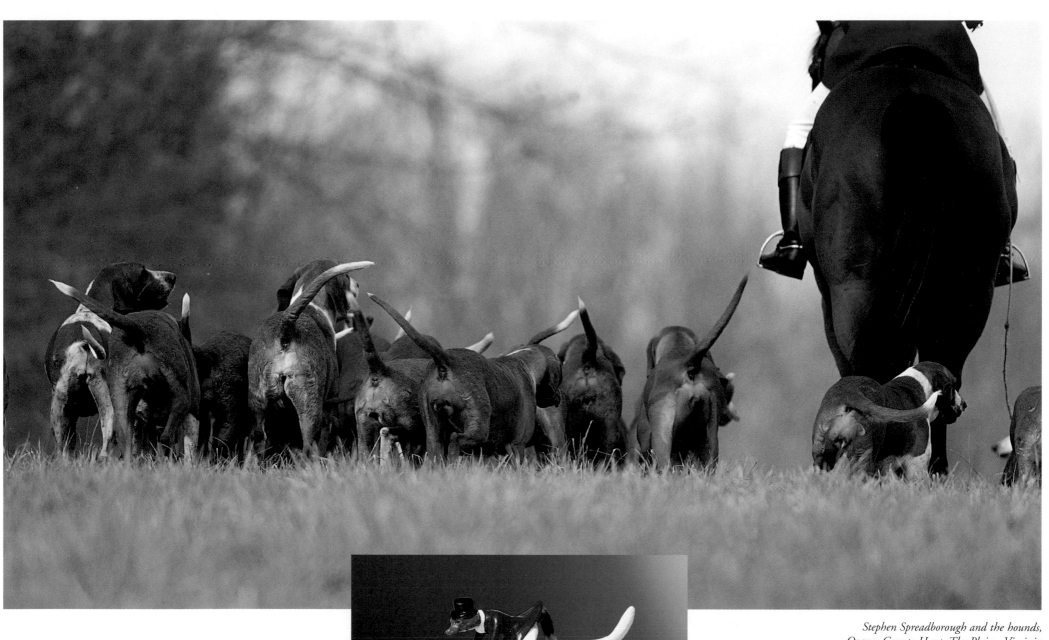

*Stephen Spreadborough and the hounds,
Orange County Hunt, The Plains, Virginia*

*Hood ornament, Orange County Hunt,
The Plains, Virginia*

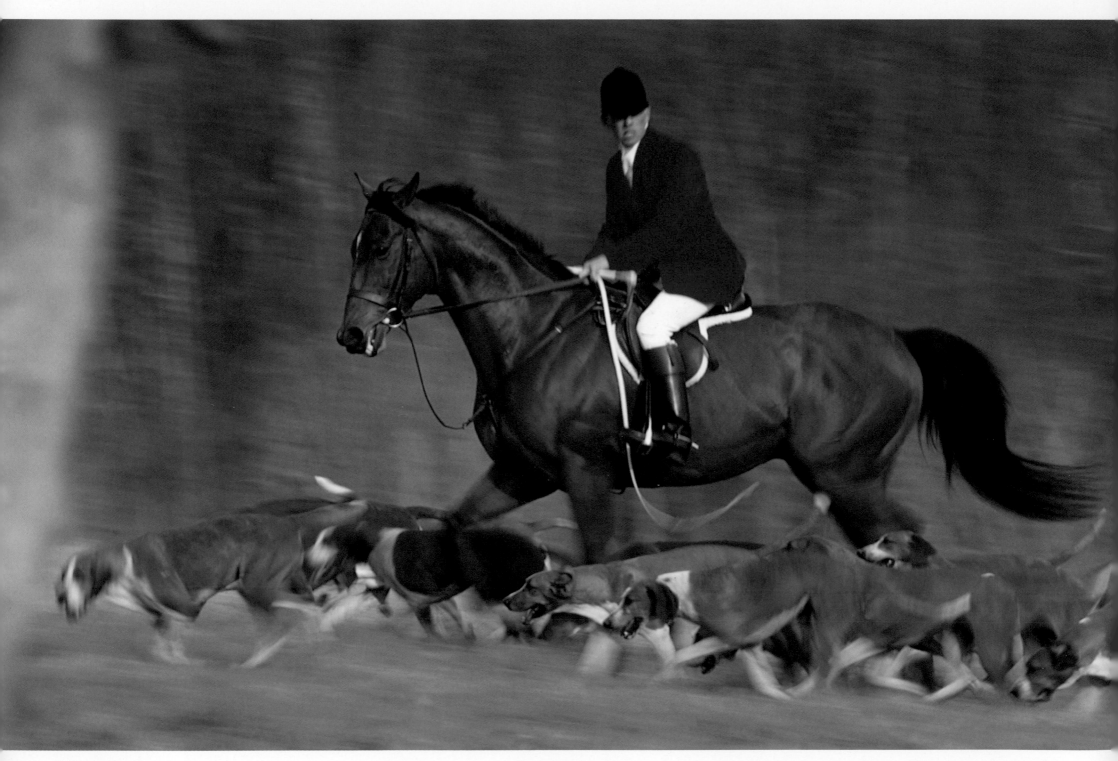

Adrian Smith, Orange County Hunt,
The Plains, Virginia

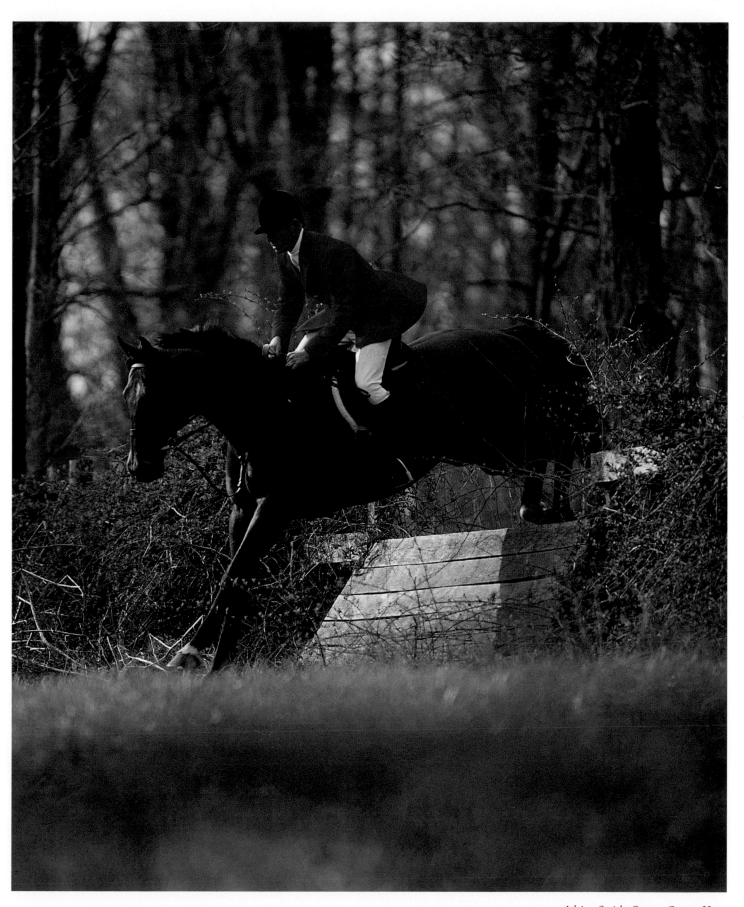

Adrian Smith, Orange County Hunt,
The Plains, Virginia

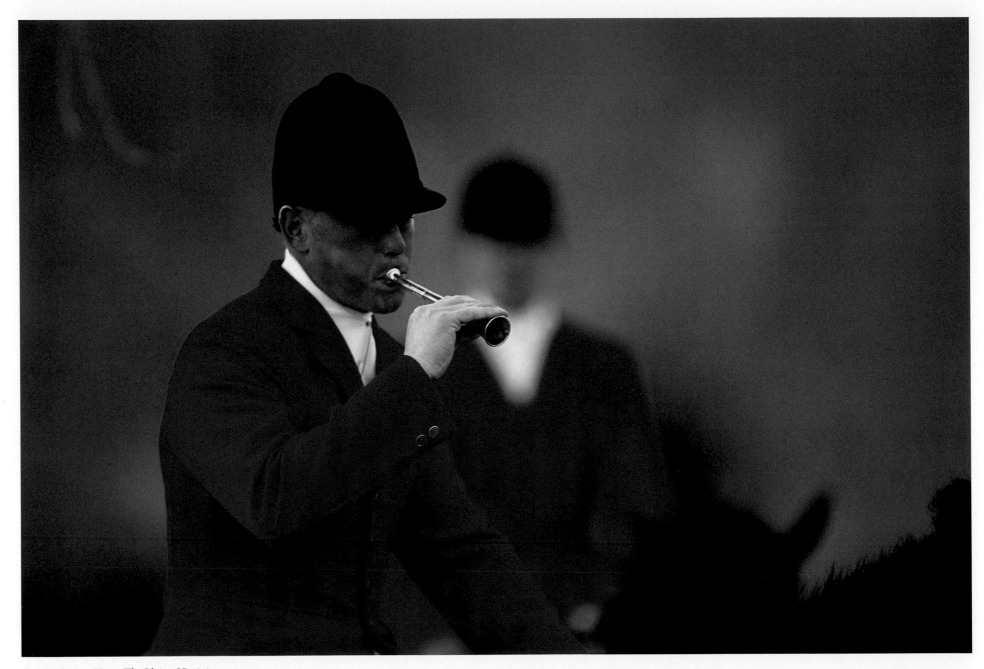

Orange County Hunt, The Plains, Virginia

Stephen Spreadborough and Adrian Smith,
Orange County Hunt, The Plains, Virginia
opposite page

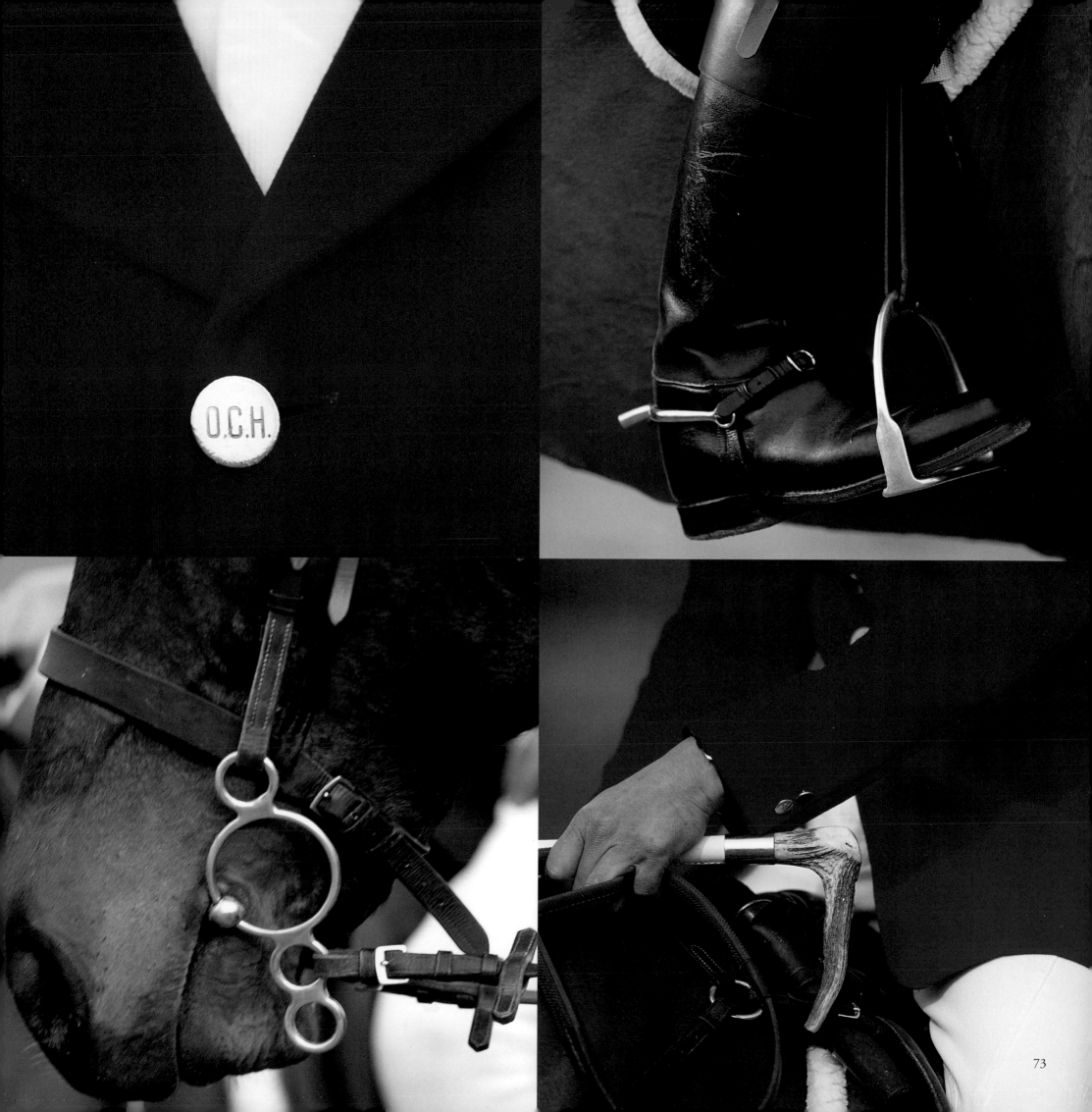

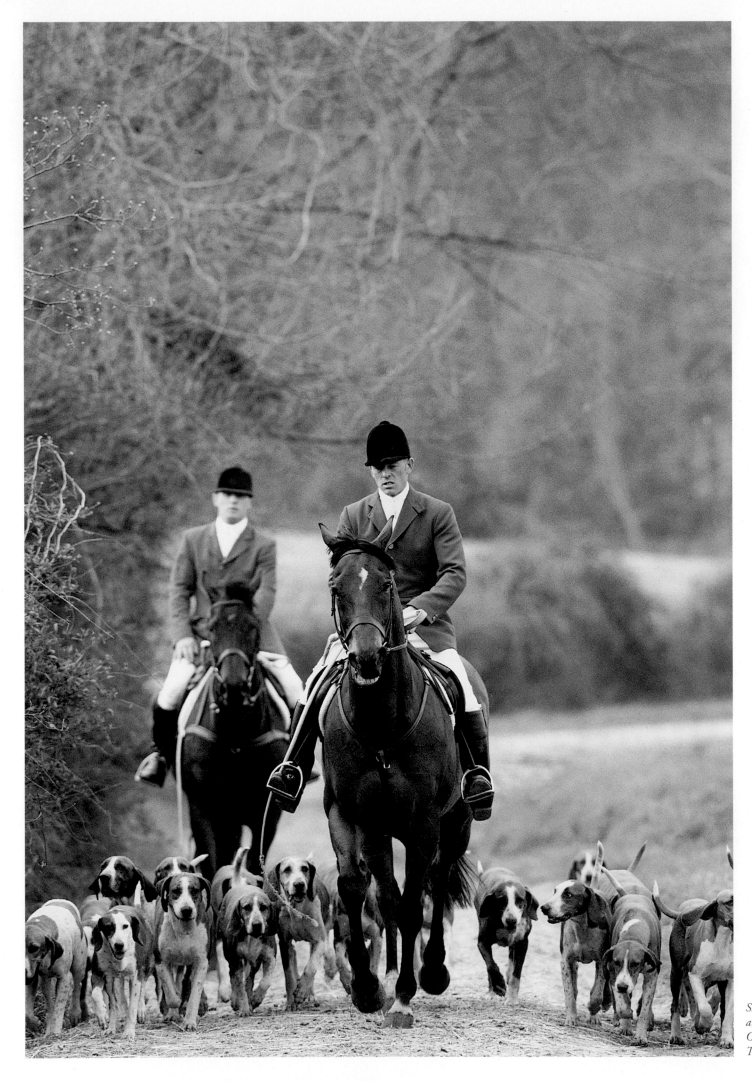

*Stephen Spreadborough
and Adrian Smith,
Orange County Hunt,
The Plains, Virginia*

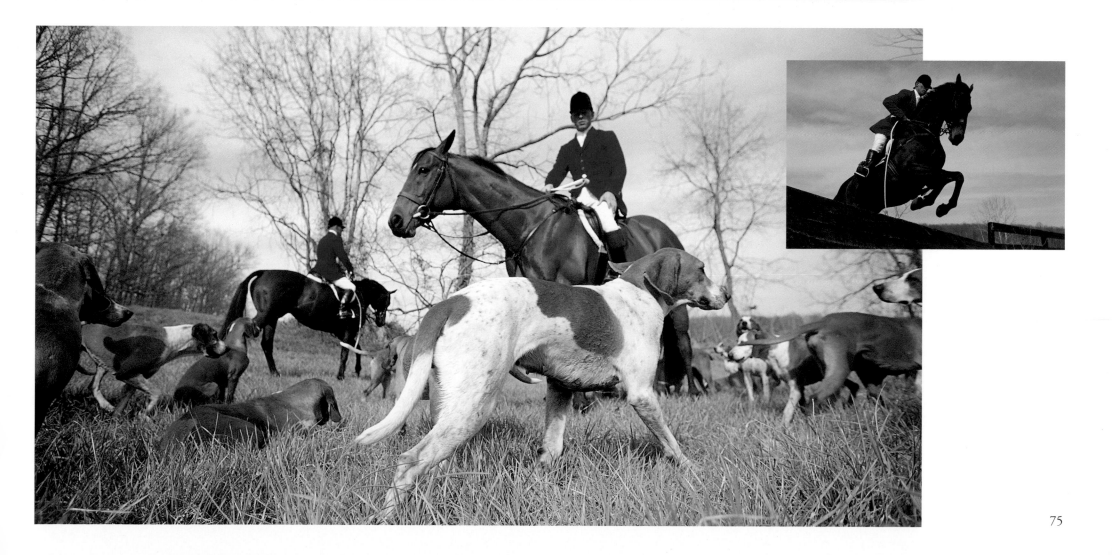

75

DRESSAGE

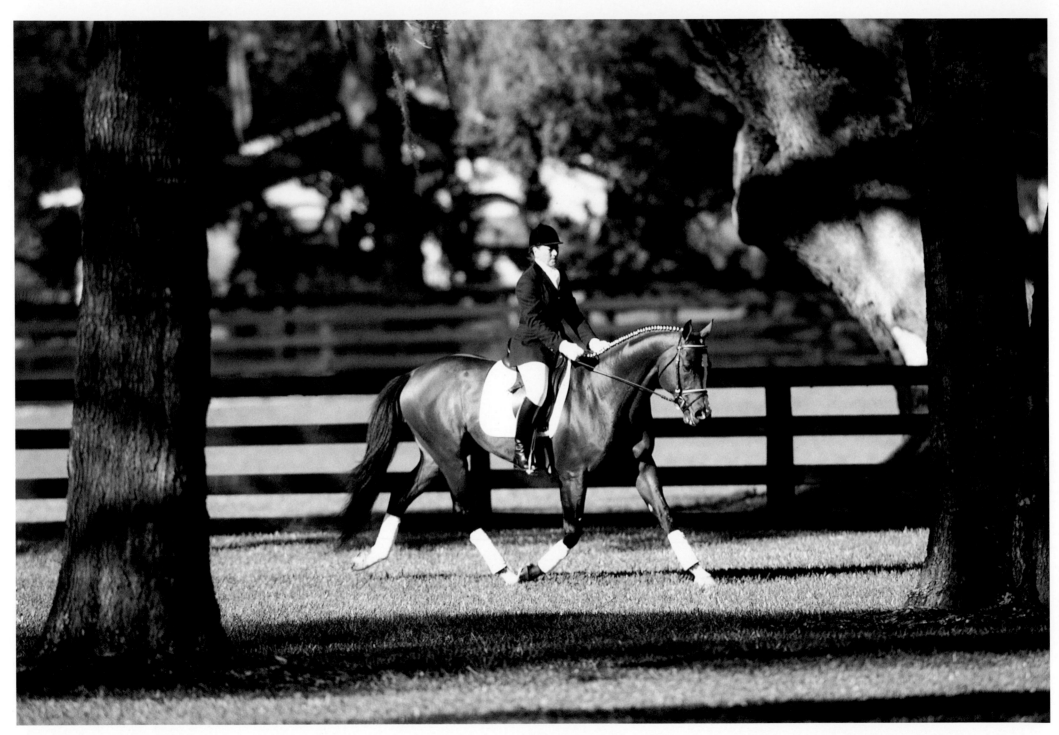

Lynn Palm, dressage, Fox Grove Farms,
Ocala, Florida

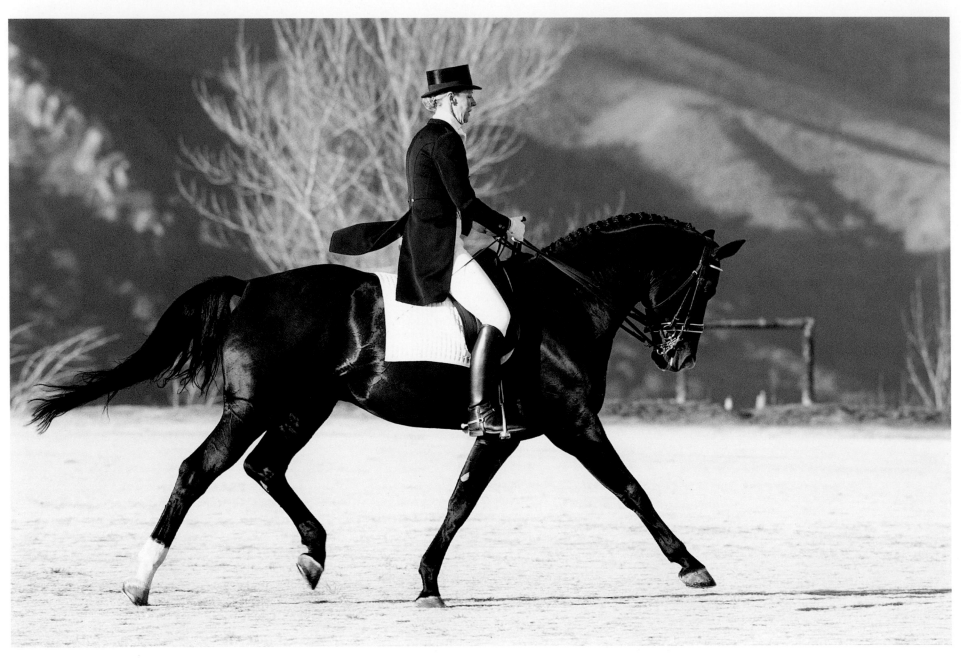

Charlotte Bredahl, Buelton, California

Charlotte Bredahl, Buelton, California

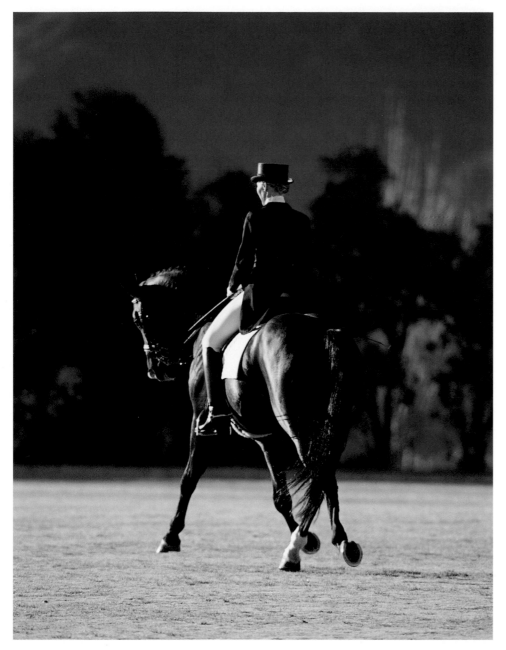

Charlotte Bredahl, Buelton, California

Charlotte Bredahl, Buelton, California

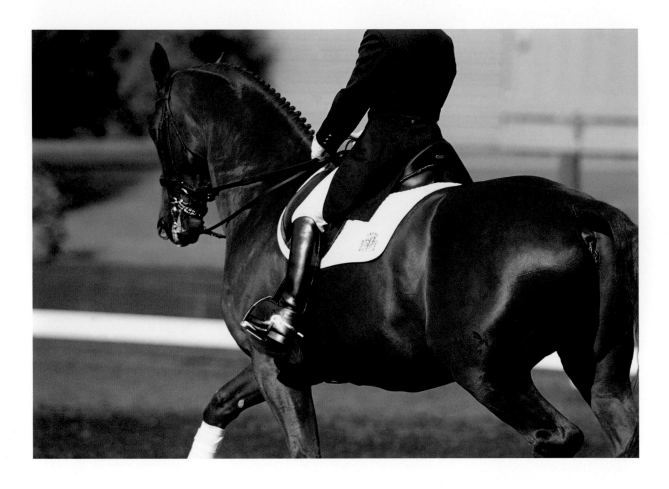

Debbie McDonald and Brentina,
River Grove Farm, Hailey, Idaho

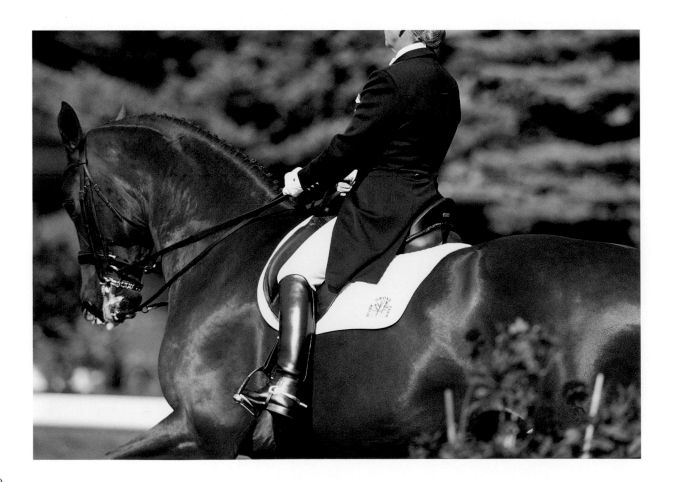

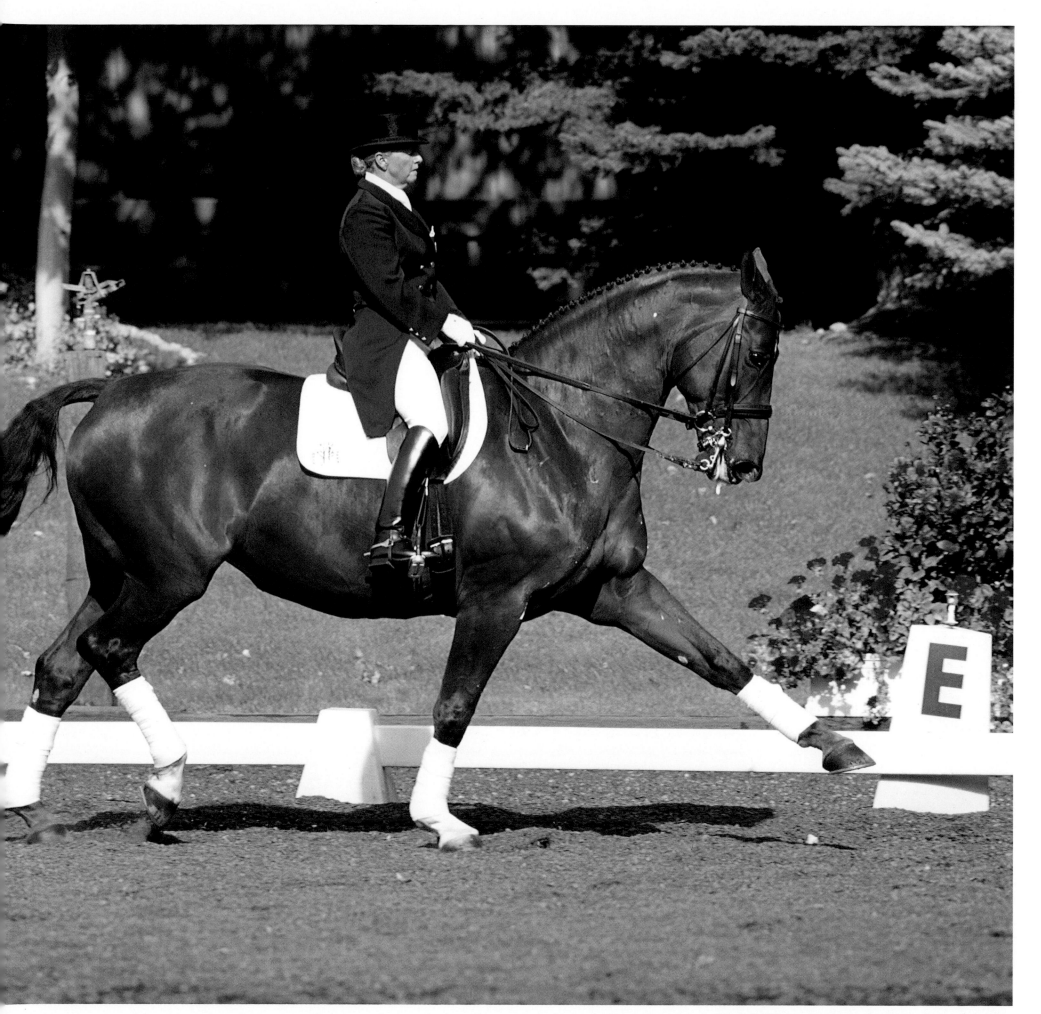

Debbie McDonald and Brentina, River Grove Farm, Hailey, Idaho 81

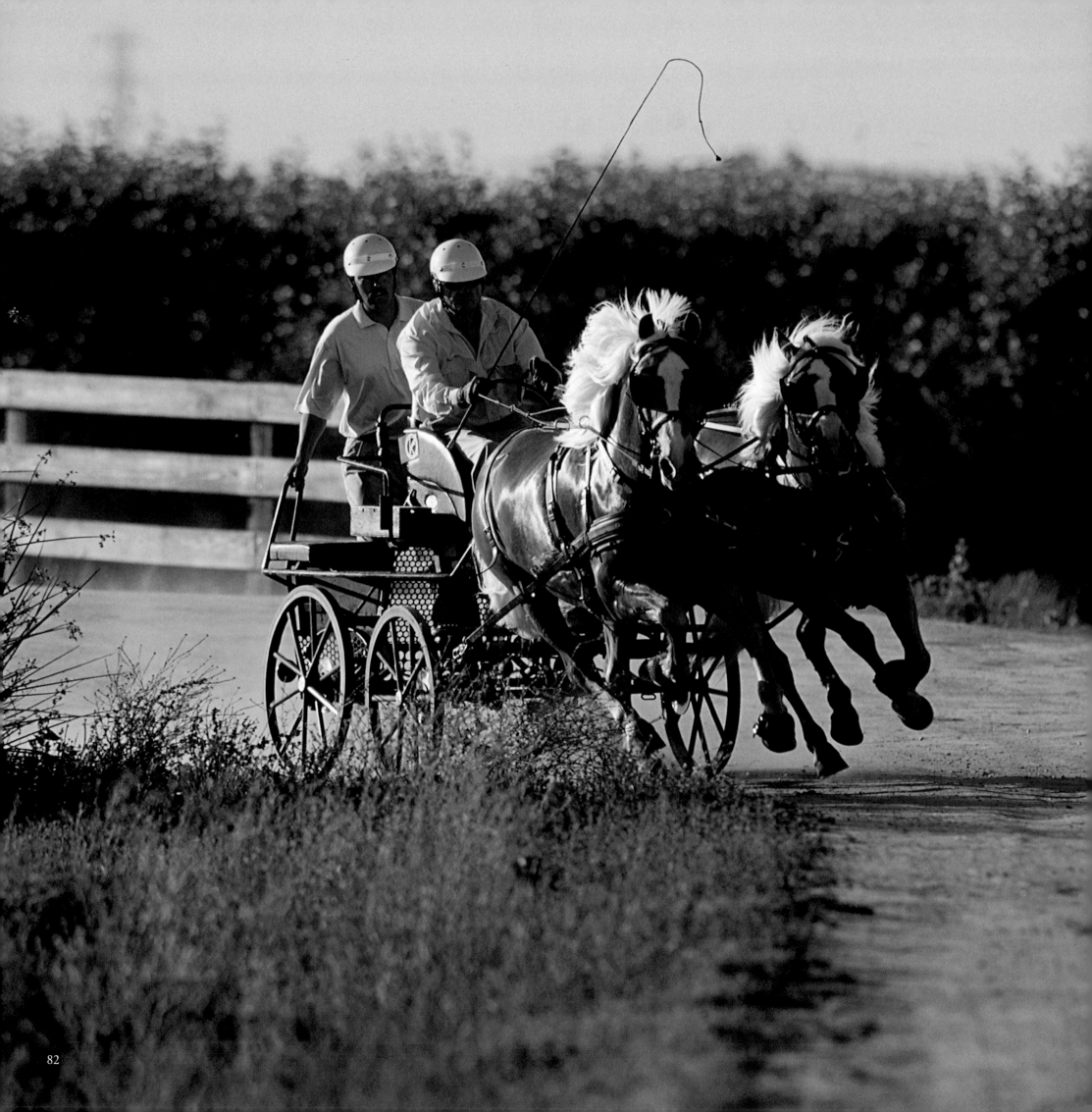

COMBINED DRIVING

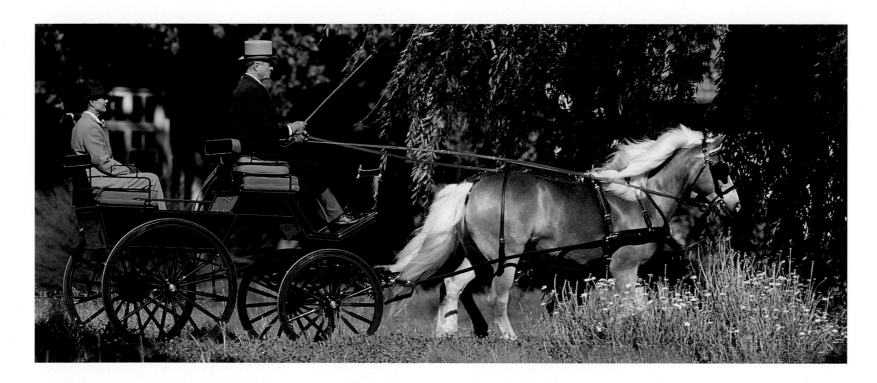

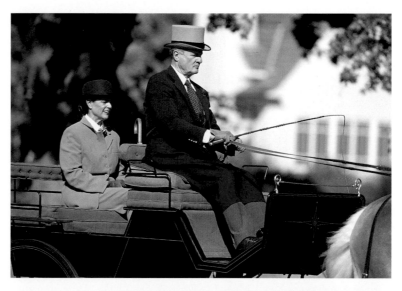

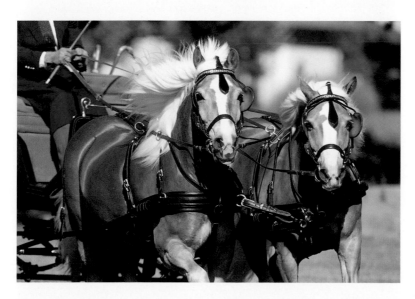

Phyllis and Fritz Grupe,
combined driving,
Stockton, California

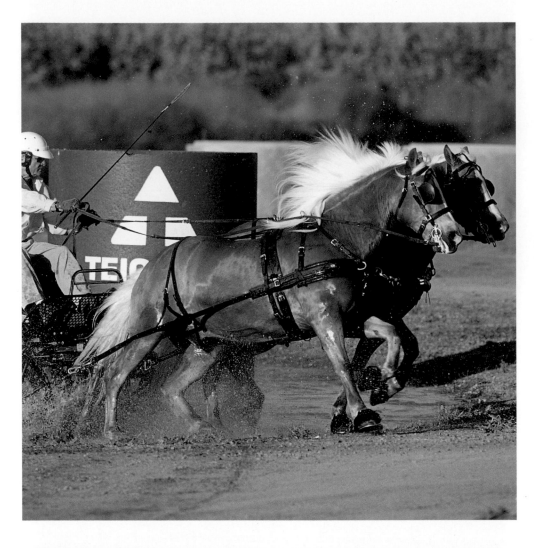
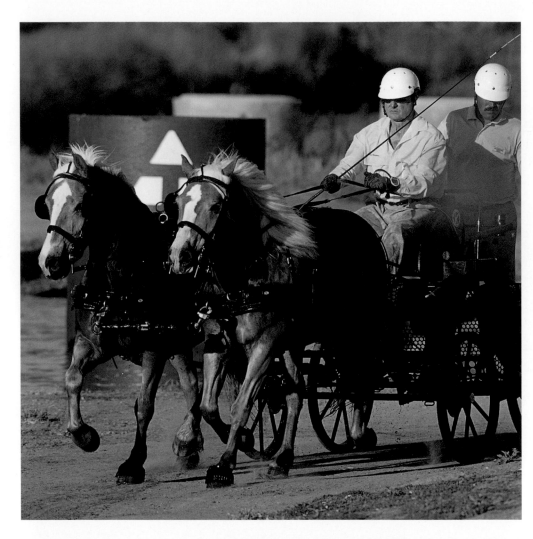
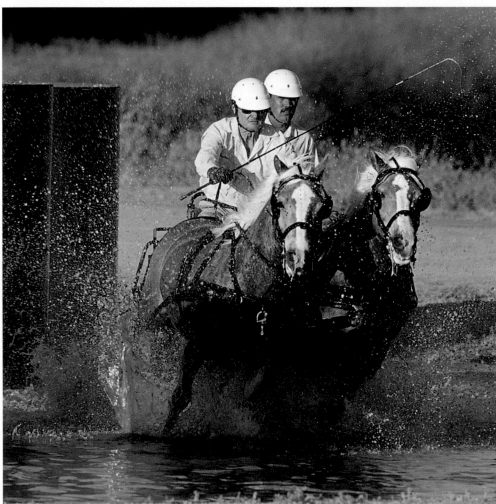
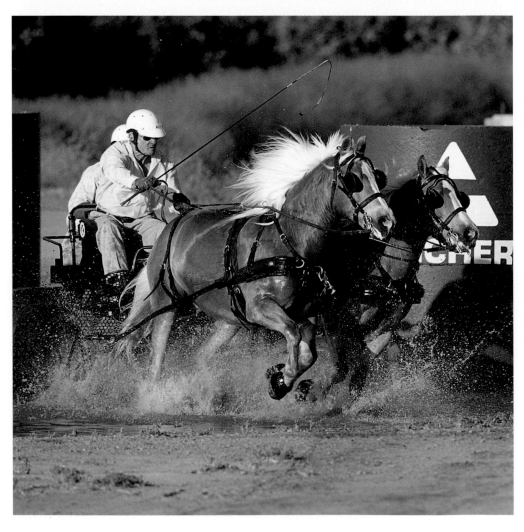

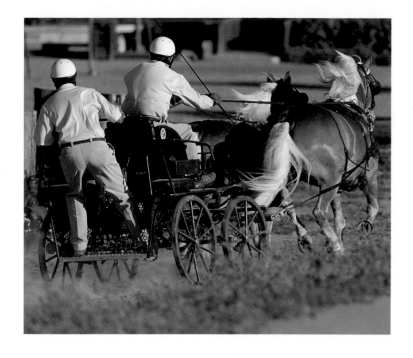

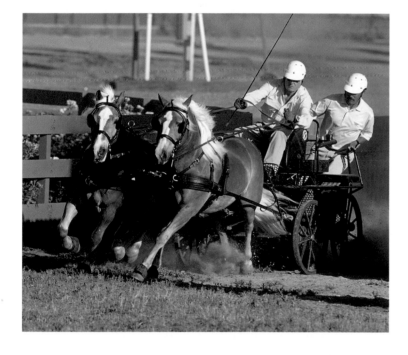

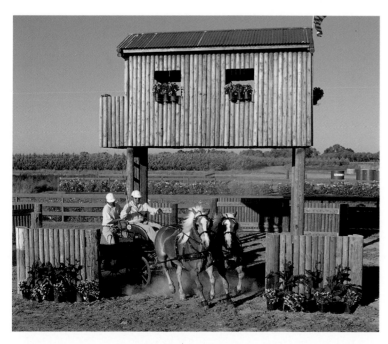

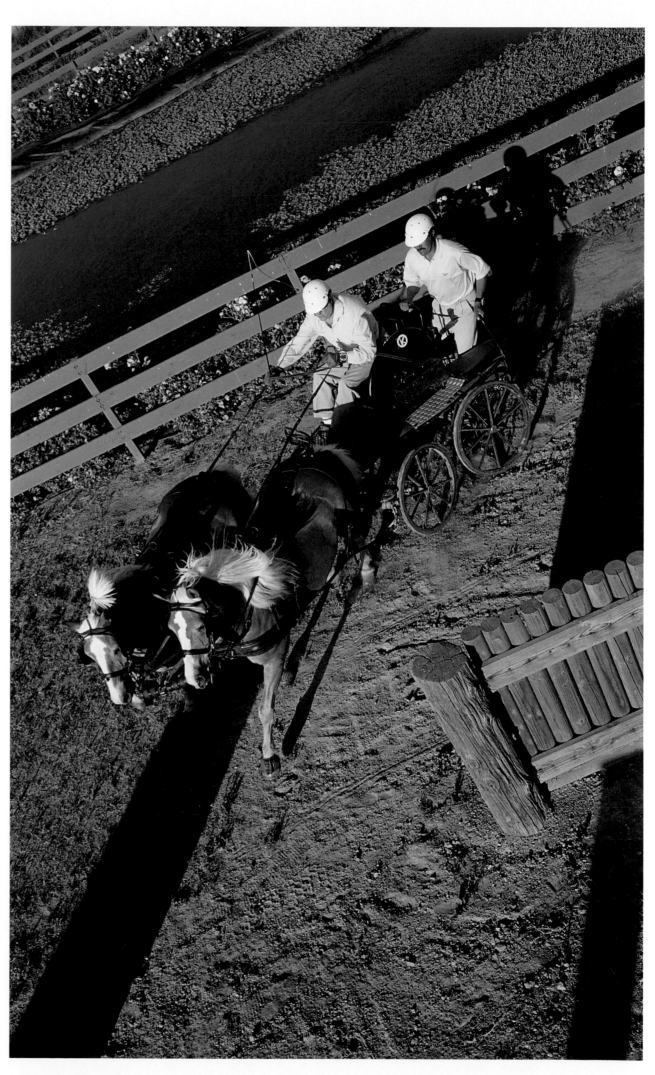

Exercise saddle, Palm Beach Downs, Florida

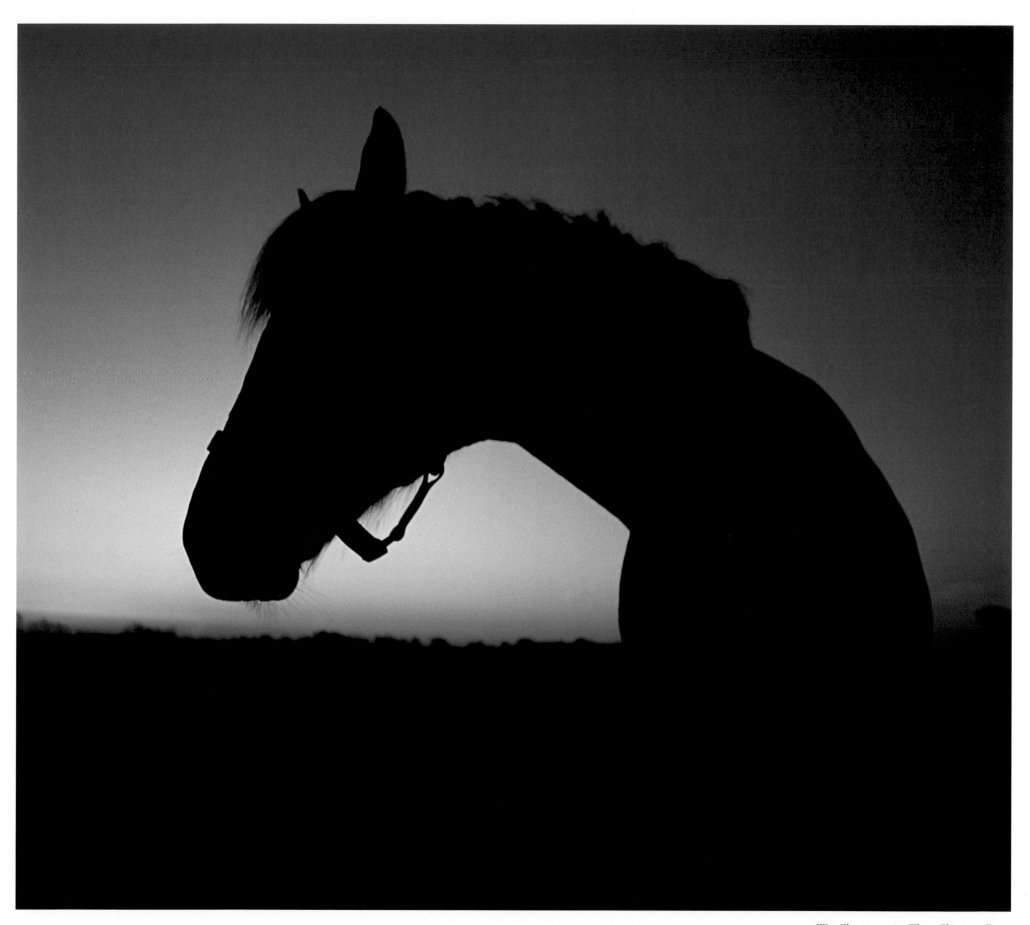

War Chant, sunrise, Three Chimneys Farm,
Lexington, Kentucky

THE RACE HORSE

The racehorse, among all performance horses, is doing what comes naturally. Running is second nature to him, like breathing. It is his pleasure, as well as his first response to danger, confusion, or anything that threatens his survival. From the time of the horse's domestication, humans have marveled at his propensity to move at speed – and have made use of it to indulge their own competitive urges.

Today the racehorse is America's premier equine athlete. The Thoroughbred and Standardbred, in particular, sustain multimillion-dollar industries and mainstream spectator sports. America is also home to several other racing breeds, notably the Quarter Horse, the Paint, and the Appaloosa. Indeed, colonial America was the birthplace of the Quarter Horse, the world's fastest equine sprinter.

But by far the most ubiquitous racehorses in America and around the world are the Thoroughbred, ruler of racing on the flat and over fences, and the Standardbred, king of harness racing.

THE THOROUGHBRED

The Thoroughbred is, arguably, the most impressive creature on earth. He is twelve hundred pounds of muscle, bone, and sinew designed for acceleration, speed, and power. More than just an athlete, however, the Thoroughbred also appeals to our finer sensibilities. Many of the same qualities that account for his speed – an elegant frame, delicate bones, sleek musculature, noble spirit – also account for his uncommon beauty and aristocratic bearing. The best specimens of the breed are prized like investments – works of living art that perform like Ferraris.

The origins of the Thoroughbred are intertwined with the origins of horse racing itself. The sport as we know it today originated in seventeenth-century England. Royals, who wished to test the speed of their hunting horses, built racecourses specifically for this purpose. King Charles II, "Father of the British Turf," loved horse racing so much that he rode in matches himself. Under his enthusiastic patronage, the sport flourished, both on the flat and over jumps. Indeed, Thoroughbred racing is known as the "Sport of Kings" today because of its enduring ties to the British monarchy.

To create ever-faster horses, early breeders crossed native English mares with fleet Arabian, Barb, and Turkish stallions. (Britain had first become aware of the Oriental horses during the Crusades to the Middle East and North Africa.) The fastest offspring of these unions were then inbred through the centuries to refine the breed. As a result, today all registered Thoroughbreds can trace their lineage to one of three founding sires (as well as to forty "royal mares" of English bloodlines). The stallions are the Darley Arabian, the Byerly Turk, and the Godolphin Arabian, all of them foaled around the turn of the seventeenth century. The Darley Arabian had the greatest influence of the three. As many as ninety percent of all Thoroughbreds can trace back to him in their males lines through his phenomenal great-great-grandson, the undefeated Eclipse.

British colonists in Maryland and Virginia introduced horse racing to America in the seventeenth century. The sport was as popular in the new world as it was in the old; even George Washington and Thomas Jefferson were enthusiasts. Before long, colonists began importing racing stock from Great Britain. Early arrivals included the stallions Bulle Rocke, by the Darley Arabian, and Janus, a descendant of the Godolphin Arabian and foundation sire of the American Quarter Horse. Diomed, a descendant of the Byerly Turk and winner of the first Epsom Derby, was imported at the age of twenty and founded one of the first great lines of American racehorses.

Today over thirty thousand Thoroughbreds are bred in America each year, many of them in Kentucky's legendary bluegrass region. The majority of these are intended for the flat track; those that do not make it often go on to careers in other sports demanding speed, agility, and competitive fire. In addition to steeplechasing – so named because an early course ran from one church spire to another – these "fall-back" sports include show jumping, eventing, and polo.

Whatever his sport, the Thoroughbred, above all other breeds, exemplifies the intangible quality that horsemen call heart. Allen Kershaw, general manager and vice-president at Gainsborough Farm in Versailles, Kentucky, describes heart in a Thoroughbred as a certain kind of arrogance. A good example, he says, is the pluck that Sunday Silence, 1989 Horse of the Year, displayed battling his rival Easy Goer in the 1989 Breeders' Cup Classic. "It was as if he was saying, 'C'mon, c'mon, try to pass me – because you're not going to,'" remembers Kershaw.

Eclipse Award-winning trainer Bob Baffert says heart is mental toughness combined with a desire to run and compete. "It's the one thing you can't measure except on the track," says the trainer, who has come close to claiming a Triple Crown victory three times – most recently with War Emblem. "Some horses hate to lose, and he's one of them," Baffert says of the 2002 Kentucky Derby and Preakness champion.

AND SUCH RUNNING! IT WAS RATHER THE LONG LEAPING OF LIONS IN HARNESS; BUT FOR THE LUMBERING CHARIOT, IT SEEMED THE FOUR WERE FLYING.

...Lew Wallace, Ben-Hur

Sometimes, the trainer adds, a horse's attitude can provide a glimpse into his mental makeup. "If you try to shoo a horse away from the stall door and he won't budge, that can be a good sign. But if he jumps right to the back of the stall, he's probably not going to have the kind of mental toughness you're looking for," he says.

Kershaw notes it can be particularly difficult to predict which young horses are going to become, in his words, "the Michael Jordans or the Tiger Woods."

"One thing I have noticed, though," he says, "is that many that do go on to successful careers don't seem to get as many bumps and scrapes in their 'teenagerhood' – yearling to two years old – as other youngsters do. Is this because they're smarter, or possessed of greater balance? Or faster, so they're always leading the pack and avoiding jostling? Or more dominant – the boss from day one? I don't know, but there seems to be some correlation," he says.

Ric Waldman is a consultant to Lexington, Kentucky's Overbrook Farm, home of Storm Cat, the leading commercial sire in North America at the turn of the twentieth century. He notes that the stallion's offspring, which had won more than sixty-five million dollars as of 2001, tend to be headstrong. "They have a very high energy level," he says. "They're responsive and willing to be trained and raced, but it takes a special kind of horseman to contain that energy."

Waldman says Storm Cat's own energy and determination were tested in the Young American Stakes and the Breeders' Cup Juvenile in 1985. "In the Young American, he came into the homestretch in the lead, then had to fight off challengers," he says. "Horses were coming at him from both inside and outside, and he just would not let them get by. In the Breeders' Cup, he held the lead the entire way, and then was caught at the wire by a horse on the extreme outside – a horse he didn't see. We're convinced that if he had, he would have fought him off."

Waldman believes a great horse responds out of his own courage, and not just because of his jockey's prompting. "Typically, at the end of a race, a jockey is doing about as much as he was a sixteenth of a mile back," he says. "So if the horse gives more at the wire, it's coming from his own heart. The jockey is probably riding the horse no harder than he was before, but the horse is reaching for more from within."

Chip Miller, a leading steeplechase trainer and rider from Pennsylvania, says great horses possess an intelligence that does indeed enable them to know the difference between the beginning and end of a race. "The good ones know the first mile is nothing to get excited about," says the horseman, who rode the great steeplechaser Lucky Boy in the 1990s. "But near the end, they get more aggressive, and braver in their jumps. They'll take off earlier, for a flatter, faster trajectory. They're very intuitive, very aware."

Moreover, he claims, they absolutely do know when they have won a race. "Anyone who says otherwise," he says simply, "has never ridden a Thoroughbred."

THE STANDARDBRED

A "country cousin" to the Thoroughbred is the Standardbred, horse of the modern-day charioteers. Less glamorous than his highborn relation, the Standardbred makes up for what he lacks in gentility with hard-working, no-nonsense staying power. If the Thoroughbred's game is the Sport of Kings, the Standardbred's is the Sport of Everyman. Harness racing evolved on the country roads and village streets of nineteenth-century America, and today Standardbreds are owned and raced by a wide cross-section of the American populace.

Two stallions are credited with founding the Standardbred breed. They are the English Thoroughbred, Messenger (son of the celebrated trotter Mambrino), and his closely inbred great-grandson, Hambletonian 10, also known as Rysdyk's Hambletonian. Foaled in 1780, Messenger was imported to Philadelphia in 1788, shortly after the end of the Revolutionary War. The fiery stallion, a successful racehorse in his homeland, carried the blood of all three of the Thoroughbred's foundation sires. Not a pretty animal, he was large and muscular, with superior trotting action and speed.

His descendant Hambletonian was foaled in New York in 1849. A plain-looking bay, he stood over fifteen-one hands high, with a brawny chest and hindquarters. His croup was two inches higher than his withers, a conformation trait known as the "trotting pitch" and thought to be associated with fleetness. Though Hambletonian himself never raced, he surely possessed speed: He sired more than thirteen hundred foals, a striking number of which became trotting stars. Hambletonian's prepotency was such that today, nearly all modern Standardbreds can trace their lineage to him. Several other breeds are also found in the blood of the Standardbred, including the Morgan, the Canadian and Narragansett Pacer, the Norfolk Trotter, and an obscure trotting line known as the Clays.

The first Standardbreds – known then simply as "trotters" – worked on farms and plantations and served as family transportation. Before there were enough passable roads to support the use of carts and buggies, horses were most often ridden, and early races were mounted contests. As roads increased in number and quality, some were also utilized as raceways. (This explains why so many American cities have a "Race Street.")

By the 1850s, with the invention of the lightweight sulky, driven events outnumbered ridden races, and the term "harness racing" was coined. The name "Standardbred" actually did not come into use until 1879, the result of a minimum speed standard (a mile in two and a half minutes) set as a requirement for registry.

In the early days, trotters (horses that move diagonal legs in unison) were much preferred to pacers (horses that move lateral legs in unison). Enthusiasts began to change their opinions, however, after Star Pointer clocked the first two-minute pacing mile, in 1897. In the early 1900s, the legendary Dan Patch glamorized pacing once and for all with his triumphant cross-country campaigns, during which he rode in his own private train car. The seventeen-hand stallion was never beaten in a race, and his record for the pacing mile stood for fifty-seven years.

The most famous trotter in history is probably Greyhound, who set twenty-five longstanding world records over various distances. The handsome, 16.2-hand gelding was known as the "Grey Ghost" to his Depression-era fans.

In the United States today, pacers outnumber trotters four to one. Pacers are not only slightly faster than trotters, but they are also less likely to break stride. (Breaking to a gallop is a racing violation that requires drivers to pull to the outside of the field to reestablish the correct gait, thereby losing precious seconds.) Pacers are almost unheard of in Europe, where trotting – considered a more natural gait – is still preferred.

The modern Standardbred resembles the Thoroughbred, only shorter in height, longer in body, and more muscular overall. His outline is somewhat angular, and his croup is often higher than his withers. His head is larger and less refined than the Thoroughbred's; Roman noses, though rare, do sometimes still occur. The breed has great stamina, and a tractable, willing temperament. The Standardbred's most common distance is the mile, and his racing speeds approach thirty-five miles-per-hour – not that much less than those of a galloping Thoroughbred.

Standardbreds make great family horses, and indeed many family-owned trotters and pacers compete on the still-popular county fair circuit in the Northeast and Midwest. One leg of pacing's Triple Crown, the Little Brown Jug, is held during the Delaware, Ohio, County Fair, a tribute to the sport's rural heritage.

Like all successful racehorses, winning Standardbreds have a discernible inner spark. "In choosing prospects, I put more emphasis on personality and heart than on talent," says Rod Allen, a longtime trainer and breeder who has produced over twenty world-record-setters. "You want a horse with good conformation and straight legs, but if he doesn't have a personality that stands out around the barn, he won't make it on the track. He won't be competitive enough."

As an example, he offers CR Renegade, a successful racer now retired to stud. "He's not huge, and he's built almost like a Quarter Horse," says Allen, whose family-run Golden Cross Farm in Ocala, Florida, owns the majority interest in the stallion. "But when you bring him out of the stall, he swells up, struts, and screams. He won't hurt you, but he sure intimidates the other stallions. It's that feeling of superiority that makes a horse a champion."

Michigan-based Allen Tomlinson has been training trotters and pacers for thirty-five years. He says a horse with enough desire can overcome amazing odds – even three stride-breaks over a one-mile distance. That is what his two-year-old colt Turbo Twin, a future record-setter, did on his way to winning Michigan's 1990 Spartan Futurity for pacers.

"It was an unbelievable feat," he says. "You can maybe come back and win after one break, but three? That colt never gave up. He was young, and hadn't figured it all out yet. But despite the trouble he was having, he just kept trying, so hard."

It is that kind of determination that makes the Standardbred the proverbial warrior that he is.

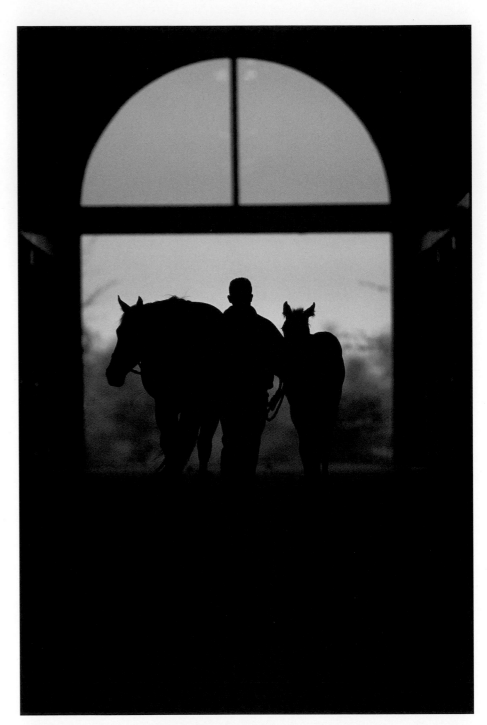

Taking out the mares, Gainsborough Farm, Versailles, Kentucky

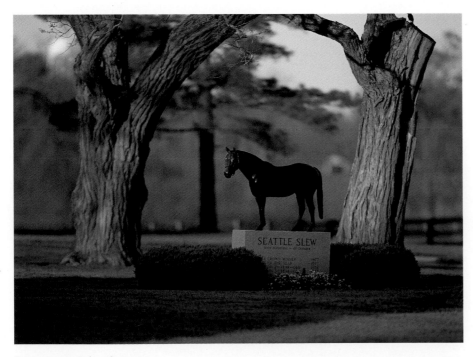

Bronze memorial to the great Seattle Slew at Three Chimneys Farm, Lexington, Kentucky

Famous signs, Kentucky

Famous signs, Kentucky

91

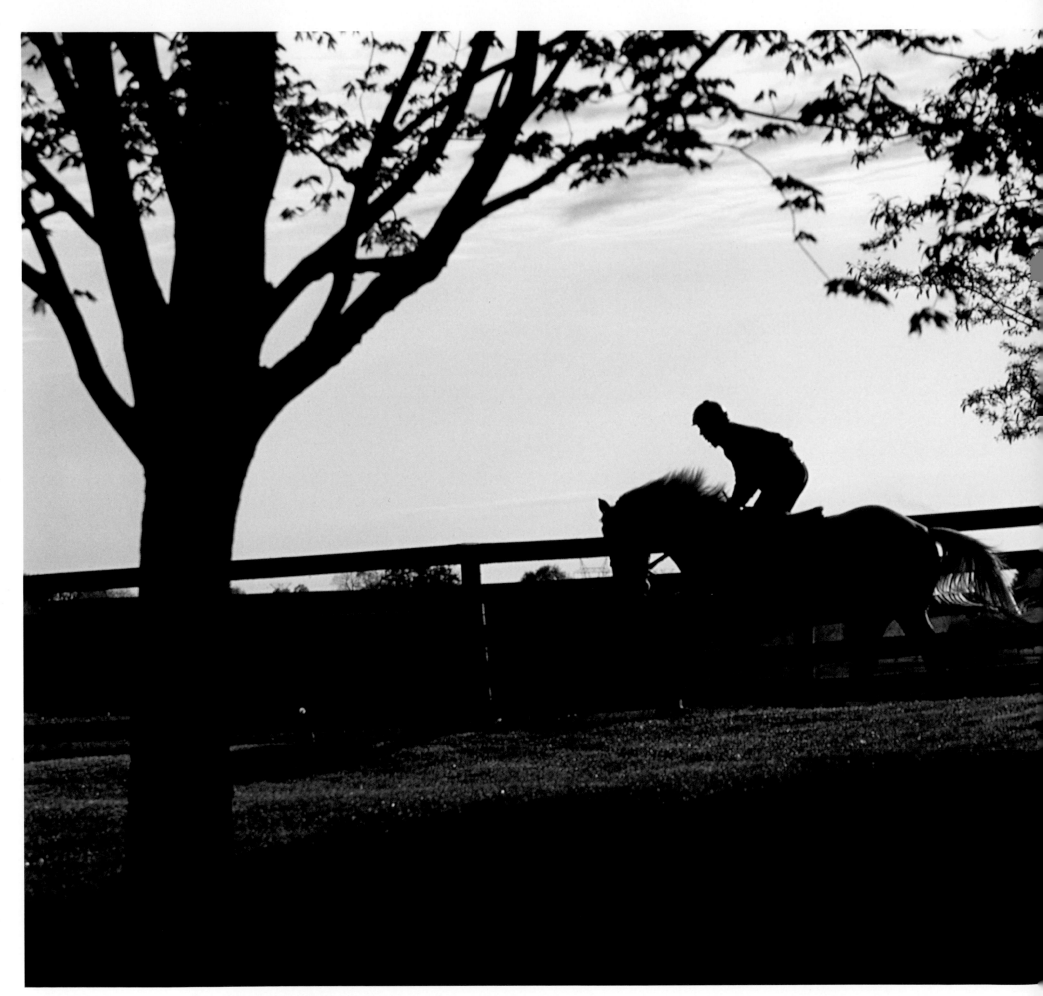

Morning, Three Chimneys Farm, Lexington, Kentucky

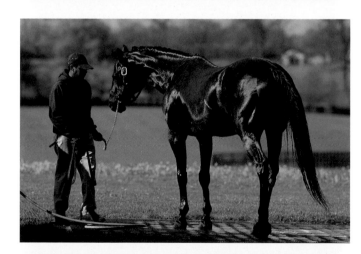

Morning, Three Chimneys
Farm, Lexington, Kentucky

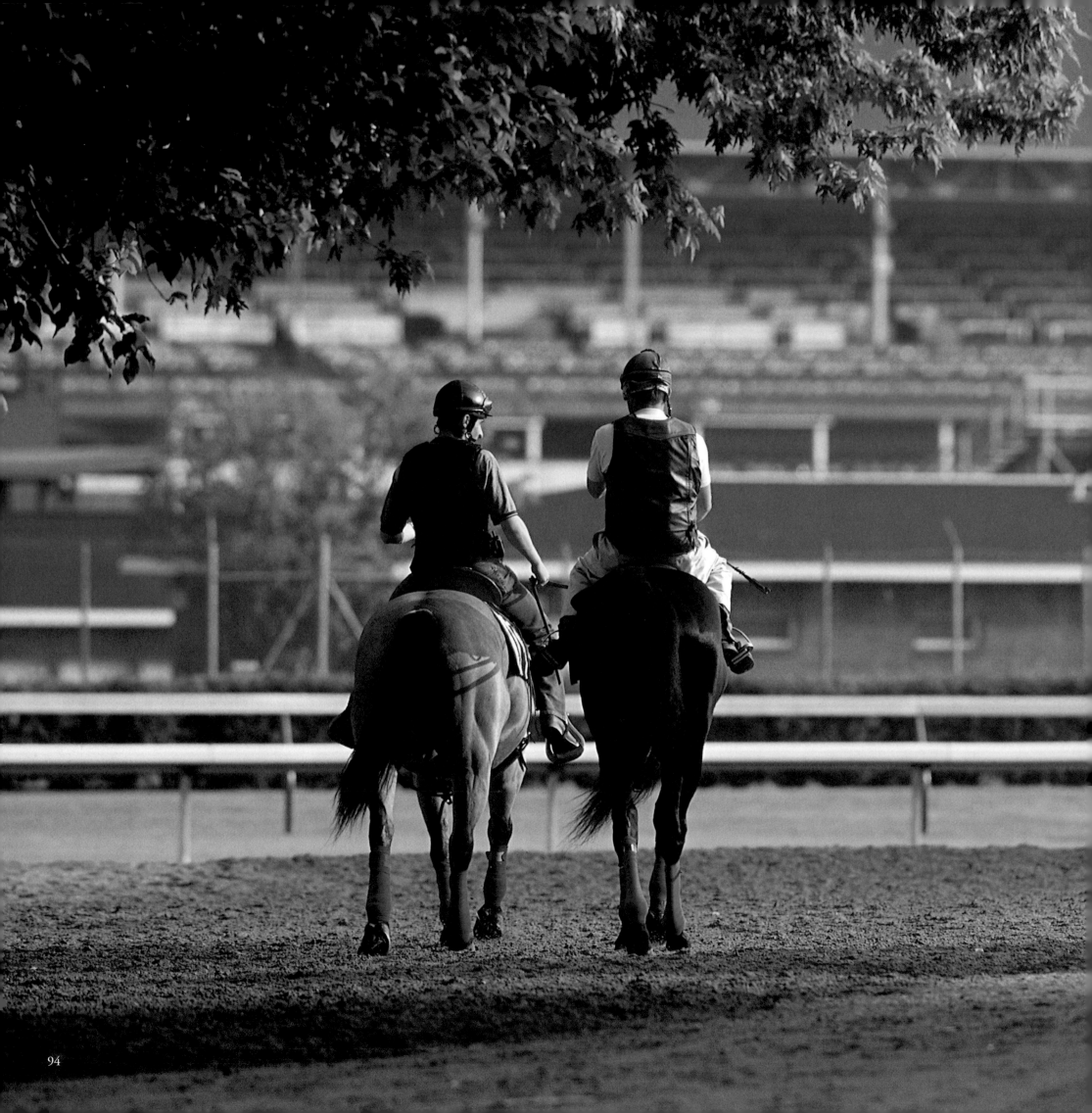

One of War Emblem's last
workouts before the 2002 Belmont,
Churchill Downs, Kentucky
opposite page

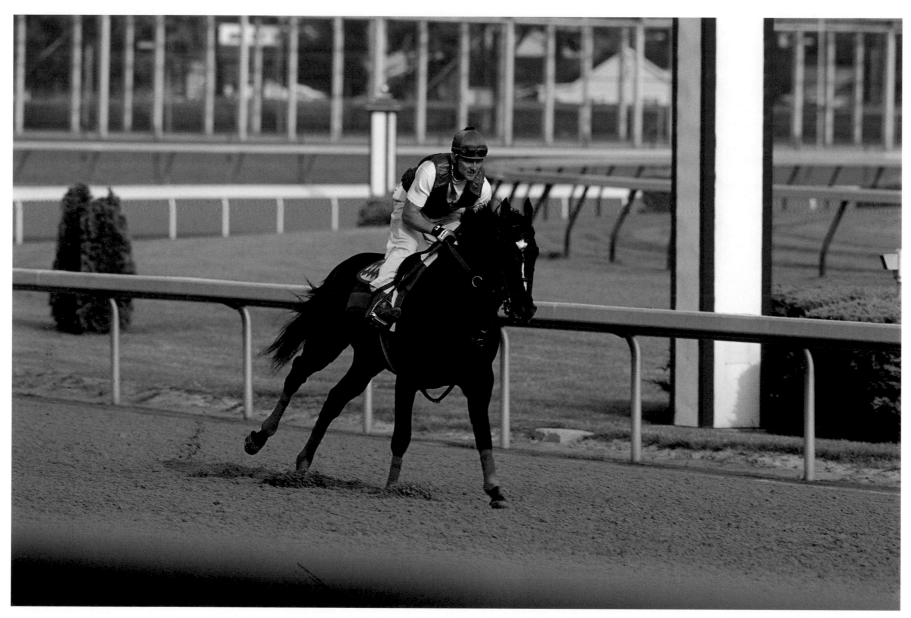

War Emblem on the track,
Churchill Downs, Kentucky

The great War Emblem

Mare pasture, Three Chimneys Farm, Lexington, Kentucky
following pages 98-99

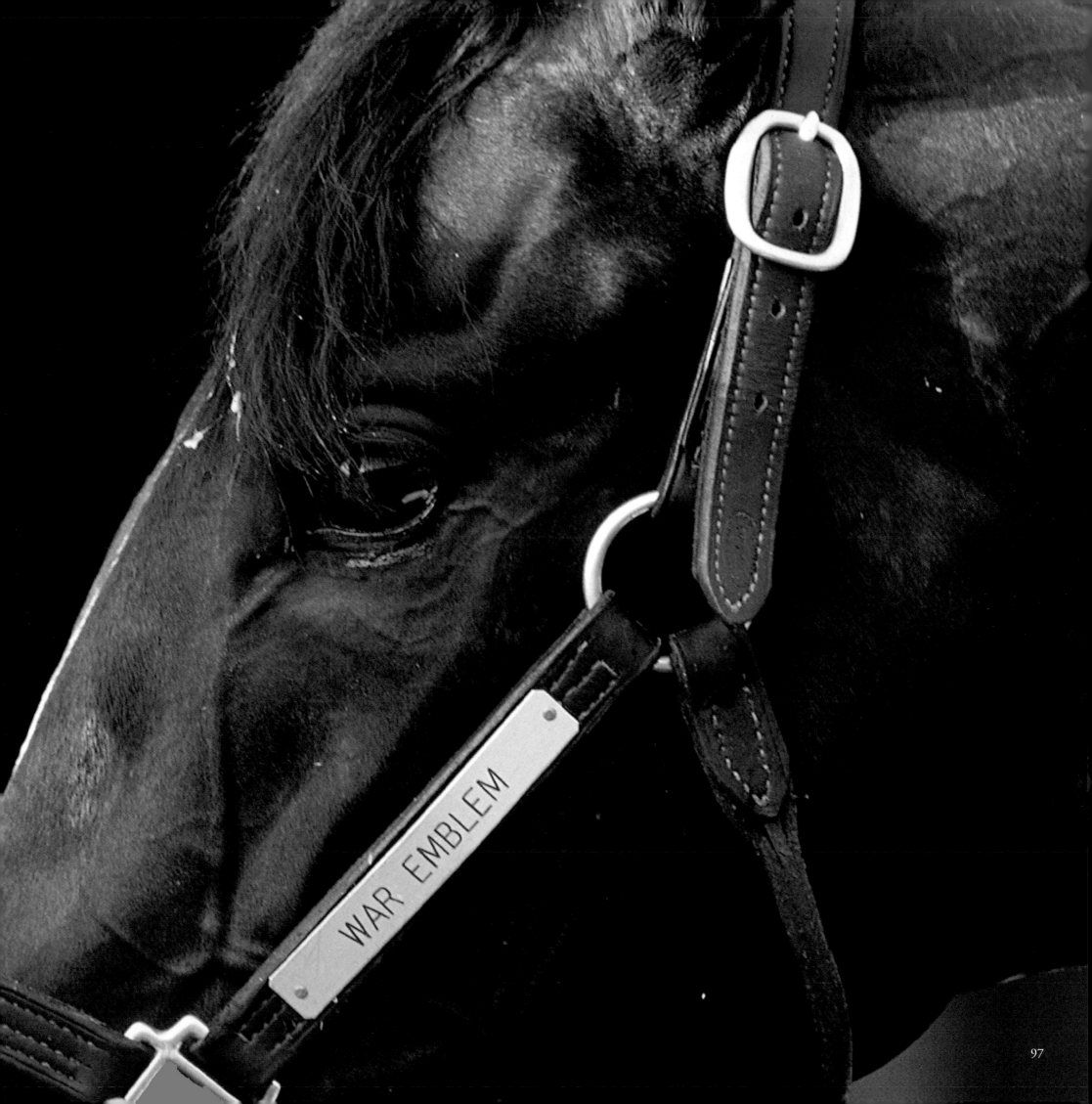

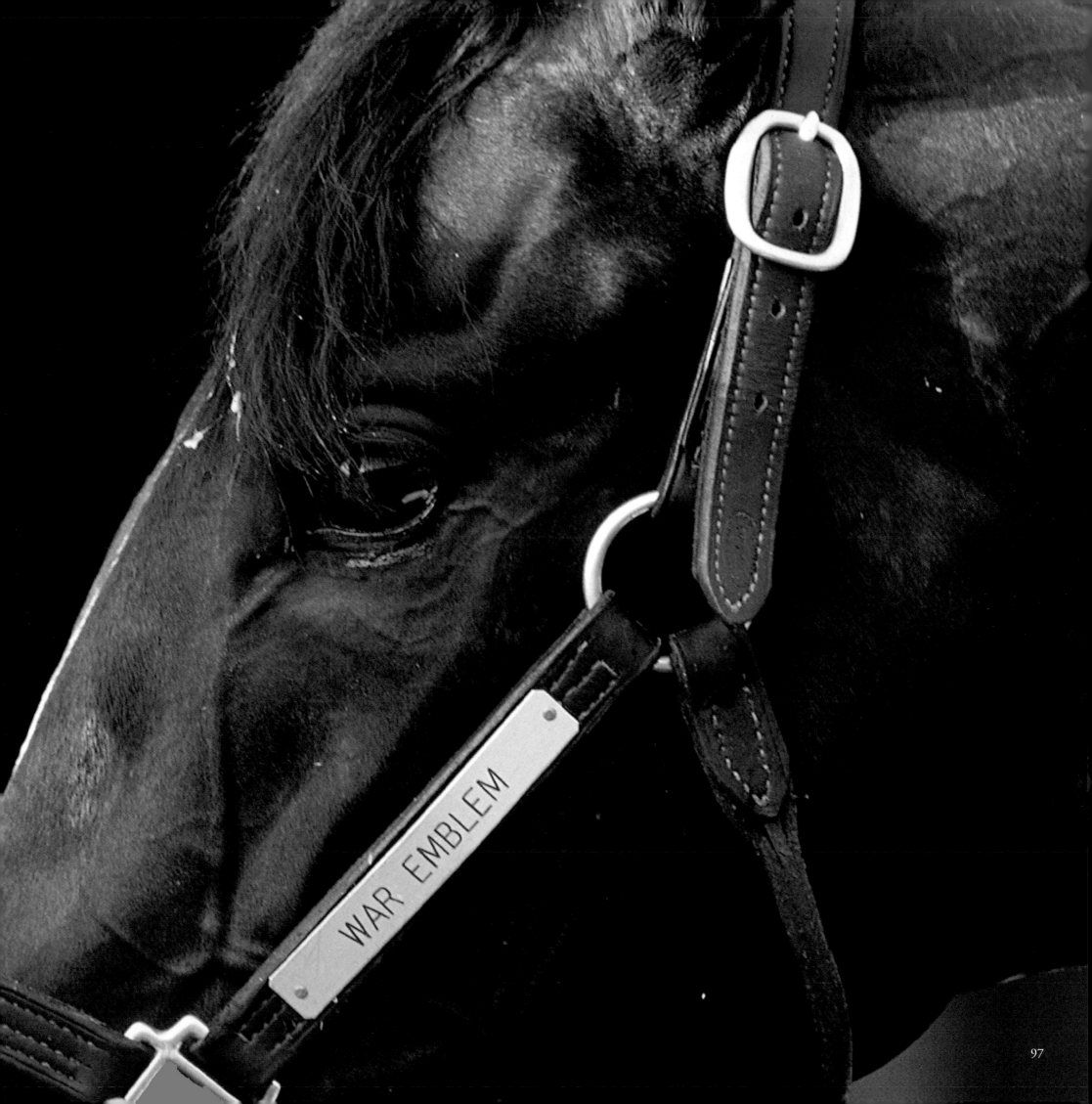

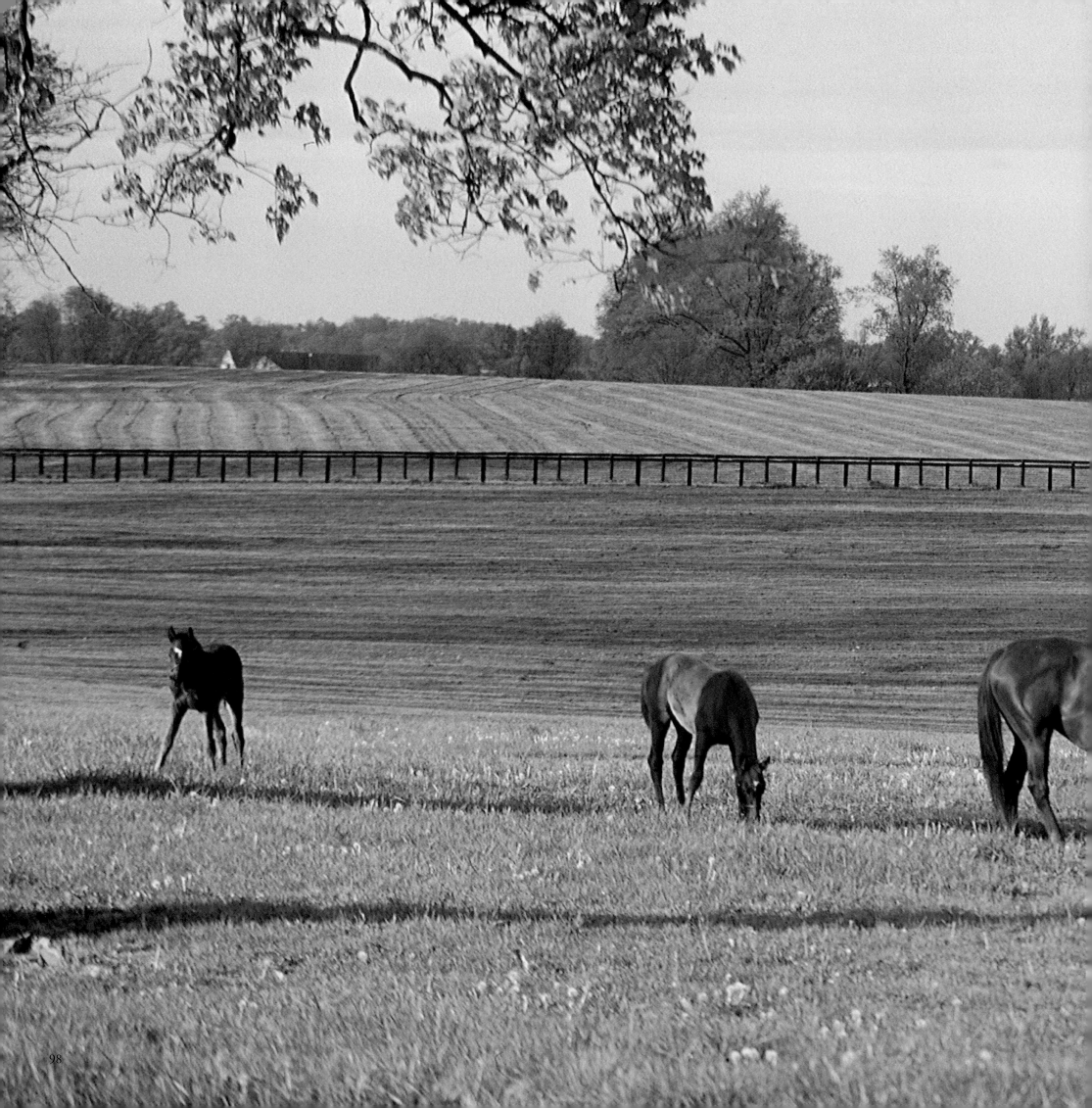

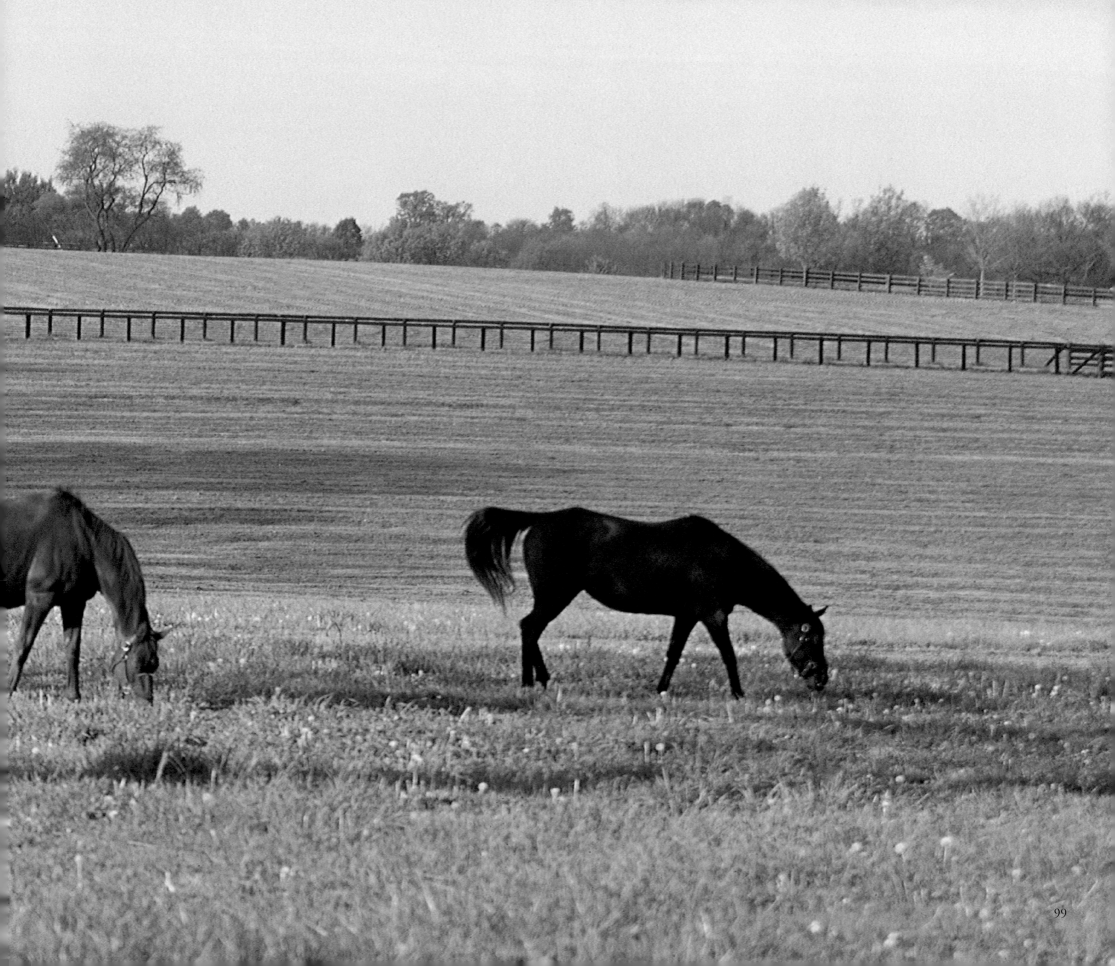

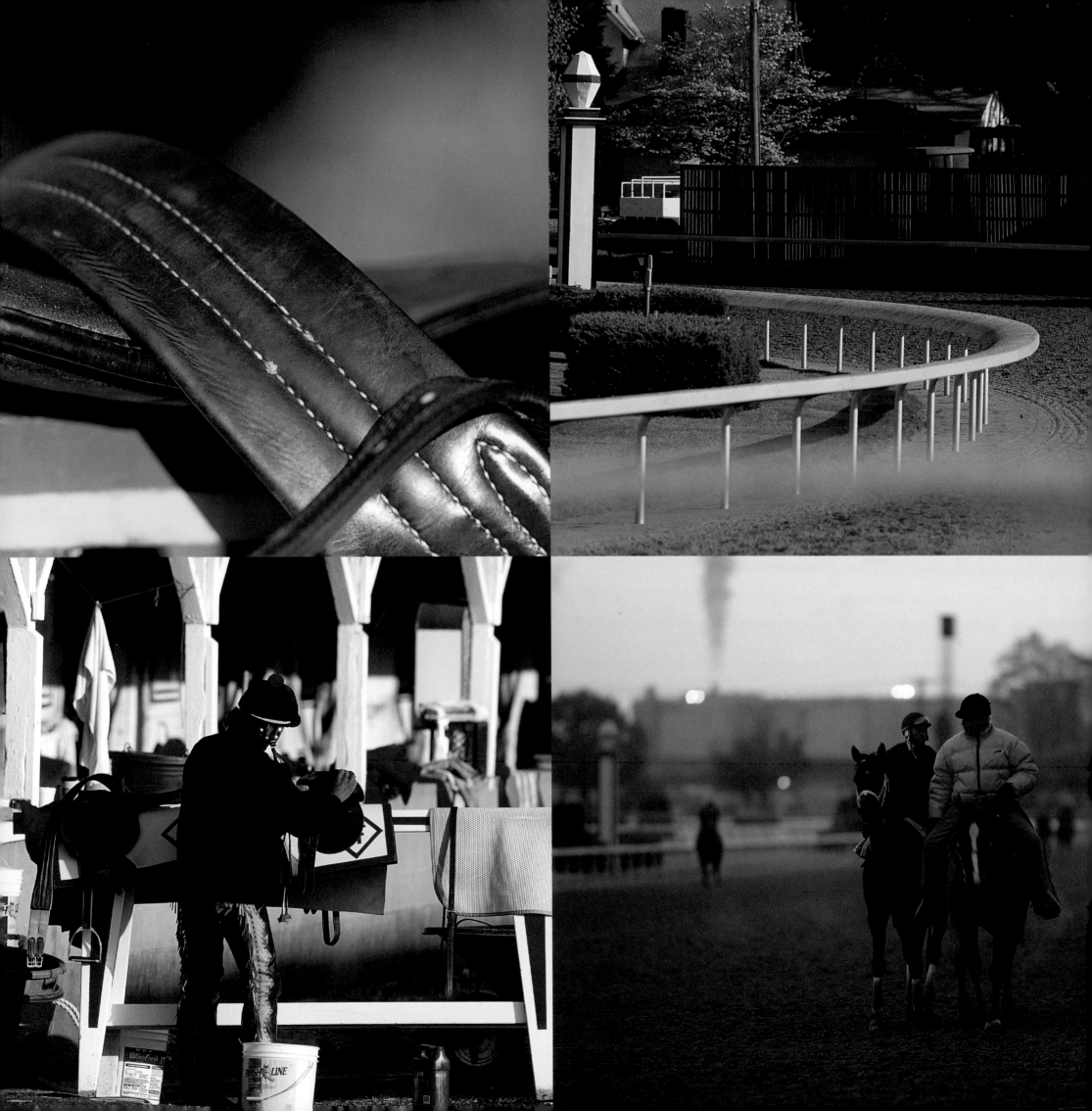

*Morning, back paddock, D. Wayne Lukas gives exercise
jockey instructions, Churchill Downs, Kentucky*
opposite page

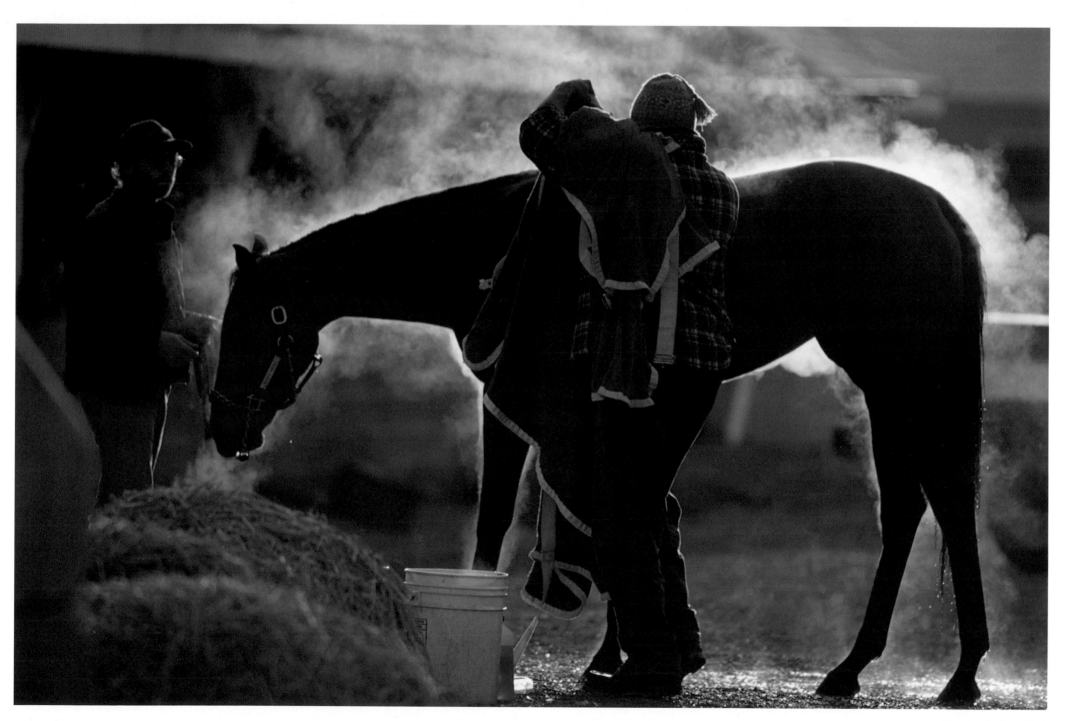

*Morning, back paddock,
Churchill Downs, Kentucky*

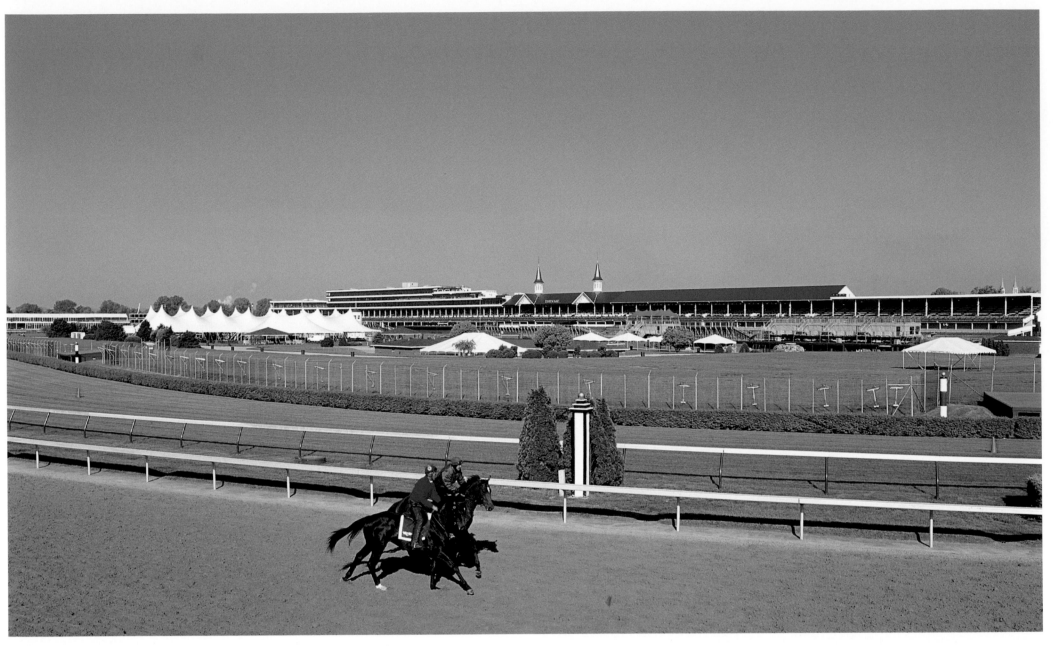

Churchill Downs, Louisville, Kentucky

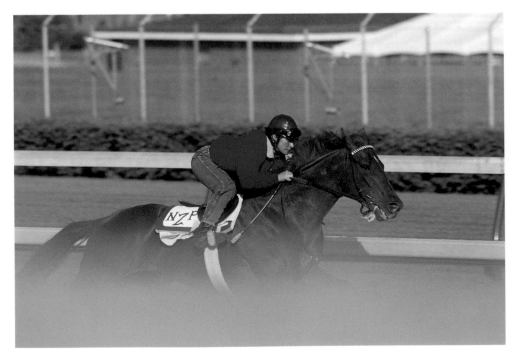

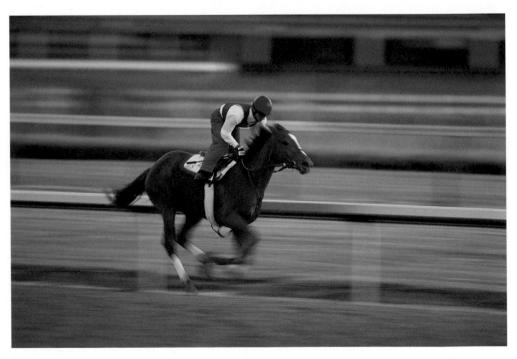

Morning exercise, Churchill Downs, Louisville, Kentucky

Morning exercise, Churchill Downs, Louisville, Kentucky

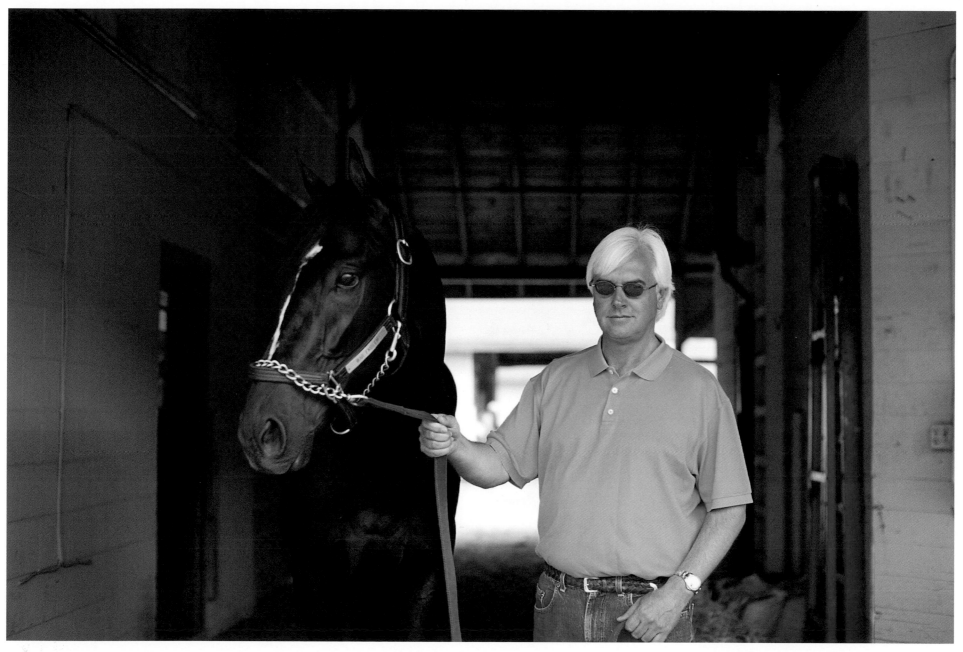

Bob Baffert with War Emblem during the last days at
Churchill Downs before moving on to the 2002 Belmont

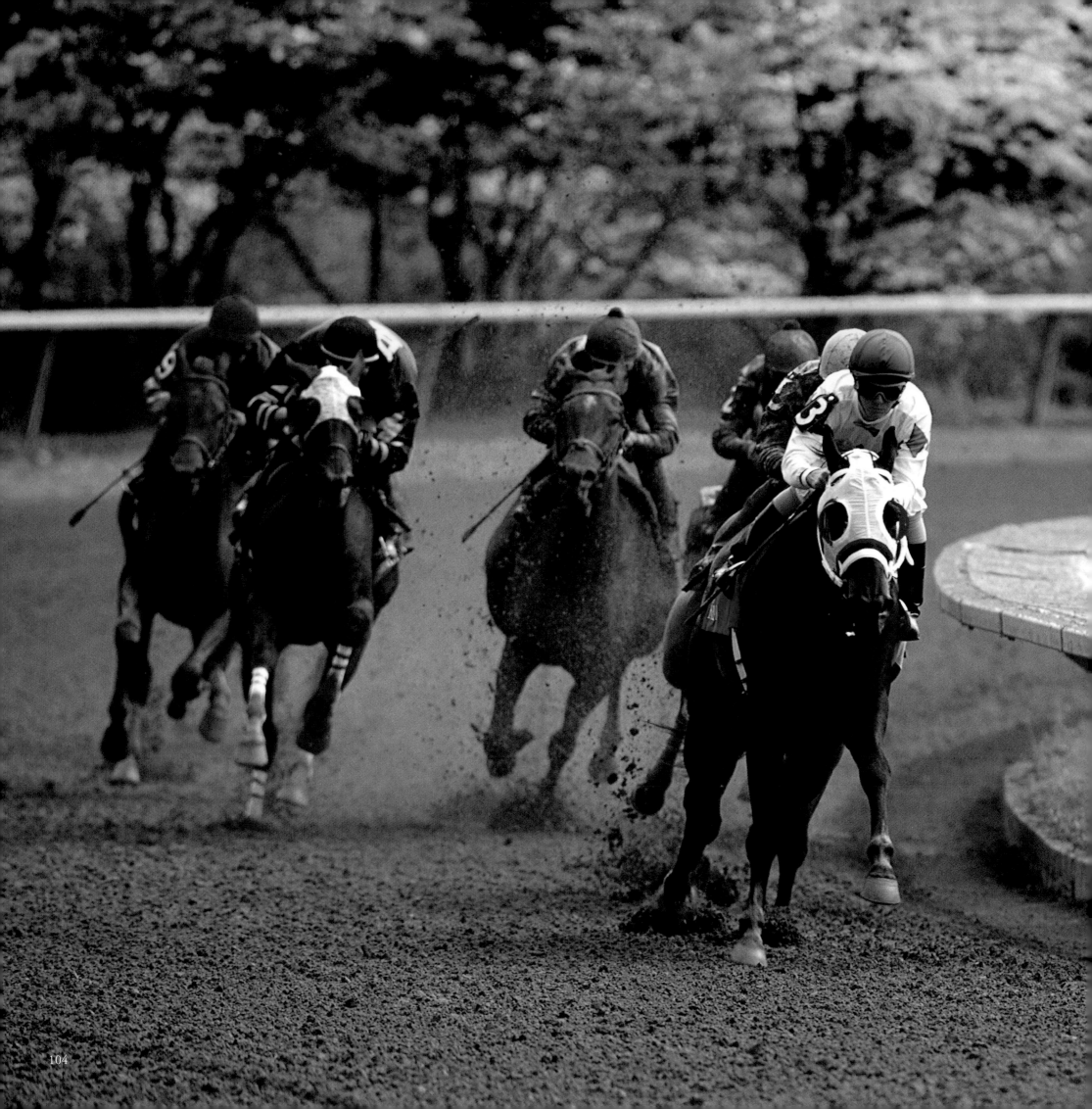

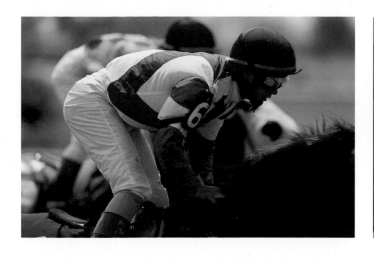
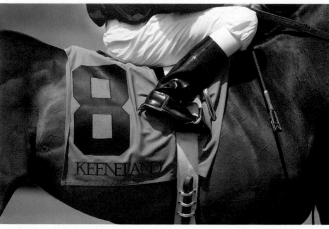
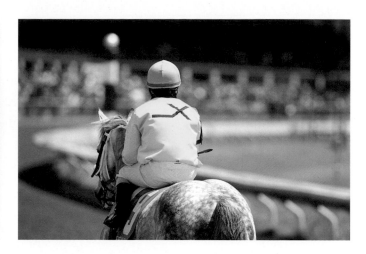
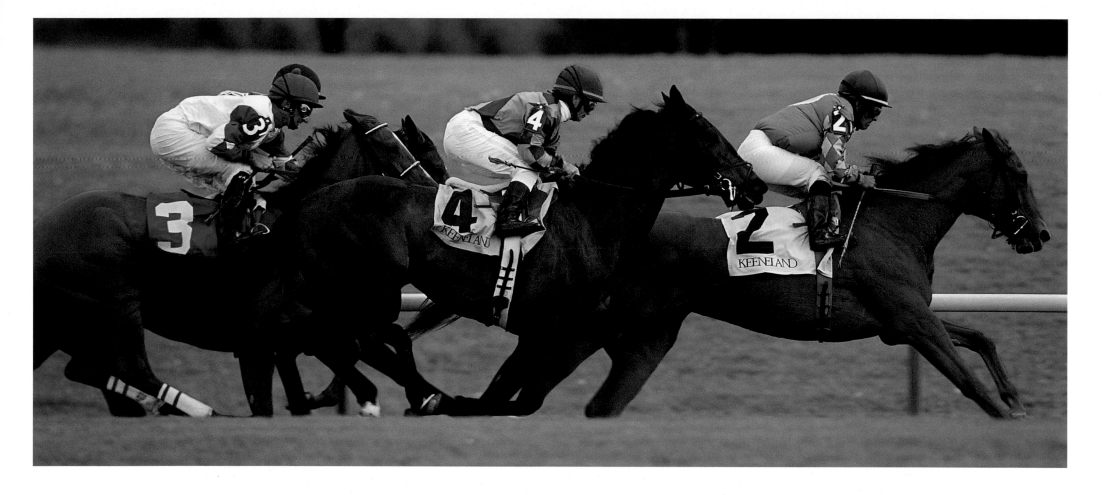
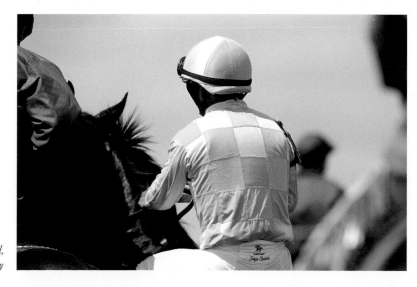

The meet at Keeneland,
Lexington, Kentucky

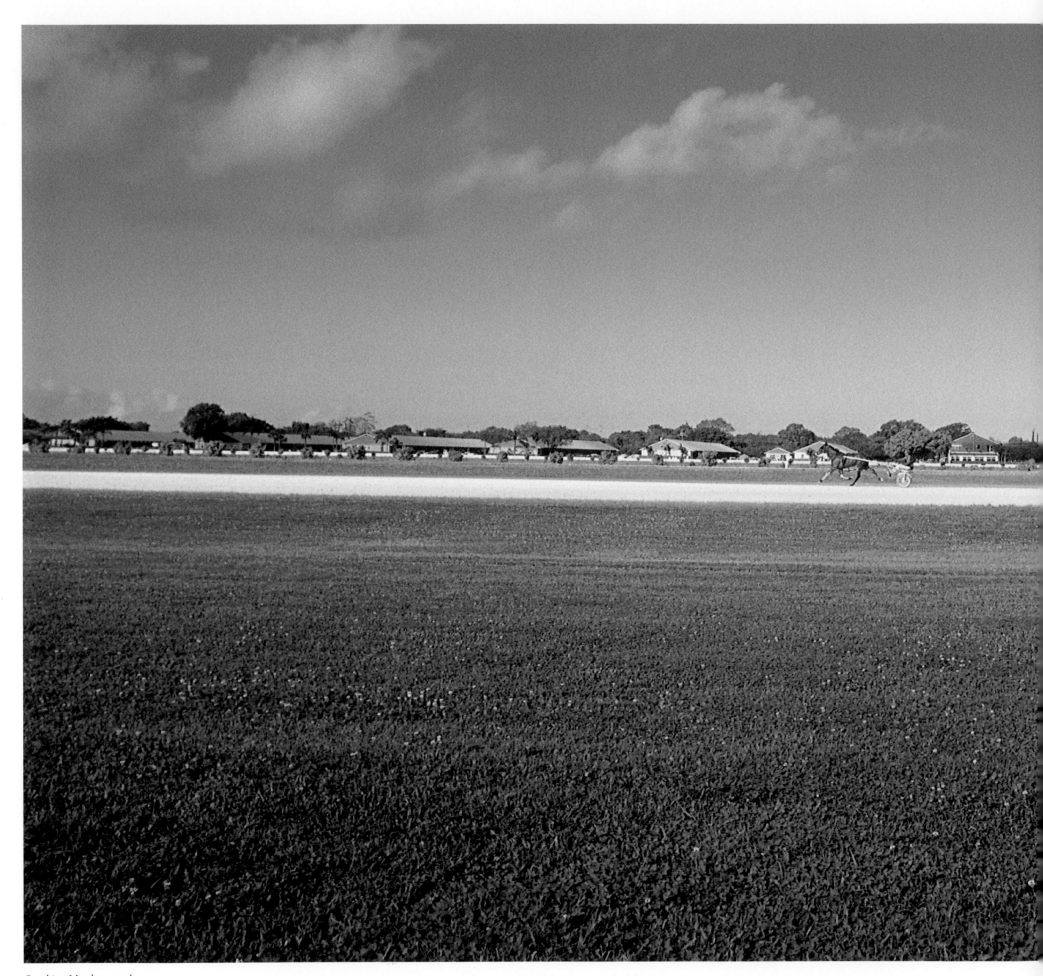

Sunshine Meadows track,
Boynton Beach, Florida

Morning swim,
Rod Allen Farms,
Ocala, Florida
following page

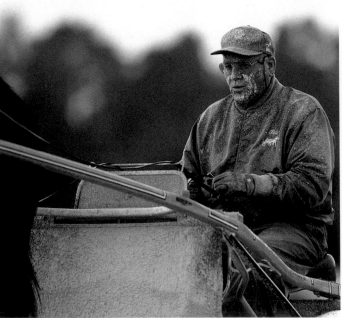

Sunshine Meadows Training Center,
Boynton Beach, Florida

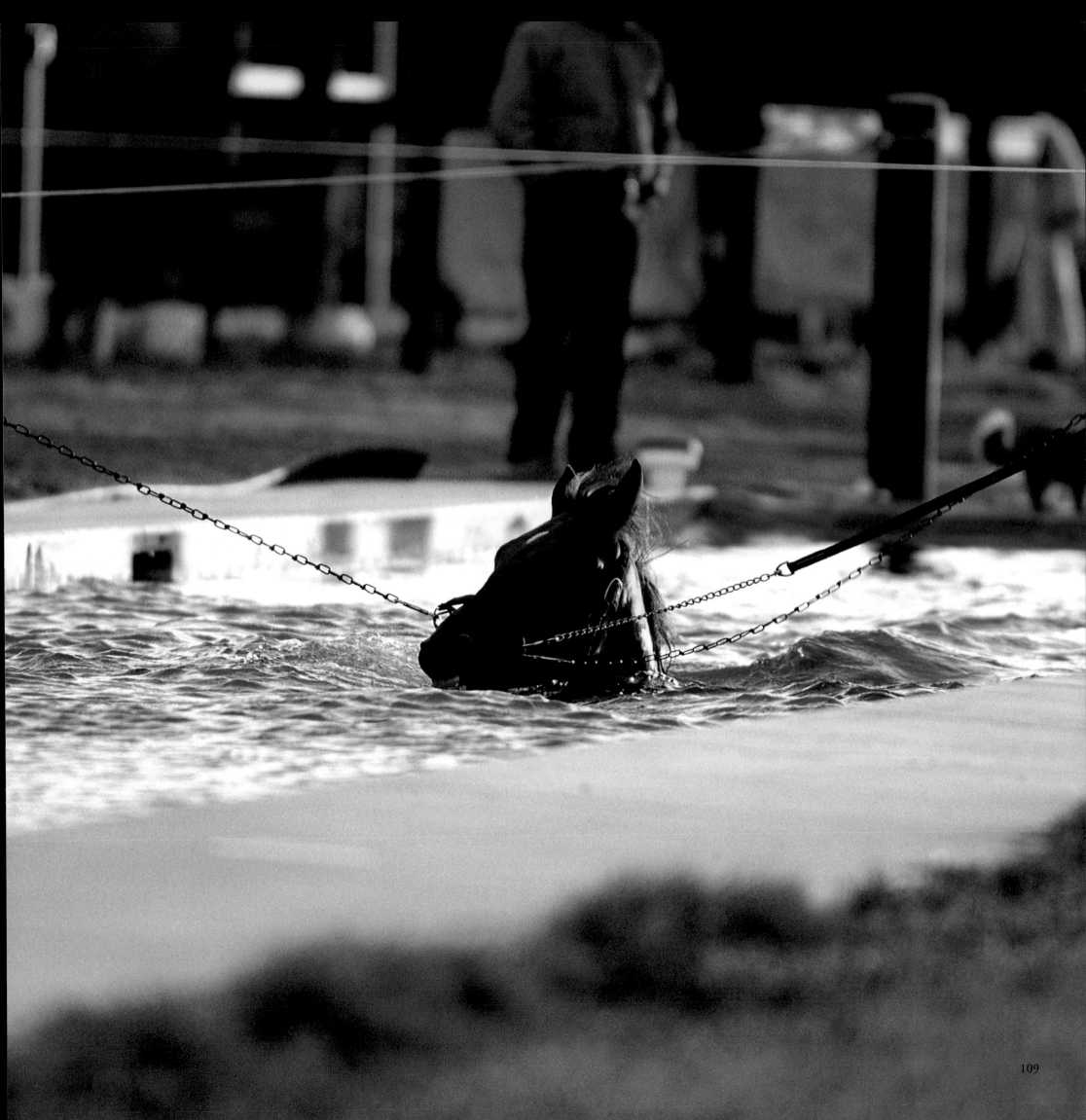

Trotters at Rod Allen Farms,
Ocala, Florida

Mare and foal, Rod Allen Farms,
Ocala, Florida

Ready for a swim, Rod Allen Farms,
Ocala, Florida

Jockey statues from around horse country
following pages 114-115

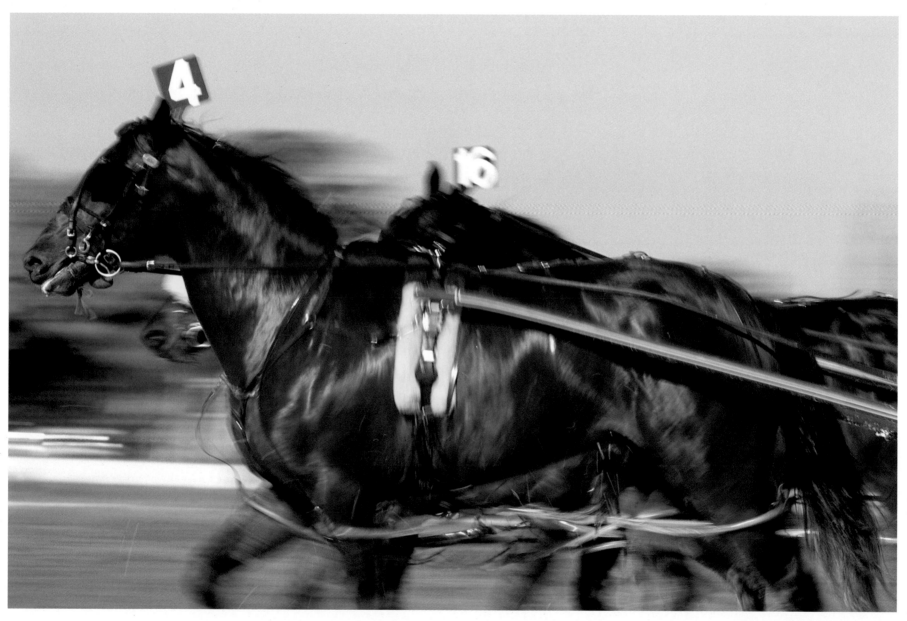

Trotters during a morning workout,
Sunshine Meadows Training Center,
Boynton Beach, Florida

KENTUCKY DERBY
WINNERS SILKS

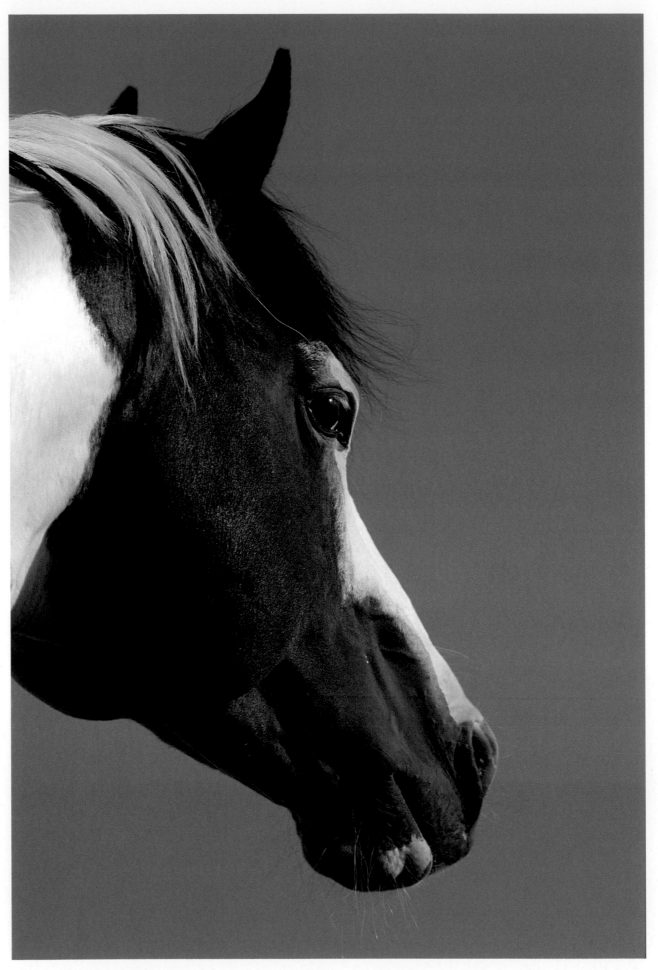

Snake River Stampede, Godby Paint Horses,
Hermiston, Oregon

THE WESTERN HORSE

The western horse is America's own. The sports he dominates are truly "American-made" and are a legacy of the West. Originally the western horse was (and, in many rural parts of the country, still is) a cowboy's hardworking best friend and partner. His skills are essential to the daily upkeep of a livestock operation. Those skills – to separate a steer from the herd, chase down a renegade calf, or simply carry his master with seemingly effortless ease – have always been a source of pride to the cowboy. He sought to match his mount against all comers, and competitions were born. These grew into the sports we know today: cutting, reining, reined cow horse, and, most recently, western pleasure.

Perhaps most appealing about the mount that won the West is his characteristic aplomb. Whatever may be required of him in competition – in many cases it is the same explosive athleticism demanded of a jumper or an eventer – at the end of his "go," a rider can drop the reins and the horse will exit the arena in a flat-footed walk. The western horse, like the cowboy he carries, is a genuine, old-fashioned gentleman.

THE WORKING PERFORMANCE HORSE

To know the true nature of the working performance horse – the cutter, the reined cow horse, and the reiner – one must watch his face as he performs. His eyes and ears tell the story. He is fierce as he blocks a cow from returning to the herd. Eager as he stares at the gate through which his quarry – the lone cow – will charge into the arena. And exuberant as he gallops in graceful figures in the show pen. His expressiveness conveys the message that he has an important job to do and is more than ready to do it.

His heritage stems from the vast working cattle ranches of the nineteenth-century American West and Southwest, especially in California and Texas. With few fences and thousands of cattle to mind, the early working cowboy had a dire need for a steady, athletic, hardy mount. A good horse had many jobs: gathering herds of cattle, driving them to market or to new grazing areas, isolating individual cows for branding or doctoring. And because cattle take exception to being driven or isolated, the horse had to outwit and outmaneuver them all.

The American Quarter Horse, who was bred selectively for agility and cow savvy and who carries the blood of the Spanish horses brought to America by the conquistadors, emerged as the cowboy's premier working performance mount. Today he rules the sports of cutting, reining, and reined cow horse, along with his brethren, the Paint and the Appaloosa.

The cutting horse may well be the only equine performer that works essentially on his own. Once a cow has been cut from the herd and the work begins, the horse must perform without visible guidance from his rider. He thinks for himself as he matches the cow eye-to-eye, feint for feint, dodge for dodge.

Cutting contests first started in the mid-1800s; the first competition with a substantial purse was held at the Cowboy Reunion in Haskell, Texas, in 1898. Today's cutting horses earn points – and cash prizes second in size only to those of racing – for aggressiveness, determination, style, and expressiveness. Enthusiasts say being atop a shifty, self-directed cutting horse is thrilling and addictive.

The reiner is the cowboy's dressage horse. Reining contests began as a way to test the handiness and obedience a mount needs in order to carry a cowboy throughout his busy day on the ranch. Today's geometric reining patterns require accuracy, fluidity, balance, and coordination from the horse, who is guided with but the lightest touch on a draped rein. The reiner must perform large, fast circles; small, slow circles; flying changes of lead at the gallop; sliding stops; 180-degree rollbacks; 360-degree spins.

Reining as we know it today began in the mid-1960s. It was sparked in part by an inspirational performance at an Ohio Quarter Horse show by legendary horseman Bill Horn and the fabulous Continental King. In 1998, reining became the first western sport to come under the auspices of the United States Equestrian Team. Reining is now an international sport, represented at such events as the USET Festival of Champions and the World Equestrian Games. The ultimate goal is to establish the sport as the first western equestrian event at the Olympics.

The reined cow horse, like the three-day event horse, combines the challenges of two other sports and adds a third. This "triathlete" of the western horse world cuts, reins, and performs what is known as "cow work" or "fence work" – controlling the movements of a single maverick running wild in the arena.

The training of a reined cow horse is based upon the methods of the Spanish vaqueros ('cowboys') who worked the early California missions and cattle ranches. The vaqueros practiced the exacting discipline of the Spanish Light Cavalry, renowned for superb horsemanship. In the vaquero tradition, young horses are started in a snaffle bit, then gradually advance over several years to a hackamore (bitless bridle), a two-rein system (half-breed or spade bit plus light hackamore), and finally into a half-breed or spade alone. In competition,

IN THE LANGUAGE OF THE RANGE, TO SAY THAT SOMEBODY IS "AS SMART AS A CUTTING HORSE" IS TO SAY THAT HE IS SMARTER THAN A PHILADELPHIA LAWYER, SMARTER THAN A STEEL TRAP, SMARTER THAN A COYOTE, SMARTER THAN A HARVARD GRADUATE – ALL COMBINED.

...Joe M. Evans, A Corral Full of Stories

the circling maneuver at the end of the cow work is based on an early cattle-slaughtering method known as *nuqueo* or 'necking.' To preserve hides for trade, the vaquero brought his mount alongside a targeted animal and, with a single thrust of a long knife just behind the steer's head, killed it instantly.

Organized reined cow horse competition began in California in the early 1950s. Today's reined cow horse displays his talents in three events in futurity competition and other large contests. Breed shows also offer "working cow horse" classes requiring reined work and cow work only, eliminating the cutting.

California trainer Bobby Ingersoll is the founder and three-time winner of the premier cow horse event – the World Championship Snaffle Bit Futurity. An inaugural inductee into the National Reined Cow Horse Association Hall of Fame, he is a staunch traditionalist with respect to Spanish training methods. Also a successful trainer of cutting horses, he says the best horses in all sports are consistent.

"You can feel a great horse learning every day that you ride him," says Ingersoll. "Some horses, despite good breeding and talent, just don't want to help you. But the great ones do – they try so hard to please. And when you call on them in competition, they answer." One of the many great horses Ingersoll has ridden was the mare Doc N Missy, who came from behind to win the 1978 Snaffle Bit Futurity by an impressive margin. He says today's competition is even tougher.

"You start a two-year-old, and while you're working him soft and slow, you're thinking, 'Hey, this is a good horse.' But later, when you start pushing him, you find he can't handle it. He falls apart. Competition is so stiff, we have to ask young horses to do things even older horses would have trouble with. But the great ones can handle it," he adds, "because they help you to help them."

Texan Leon Harrel is a two-time winner of the National Cutting Horse Association Futurity and a member of the NCHA Hall of Fame. He is awed by the athletic ability of great cutting horses, as well as the mental focus they bring to their job.

"Things happen in a flurry in cutting," says the horseman, who rode Doc's Playmate to the 1978 NCHA open world championship. "You cut a bad calf, and in an instant it's running wide open across the pen. Your horse is running parallel to it, but when that cow doubles back on itself, you think there's no way your horse is going to be able to stay with it. But he does – out of tremendous desire, concentration, and athleticism. When you feel that exuberance – your horse throwing his heart over the bar for you – you understand why this sport is so addictive."

Bob Avila, formerly of Oregon and now based in southern California, has ridden many great performance horses in a range of events. Winner of the NRCHA Snaffle Bit Futurity, the National Reining Horse Association Futurity, and the World's Greatest Horseman Contest, he says heart is when a horse cannot try anymore and yet keeps trying anyway. In the cow work of the 1999 Snaffle Bit Futurity, he was shocked when a rank cow tried to jump over his horse Smart Zanolena – and landed right on top of him instead. It was the sort of thing that can take the courage right out of a horse.

"But he just kept going down the fence," Avila says of the stallion. "It was a crazy cow, but we worked it, and were given 'degree of difficulty' points for it." The pair ended up winning the futurity that year.

Sandy Collier, the only woman to win the open division of the Snaffle Bit Futurity, says great horses have a certain charisma that makes the judge want to like them. "They're like certain people – they have a blend of grace, elegance, style, confidence, and consistency that adds up to charisma," she says. "They're the crowd favorite, and they know it. The judge will look for ways to reward a horse like that."

The California trainer says the mare Sheeza Shinette, her mount in the 2001 Snaffle Bit Futurity, had charisma *and* heart, both of which shone through in the cow work. "We drew a Charolais that flat didn't want to be stopped," she recalls, "so the mare just body-blocked it. The cow slammed into my leg like a pile-driver, then took off again, and the mare chased it down and stopped it again. Then she went to its head and pushed it around in a circle. She did everything like a seasoned, well-broke horse – not the three-year-old baby that she was."

Central Californian Les Vogt, who tied with Bobby Ingersoll for the championship at the inaugural Snaffle Bit Futurity in 1970, has won over a dozen world titles in cow horse and reining competition. He says great horses sometimes "train" their riders.

"Moon Chex, Royal Chex, Chex of Chex – those horses developed *me*," he says of his earliest champions. "At the time, of course, I thought I was developing them. But I was young and ignorant. I didn't know about setting a horse up – getting him into the correct form before asking him to perform a maneuver. I just pushed my horses around, and some were so great they won in spite of me.

"Today," he continues, "with horses like Chex A Nic and Tux N Tails, I use a more sophisticated program. I help them develop form, which brings out their greatness. Proper training is a negotiation process, a back-and-forth between the horse and rider. I usually get what I want, but the horses think they're getting what they want, too. This approach makes for a longer show life."

He points to his veteran campaigner, Tux N Tails, now eighteen. "I just sold him to an eleven-year-old boy who's won two buckles with him in cow horse classes," he says. And indeed the gelding – smart, hardworking, reliable – exemplifies the qualities of the ideal western performance horse.

THE PLEASURE HORSE

A good western pleasure horse lives up to his name. Like a Cadillac on cruise control, he motors along, maintaining the programmed pace and guiding with merely a touch of the rein. A comfortable, worry-free ride is his hallmark. Though a pleasure horse may not be heart-stopping to watch, he is a genuine sweetheart to ride.

Western pleasure has been around as long as there have been horse shows. The class requires entrants to walk, jog, and lope both ways of the arena; horses are evaluated for their movement and compliance. In the early 1980s, western pleasure became more exacting. Rich futurities rewarded horses that traveled in a highly controlled manner, with no visible cuing from the rider. Carrying the "more is better" viewpoint to an extreme, exhibitors soon had horses moving *too* slowly, in a drooping frame and with inhibited gaits. Breed registries, most notably the American Quarter Horse Association, promptly revised rules to encourage natural movement and normal, free-flowing gaits.

Today's best pleasure horses move in a balanced frame with a stride appropriate to their conformation. They maintain a level topline, their polls more or less even with their withers. Their gaits are cadenced and correct – a four-beat walk, two-beat jog, and three-beat canter. Relaxed and confident, they move in a way that is comfortable for them as well as for their riders, and they guide easily on a draped rein.

Western pleasure is an extremely popular sport, especially for amateurs. Less risky than faster-paced events, it is still every bit as demanding from a mental standpoint. A good pleasure horse meets the highest standard of controlled, refined movement – but with scant guidance from his rider in the show pen. For this reason, the event requires a well-trained horse with a willing disposition and "pleasure-enabling" conformation.

Not all pleasure horses are "western." The hunter under saddle is a pleasure horse in English tack, and the pleasure driving horse displays the same desirable qualities in harness.

Greg Wheat, lead trainer at Roberts Quarter Horses in Reddick, Florida, has ridden many a champion pleasure horse. He says the event requires a special kind of animal.

"He has to be deep-hocked behind – his hind leg must reach well up underneath his belly," he notes. "At the same time, he has to be soft and smooth in his movement. When they're bred right, pleasure horses want to move that way naturally. Then the hardest part of training them is just avoiding ruining that nice way of going."

Wheat says the best pleasure horses are also kind and willing. "It takes a big heart to go out and show over and over, always giving a hundred percent," he says. "We go to the big shows, where the horses have to be perfect every time they enter the ring. That's tough. Plus, you can't force them to go on a loose rein. It's something they have to want to do on their own. That's why the best horses are sweet-tempered. They're easy to work around – very people-oriented. And they don't spook easily. In the ring, they tune out things that might otherwise frighten them. They're also expressive in the ears and eyes. A horse that's looking ahead, interested in where he's going, makes a pretty picture."

Brooke Berg of Jacksonville, Florida, shows western pleasure and hunter under saddle horses in the amateur division. She says the best thing about a good pleasure mount is the partnership you form with him.

"It's wonderful when you really connect," she says. "With a great horse, you form an unbreakable bond. You know him the way you know your best friend – you recognize his every mood, and you know how to get the best out of him. Plus, he doesn't let you down. Even at the end of the show day, when everyone's tired, he'll be trying his best for you – holding up his end of the team."

And making showing a genuine pleasure.

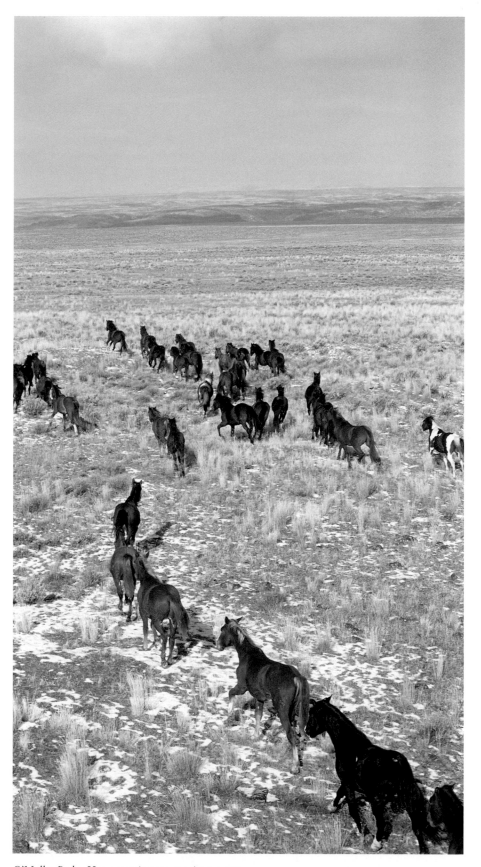

O'Malley Rodeo Horses turning out to winter pasture, Shoshone, Idaho

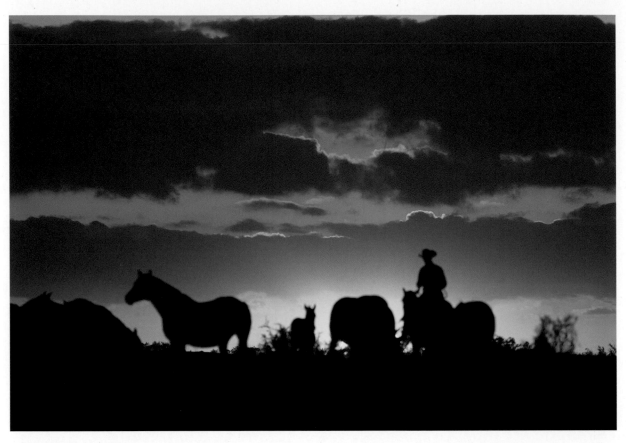

R.A. Brown Quarter Horses,
Throckmorton, Texas

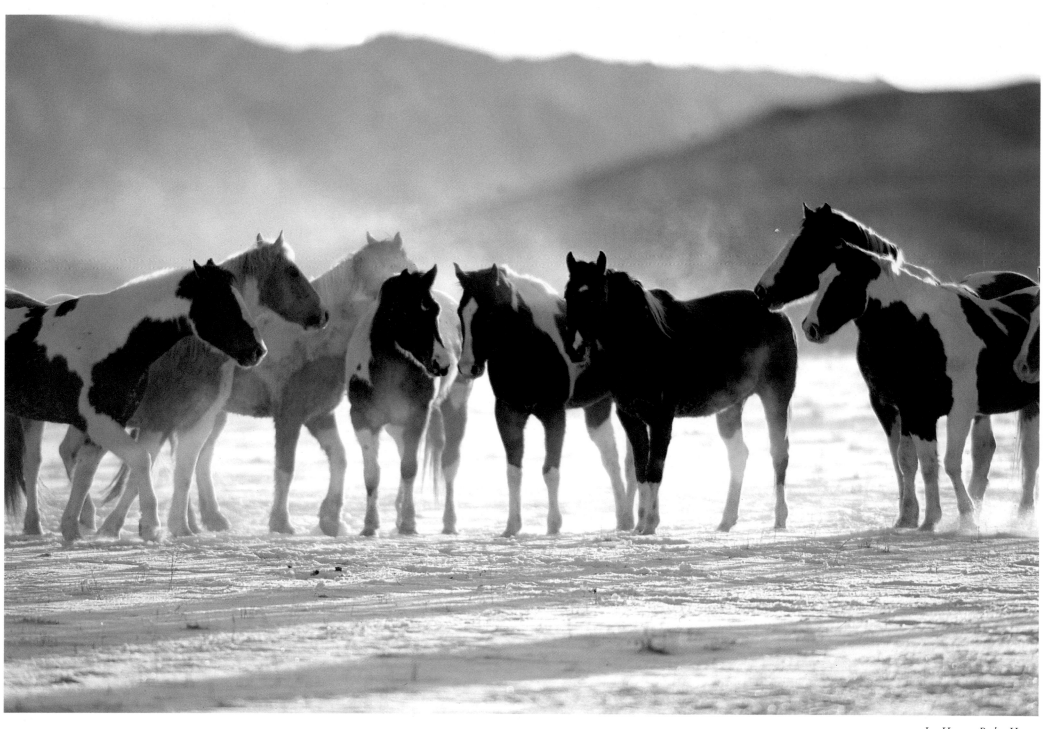

Jay Hoggan Rodeo Horses,
Hamer, Idaho

121

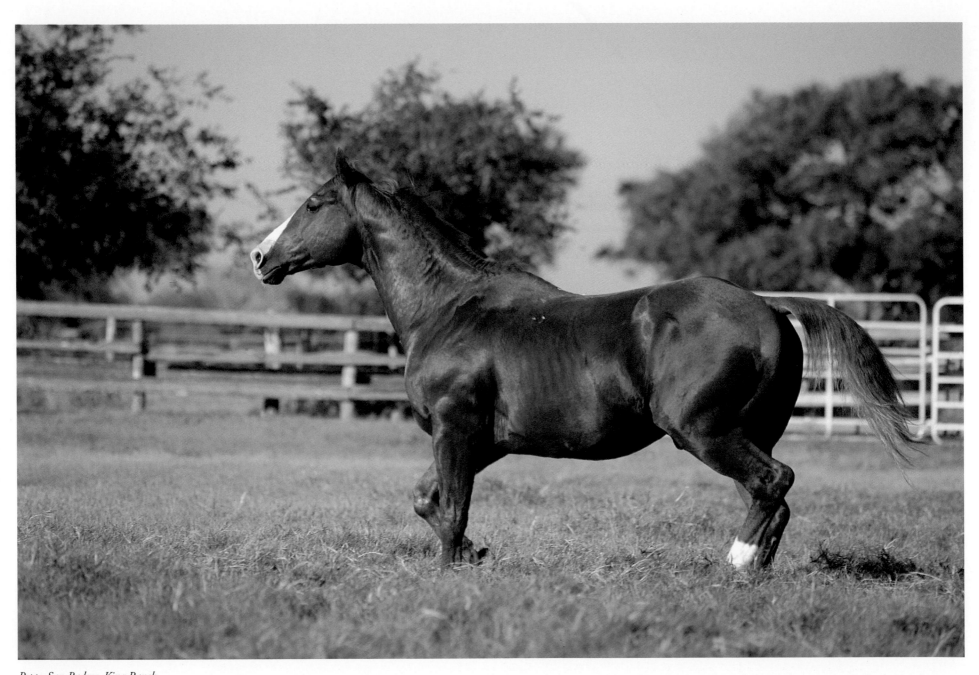

Peppy San Badger, King Ranch,
Kingsville, Texas

Peppy San Badger and Mr. San Peppy
are two of the greatest sires in quarter horse history.

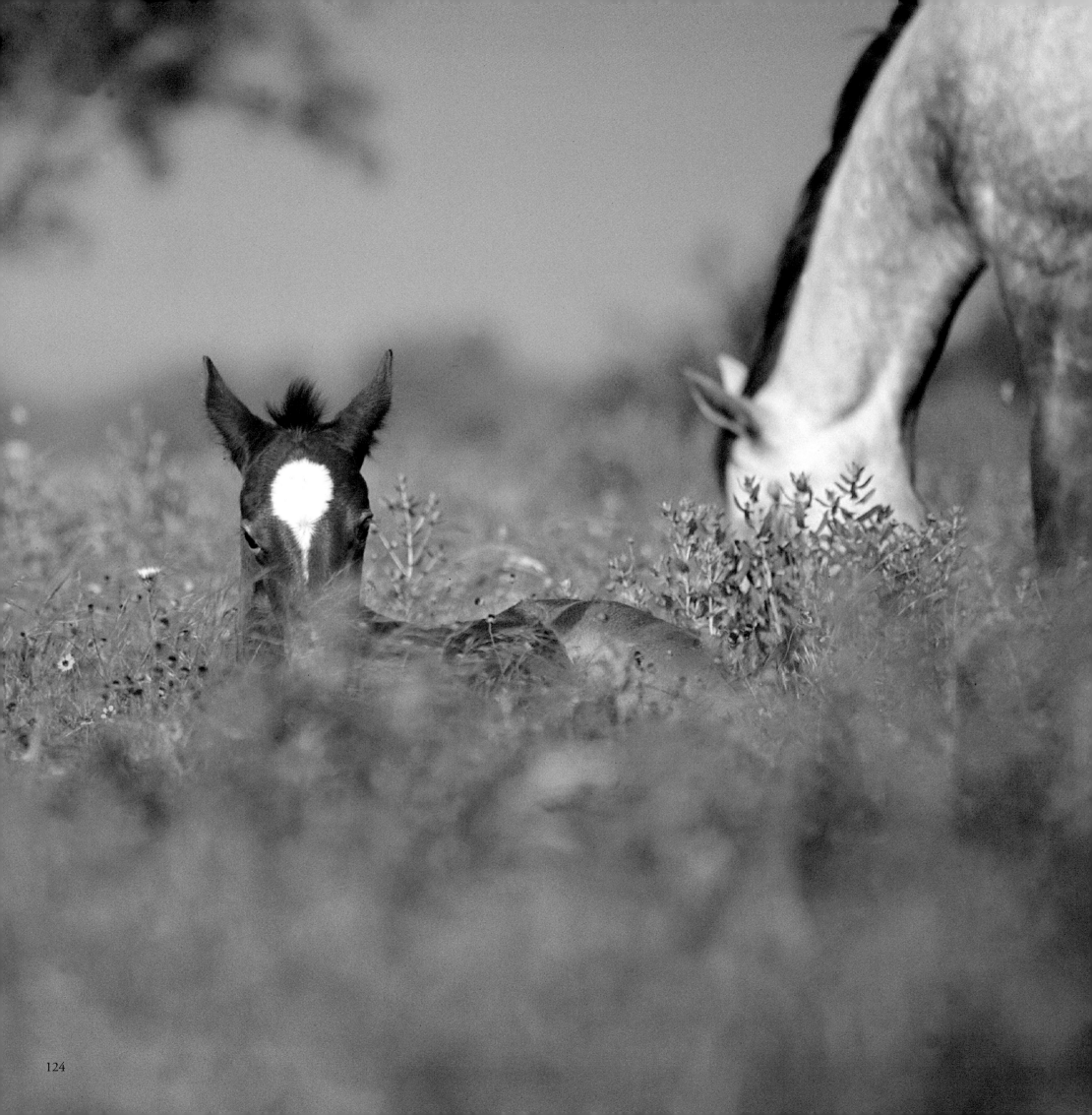

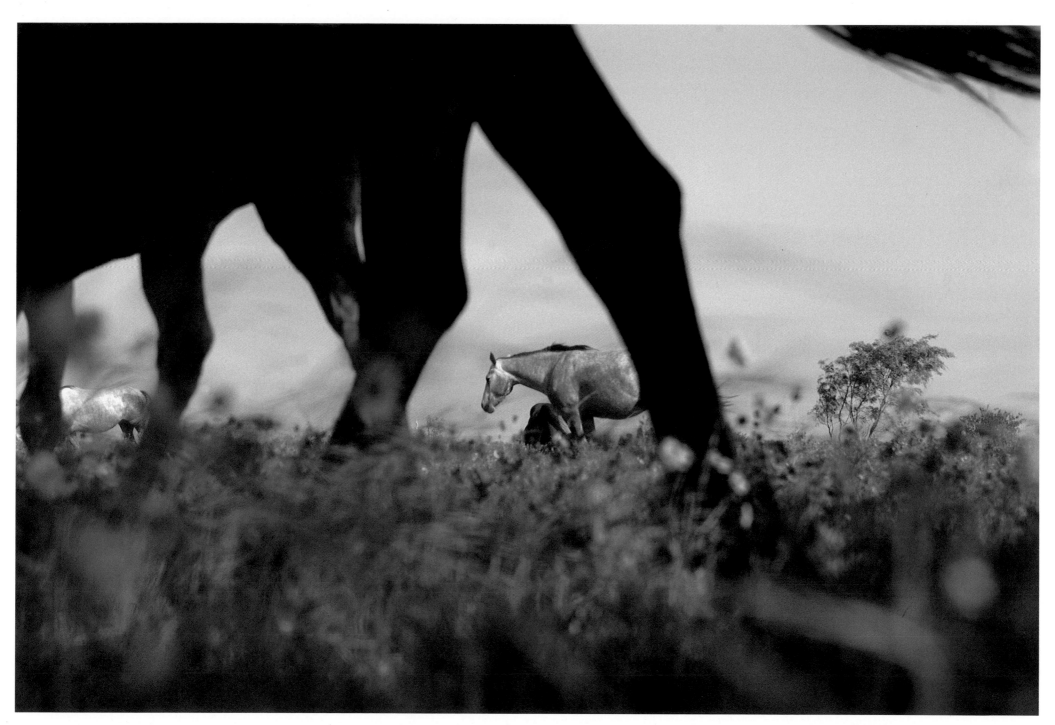

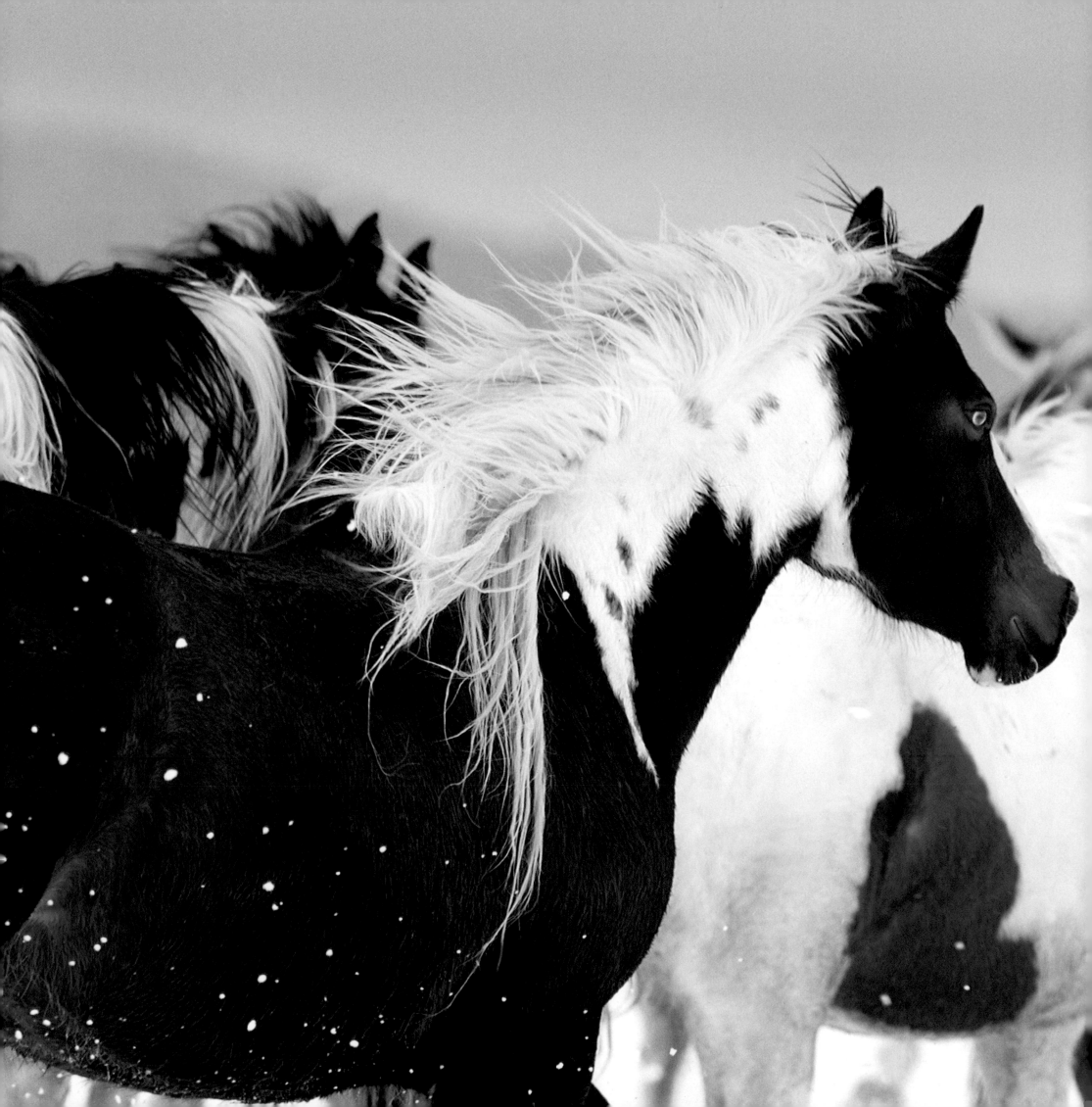

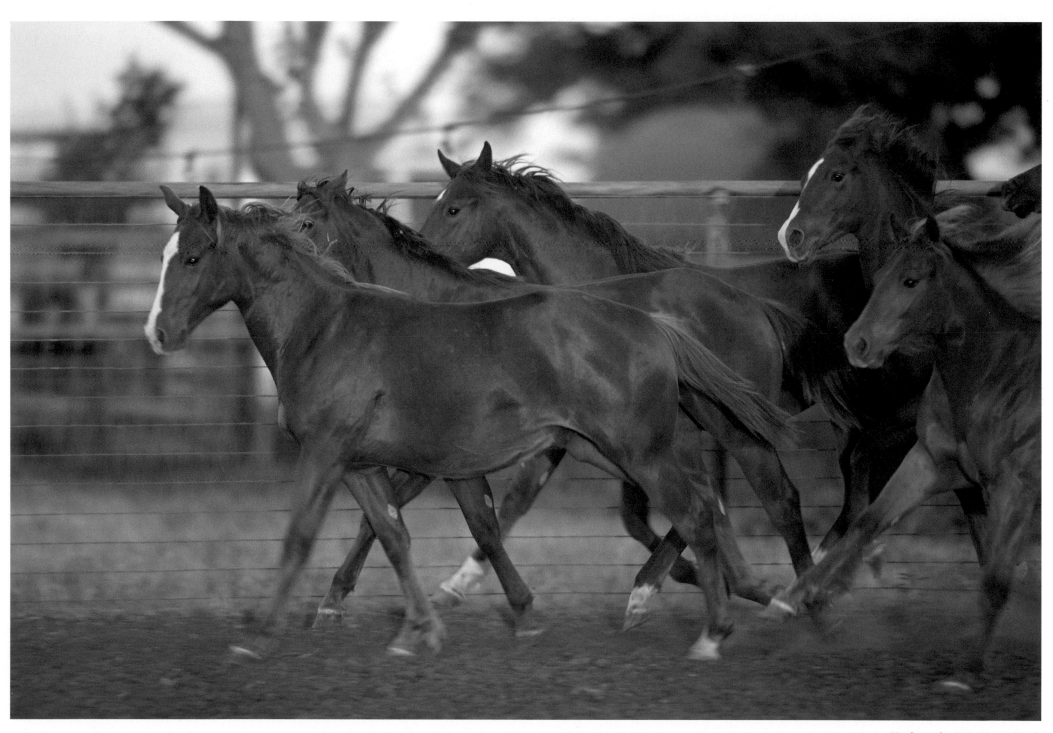

Yearling colts, R.A. Brown Ranch,
Throckmorton, Texas

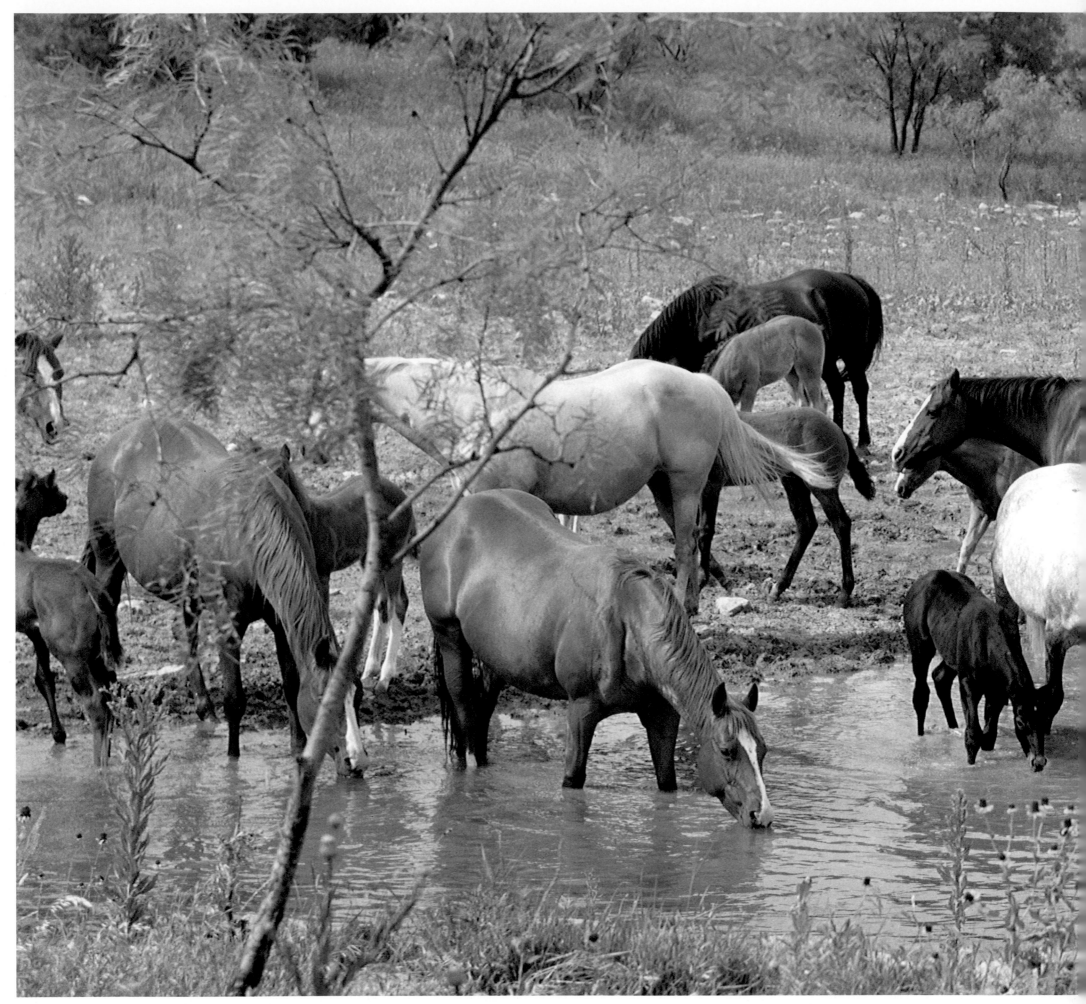

Mares and foals, R.A. Brown Ranch, Throckmorton, Texas

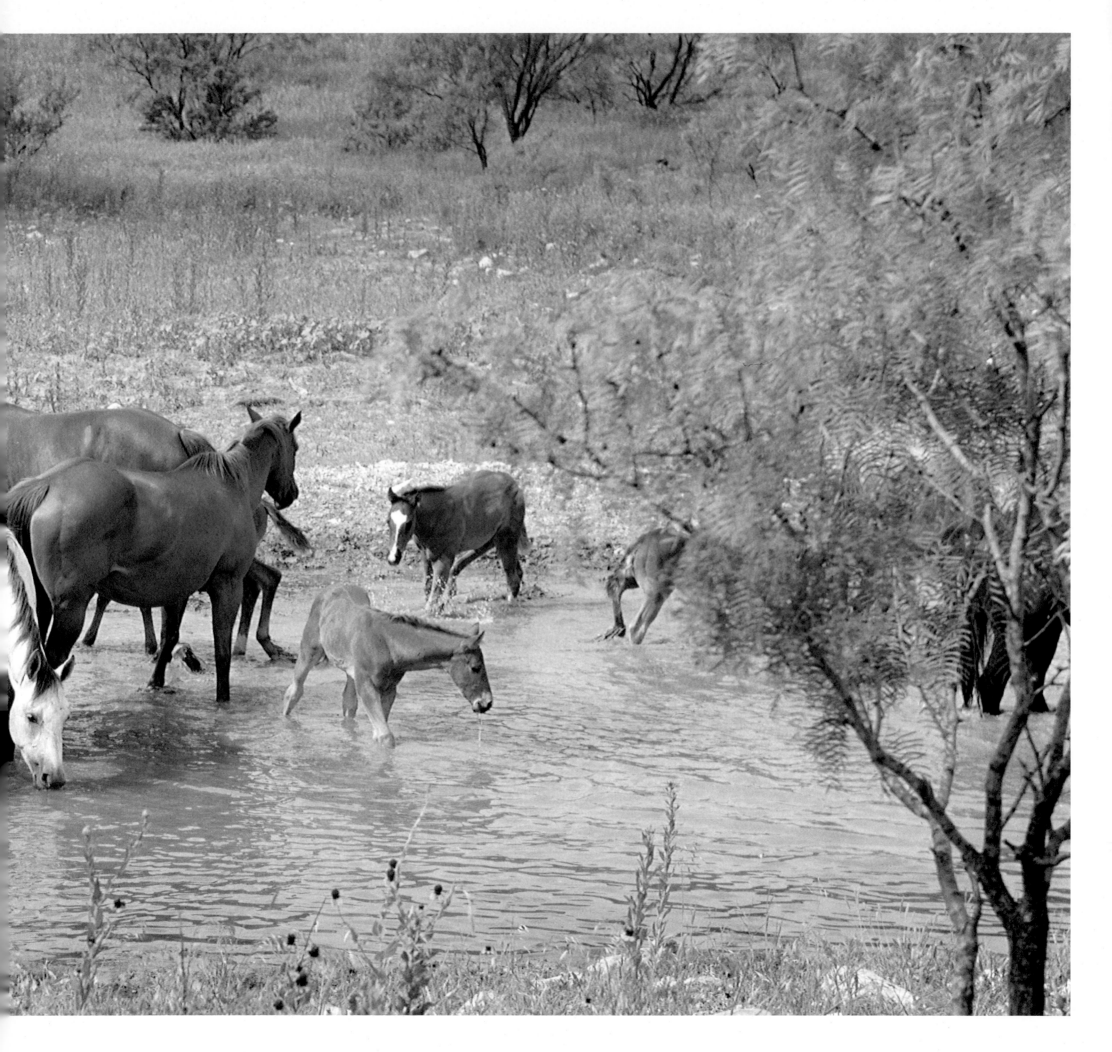

Les Vogt's bridle horse,
Danny, Santa Maria, California

Les Vogt bridle,
Santa Maria, California

Les Vogt fancy western chaps

Western snaffle bit

Les Vogt spade bit

Les Vogt trophy saddle

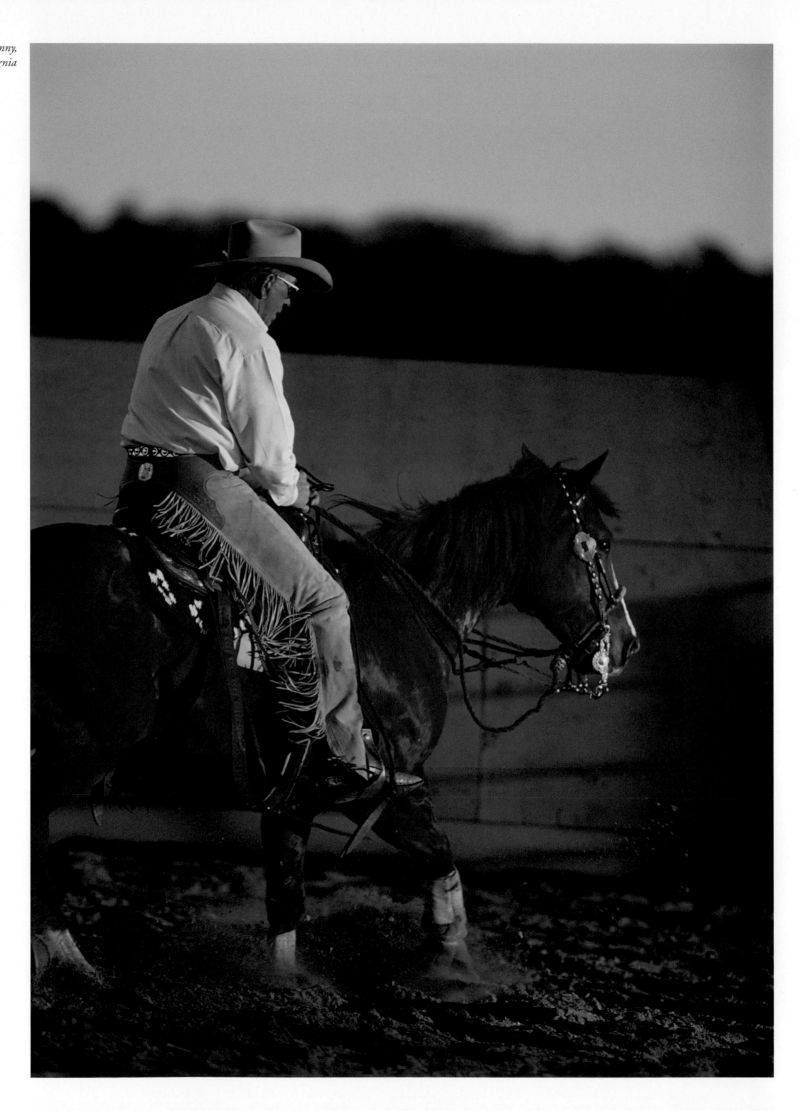

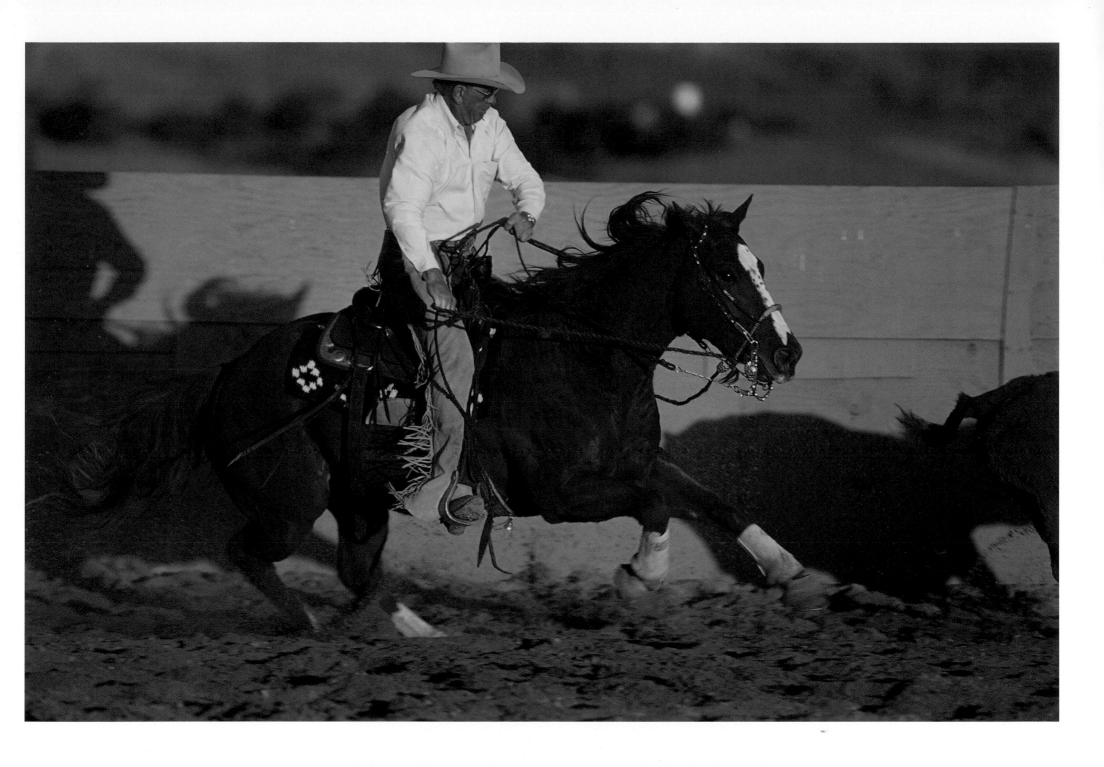

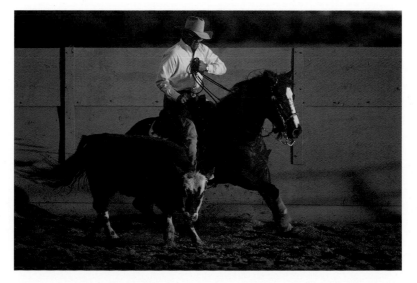

Les Vogt, Santa Maria, California

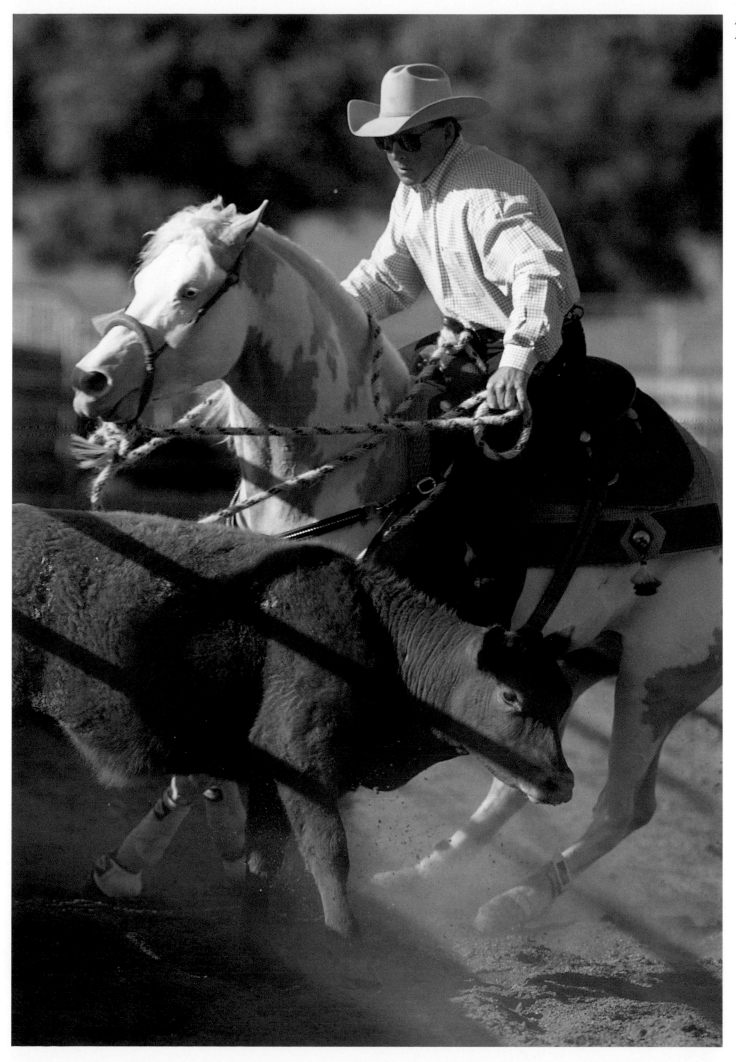

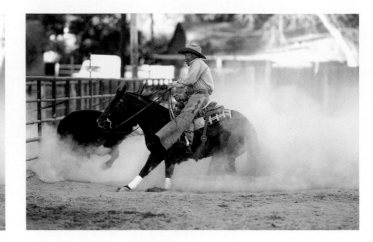

Ted Robinson, Oakview, California

Ted Robinson trophy saddle

Ted Robinson trophy saddle

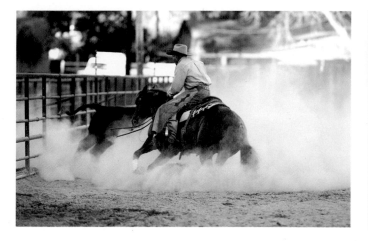 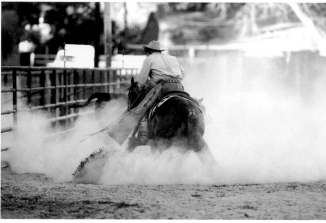 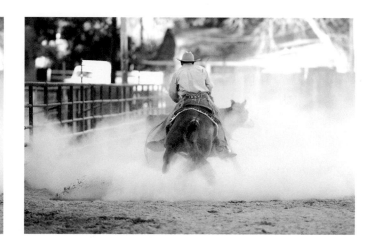

Ted Robinson trophy saddle

Ted Robinson trophy buckle

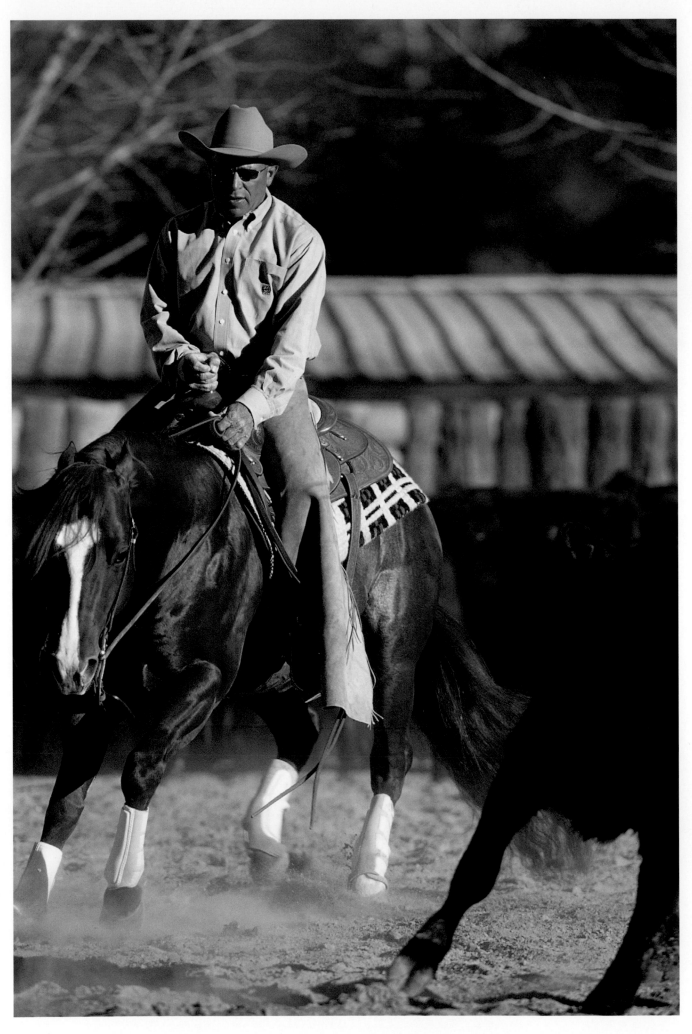

Ted Robinson, reining cow horse,
Oakview, California

138

Ted Robinson, reining cow horse,
Oakview, California

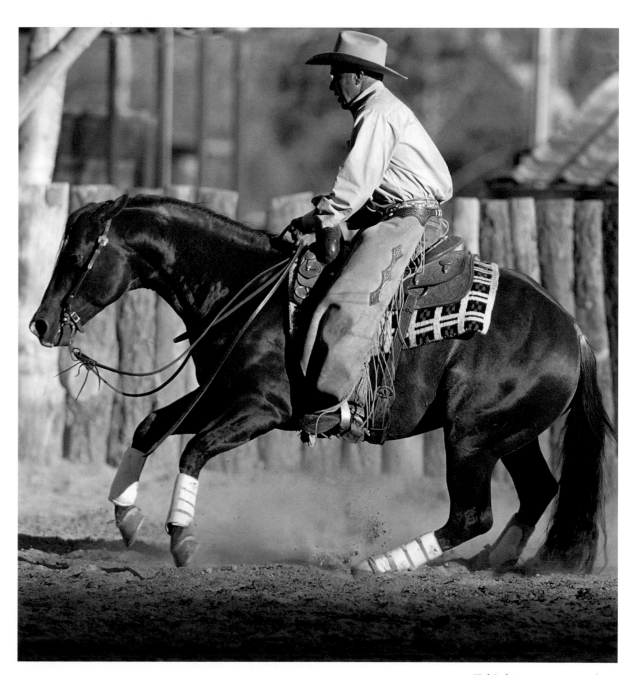

Ted Robinson, reining cow horse,
Oakview, California

139

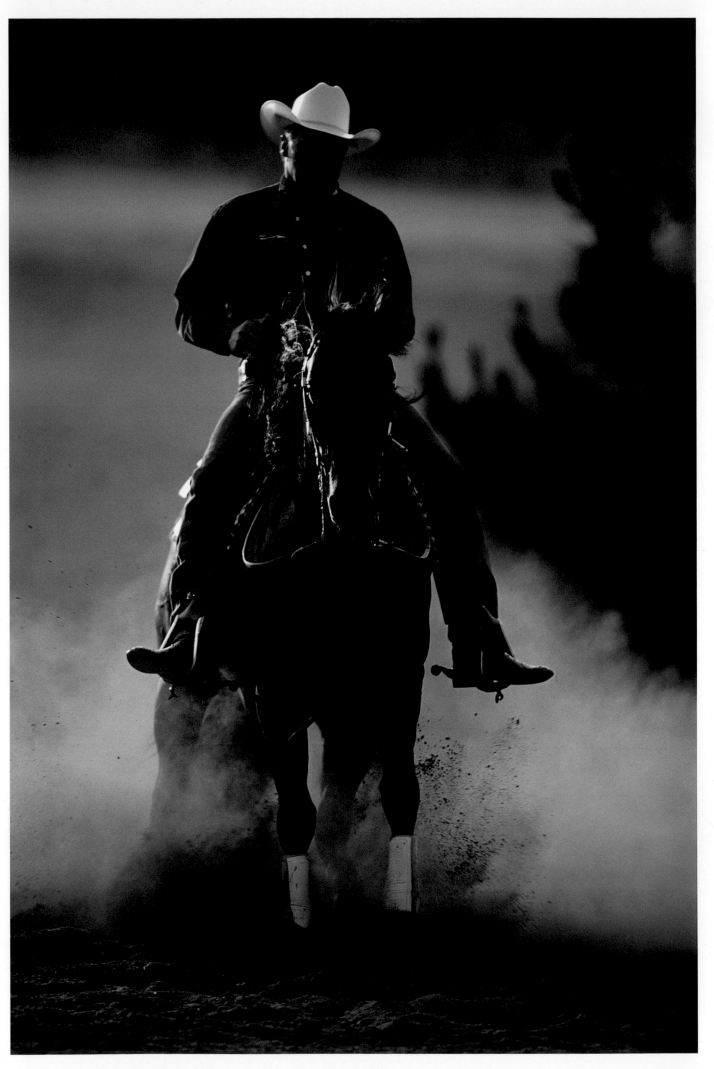

Bob Avila,
Tucalota Creek Ranch,
Temecula, California
opposite page

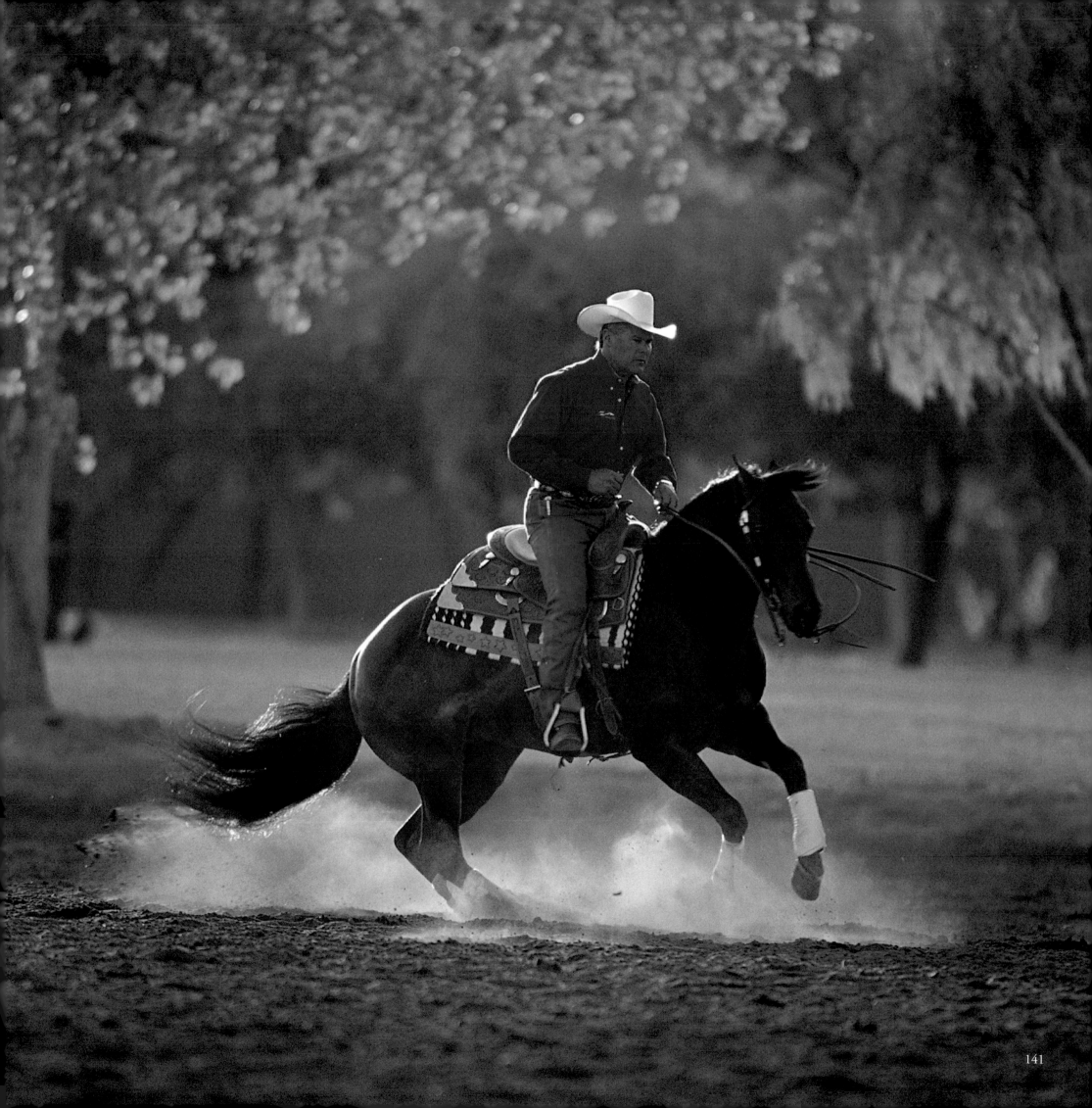

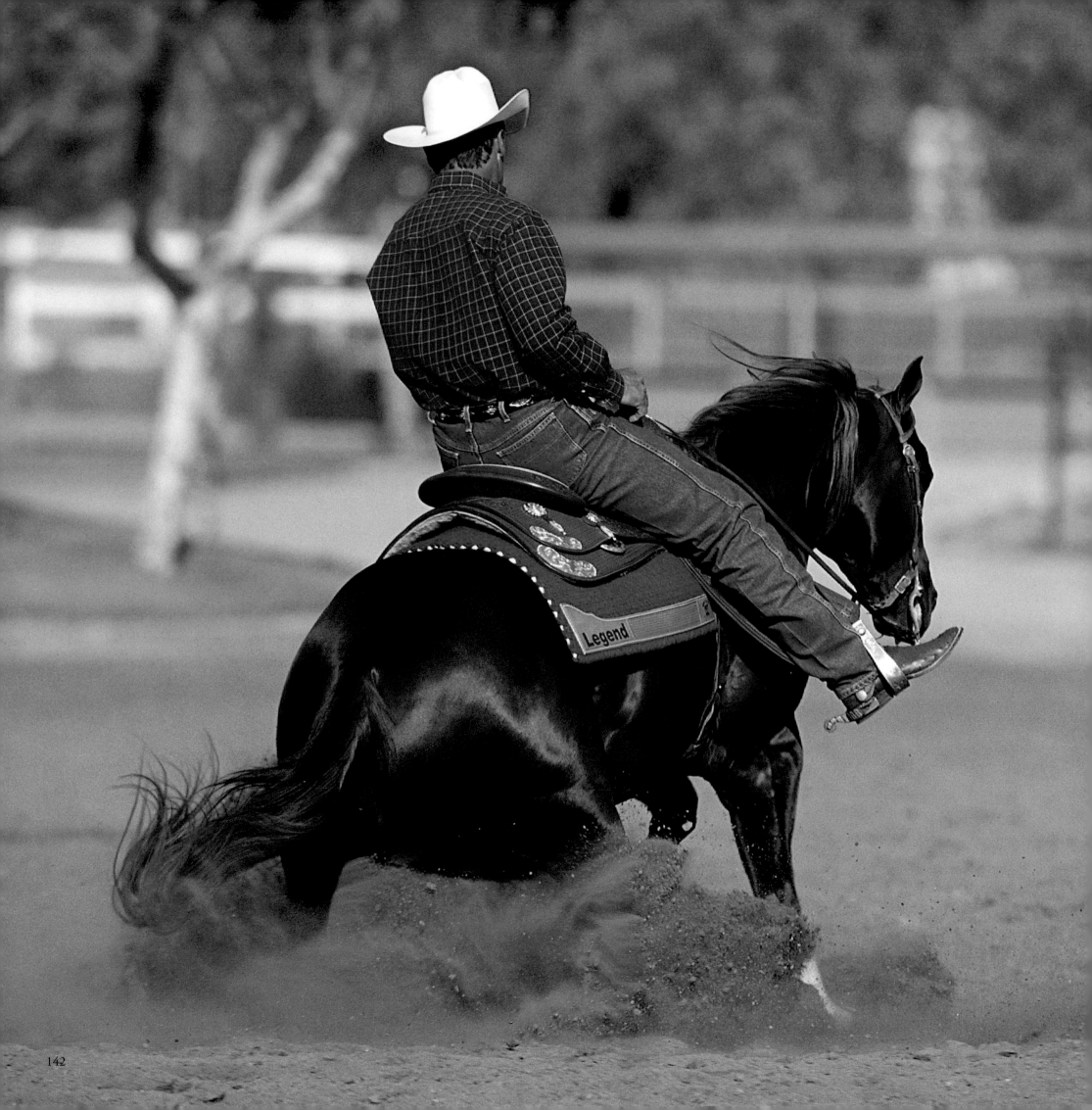

Bob Avila training at Tucalota Creek Ranch, Temecula, California

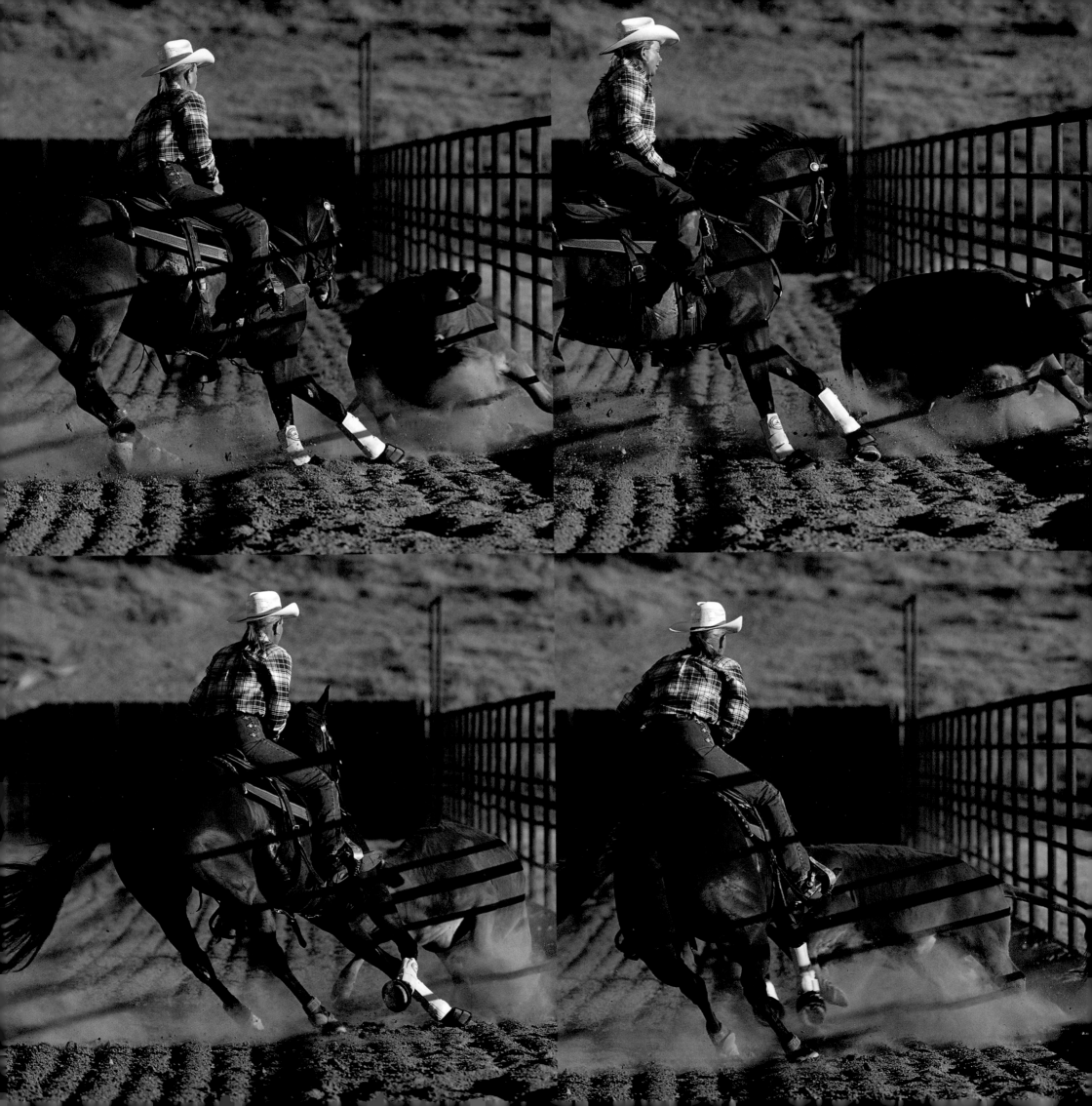

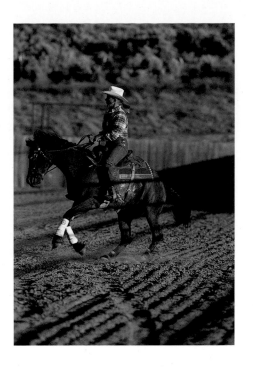
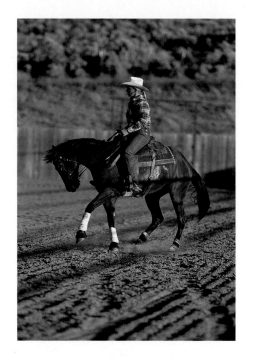
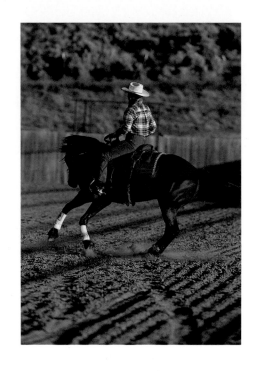
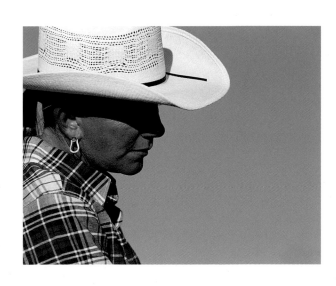
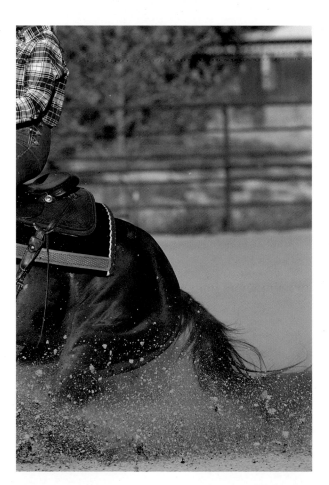
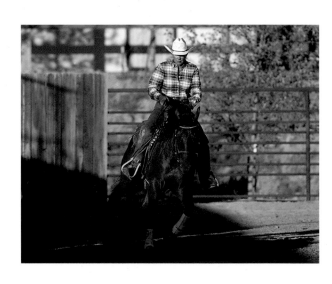
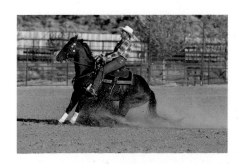
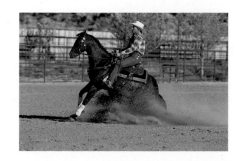
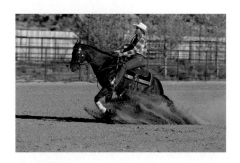
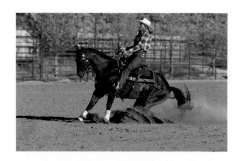

Anne Reynolds Jones, Glenns Ferry, Idaho

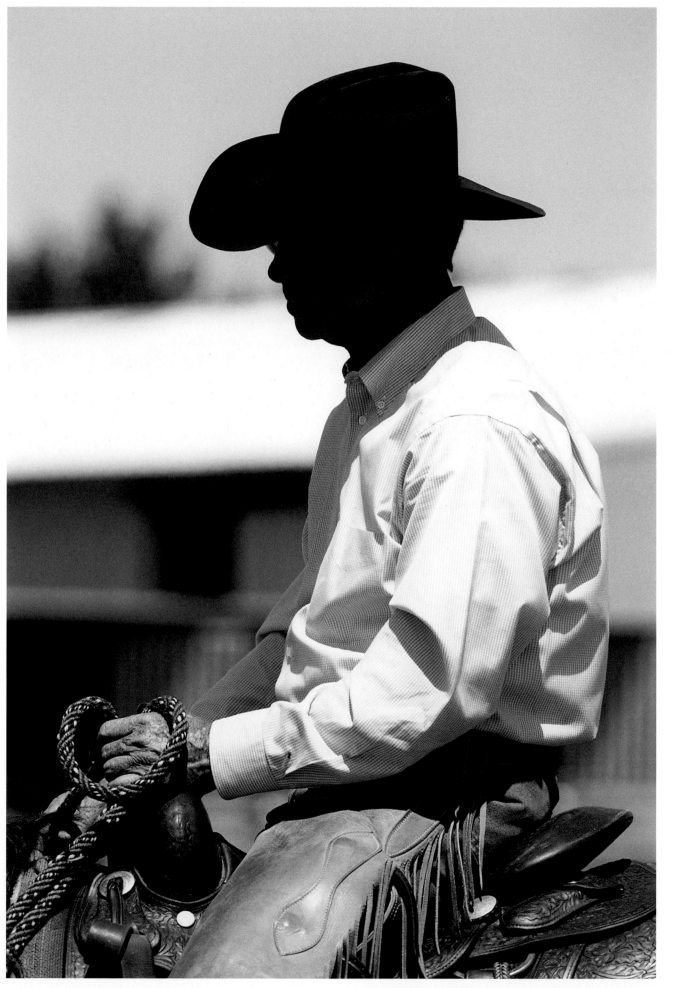

Bob Ingersoll, Ingersoll Ranch, Pleasant Grove, California

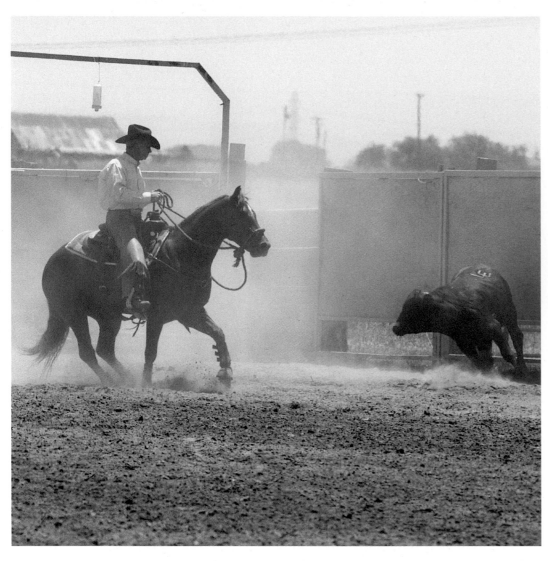
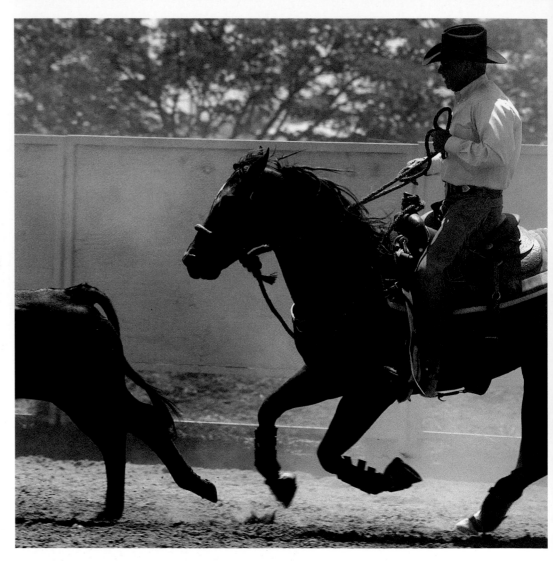
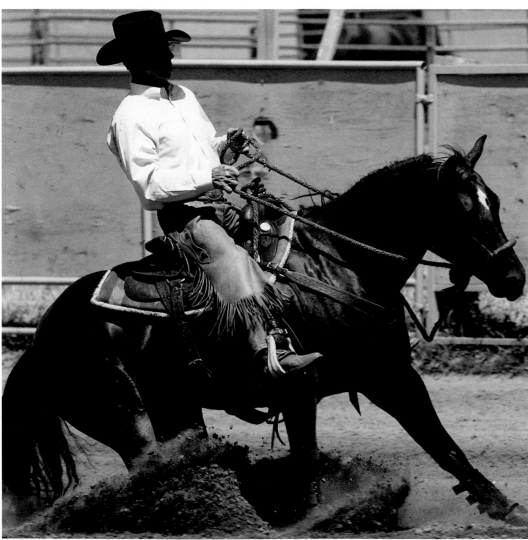
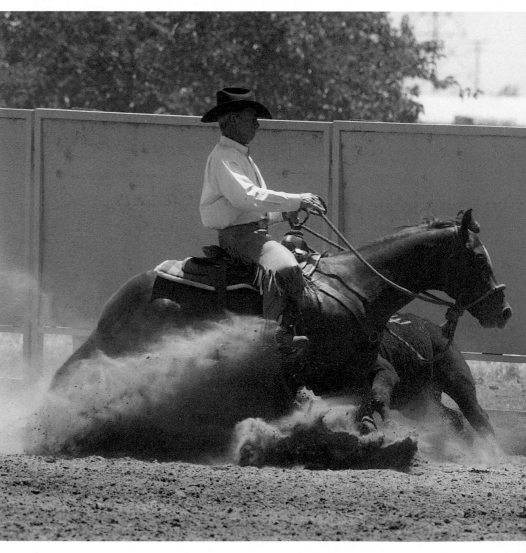

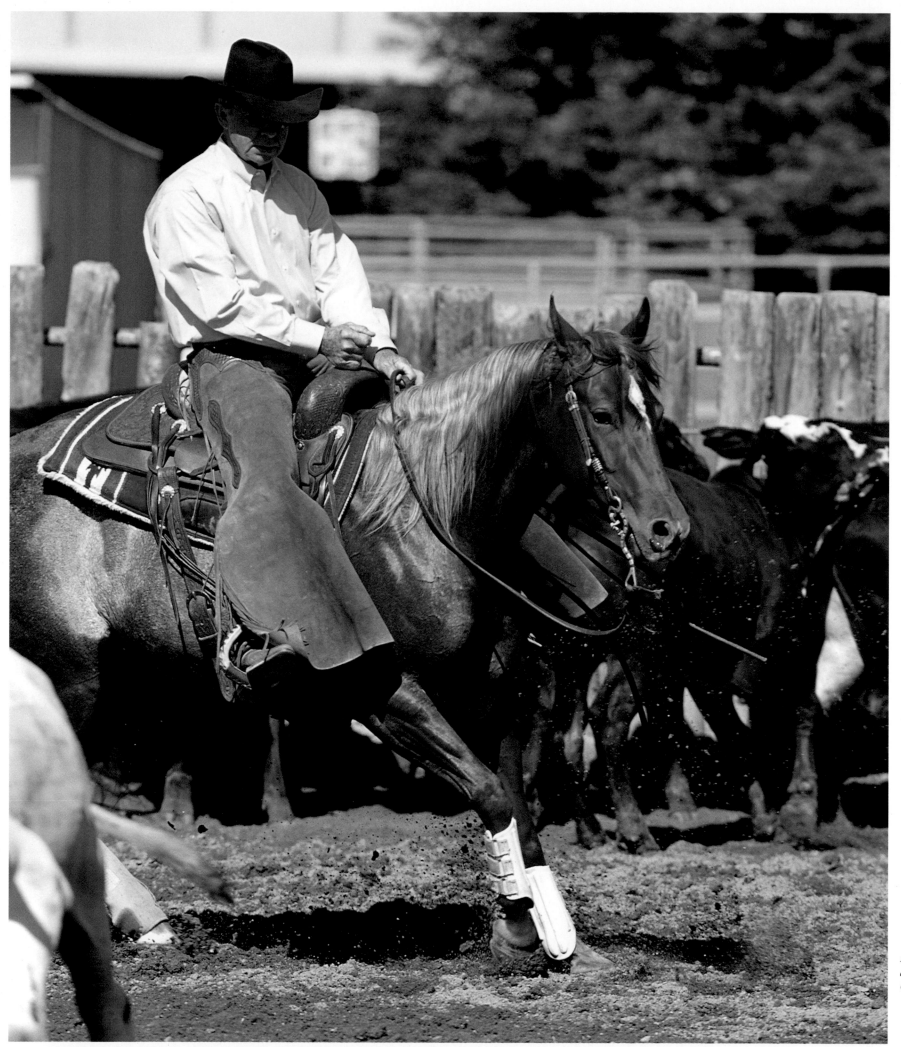

*Bob Ingersoll
doing fencework,
Pleasant Grove,
California*
opposite page

*Bob Ingersoll in the
cutting pen, Pleasant
Grove, California*

149

Kay Williams, Santa Maria, California

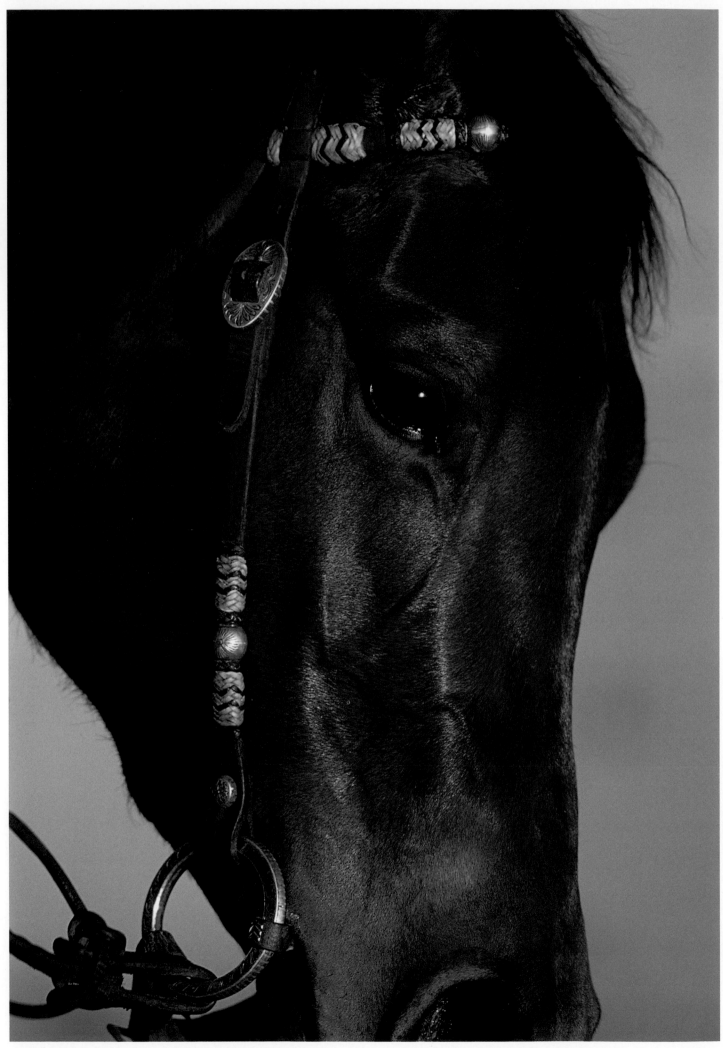

A Starlight Express

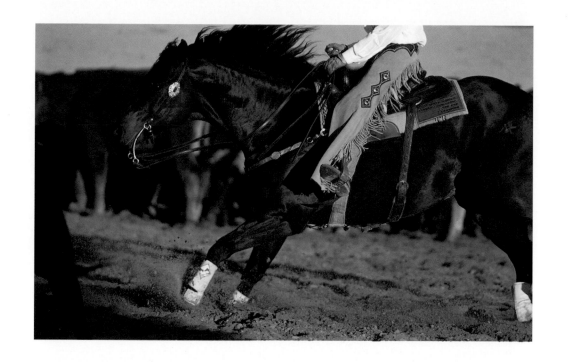

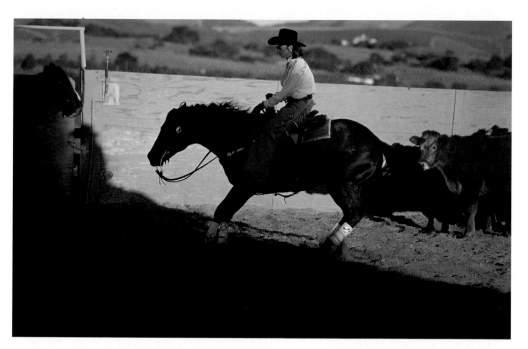

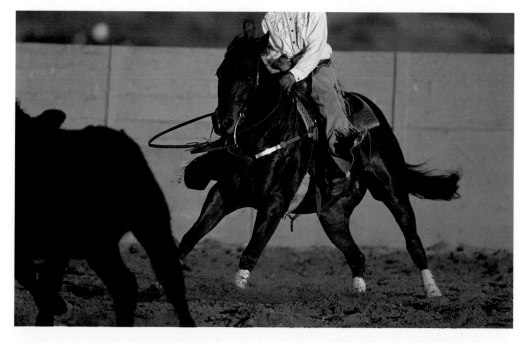

Kay Williams cutting,
Santa Maria, California

151

*Leon Harrel in the pasture with his
retired mares, Doc's Playmate, age 32,
and Doc's Peppy Belle*

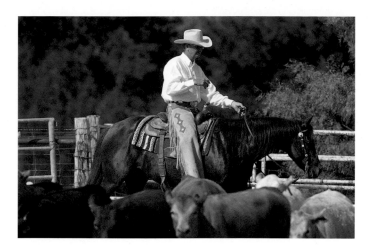

Leon Harrel looking over the herd

The horseman's view, Harrel Ranch, Kerrville, Texas

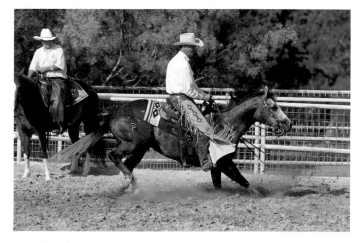

Leon Harrel cutting

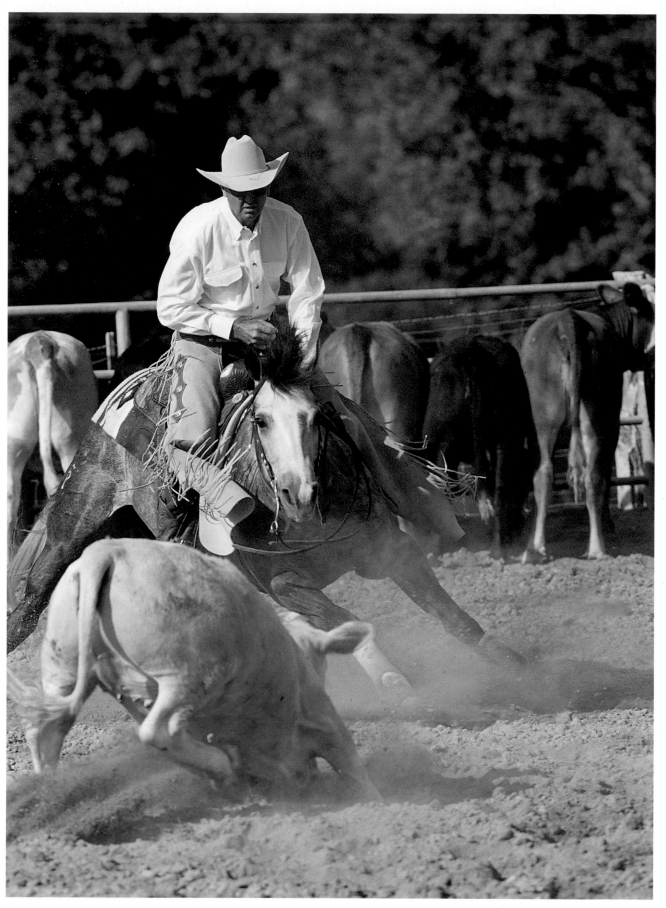

Leon Harrel cutting on his grey mare Annie

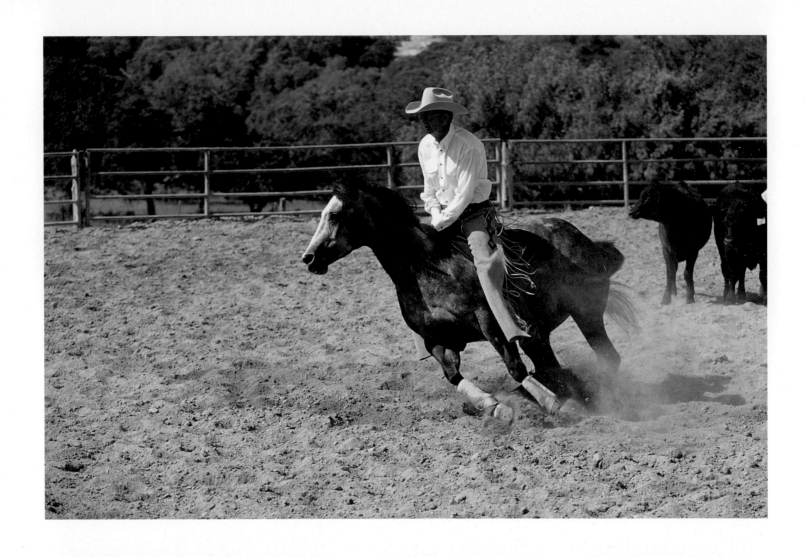

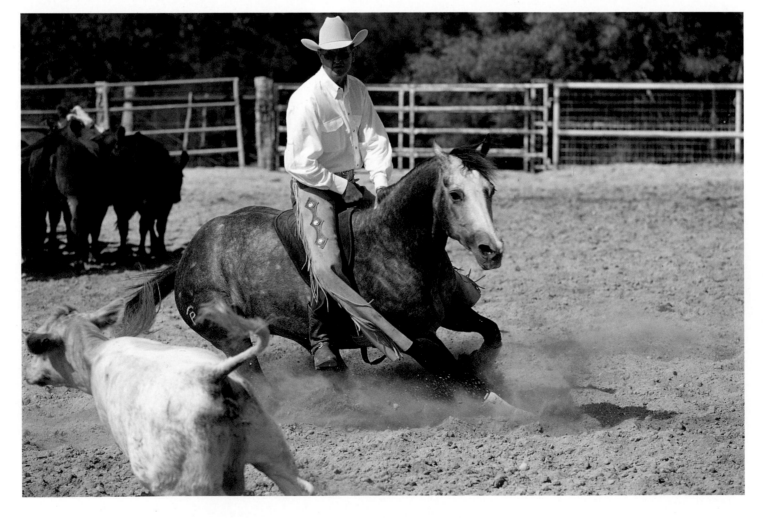

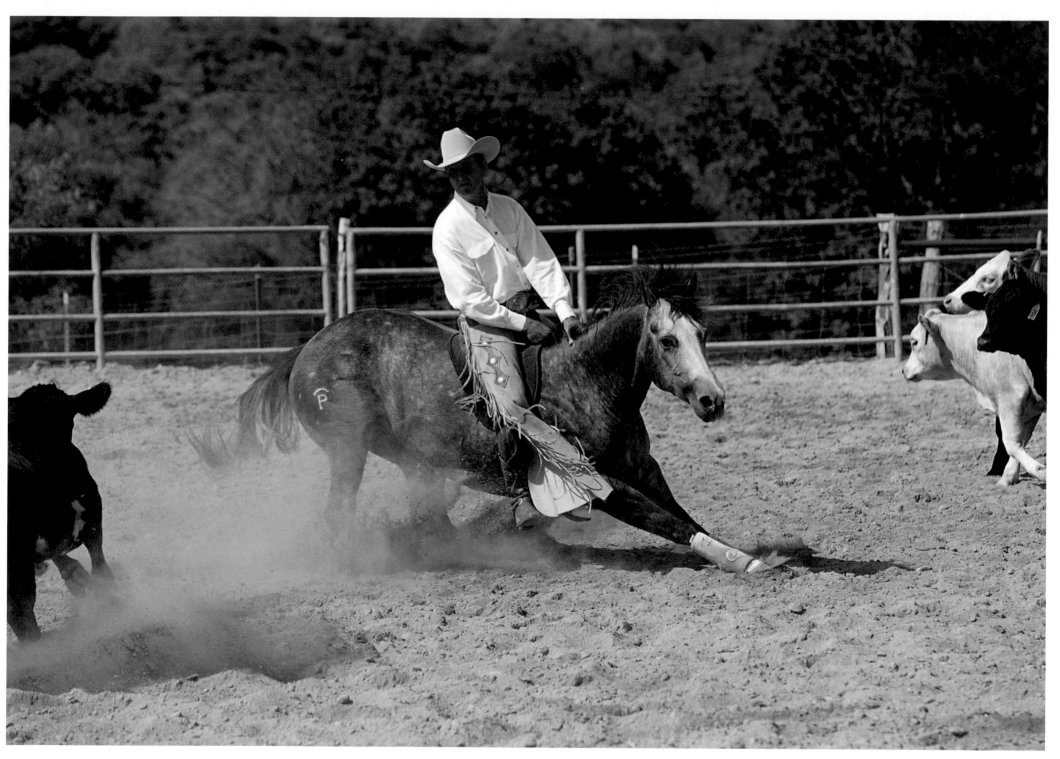

Leon Harrel riding Annie without a saddle or bridle – a true demonstration of balanced horsemanship and the willingness and desire of a horse to do his job.

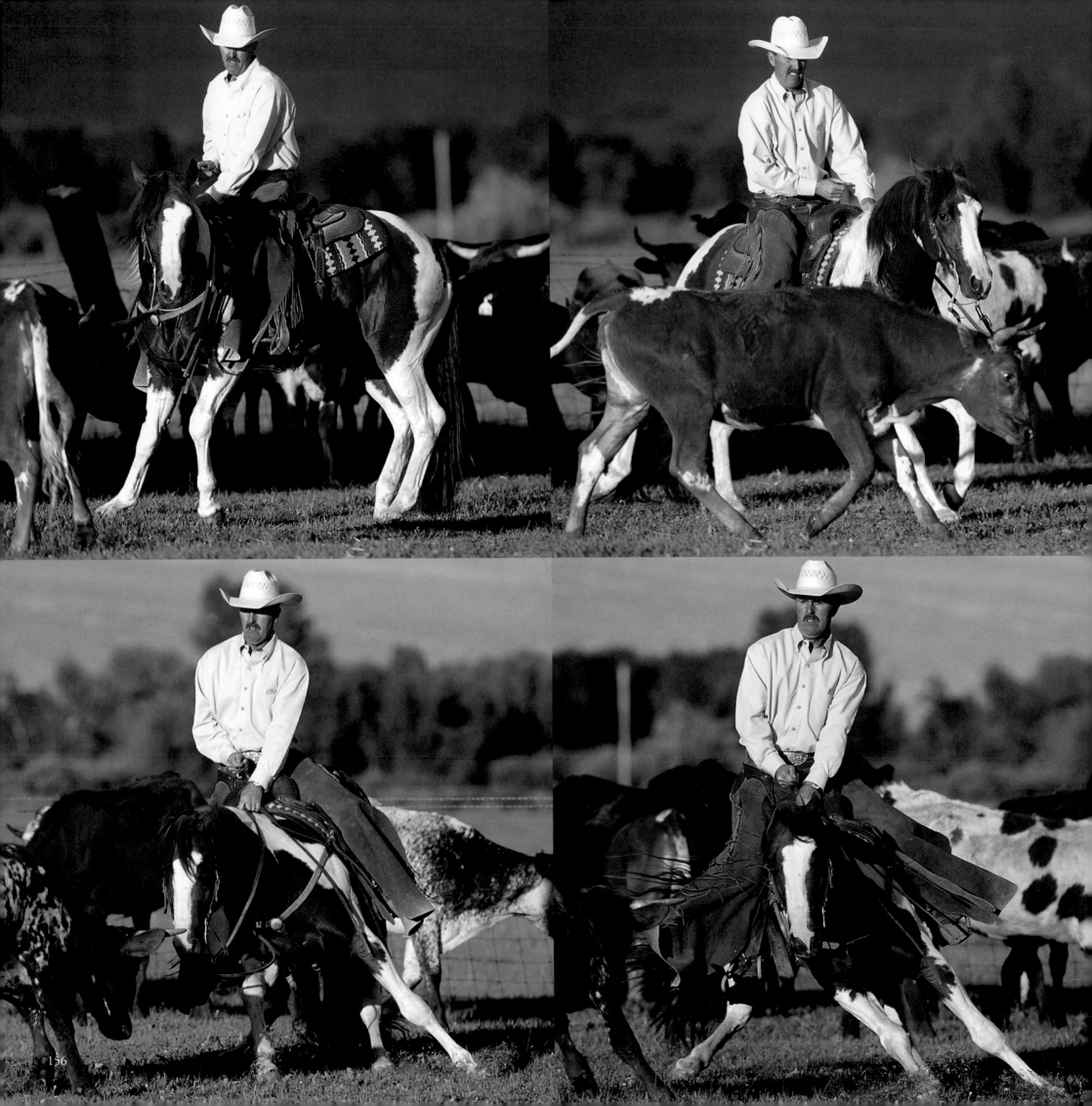

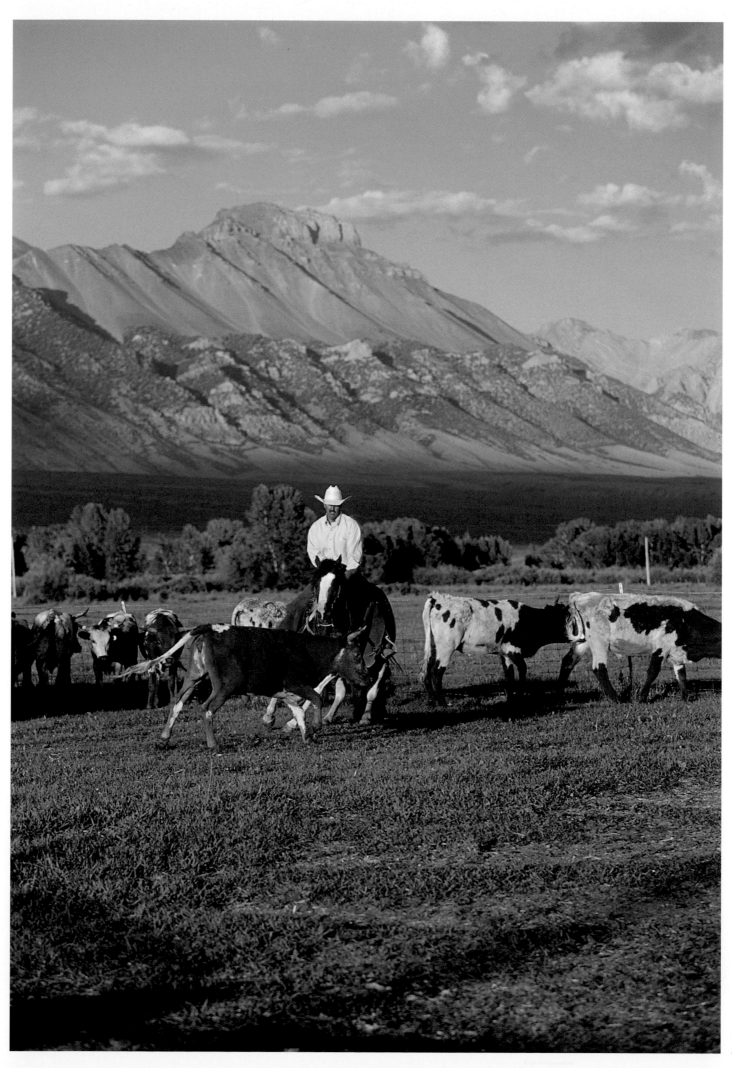

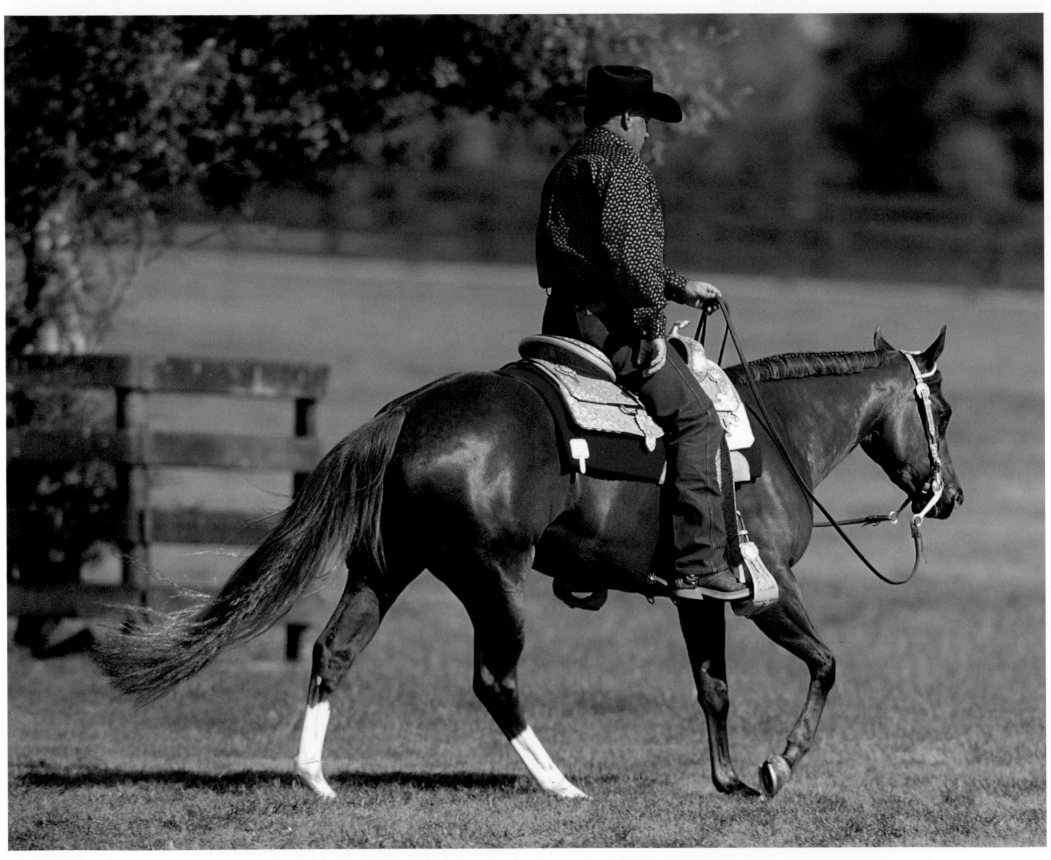

*Greg Wheat of Roberts Quarter Horses in
Ocala, Florida, western pleasure riding*

Fancy western pleasure saddle

Fancy western pleasure headgear

Western pleasure saddle

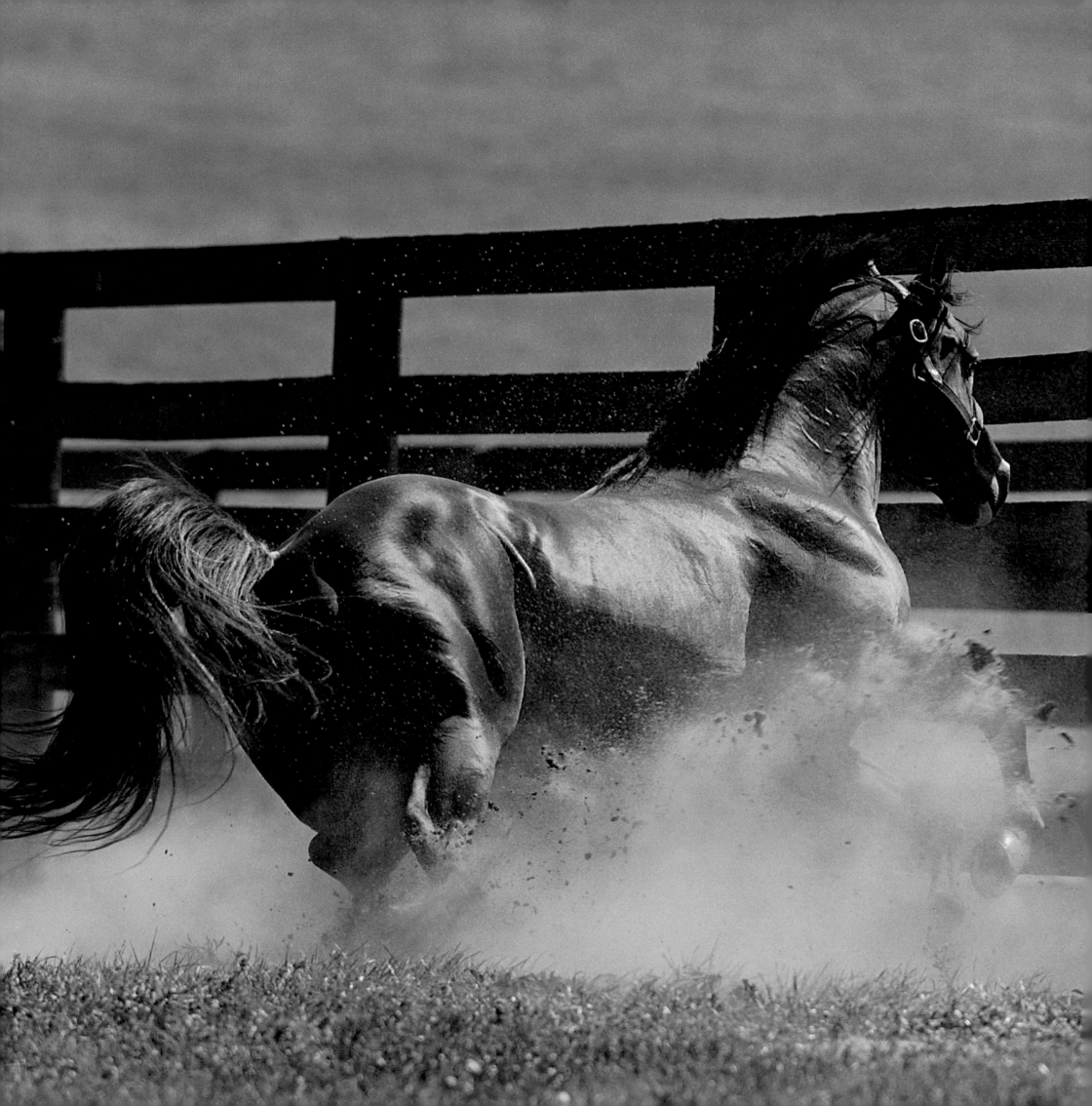

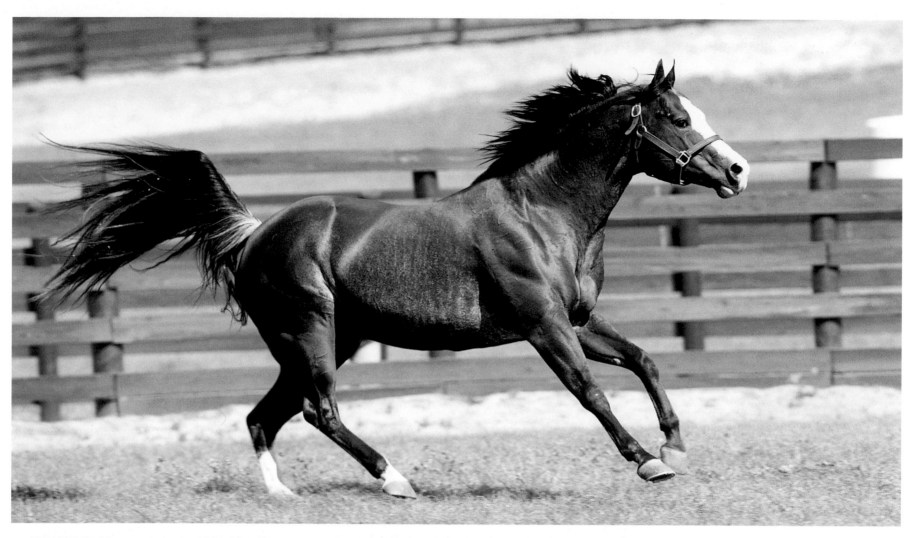

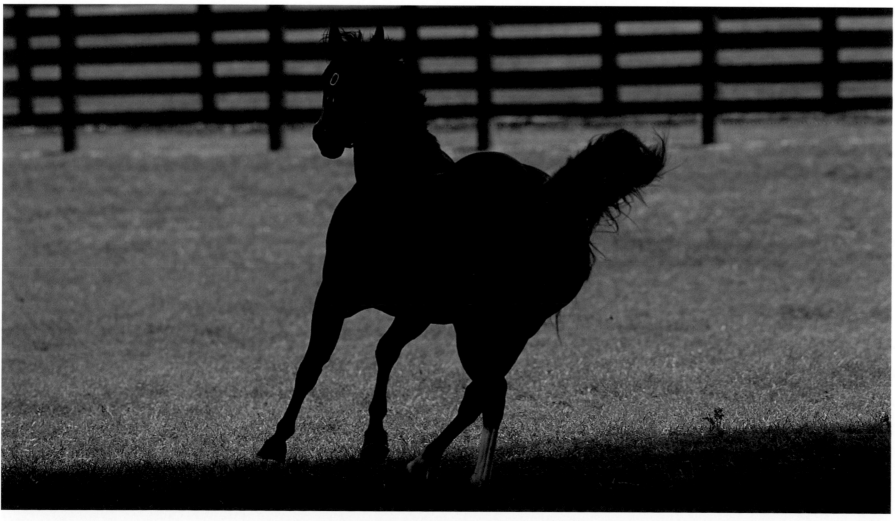

161

A Sudden Impulse, Roberts Quarter Horses, Ocala, Florida

A Sudden Impulse – stallion at Roberts
Quarter Horses, Ocala, Florida
previous page 160

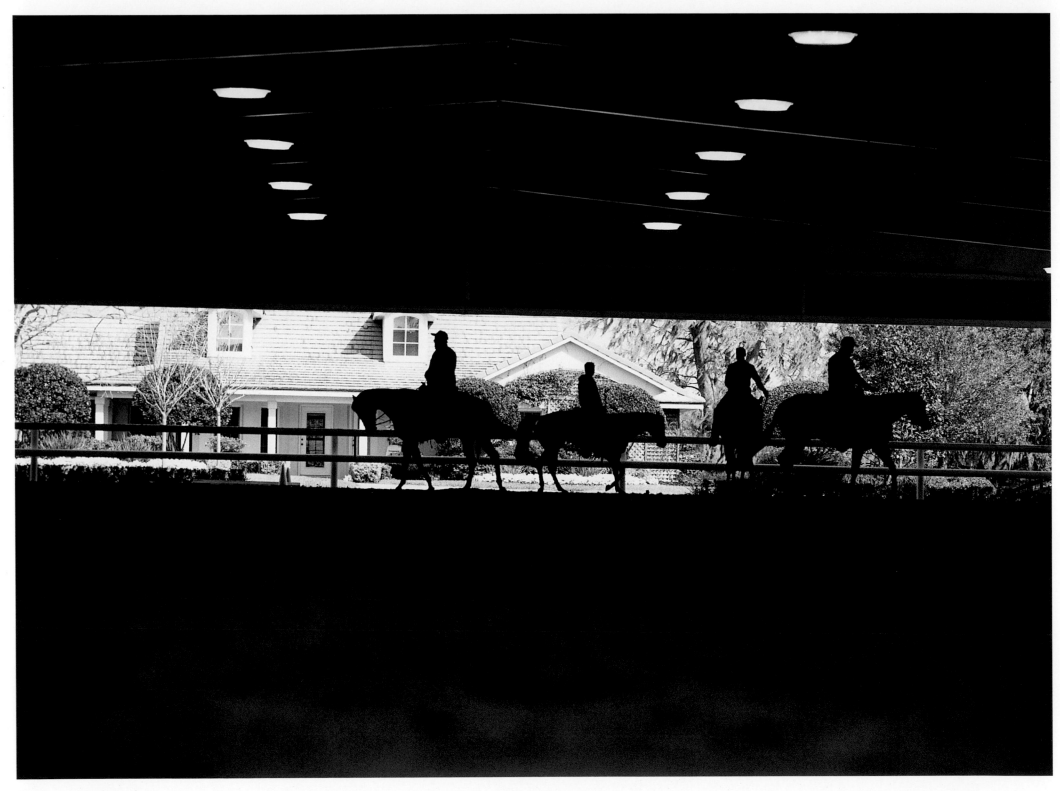

Training western pleasure horses,
Roberts Quarter Horses,
Ocala, Florida

The babies, Roberts Quarter Horses,
Ocala, Florida

163

Brooke Berg's fancy western pleasure saddle

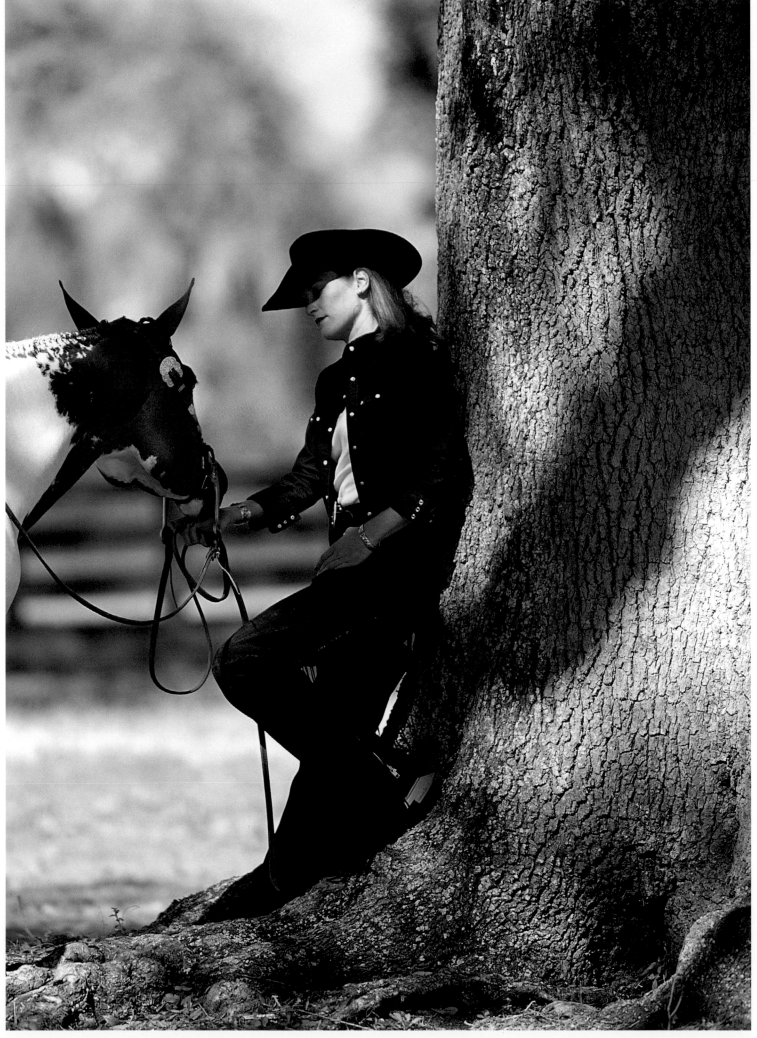

*Jennifer Leckey, pleasure
driving, Perry Farms,
Ocala, Florida*
following page

Brooke Berg, Ocala, Florida

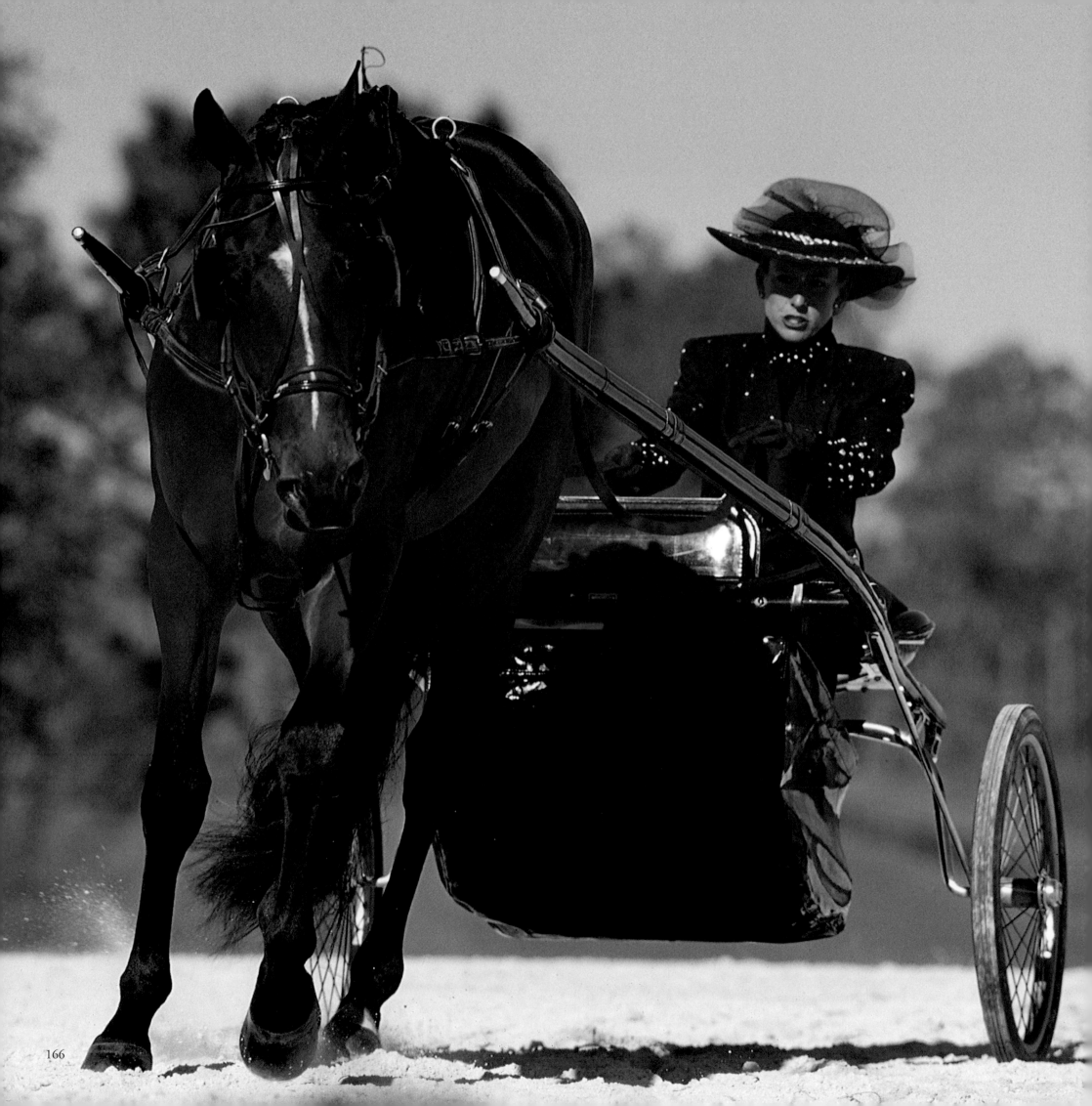

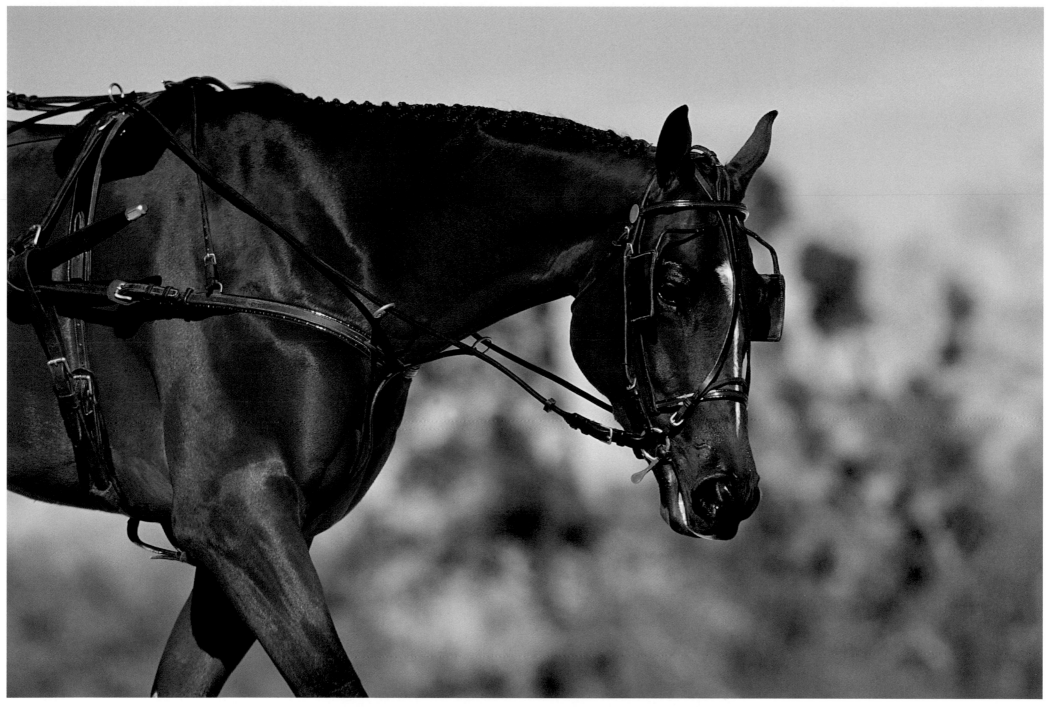

*Jennifer Leckey, pleasure
driving, Perry Farms,
Ocala, Florida*

Elegant attire for pleasure driving

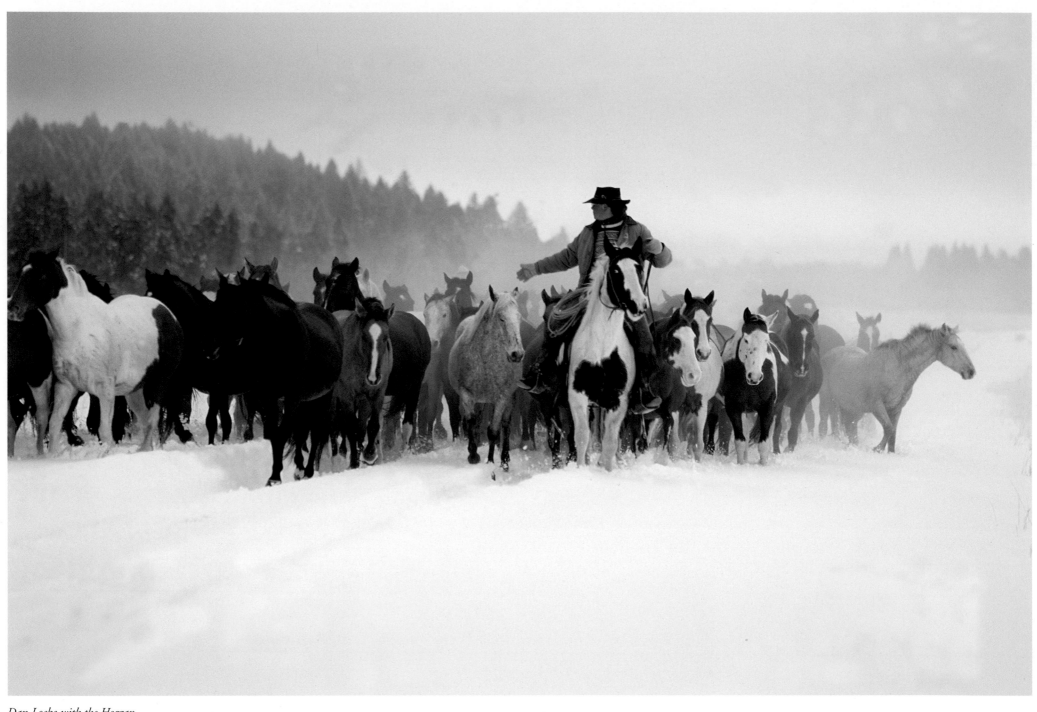

Dan Locke with the Hoggan
Rodeo Horses, Idaho

THE RODEO HORSE

Nothing embodies American spirit like rodeo. The sport reflects the pioneer roots of the United States and celebrates its most cherished ideals – individualism, courage, free-spiritedness, industry. Rodeo, bold and brash, is a genuine slice of the American way of life.

At the heart of the sport is the stout rodeo horse, both the cowboy's right hand and, at times, his nemesis. Indeed, rodeo is the only equine sport where horse and rider flaunt their athleticism and cunning as they work as a team in certain events and as they square off in events like bronc riding.

Rodeo was born on the American frontier. After the Civil War, thousands of wild cattle roamed the Southwest, descendants of animals brought by Spanish-Mexican settlers. These cattle, mostly Spanish longhorns, were driven to markets in the East. After long cattle drives, weary range cowboys sought relaxation and diversion. Inevitably, bragging about roping and riding skills led to impromptu contests, and the prototype for rodeo was born.

As makeshift rodeos began to flourish, so did America's growing fascination with the West. Capitalizing on this interest, William T. "Buffalo Bill" Cody – scout, hunter, and showman extraordinaire – organized his first Wild West Show in North Platte, Nebraska, in 1882. His productions, which featured roping, bull riding, bronco-busting, trick shooting, and mock battles between cowboys and Indians, went on to become hugely successful. They toured throughout the country, spawning many imitators. Though the Wild West shows eventually faded, the contests featuring cowboy skills endured.

Early rodeos were held in Pecos, Texas, in 1883 (the first to award prizes), and in Prescott, Arizona, in 1888 (the first to charge admission). Rodeos often took place around the Fourth of July, which came to be known as "Cowboy Christmas." The events of rodeo reflect the workday needs of a cowhand on the range – from breaking a horse to saddle in short order to doctoring a sick calf when the only help is a trusty, four-legged companion.

Today, rodeo remains a uniquely American sport. Although it has been introduced in other countries, it has not truly thrived anywhere outside the United States or Canada. In America, rodeo is an equine spectator sport that outpaces even horse racing in actual attendance. Although all rodeo events involve horses to some extent, the events most dependent on a good rodeo mount are roping, barrel racing, and bronc riding.

THE ROPE HORSE

Strong and savvy, the rope horse works as diligently as the cowboy who rides him. In calf and steer roping, especially, he is an essential part of the team, at times working independently of his rider. His explosive speed and maneuverability enable the cowboy to make the catch. His sensitivity to a rider's shifting weight as the rope is thrown tells him when to stop. His expertise in holding the rope taut affords the cowboy time to approach and secure the roped animal with the piggin' string before it scrambles back to its feet. As any cowboy will tell you, it is the horse's contribution that makes winning times – sometimes under seven or eight seconds – possible.

Calf and steer roping contests originated as a way to test a lone cowboy's ability to immobilize a member of the herd for branding, vaccinating, or doctoring. Team roping allows two cowboys working together to demonstrate the same ability. The mount of the header – the one who ropes the steer's neck or horns – must blast out of the starting box and sprint to the steer; champion headers depend on fleet horses to make a catch in five seconds or less. Simultaneously, the handiness of the heeler's mount positions the second rider to rope the steer's hind feet, a feat which is also accomplished in mere seconds.

"The best rope horses are strong and have a lot of run in them," says Julio Moreno, a header who has made it to the Wrangler National Finals Rodeo in Las Vegas – the sport's premier event – eleven times. "They're also tough campaigners. You can haul them all night to get to the next show, and they're still good-natured while you're waiting in the starting box. They race to the steer, do whatever you need them to do, and afterwards they hop back on the trailer and go on down the road."

A lifelong roper, Moreno says he has had the good fortune to own three exceptional roping horses over the years. Two of them, including the sensational Six Pack, a Driftwood-bred Quarter Horse who excelled in the 1970s and '80s, could even perform without a bridle.

"I could practice on them with just a rope around their necks," says the Californian proudly. "They were so responsive and knew their jobs so well." He notes that Six Pack, like many good rope horses, seemed to appreciate the sport.

"I swear he understood when the fans were clapping," he says. "It's the same as with any athlete. When they're good, they really do enjoy the game."

And, in the case of good rope horses, they make the game possible for diehard cowboys and fans.

THAT HOSS WASN'T BUILT TO TREAD THE EARTH, HE TOOK NATURAL TO THE AIR, AND EVERY TIME HE WENT ALOFT, HE TRIED TO LEAVE ME THERE.

...Anonymous

THE BARREL HORSE

In terms of quickness and agility, nothing tops the barrel racing horse. His all-out sprints are punctuated with scrambling turns. Intense and athletic, the barrel horse is rodeo's answer to the polo pony.

In rodeo competitions, barrel racing is for women only. In open contests such as futurities, men also compete, but in the rodeo arena, gutsy, glamorously appointed cowgirls make the event a crowd favorite. Three barrels, set in a triangular, cloverleaf pattern, are negotiated at high speed. The barrels may be touched and even tipped, but knockovers earn penalties. To be successful, the barrel horse must be highly trained and work in perfect harmony with his rider.

Danyelle Campbell, who has been winning barrel races for fourteen years, says a Quarter Horse off the track is her mount of choice. "A barrel horse needs to be fast and catty, but also smart and somewhat quiet," says the Utah cowgirl. "When they compete, it's usually in the midst of a band, an announcer, and a crowd, so it's best if they're level-headed."

Still, she notes, a bit of equine attitude can be a good thing. "The best horses often don't put up with much – it's what gives them an edge," she says. "My mare 'Petie' was a good example. Her real name was Hittin' Pay Dirt, and she was off the track. She hated other horses and was very 'mare-y.' We had to put kicking shoes on her in the trailer to keep her from taking it apart, and you couldn't put her in a concrete stall – she'd hurt herself."

Though unforgiving with her own kind, the mare was mild around people. "She had a lovely eye, and when you were working around her, she had a way of just standing quietly and watching you," says Campbell. "Plus, that mare had so much heart. Nothing slowed her down – even injuries. Once she had eleven bone chips in a hind ankle, and we didn't even realize it at first. Most horses will favor a sore leg. She didn't – she was too busy trying."

Not even surgeries to repair the ankle sidelined the mare for long. "After one of them," Campbell recalls, "Petie had a reaction to a painkiller and developed a bacterial infection in her neck. The vet had to slice her neck open from top to bottom to expose the bacteria to air – it was the only way it would heal. Three times in one night we thought we were going to lose her, and the vet told us she'd never race again.

"The next summer, though, she came back one more time," says Campbell. "Not only that, she ran great – even set an arena record. I've had other horses that have won more, but Petie definitely had the most heart."

Now retired to a broodmare band, Petie is busy raising a few of tomorrow's barrel racing stars – talented athletes with spunk.

THE BRONC

The rodeo bronc, proud and defiant, is a popular symbol of American fighting spirit. To many, bronc riding defines rodeo. Bronc-busting was, after all, a cowboy's first order of business on the frontier. Without a horse to ride, a cowboy was out of commission. Early bronc-riding contests had no time limits; the duel sometimes continued for up to twenty minutes – until either the bronc or the bronc buster gave up.

Today, saddle bronc riding is considered the classic rodeo event, as well as one of the most challenging to master – and most beautiful to watch. Despite its roughness, it shares some of the elements of dance. The rider matches his movements to those of the horse in a fluid, cadenced motion. To do it well requires not only strength and balance, but also timing, quick reflexes, and natural rhythm.

In saddle bronc riding, the cowboy sits in a saddle with stirrups but has nothing to hold onto except the halter rope. In bareback riding, an event born in the rodeo arena in the late 1950s, there is no saddle, but a handhold at the horse's withers gives the cowboy a fighting chance of staying aboard. In both events, a rider must endure for eight seconds in order to score, and is judged on his form and style as he urges the horse on with blunt spurs. A flank strap, which irritates but does not hurt or injure the horse, also encourages his action.

Some broncs are ranch horses gone bad; more often, especially in recent years, they are animals specially bred for the event. Stock contractors provide bucking horses and other necessary animals to rodeos; in years past, western personalities such as Gene Autry and Roy Rogers have helped supply stock.

Jay Hogan, a second-generation rodeo stock contractor from Idaho, says changing times have changed the way bucking horses are made. "When I was a kid," he says, "my uncle had a rodeo outfit. In those days, every ranch had horses, so it was easy to get your hands on culls – animals that wouldn't work as ranch horses, but would be perfect for bucking strings.

"By the late 1970s, fewer ranches had a lot of horses, and the horses they did have were bred to be tractable. A bronc prospect might buck the first four or five times out, but after that he wouldn't. And if a horse decides not to buck, you can't make him, even with a flank strap. What the strap does is influence how a horse bucks – it prompts him to kick out with his hind legs. But it won't make a non-bucker buck.

"So a lot of us decided to start raising our own broncs," he continues. "I'm now into my third and fourth generations of bucking stock. I mix different breeds together to get what I want – Thoroughbred for athleticism and fire; Paint, Pinto, and Quarter Horse for toughness; and Shire, Belgian, Clydesdale, and Percheron for size. A lot of my horses are three-quarters draft."

Hogan tests his young stock as two-year-olds, offering them as practice mounts for high school rodeo programs. "Some outfits don't buck their horses until they're five or six," he says, adding that sometimes older is better. "It's like taking a sixteen-year-old kid who's never had to do anything he didn't want to do, and saying, 'Okay, you're going to work today.' Like that stubborn kid, older horses tend to resist more."

Hogan says the best horse he has raised is Jay 2 Classy, a gelding foaled in 1992. Unlike a lot of his horses, the gelding did not have much draft blood. "He looked like a cute riding horse, about eleven hundred or twelve hundred pounds," says Hogan. "He was out of my mare Back Door" – so named because she tended to toss cowboys off her back end – "and he bucked hard. He needed very little flank strap, because he kicked out just fine on his own."

Though some broncs are more volatile than others, Hogan says a surprising number of them are easy to handle from the ground. "Most of them have been around people from the time they were babies, and they'll stand pretty quietly, even before they're halter broke. Most of them know bucking is their job, and they're happy to do it."

Indeed, even the rodeo bronc, like his ancestors from the time of domestication, is simply performing the job humans have asked of him. Watching him in action, we are reminded of what might have been had the horse not been such a willing creature. Given his strength and resolve, the horse might never have become our partner at all. Yet, for seven thousand years, he has been exactly that – thanks to his generosity, and especially his heart.

"Mr. Rodeo," Cotton Rosser with his wife,
Karin and daughter, Katharine
following page

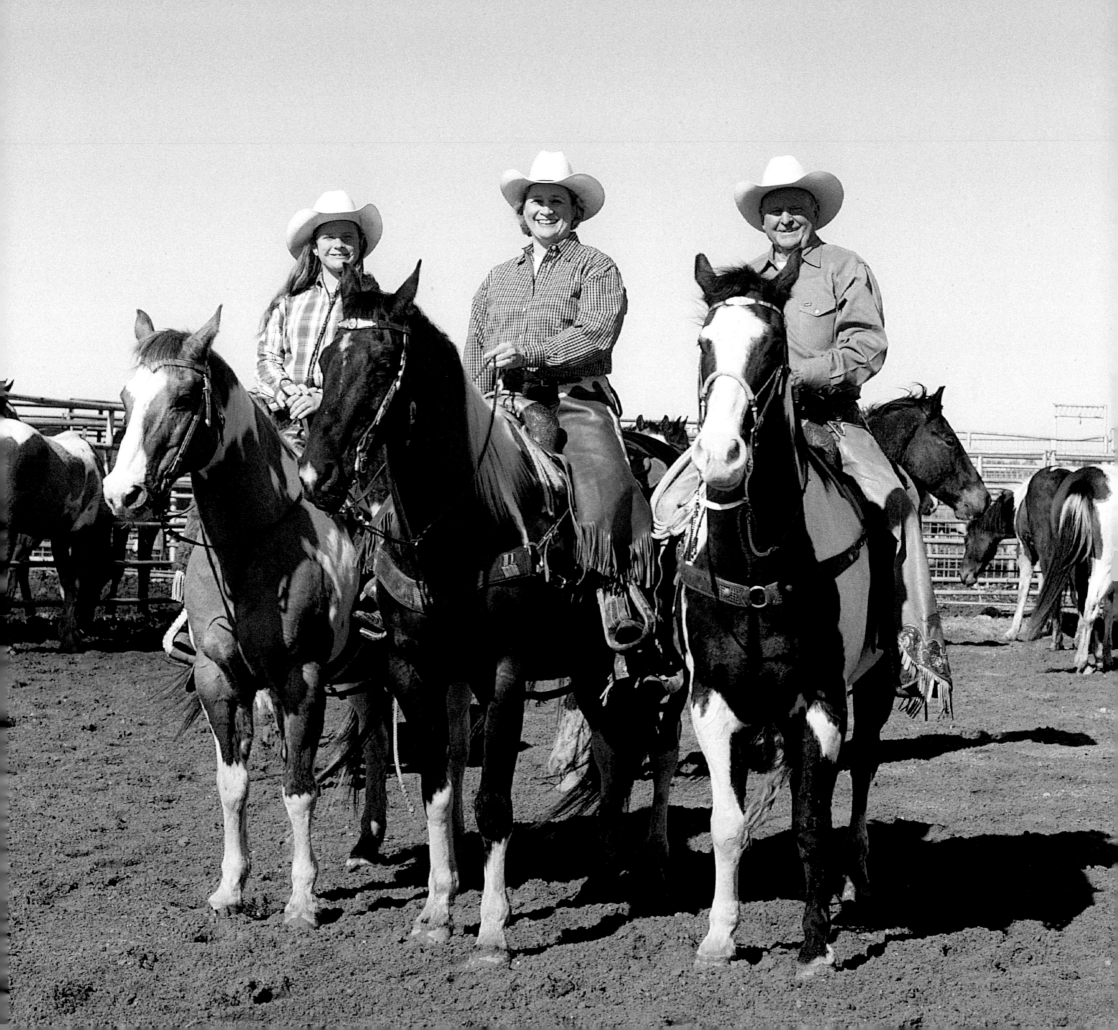

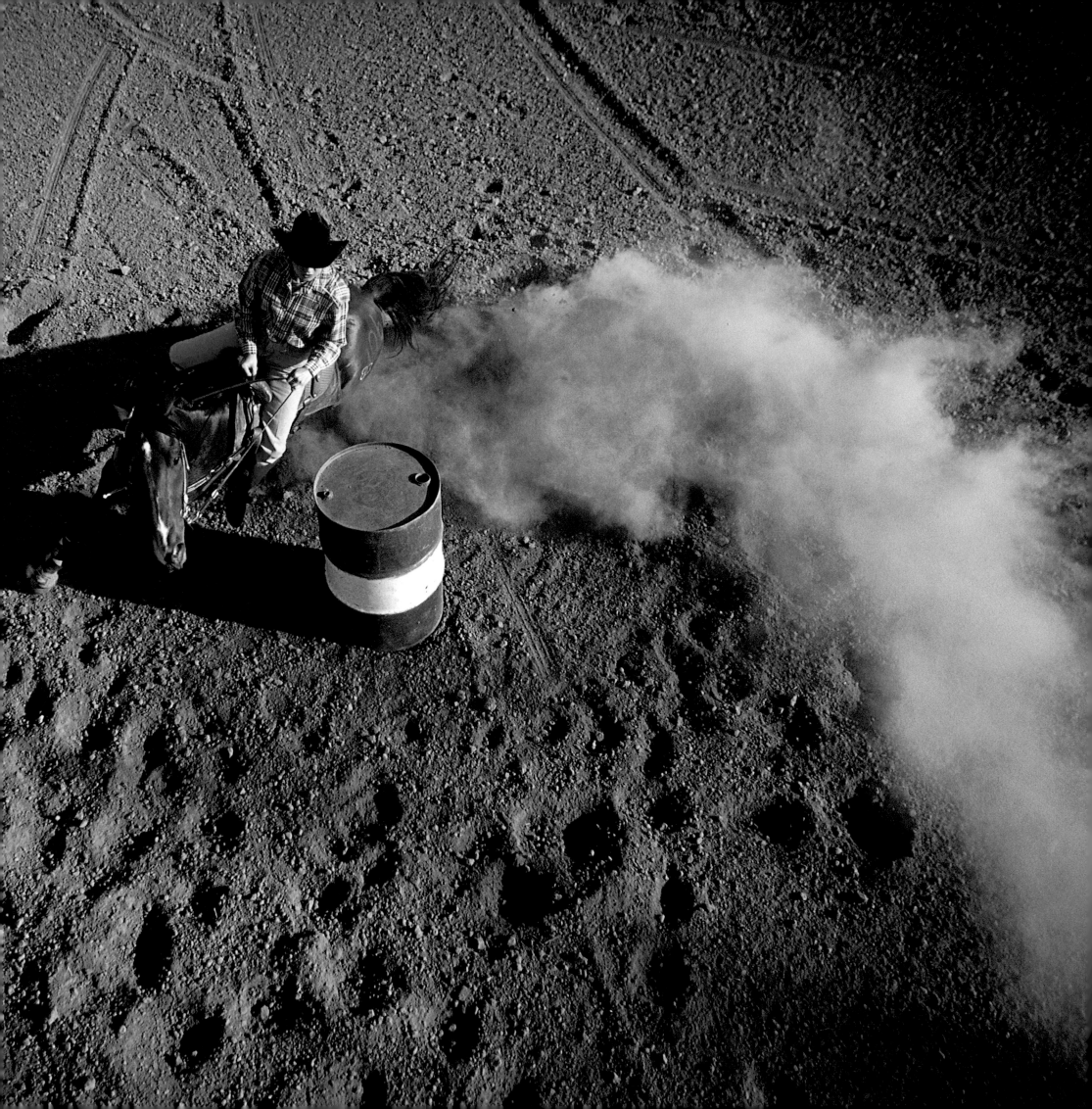

One of Danyelle Campbell's trophy barrel racing saddles

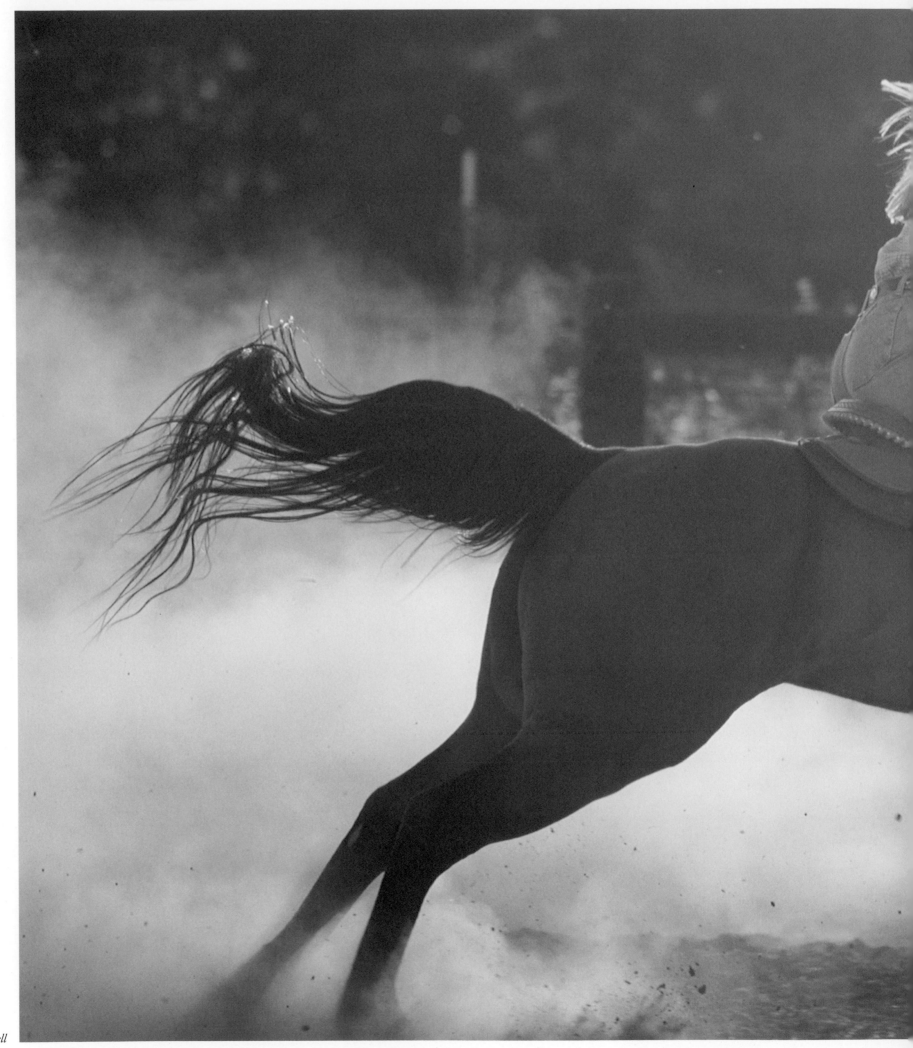

Danyelle Campbell

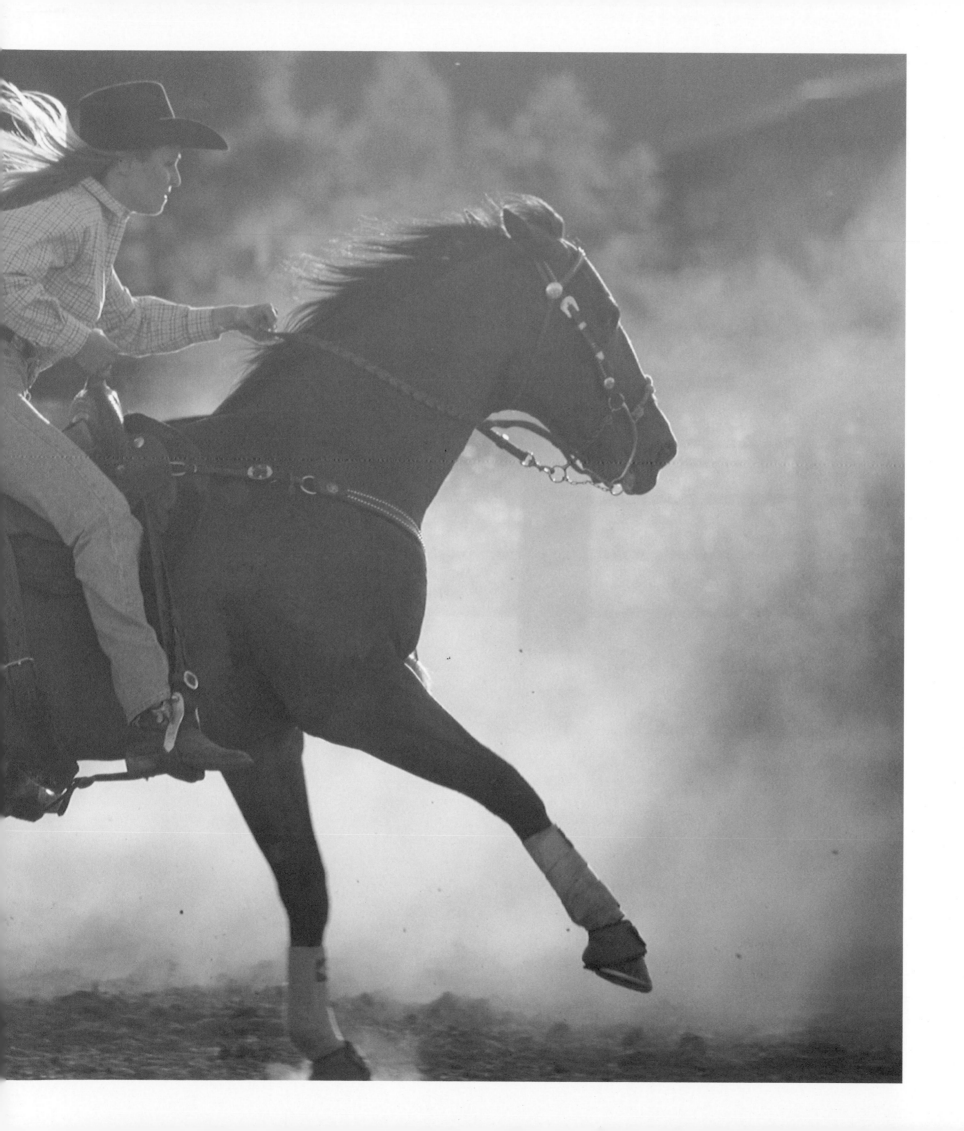

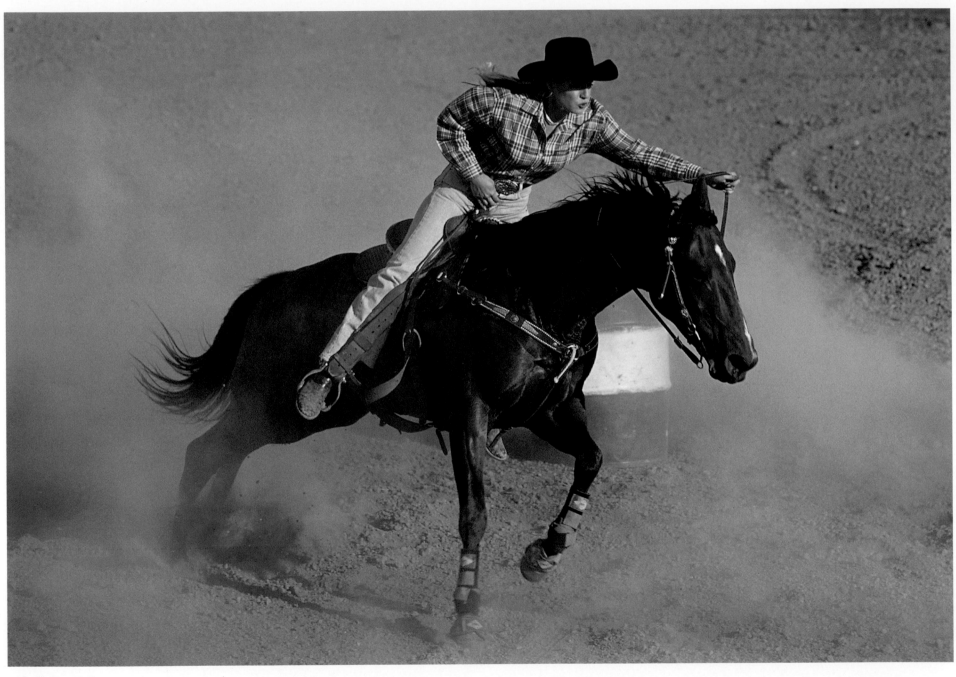

Danyelle Campbell

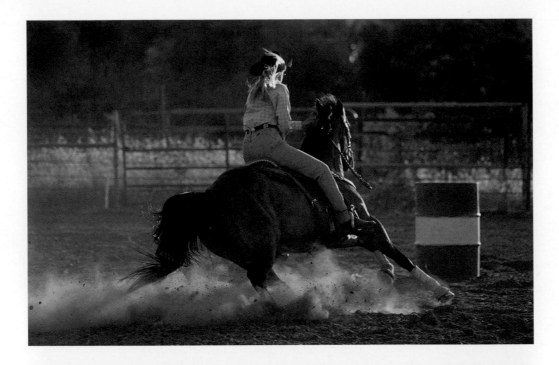

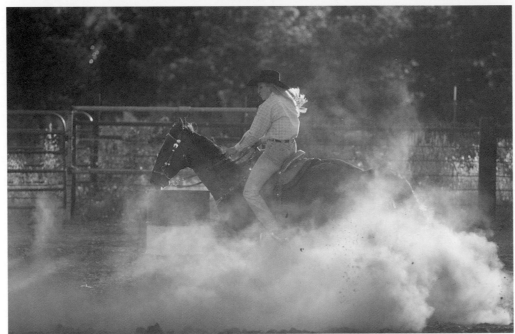

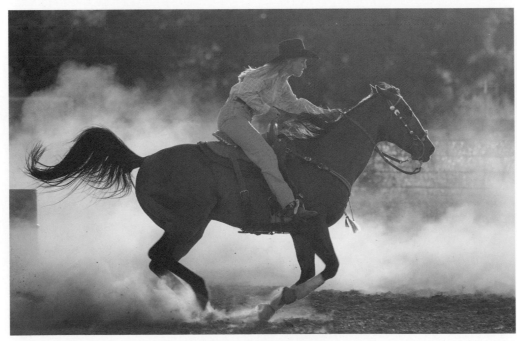

Danyelle Campbell

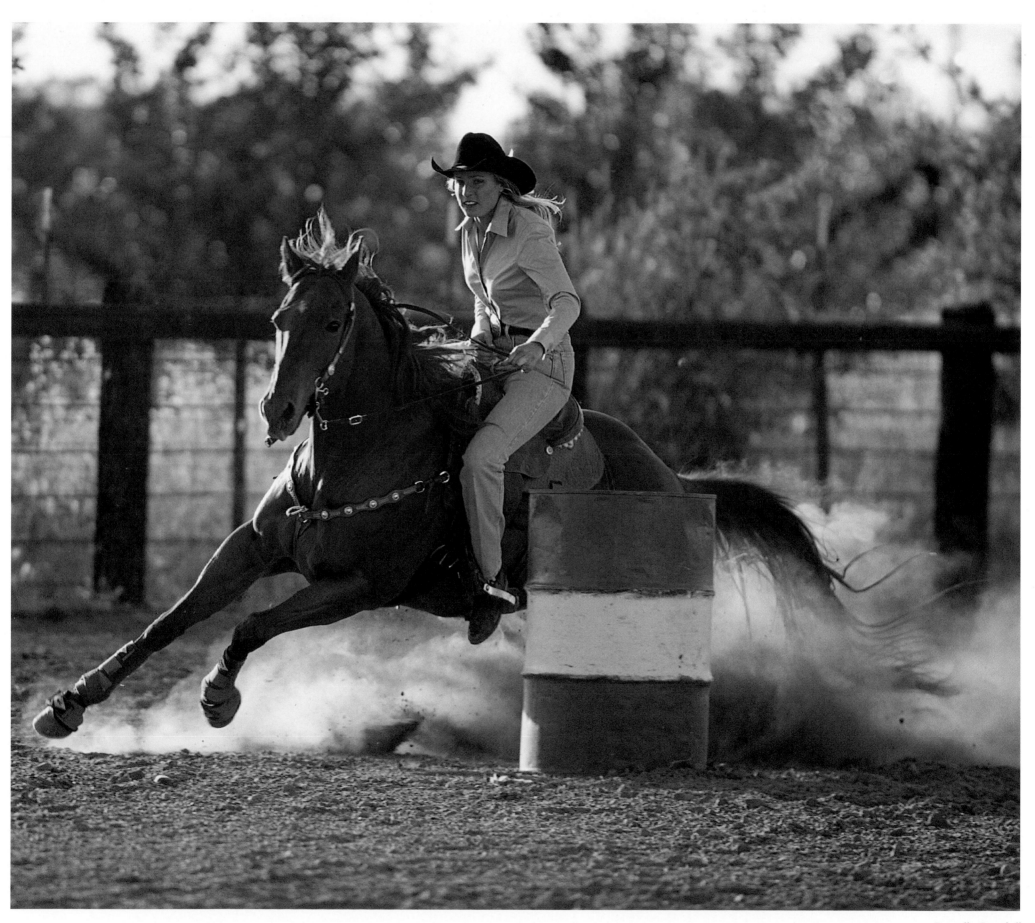

Danyelle Campbell

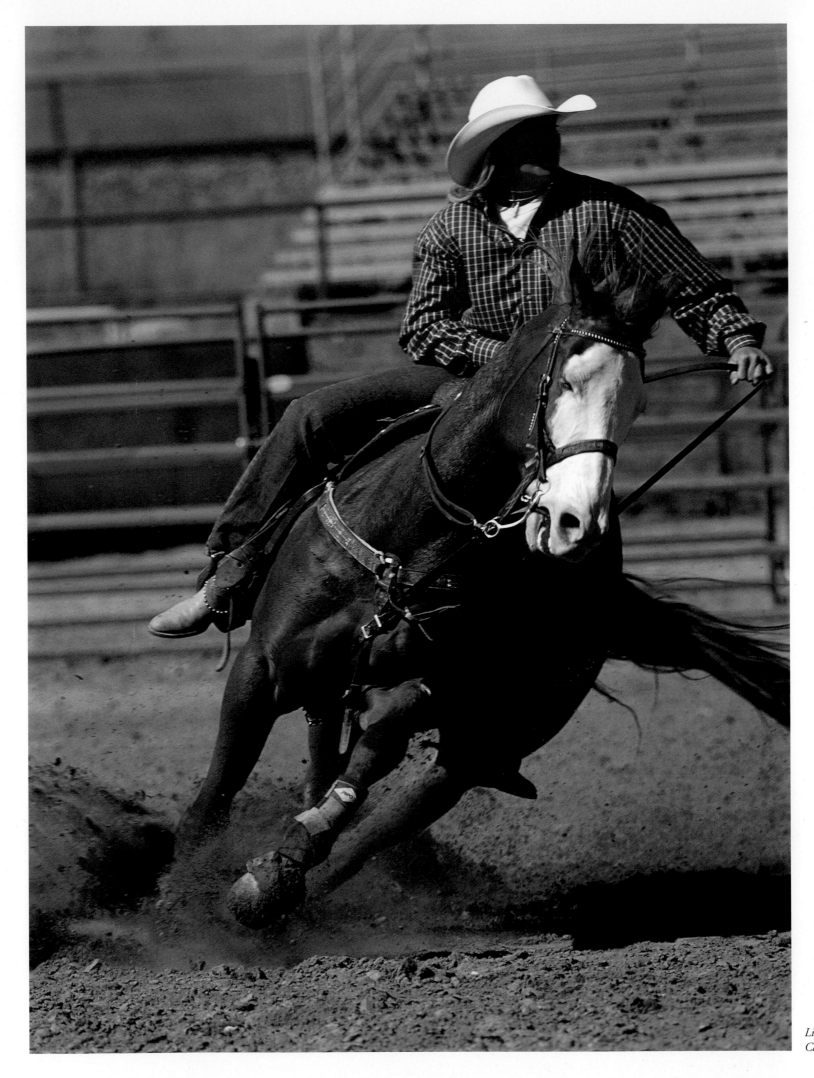

Linsay Rosser, barrel racer,
Cal Poly Rodeo Team

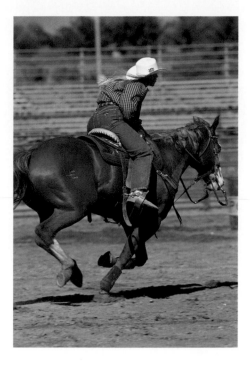

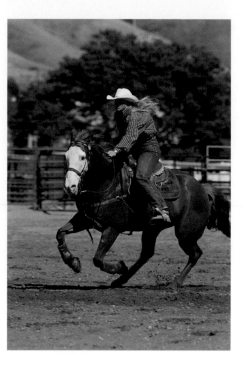

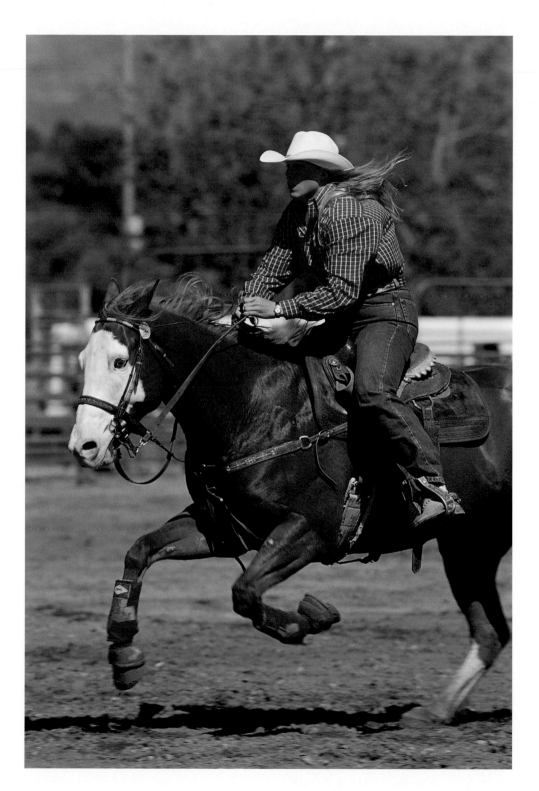

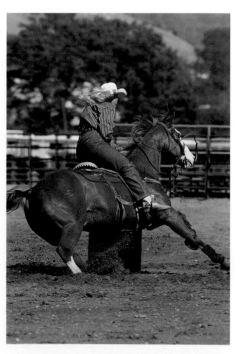

Jacque Hannon, barrel racer,
Cal Poly Rodeo Team
following pages 182-183

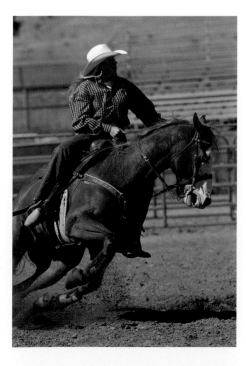

Linsay Rosser, barrel racer,
Cal Poly Rodeo Team

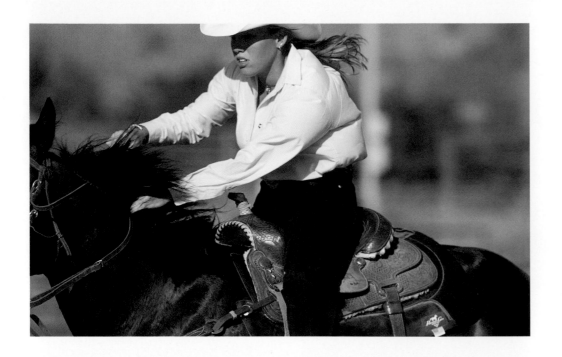

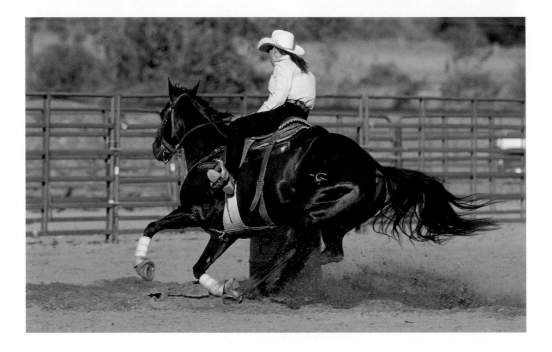

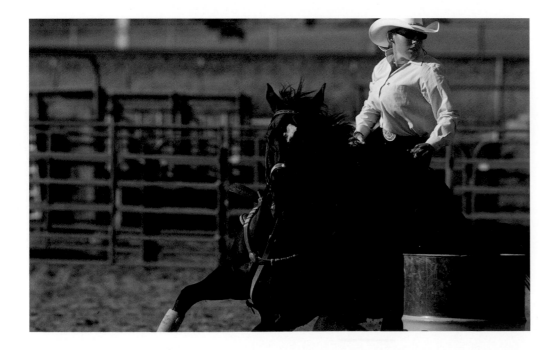

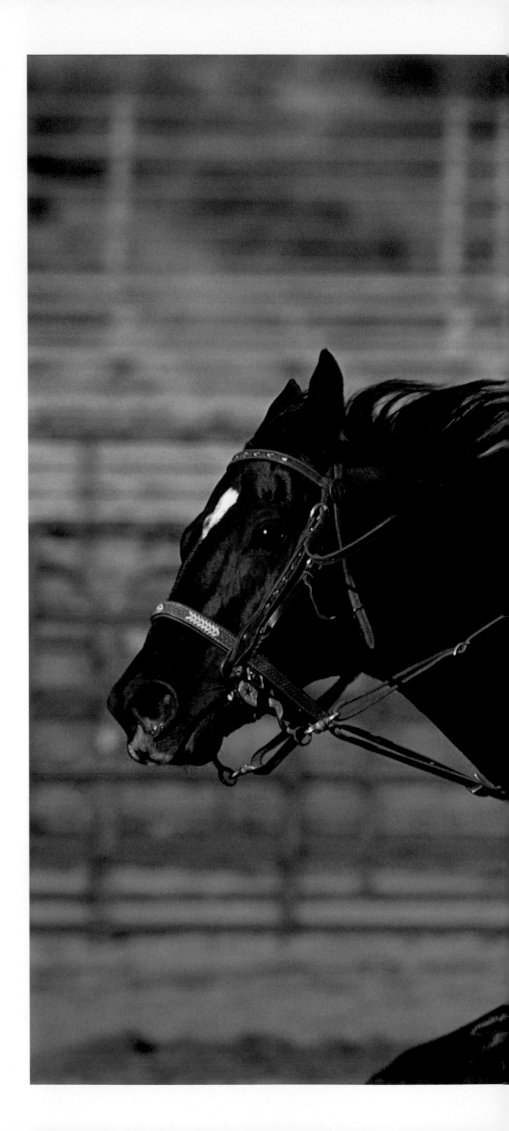

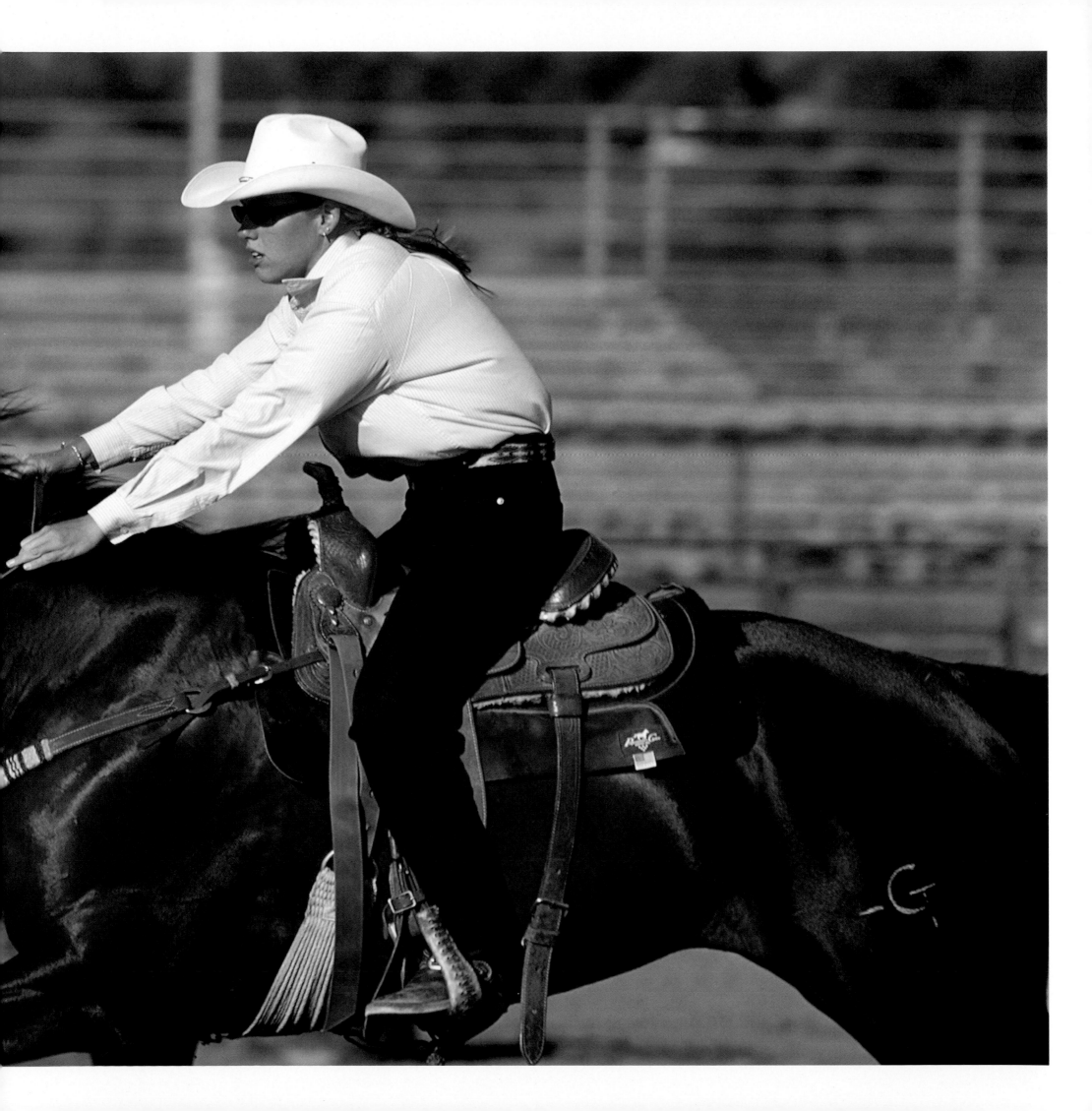

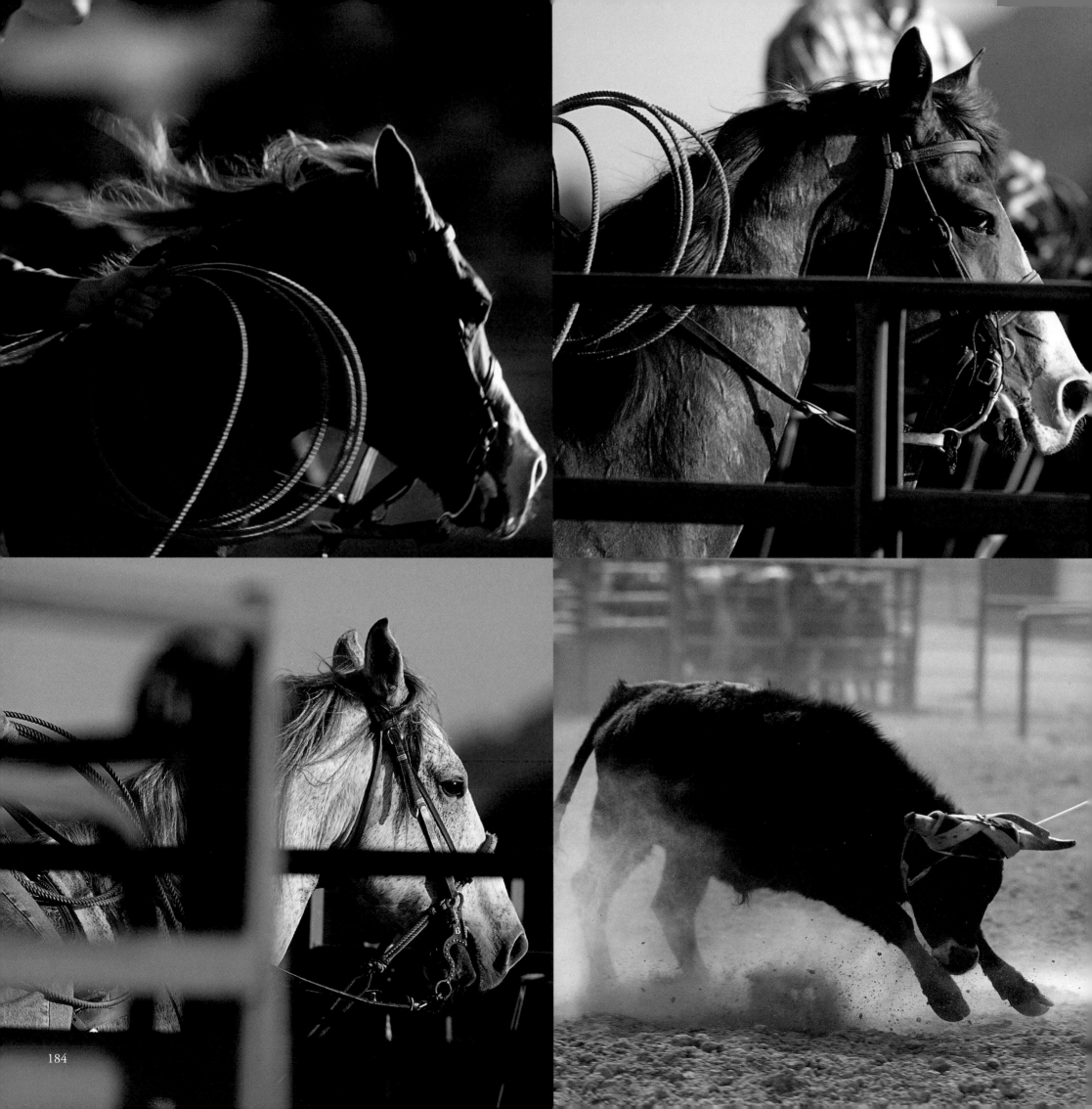

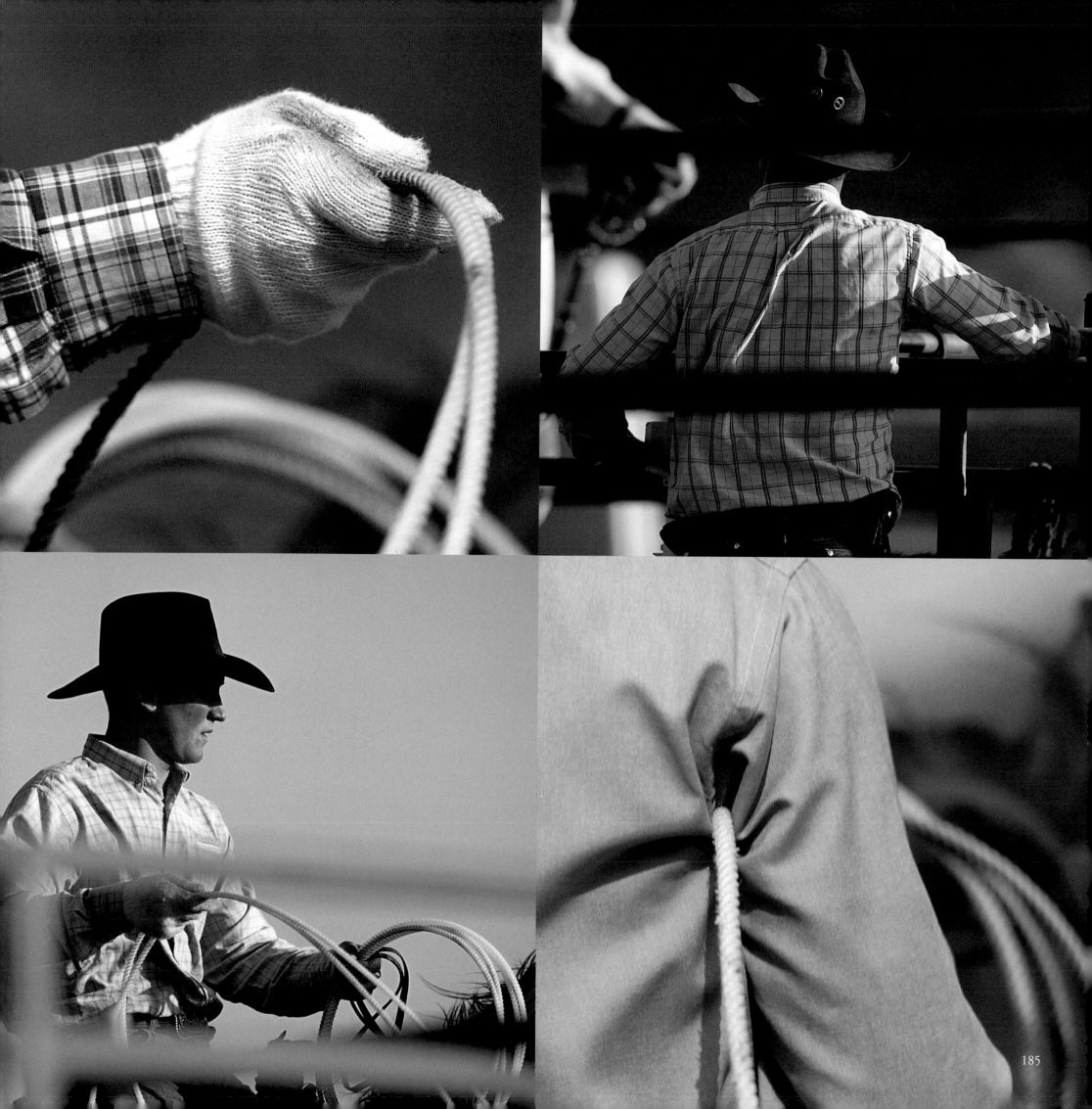

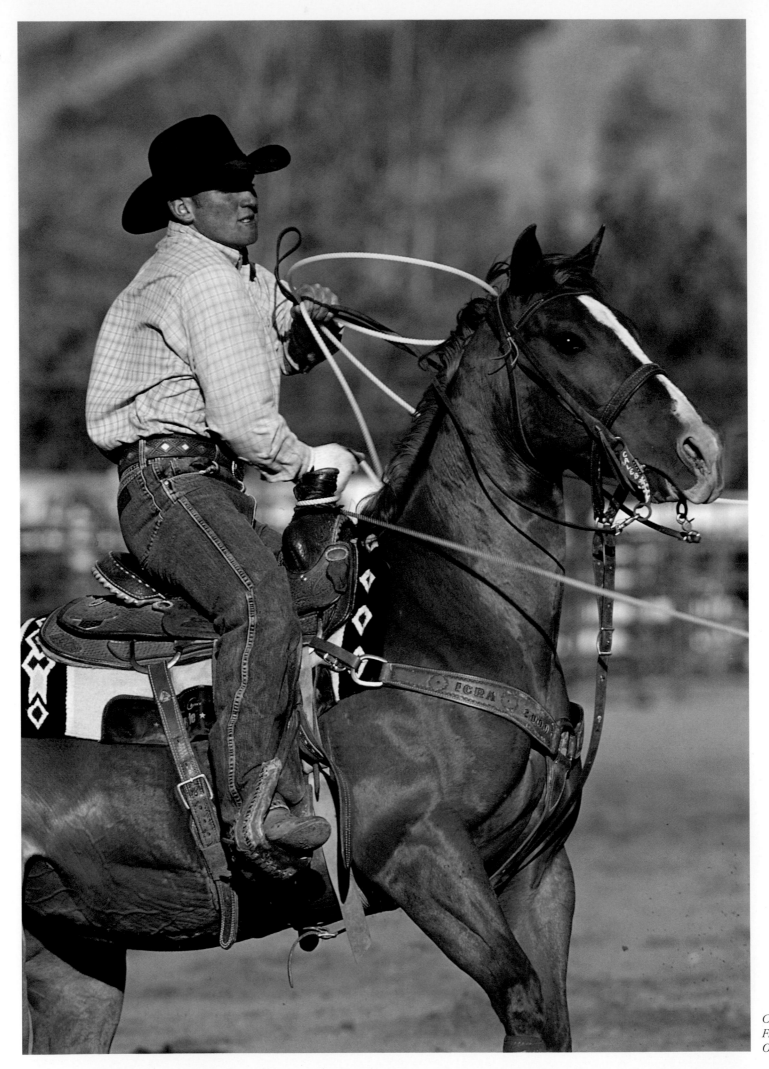

*Caleb Twisselman, National
Finalist Roper, San Luis
Obispo, California*

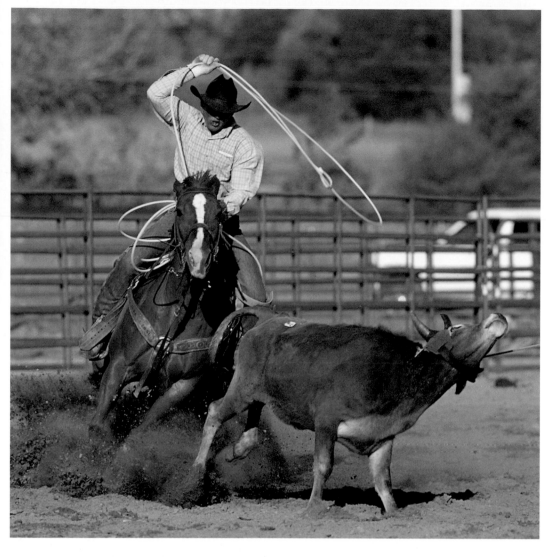

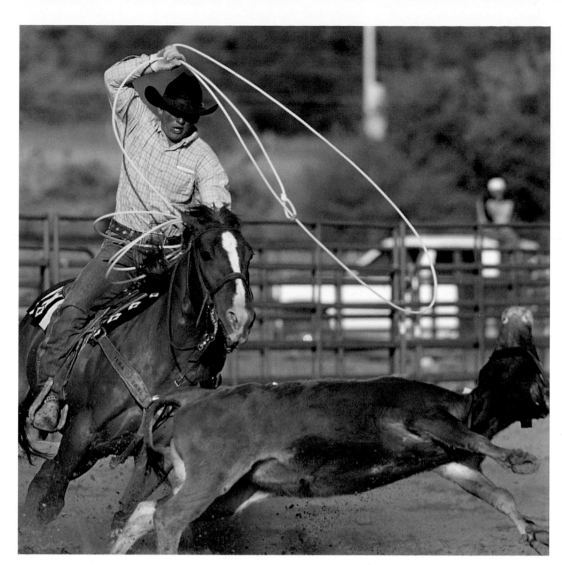

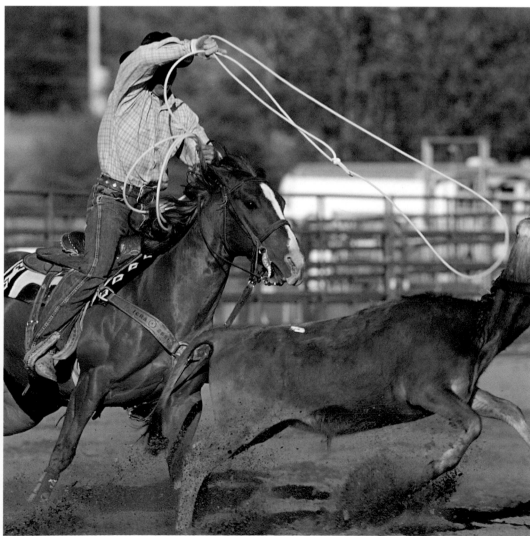

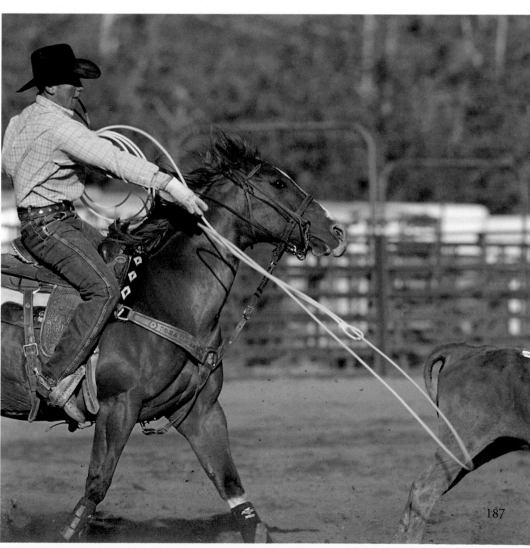

Caleb Twisselman, National Finalist Roper, San Luis Obispo, California
previous page

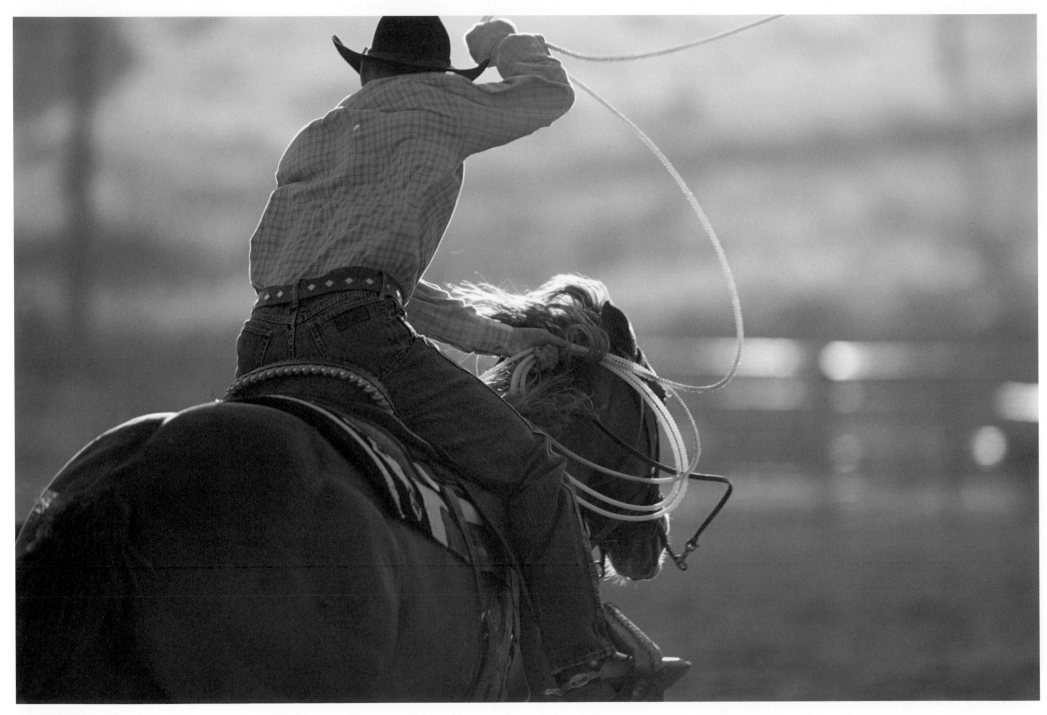

*Caleb Twisselman, National
Finalist Roper, San Luis
Obispo, California*
previous page

*Caleb Twisselman, National Finalist
Roper, San Luis Obispo, California*
following page

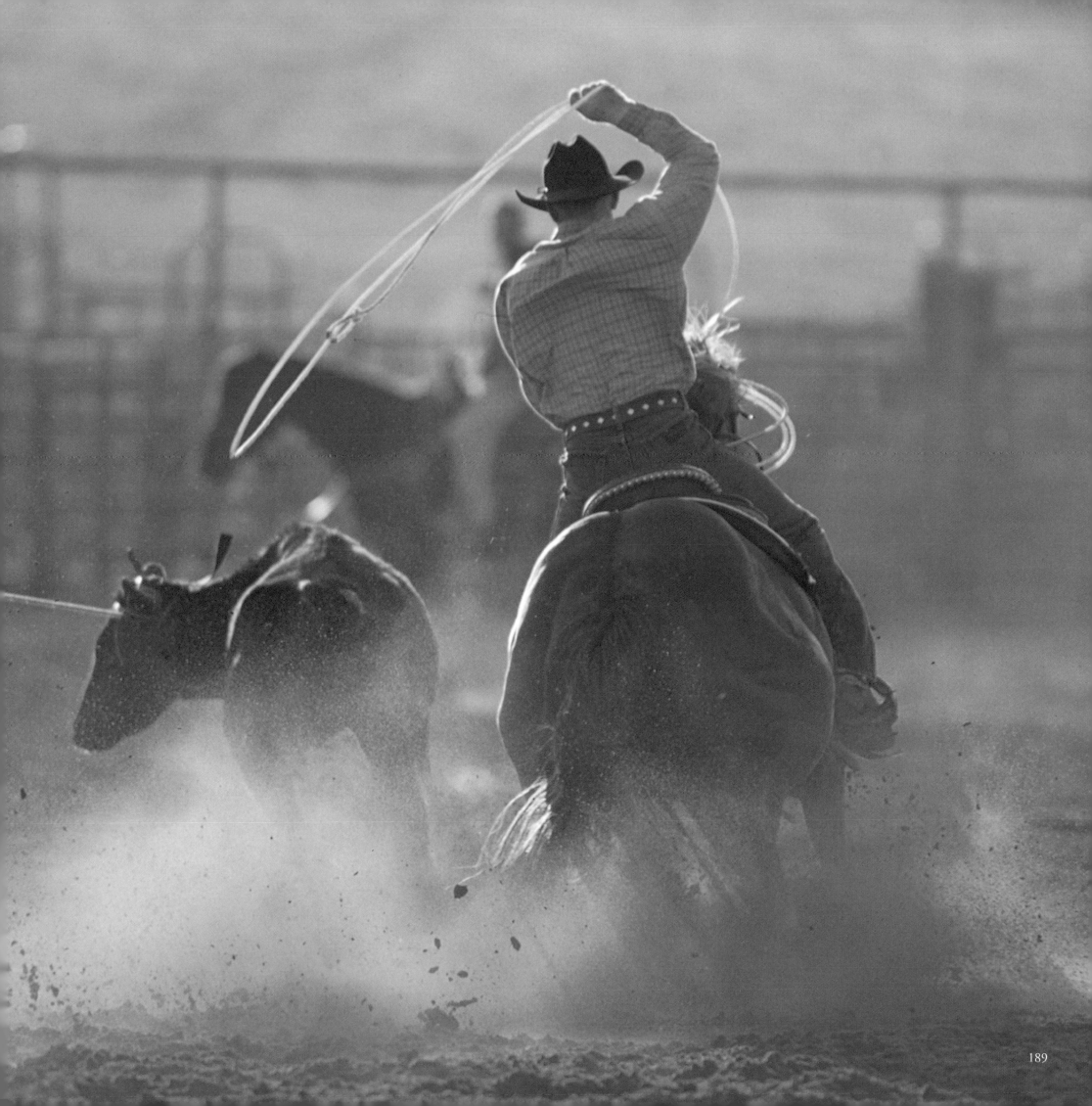

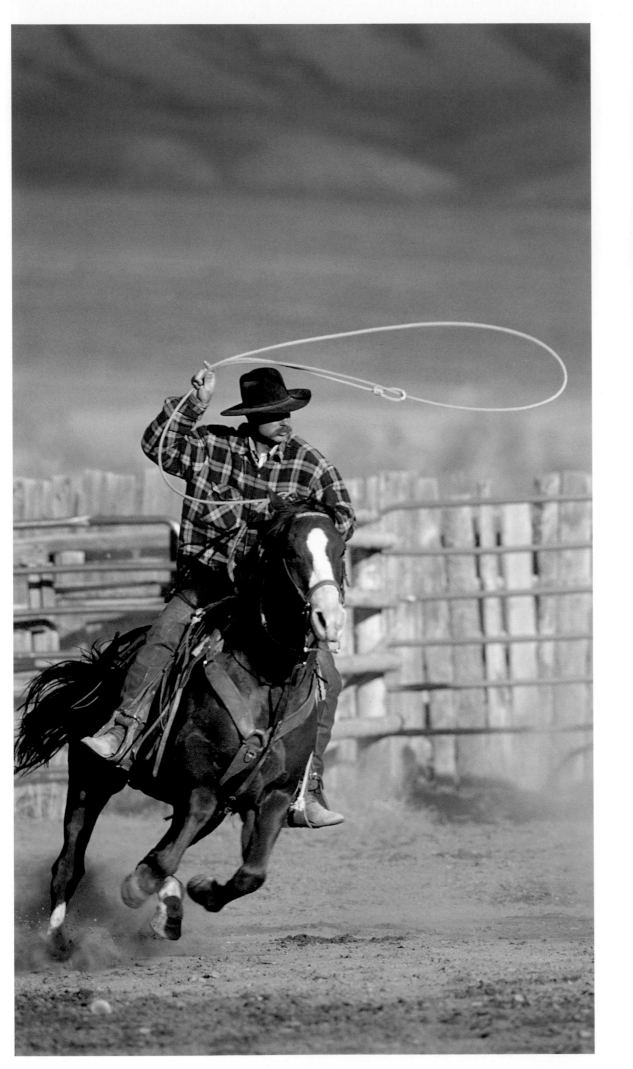

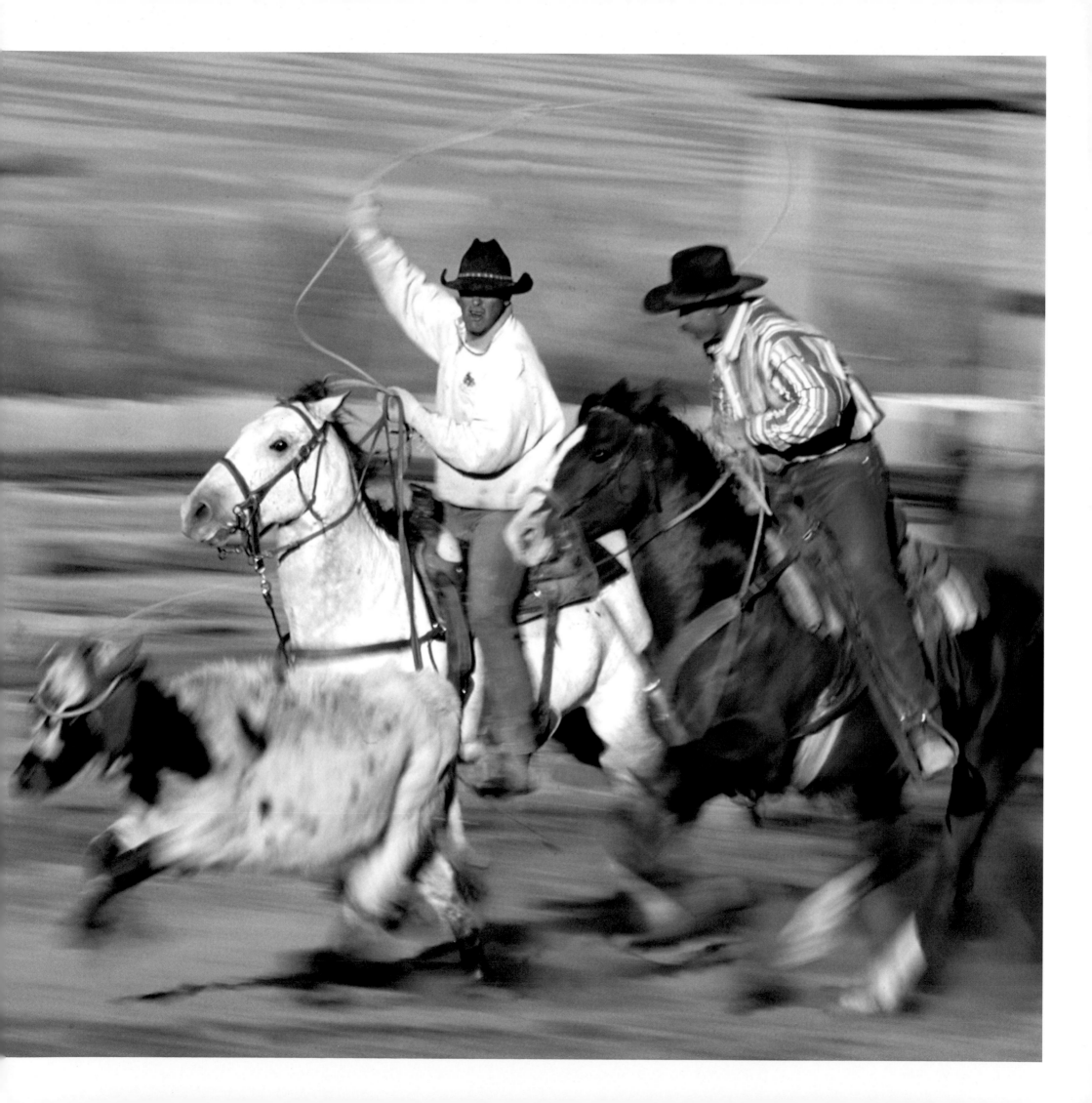

*J2 Brown roping, Bar Horseshoe
Ranch, Mackay, Idaho*
previous page 190

*J2 Brown and Pete Birrer roping,
Bar Horseshoe Ranch, Mackay, Idaho*
previous page 191

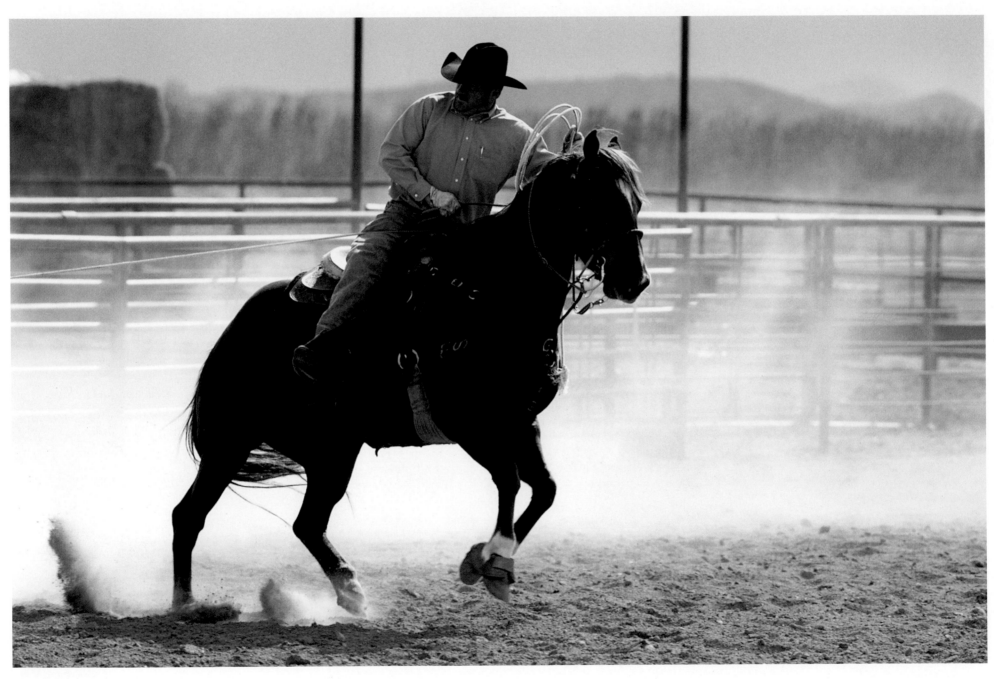

Lewis Fields, Spanish Fork, Utah

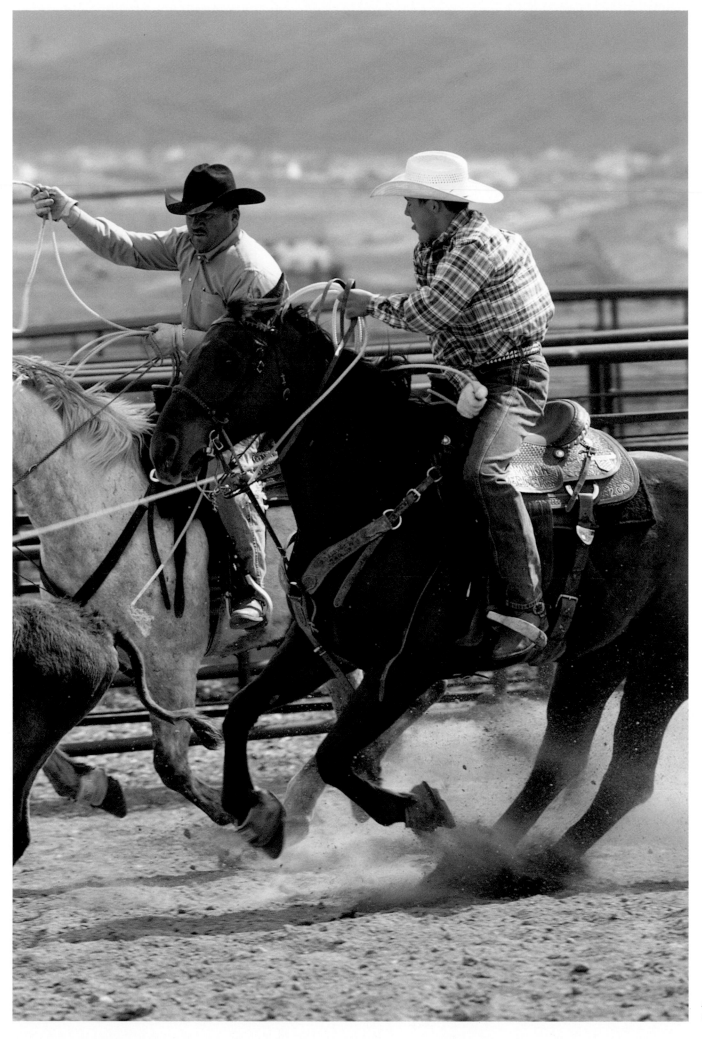

Lewis Fields and his son,
Casey, Spanish Fork, Utah

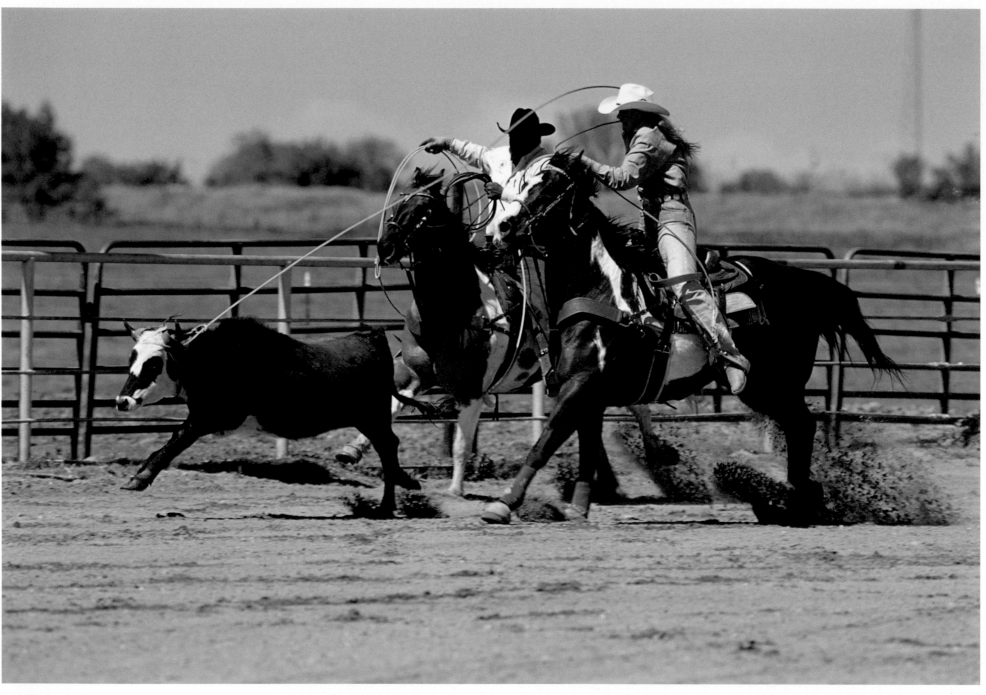

Julio Moreno and Linsay Rosser,
Flying U Rodeo, Marysville, California

Calf roping horse with all the ropes,
Cal Poly University

Troy Murray,
Cal Poly Roping Team

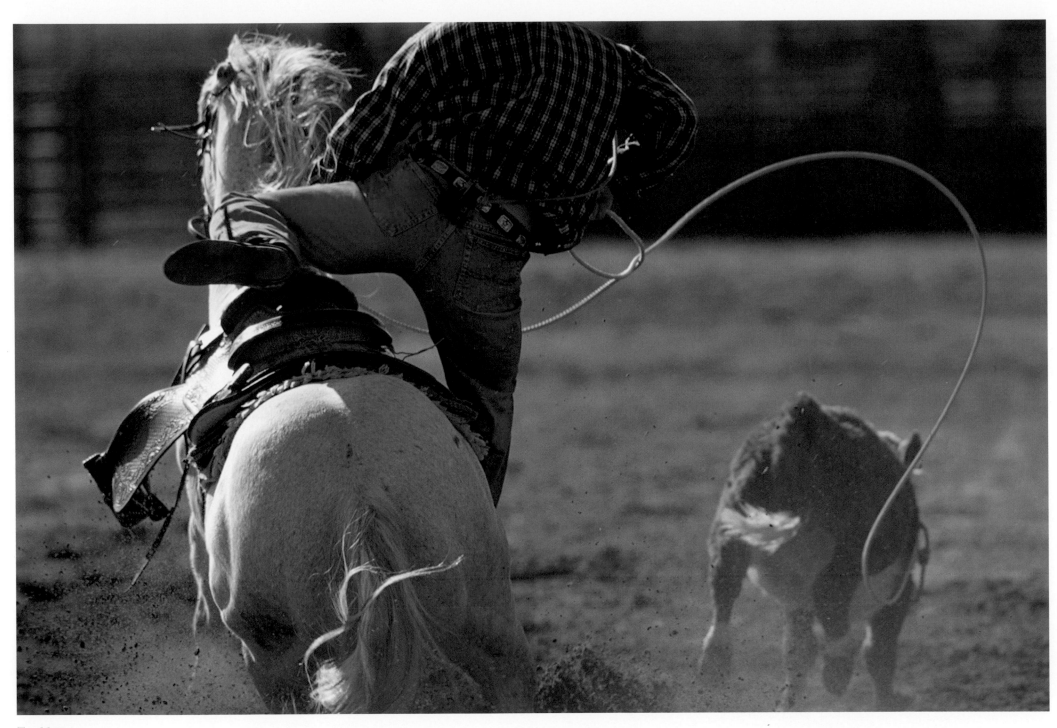

Troy Murray,
Cal Poly Roping Team

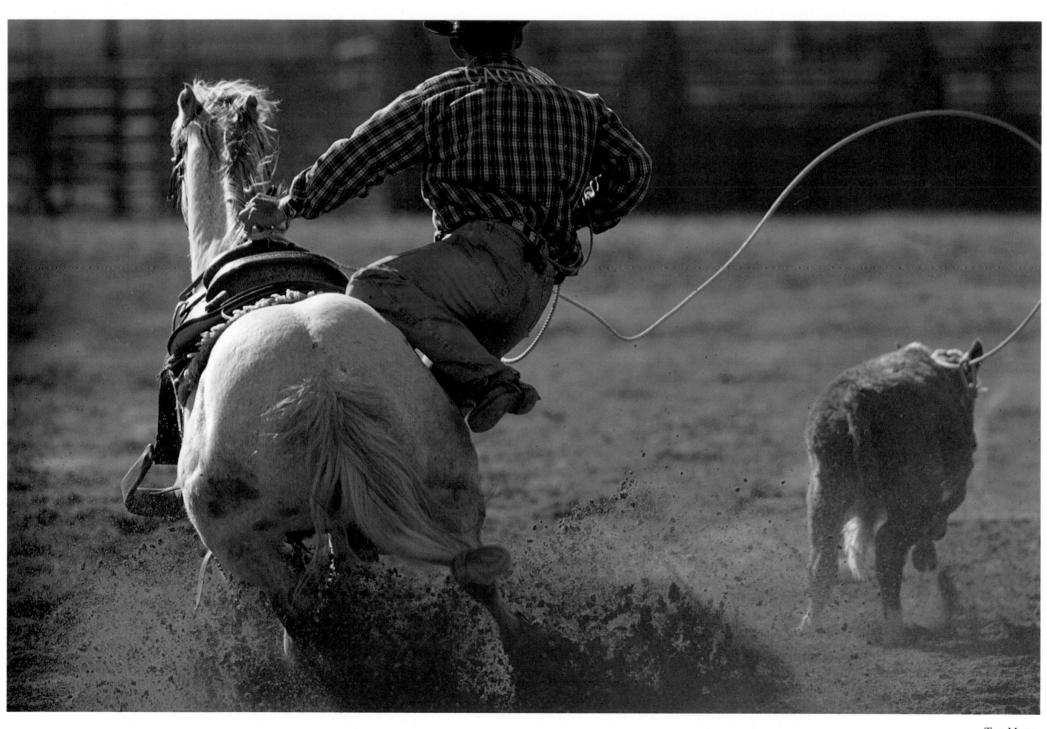

Troy Murray,
Cal Poly Roping Team

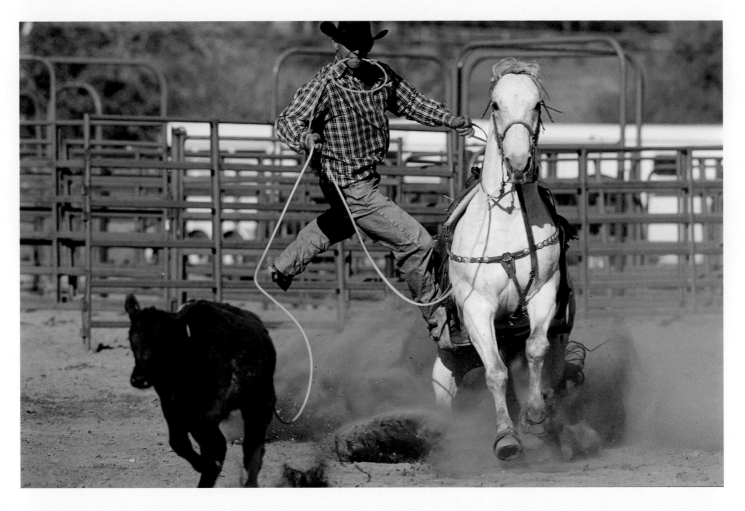

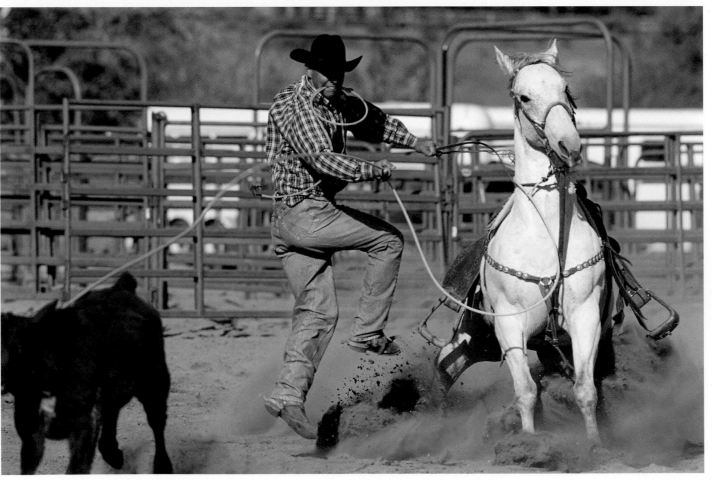

Troy Murray,
Cal Poly Roping Team

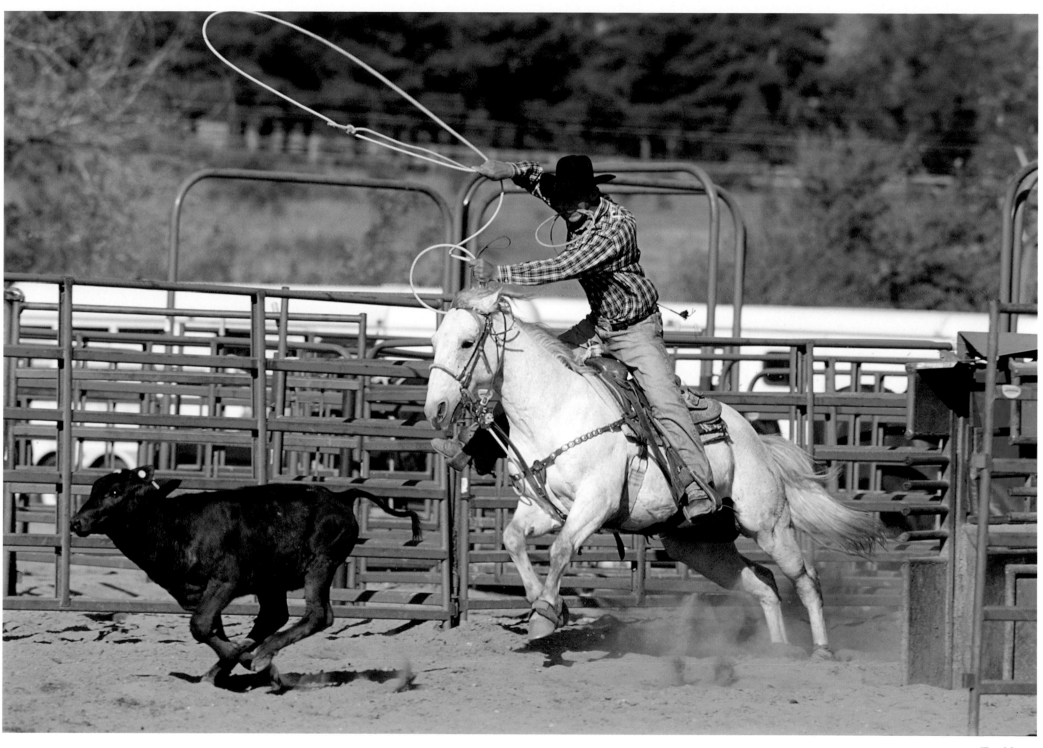

Troy Murray,
Cal Poly Roping Team

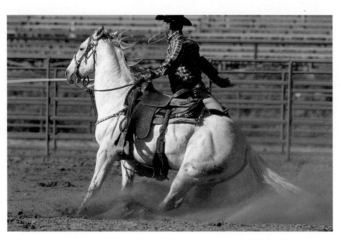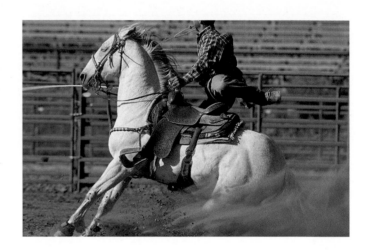

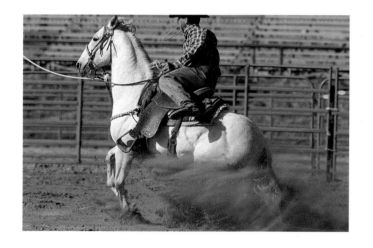 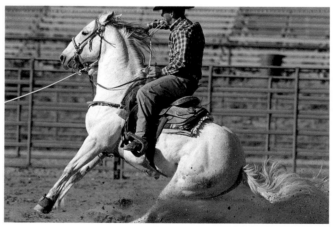 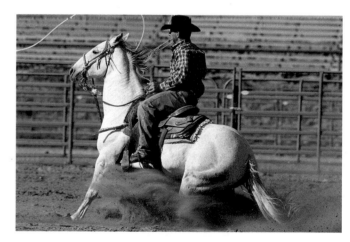

Troy Murray, calf roper, Cal Poly Roping Team

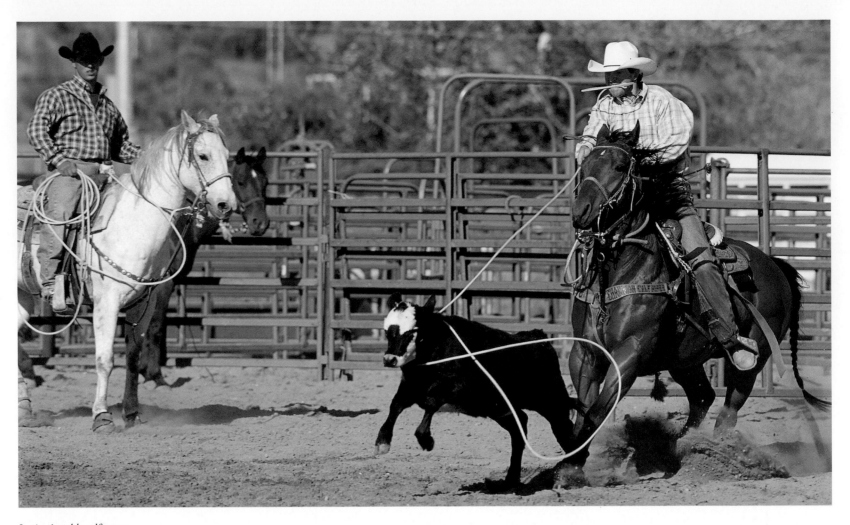

Justin Arnold, calf roper,
Cal Poly Rodeo Team

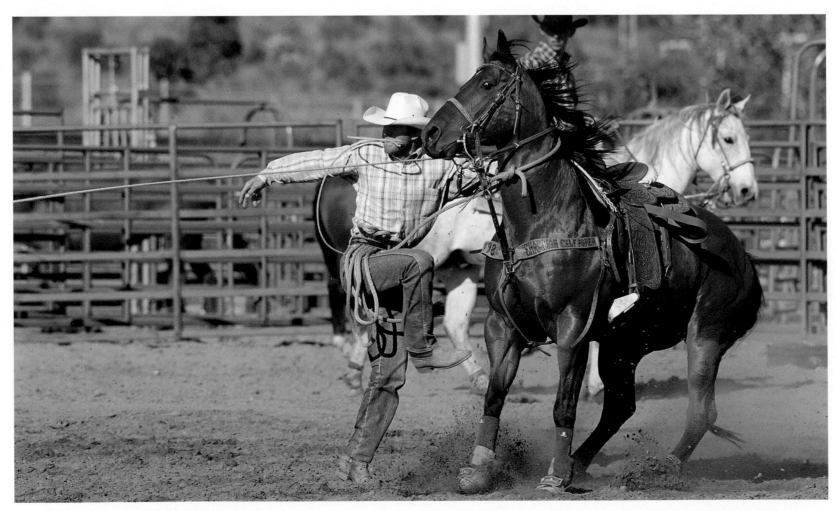

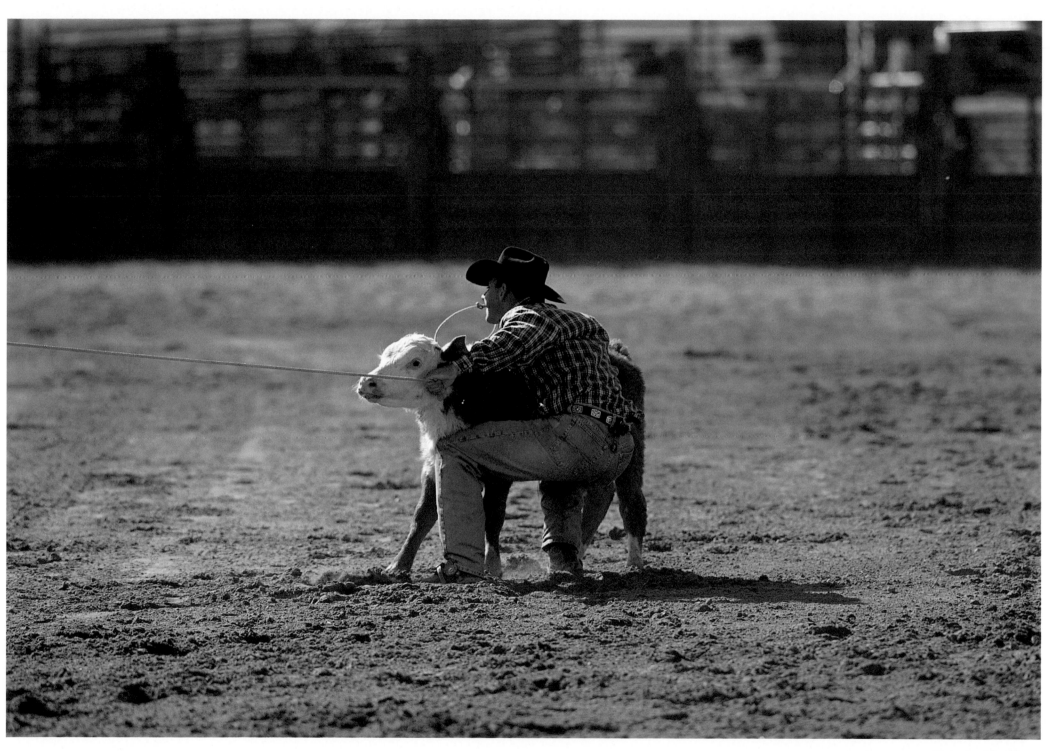

Justin Arnold, calf roper,
Cal Poly Rodeo Team

Bareback rigging, California Rodeo,
Salinas, California

Saddle bronc saddle, California Rodeo,
Salinas, California

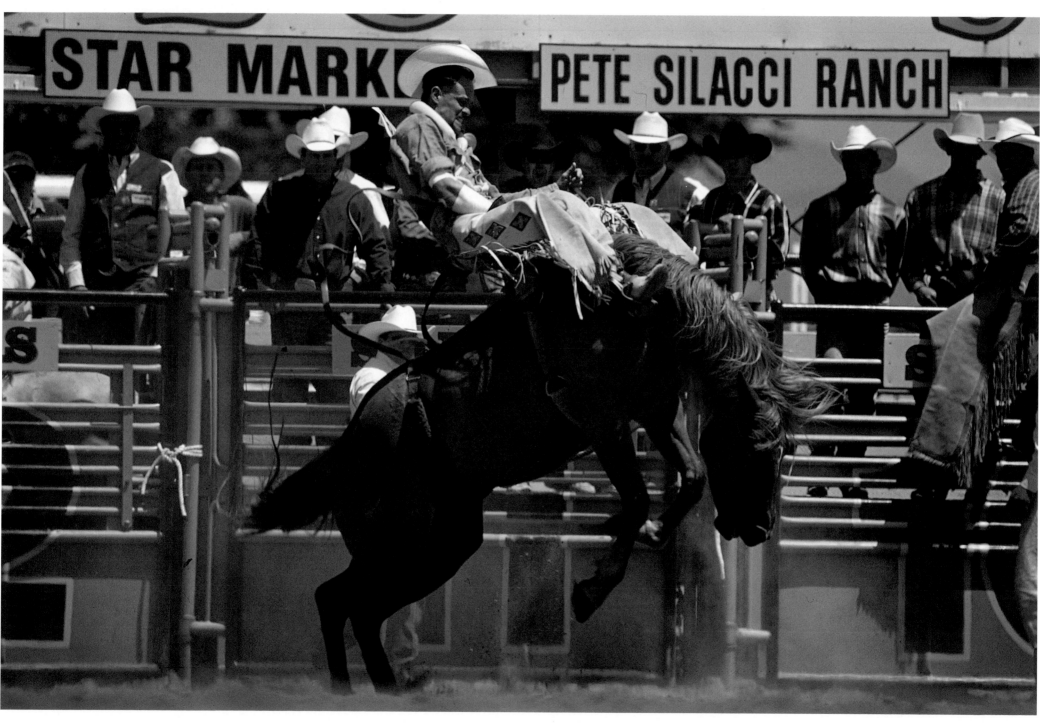

World champion bareback
rodeo cowboy, Kelly Wordell,
California Rodeo,
Salinas, California

Rigging, California Rodeo,
Salinas, California

Bareback rider, California Rodeo,
Salinas, California
opposite page

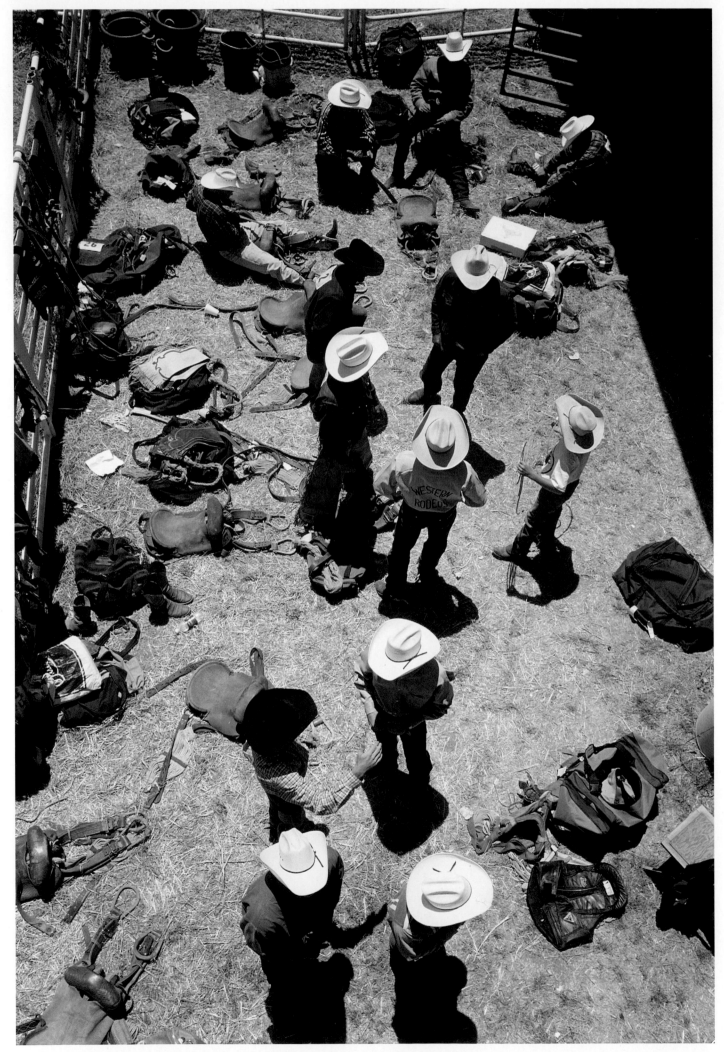

Getting ready, California Rodeo,
Salinas, California

The pick-up man, Lewis Fields,
California Rodeo,
Salinas, California

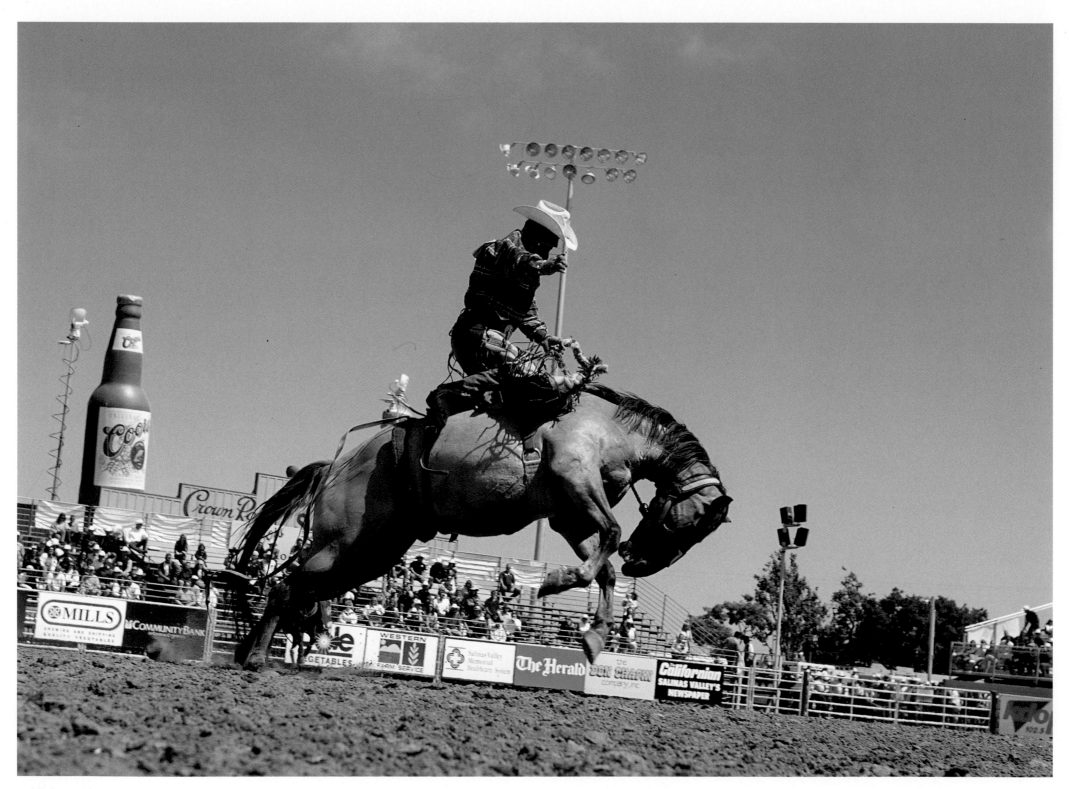

Saddle bronc rider, California
Rodeo, Salinas, California

 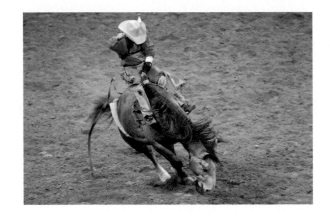

Las Vegas Buckin' Horse Sale – Each year, tens of thousands of rodeo fans invade Las Vegas, Nevada, for the National Finals Rodeo. During the finals, there is a spectacular event in which the rodeo contractors sell their bucking horses, bulls, and pickup horses to each other or to the general public. These photos are from the 2001 sale.

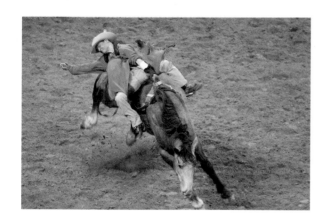 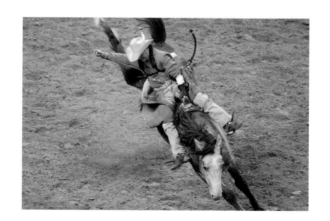 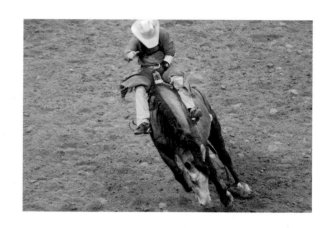

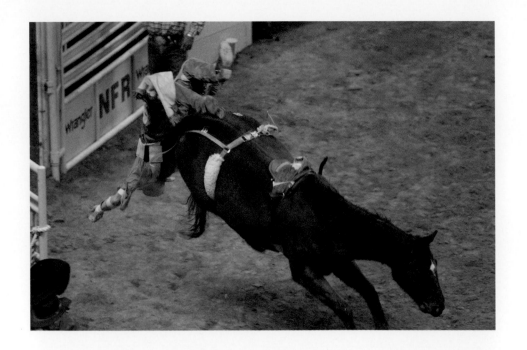

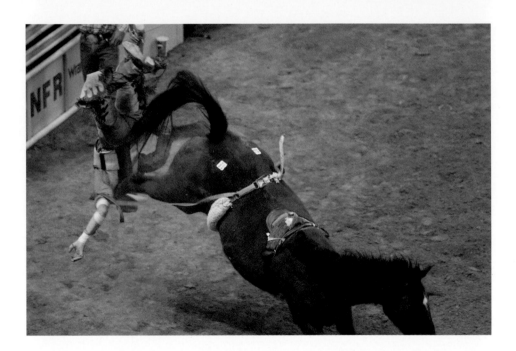

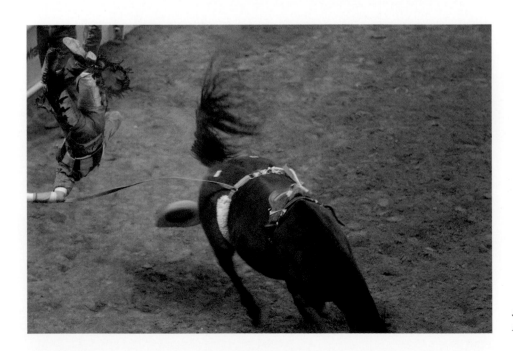

Saddle bronc rider, California
Rodeo, Salinas, California

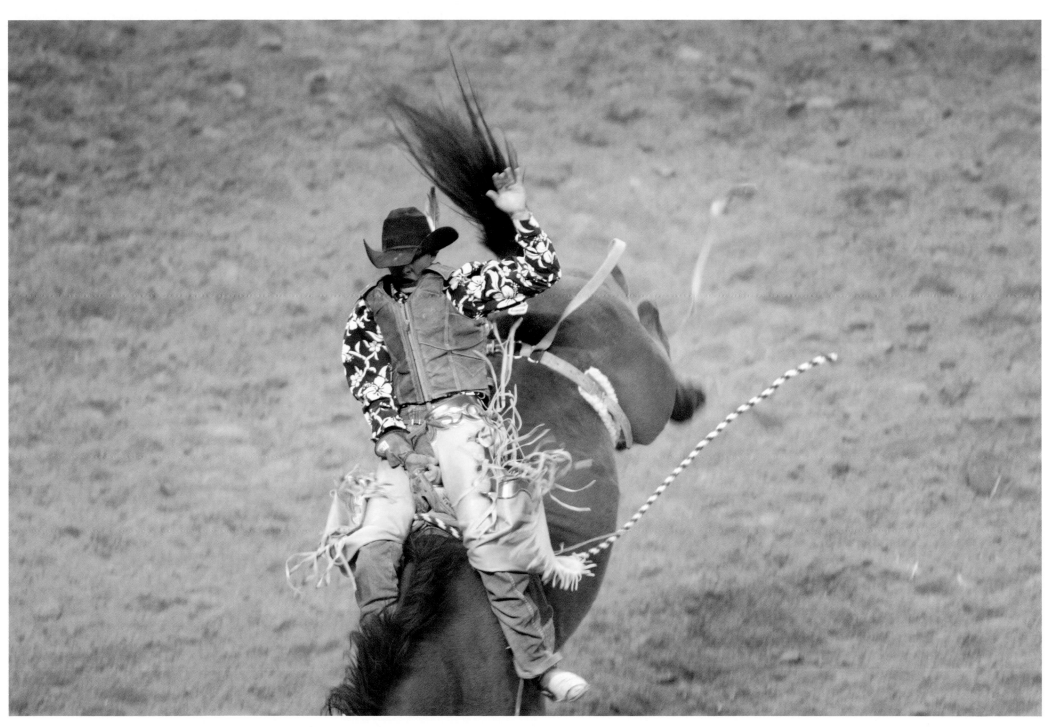

Las Vegas Buckin' Horse Sale

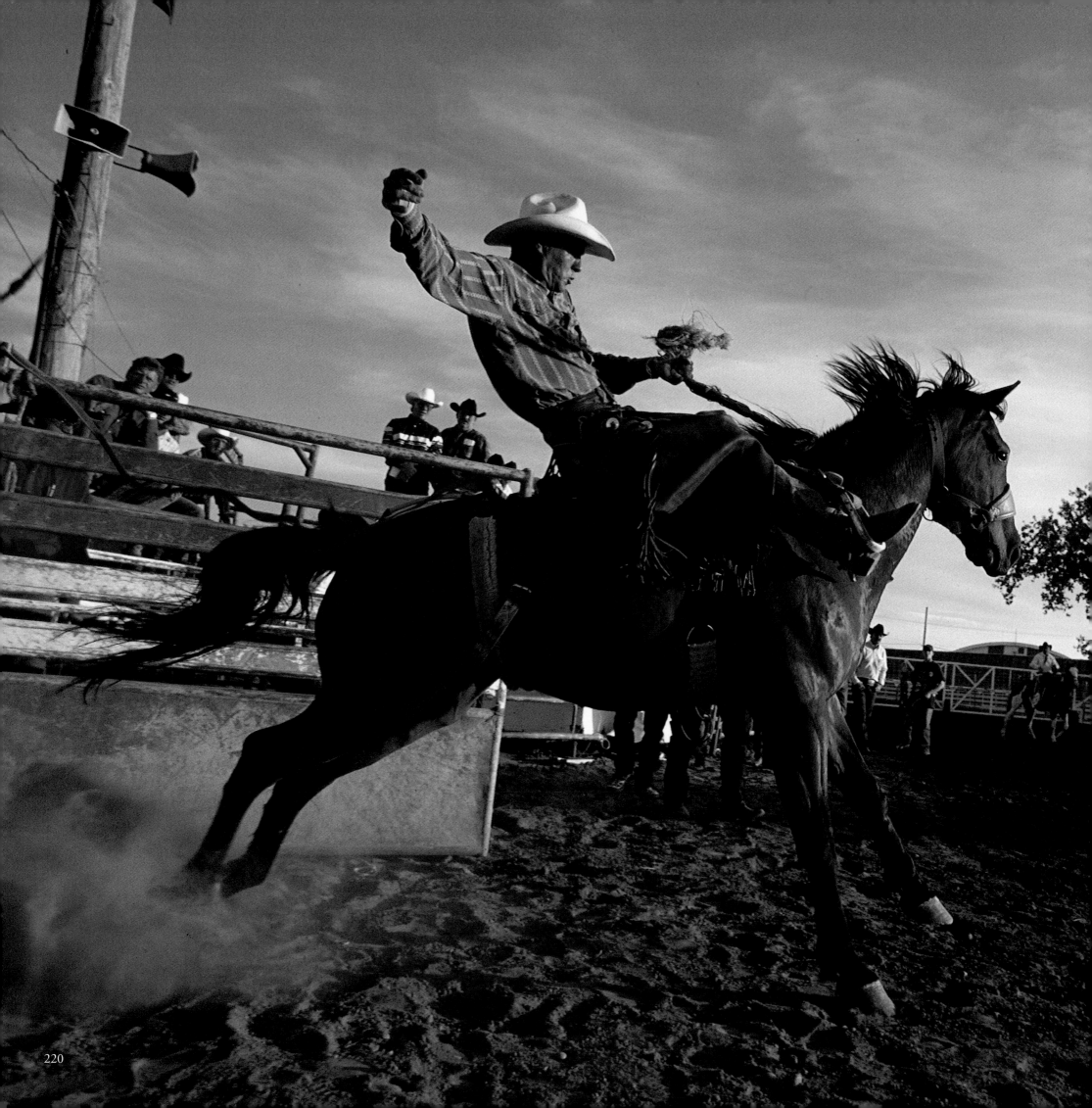

Mare pasture, R.A. Brown Ranch,
Throckmorton, Texas

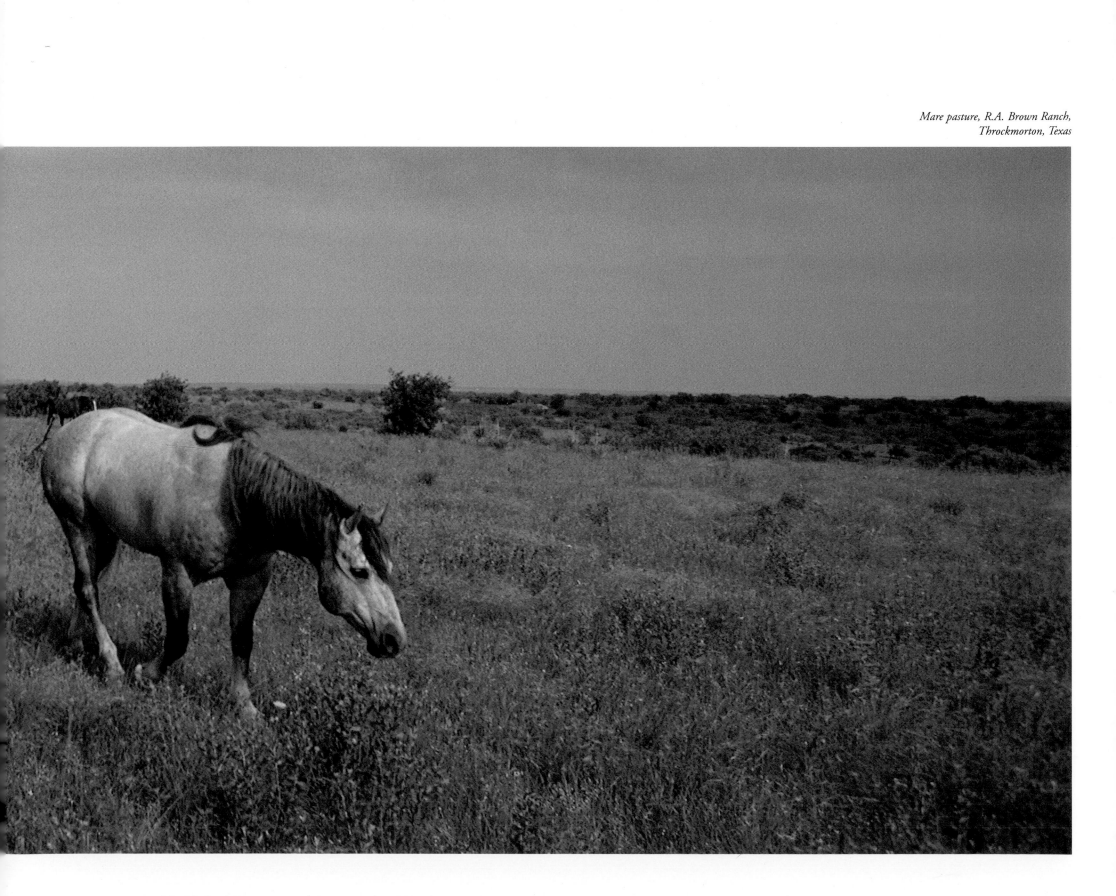

Colt, Van Berg Stables,
Louisville, Kentucky

Colts, Van Berg Stables,
Louisville, Kentucky
opposite page

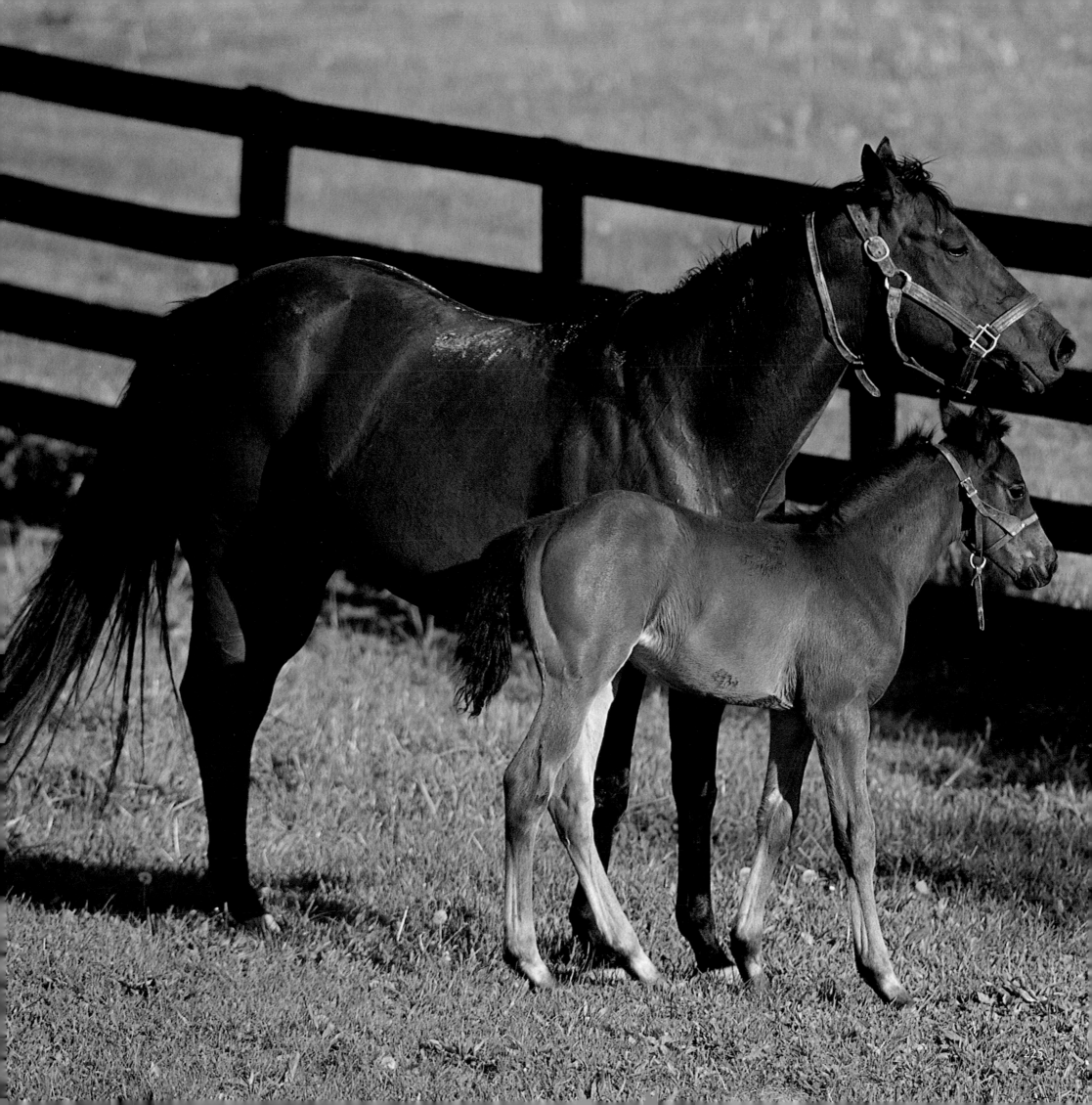

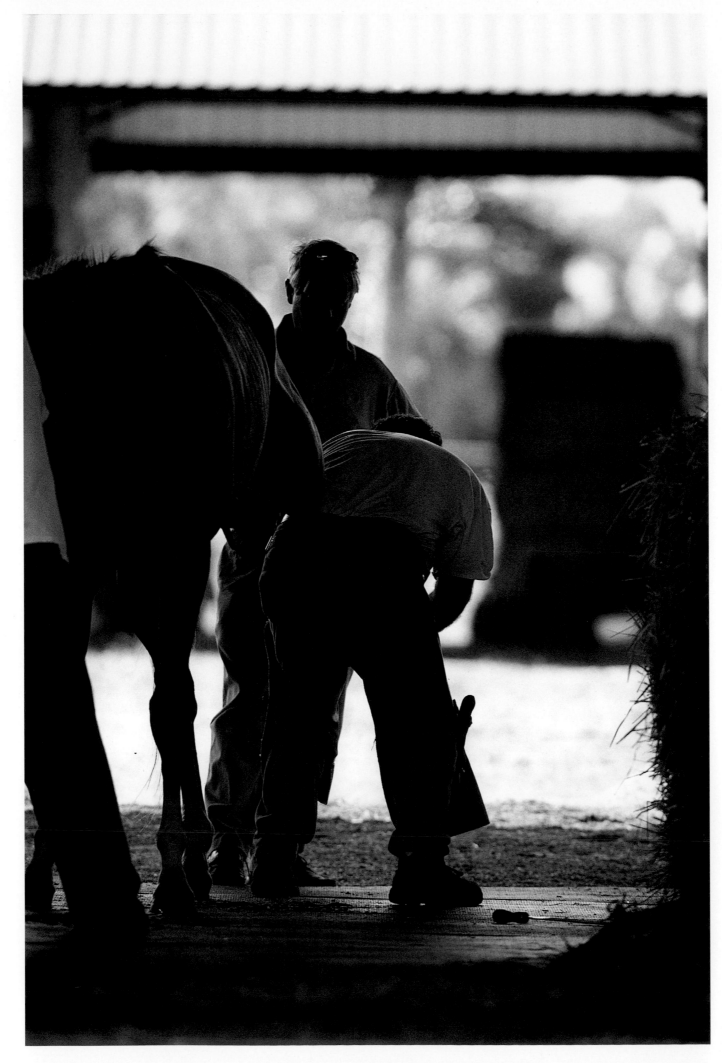

Farrier, Palm Beach Downs,
Palm Beach, Florida

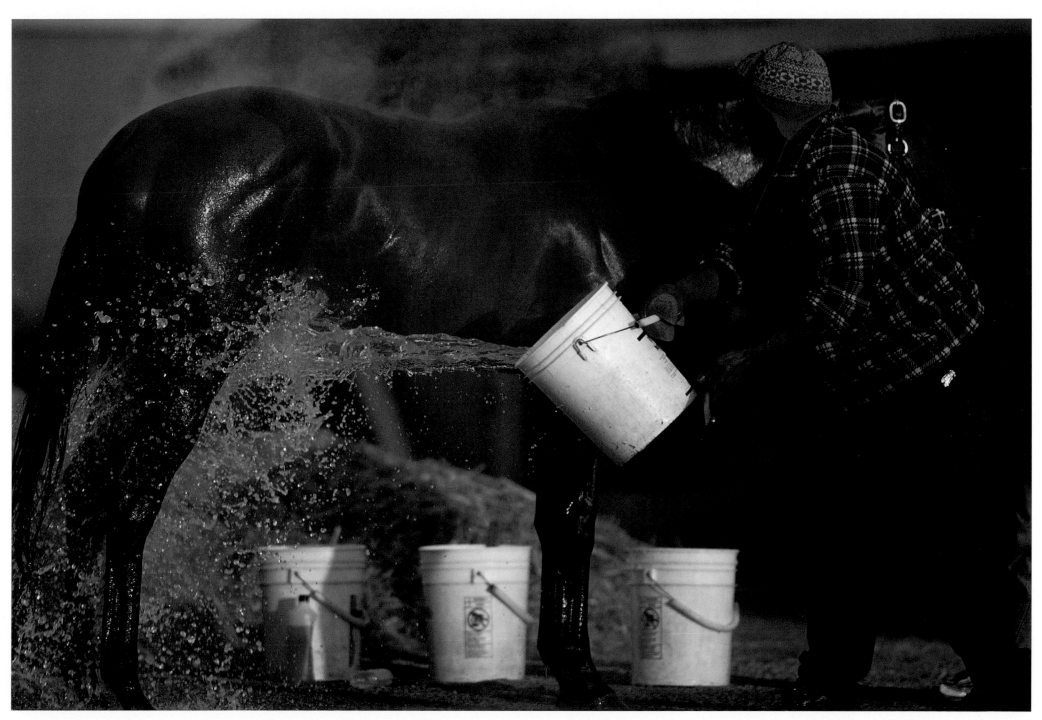

Bath time, Churchill Downs,
Louisville, Kentucky

227

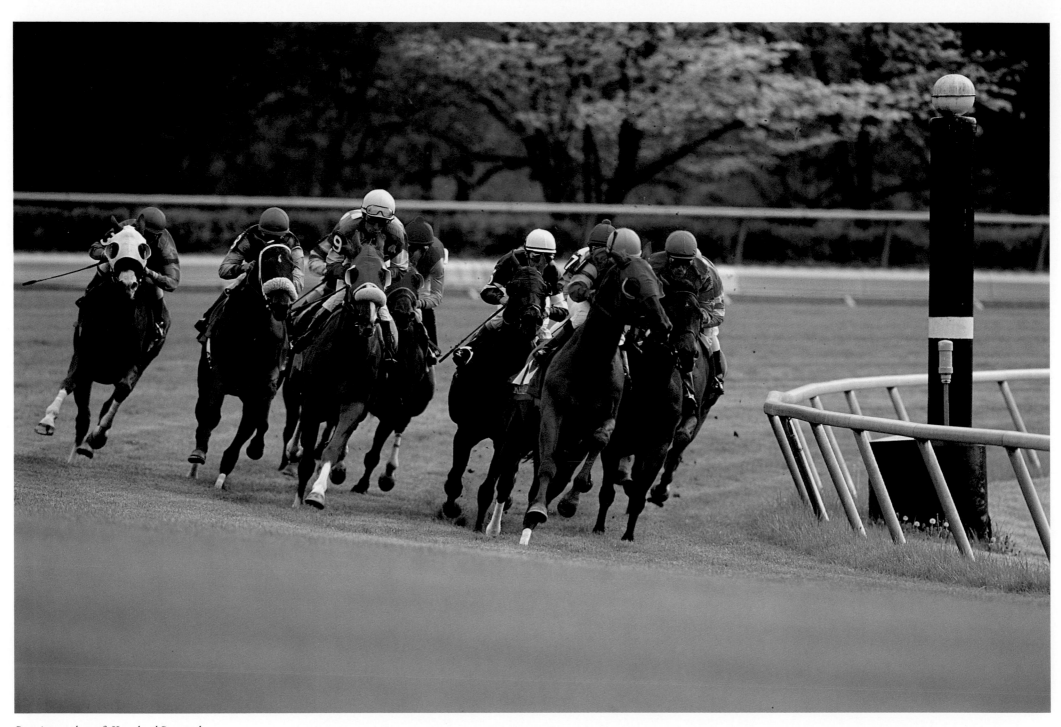

Running on the turf, Keeneland Racetrack,
Lexington, Kentucky

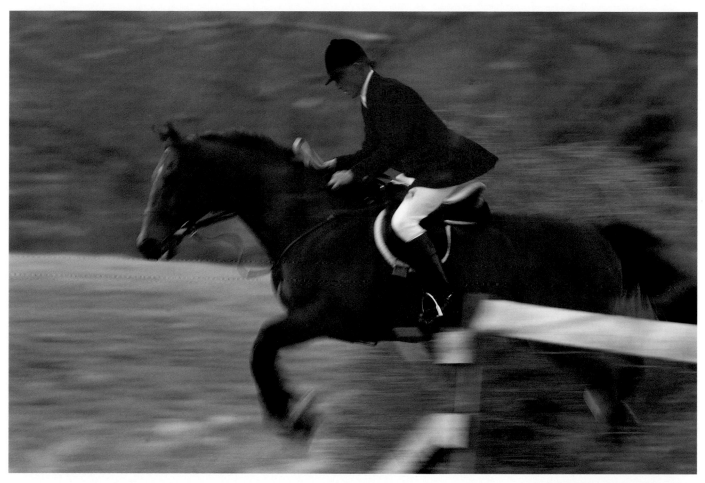

*Over the gate, Adrian Smith, Orange
County Hunt, The Plains, Virginia*

The stirrup, Vogt Ranch,
Santa Maria, California

California style-head stahl, and spade bit,
Vogt Ranch, Santa Maria, California

Polo pony, Everglades Polo Ranch,
Wellington, Florida

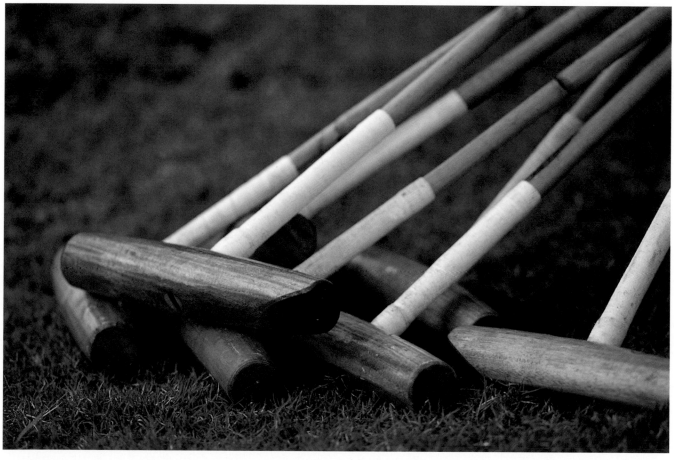

Polo mallets

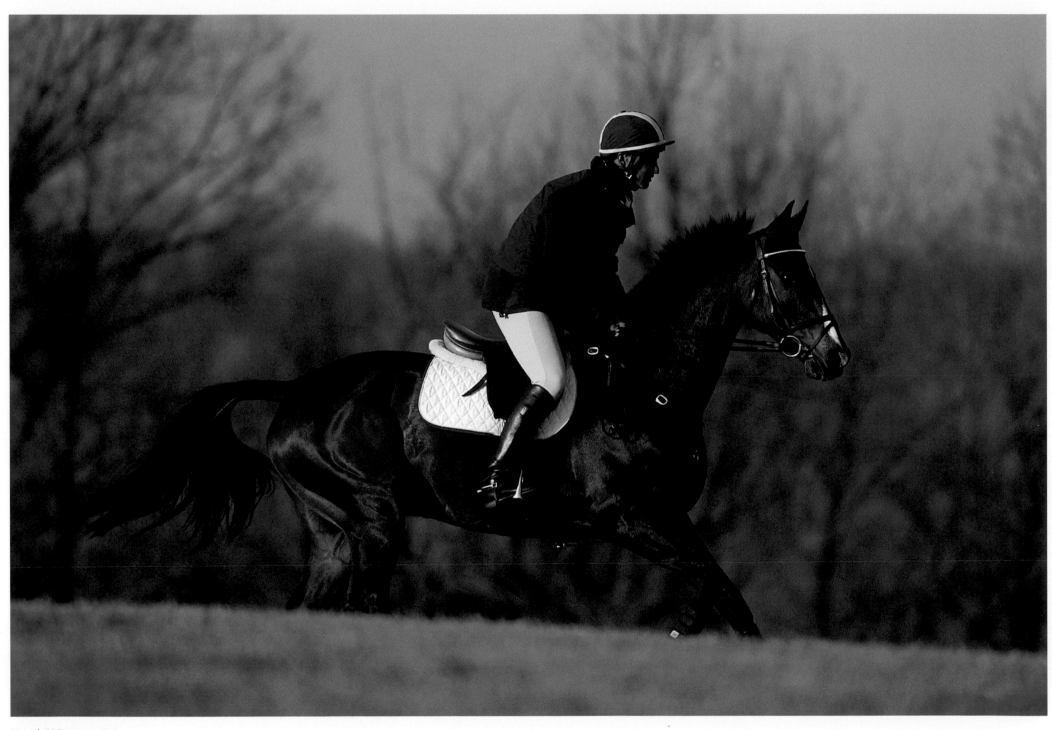

David O'Connor training,
The Plains, Virginia

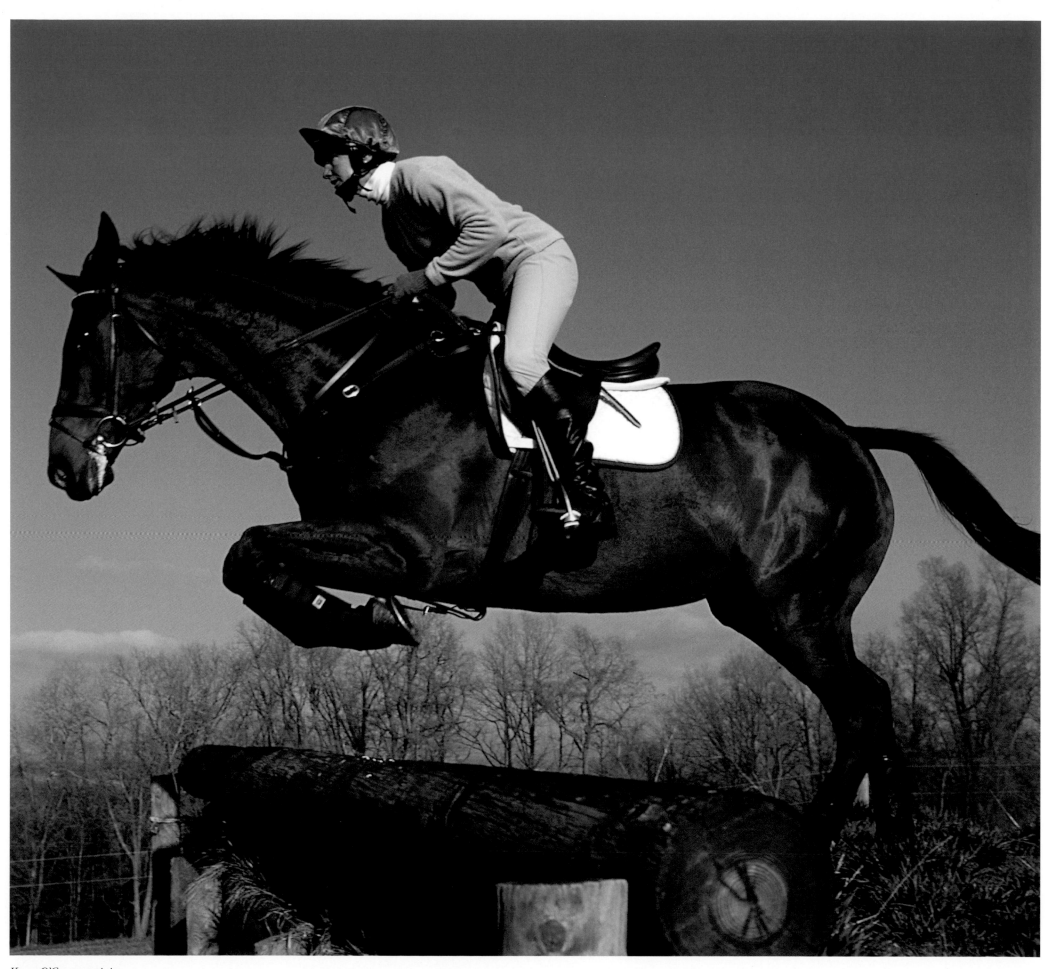

Karen O'Connor training,
The Plains, Virginia

*Boot shop, Wellington
Equestrian Center,
Wellington, Florida*

The blue ribbon, Wellington Grand Prix,
Wellington, Florida

Ted Robinson's saddle room

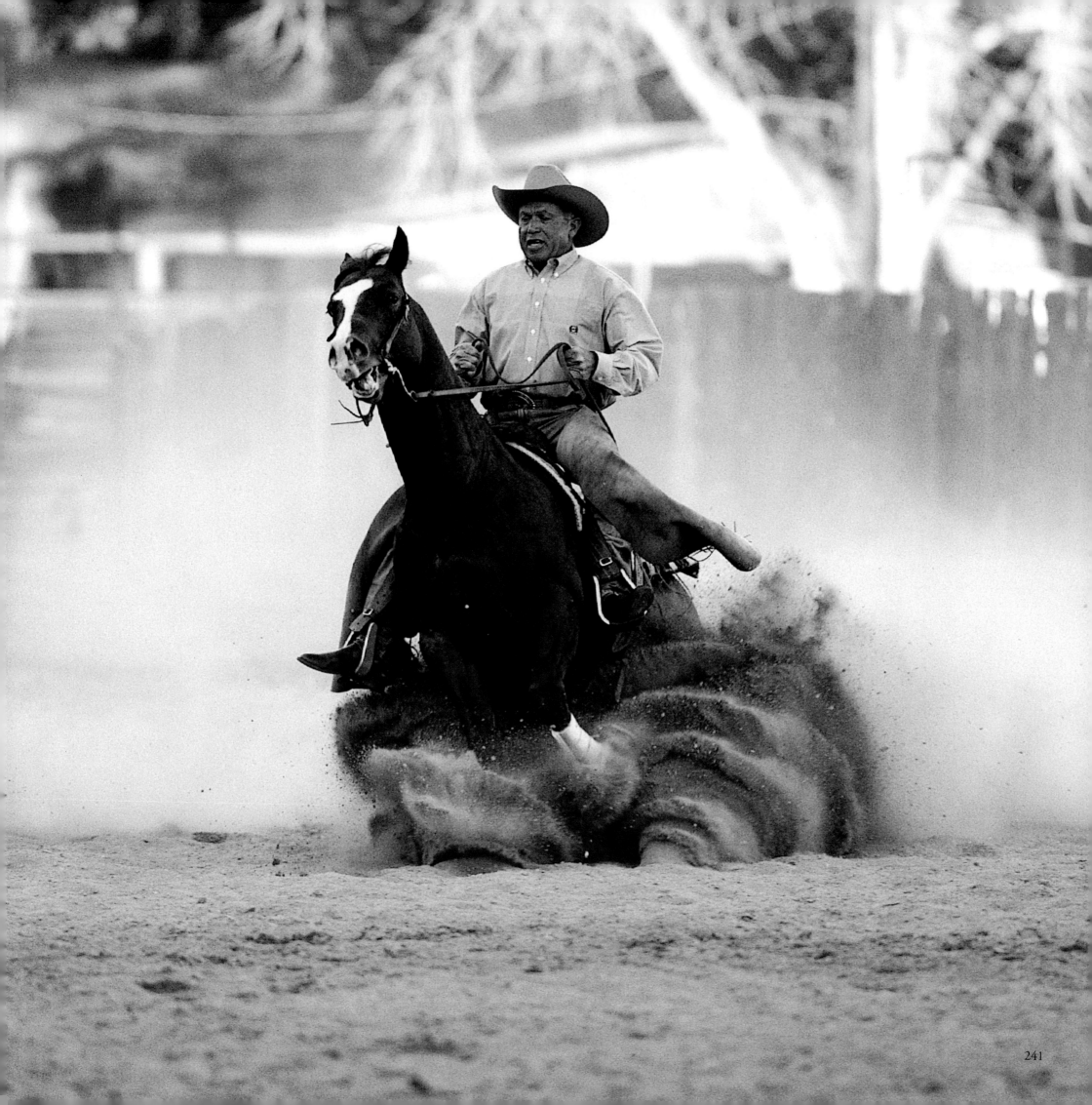

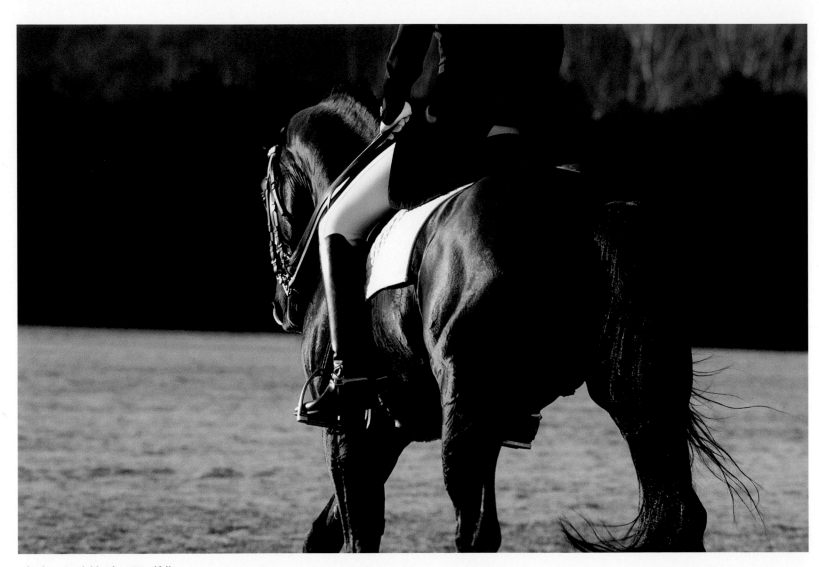

Charlotte Bredahl riding Windfall,
Buelton, California

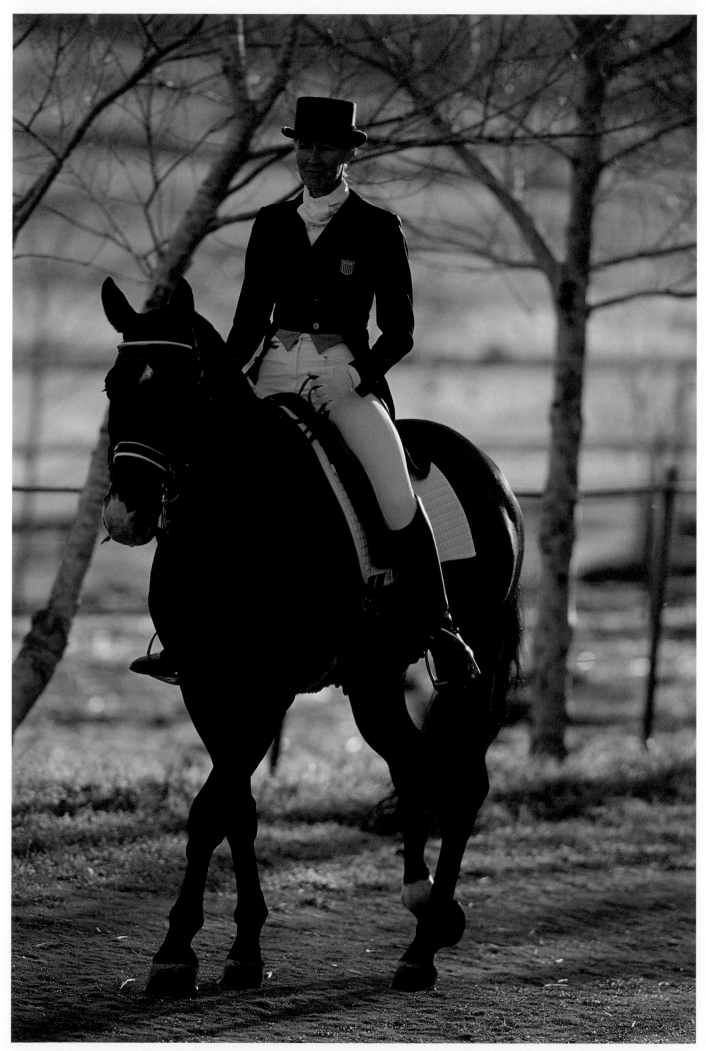

Charlotte Bredahl,
Buelton, California

PHOTOGRAPHER'S NOTES

*F*or me, this was the ultimate photographic assignment—horses in action and performance horses. The challenge was to do it differently, and to look at the subject in a new way. The polo and English horses were new to me, but what a thrill! The biggest challenge during the whole project was not only just to get the shot, but also to capture it from a different angle: in motion or backlit; from a side or front angle; before the sun rose or after it set; early in the morning, late in the evening, or even in the middle of the day.

I used more black and white film for this project than in my previous books. I had used a bit of it for *The California Cowboy* book and I was pleased with how it turned out. Since then, I have been experimenting more and more with a black and white film called Scala made by AGFA. The film is rated at 200 ASA, but we shot all of the film for this book at 400 and pushed the processing accordingly. The Kodak VS and E100SW slide film was processed along with the Scala at the BWC lab in Miami, Florida. They have been processing the film for all of my books as well as the 35mm film for my regular assignments for the last thirteen years. We have a great working relationship, one that is essential in this line of work to maintain consistency and accuracy.

I have been using Canon cameras and lenses for all the photography in my ten latest books. I think and hope that my work has gotten better with each project. It seems better to me and I feel like I am experimenting more with improved and more consistent results. I owe all of this to Canon. Their cameras have never failed me, no matter how cold, windy, dusty, wet, or hot the conditions have been. The lenses are always sharp and accurate. I almost always use the auto focus setting, which is tack sharp. No other lens can see into the shadows like a Canon. No camera helps you find the right exposure for a difficult backlit shot or keeps working in a torrential downpour like a Canon.

I am extremely lucky to have all the good people at Canon USA as a support team while I fly around the country on assignments. I would especially like to thank Mike Newler, who is always there for my assistant and me when we have questions about a special lens or a new camera. Dave Metz and Mike Newler are the team leaders at Canon and we owe them a lot for their dedication to photographers and to great pictures.

I also have a great team back at the office and they do all the dirty work for me. Brian keeps the money flowing; Carrie and Hilary keep everything organized; Randy sheets the film and keeps the stock library in order.

Last but not least, I must thank my good-humored assistant, Kenton. He traveled all over the country with me this winter to finish this project and kept me laughing. I do not know how I could have done it all without him.

The following are technical notes from some of my favorite photographs in this book. You will notice towards the end that I used the Canon 1D digital camera to photograph the Buckin' Horse Sale in Las Vegas, Nevada. I shot these photos indoors under three or four different types of lighting. The results were outstanding. With the color temperature and ASA adjustments, the pictures came out as if I had taken them outside in perfect evening light. In these photos I used my normal Canon lens and set the camera up to shoot eight frames per second. I could not believe the great results!

You will also notice that I used the Canon Image Stabilizer lens whenever I could, which was most of the time. All these new developments and innovations from Canon make my job so much easier. It will not be long before I am able to produce all of my books and calendars digitally. All my friends and contemporaries are doing it and I just have to catch up to them. I love transparencies, but some day soon I will switch over completely. I am just an old dog trying to learn some new tricks.

–David R. Stoecklein

TECHNICAL NOTES

Canon 1V camera; EF 400mm f/2.8L IS USM lens; 200 sec @ f/5.6; Kodak E100 VS film

Canon 1V camera; EF 400mm f/2.8L IS USM lens; 500 sec @ f/6.3; Kodak E100 VS film

Canon 1V camera; EF 400mm f/2.8L IS USM lens; 500 sec @ f/3.5; Kodak E100 VS film

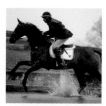
Canon 1V camera; EF 70-200mm f/2.8L IS USM lens; 250 sec @ f/5.6; AGFA Scala black & white slide film shot @ 400ASA

Canon 1V camera; EF 400mm f/2.8L IS USM lens; 500 sec @ f/6.3; Kodak E100 VS film

Canon 1V camera; EF 300mm f/2.8L IS USM lens; 500 sec @ f/5.6; AGFA Scala black & white slide film shot @ 400ASA

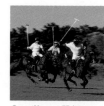
Canon 1V camera; EF 400mm f/2.8L IS USM lens; 100 sec @ f/6; Kodak E100 VS film

Canon 1V camera; EF 300mm f/2.8L IS USM lens; 500 sec @ f/2.8; Kodak E100 VS film

Canon 1V camera; EF 400mm f/2.8L IS USM lens; 500 sec @ f/3.5; Kodak E100 VS film

Canon 1V camera; EF 400mm f/2.8L IS USM lens; 15 sec @ f/22; Kodak E100 VS film

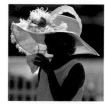
Canon 1V camera; EF 300mm f/2.8L IS USM lens; 500 sec @ f/4.0; Kodak E100 VS film

Canon 1V camera; EF 300mm f/2.8L IS USM lens; 500 sec @ f/8; AGFA Scala black & white slide film shot @ 400ASA

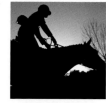
Canon 1V camera; EF 20mm f/2.8 USM lens; 1000 sec @ f/5.0; Kodak E100 VS film

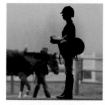
Canon 1V camera; EF 300mm f/2.8L IS USM lens w/ yellow gel filter; 500 sec @ f/4.5; Kodak E100 VS film

Canon EOS 1N camera; EF 400mm f/2.8L IS USM lens; 500 sec @ f/3.5; AGFA Scala black & white slide film shot @ 400ASA

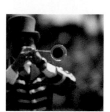
Canon EOS 1N camera; EF 300mm f/2.8L IS USM lens; 500 sec @ f/5.6; Kodak E100 VS film

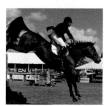
Canon 1V camera; EF 70-200mm f/2.8L IS USM lens; 500 sec @ f/6.3; Kodak E100 VS film

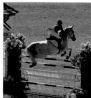
Canon EOS 1N camera; EF 400mm f/2.8L IS USM lens; 500 sec @ f/5.0; Kodak E100 VS film

Canon 1V camera; EF 400mm f/2.8L IS USM lens; 30 sec @ f/8; Kodak E100 VS film

Canon 1V camera; EF 400mm f/2.8L IS USM lens; 20 sec @ f/11; AGFA Scala black & white slide film shot @ 400ASA

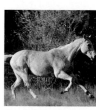
Canon EOS 1N camera; EF 400mm f/2.8L IS USM lens; 500 sec @ f/5.6; Kodak E100SW film

Canon 1V camera; EF 300mm f/2.8L IS USM lens w/ yellow gel filter; 500 sec @ f/3.5; Kodak E100 VS film

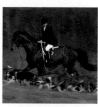
Canon 1V camera; EF 400mm f/2.8L IS USM lens w/ Lee #3 coral filter; 500 sec @ f/4.0; Kodak E100 VS film

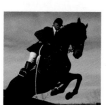
Canon 1V camera; EF 20mm f/2.8 USM lens; 1000 sec @ f/3.5; Kodak E100 VS film

Canon 1V camera; EF 400mm f/2.8L IS USM lens; 500 sec @ f/5.6; Kodak E100 VS film

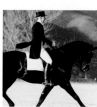
Canon EOS 1N camera; EF 400mm f/2.8L IS USM lens; 500 sec @ f/8; AGFA Scala black & white slide film shot @ 400ASA

Canon 1V camera; EF 16-35mm f/2.8L USM lens; 500 sec @ f/5.6; Kodak E100SW film

Canon 1V camera; EF 400mm f/2.8L IS USM lens; 500 sec @ f/4.5; Kodak E100 VS film

Canon EOS 1N camera; EF 16-35mm f/2.8L USM lens; 250 sec @ f/2.8; Kodak E100SW film

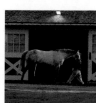
Canon EOS 1N camera; EF 400mm f/2.8L IS USM lens; 500 sec @ f/2.8; Kodak E100 VS film

Canon 1V camera; EF 400mm f/2.8L IS USM lens; 500 sec @ f/5.0; Kodak E100 VS film

Canon 1V camera; EF 400mm f/2.8L IS USM lens; 500 sec @ f/3.5; Kodak E100 VS film

Canon 1V camera; EF 20mm f/2.8 USM lens; 500 sec @ f/5.6; Kodak E100 VS film

Canon 1V camera; EF 400mm f/2.8L IS USM lens; 500 sec @ f/5.6; AGFA Scala black & white slide film shot @ 400ASA

Canon 1V camera; EF 400mm f/2.8L IS USM lens; 500 sec @ f/5.6; Kodak E100 VS film

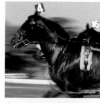
Canon 1V camera; EF 400mm f/2.8L IS USM lens; 250 sec @ f/5.6; Kodak E100 VS film

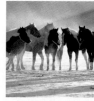
Canon EOS 1N camera; EF 400mm f/2.8L IS USM lens; 500 sec @ f/4.5; Kodak E100 VS film

Canon EOS 1N camera; EF 70-200mm f/2.8L IS USM lens; 500 sec @ f/5.6; Kodak E100SW film

Canon EOS 1N camera; EF 400mm f/2.8L IS USM lens; 500 sec @ f/4.5; Kodak E100SW film

Canon EOS 1N camera; EF 300mm f/2.8L IS USM lens; 250 sec @ f/2.8; Kodak E100 VS film

Canon 1V camera; EF 300mm f/2.8L IS USM lens; 500 sec @ f/2.8; Kodak E100 VS film

Canon EOS 1N camera; EF 300mm f/2.8L IS USM lens; 500 sec @ f/6.3; Kodak E100SW film

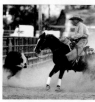
Canon 1V camera; EF 400mm f/2.8L IS USM lens; 500 sec @ f/2.8; AGFA Scala black & white slide film shot @ 400ASA

Canon 1V camera; EF 300mm f/2.8L IS USM lens; 500 sec @ f/5.6; Kodak E100SW film

Canon 1V camera; EF 300mm f/2.8L IS USM lens; 500 sec @ f/4.0; Kodak E100SW film

Canon 1V camera; EF 300mm f/2.8L IS USM lens; 500 sec @ f/3.5; Kodak E100 VS film

Canon 1V camera; EF 300mm f/2.8L IS USM lens; 500 sec @ f/11; AGFA Scala black & white slide film shot @ 400ASA

Canon EOS 1N camera; EF 20mm f/2.8 USM lens; 500 sec @ f/6.3; Kodak E100 VS film

Canon 1V camera; EF 300mm f/2.8L IS USM lens; 500 sec @ f/4.5; Kodak E100 VS film

Canon 1V camera; EF 300mm f/2.8L IS USM lens; 500 sec @ f/4.5; Kodak E100 VS film

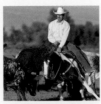
Canon 1V camera; EF 300mm f/2.8L IS USM lens; 500 sec @ f/4.5; Kodak E100 VS film

Canon 1V camera; EF 300mm f/2.8L IS USM lens; 500 sec @ f/4.5; Kodak E100 VS film

Canon 1V camera; EF 70-200mm f/2.8L IS USM lens; 55 sec @ f/4.5; Kodak E100 VS film

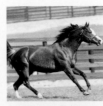
Canon 1V camera; EF 400mm f/2.8L IS USM lens; 500 sec @ f/11; AGFA Scala black & white slide film shot @ 400ASA

Canon 1V camera; EF 35mm f/1.4L USM lens; 500 sec @ f/8; AGFA Scala black & white slide film shot @ 400ASA

Canon EOS 1N camera; EF 400mm f/2.8L IS USM lens; 500 sec @ f/4.5; Kodak E100 VS film

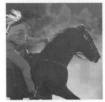
Canon 1V camera; EF 300mm f/2.8L IS USM lens; 500 sec @ f/4.0; Kodak E100 VS film

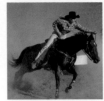
Canon 1V camera; EF 28-70mm f/2.8L USM lens; 500 sec @ f/6.3; Kodak E100 VS film

Canon 1V camera; EF 300mm f/2.8L IS USM lens; 500 sec @ f/3.5; Kodak E100 VS film

Canon 1V camera; EF 300mm f/2.8L IS USM lens; 500 sec @ f/7.1; Kodak E100 VS film

Canon EOS 1N camera; EF 400mm f/2.8L IS USM lens; 500 sec @ f/4.5; Kodak E100 VS film

Canon EOS 1N camera; EF 400mm f/2.8L IS USM lens; 60 sec @ f/5.6; Kodak E100SW film

Canon EOS 1N camera; EF 70-200mm f/2.8L IS USM lens; 500 sec @ f/6.3; Kodak E100SW film

Canon EOS 1N camera; EF 400mm f/2.8L IS USM lens; 125 sec @ f/2.8; Kodak E100SW film

Canon EOS 1N camera; EF 400mm f/2.8L IS USM lens; 500 sec @ f/4.5; Kodak E100SW film

Canon EOS 1N camera; EF 70-200mm f/2.8L IS USM lens; 500 sec @ f/5.6; Kodak E100SW film

Canon EOS 1N camera; EF 70-200mm f/2.8L IS USM lens; 500 sec @ f/4.5; Kodak E100SW film

Canon EOS 1N camera; EF 400mm f/2.8L IS USM lens; 15 sec @ f/2.8; Kodak E100SW film

Canon EOS 1N camera; EF 16-35mm f/2.8L USM lens; 500 sec @ f/5.6; Kodak E100SW film

Canon EOS 1N camera; EF 35mm f/1.4L USM lens; 500 sec @ f/2.8; Kodak E100SW film

Canon EOS 1N camera; EF 70-200mm f/2.8L IS USM lens; 500 sec @ f/5.6; Kodak E100SW film

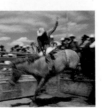
Canon EOS 1N camera; EF 50mm f/1.4 USM lens; 60 sec @ f/16; Kodak E100SW film

Canon EOS 1N camera; EF 20mm f/2.8 USM lens; 500 sec @ f/3.5; Kodak E100SW film

Canon 1V camera; EF 300mm f/2.8L IS USM lens; 500 sec @ f/8; AGFA Scala black & white slide film shot @ 400ASA

Canon 1V camera; EF 400mm f/2.8L IS USM lens; 500 sec @ f/3.5; Kodak E100 VS film

Canon 1V camera; EF 400mm f/2.8L IS USM lens; 500 sec @ f/5.6; Kodak E100 VS film

Canon 1V camera; EF 35mm f/1.4L USM lens; 30 sec @ f/8; Kodak E100 VS film

Canon 1V camera; EF 300mm f/2.8L IS USM lens; 500 sec @ f/5.0; Kodak E100 VS film

Canon 1V camera; EF 300mm f/2.8L IS USM lens; 500 sec @ f/2.8; Kodak E100 VS film

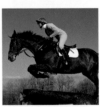
Canon 1V camera; EF 35mm f/1.4L USM lens; 500 sec @ f/3.5; Kodak E100 VS film

Canon 1V camera; EF 70-200mm f/2.8L IS USM lens; 500 sec @ f/3.5; Kodak E100SW film

Canon EOS 1N camera; EF 300mm f/2.8L IS USM lens; 500 sec @ f/6.3; Kodak E100 VS film

Canon 1V camera; EF 400mm f/2.8L IS USM lens; 500 sec @ f/8; AGFA Scala black & white slide film shot @ 400ASA

Canon 1V camera; EF 400mm f/2.8L IS USM lens; 500 sec @ f/2.8; Kodak E100 VS film

BIBLIOGRAPHY & SUGGESTED READINGS

Bryant, Jennifer O.: *Olympic Equestrian.* The Blood-Horse, Inc., 2000.

Budiansky, Stephen: *The Nature of Horses: Exploring Equine Evolution, Intelligence, and Behavior.* The Free Press/Simon & Schuster Inc., 1997.

Burris-Davis, Beverley: "Parthian Horses – Parthian Archers." Parthia.com. 15 May 2002, **www.parthia.com/parthia_horses_burris.htm**

Charlish, Anne: *A World of Horses.* Franklin Watts, Limited, 1982.

Clutton-Brock, Juliet: *Horse Power.* Natural History Museum Publications, 1992.

Coombs, Tom: *Horsemanship: The Horse in the Service of Man.* The Crowood Press Ltd., 1991.

Denhardt, Robert M: *Quarter Horses: A Story of Two Centuries.* University of Oklahoma Press, 1967.
 The Horse of the Americas. University of Oklahoma Press, 1947.
 The Quarter Running Horse. University of Oklahoma Press, 1979.

Dent, Anthony: *The Horse Through Fifty Centuries of Civilization.* Holt, Rinehart and Winston, 1974.

Dien, Albert: "The Stirrup and Its Effect on Chinese Military History." Silkroad Foundation. 2 May 2002, **www.silk-road.com**

Dossenbach, Monique and Hans D.: *The Noble Horse.* Portland House, 1987.

Edwards, Elwyn Hartley: *The Encyclopedia of the Horse.* Dorling Kindersley Publishing, Inc., 1994.

Geddes, Candida: *The Complete Book of the Horse.* Octopus Books Ltd., 1978.

IndiaPolo.com: "The Mists of Time: Origins of Polo." 23 May 2002, **www.indiapolo.com**

Institute for Ancient Equestrian Studies: "Early Horseback Riding and Warfare in the Steppes." 1 May 2002, **http://users.hartwick.edu/iaes**

International Museum of the Horse: "The Legacy of the Horse." 13 March 2002, **www.imh.org**

Morris, Desmond: *Horsewatching.* Crown Publishers, Inc., 1988.

NetPets/The Horse Center: "Domestication: A Cooperative Venture?" 1 May 2002, **www.netpets.com/horses**

Price, Steven D.: *The Quotable Horse Lover.* The Lyons Press, 1999.

Reusser, Stacey: "The 50 Most Influential Horses of the 20th Century." *The Chronicle of the Horse,* December 24, 1999.

Steinkraus, William C. and M.A. Stoneridge: *The Horse in Sport.* Stewart, Tabori & Chang, Inc., 1987.

Stoecklein, David and Buster McLaury: *The Western Horse: A Photographic Anthology.* Stoecklein Publishing, 1999.

Stoecklein, David; Darrell Dodds, and Jennifer Forsberg Meyer: *The American Paint Horse: A Photographic Portrayal.* Stoecklein Publishing, 2001.

Watson, J.N.P.: *The World of Polo, Past & Present.* Salem House Publishers, 1986.

INDEX & RELEVANT ASSOCIATIONS AND ORGANIZATIONS

American Driving Society
PO Box 160
Metamora, MI 48455
810.664.8666 / fax 810.664.2405
www.americandrivingsociety.org

American Horse Council
1700 K Street, NW, Suite 300
Washington, DC 20006-3805
202.296.4031 / fax 202.296.1970
www.horsecouncil.org

American Quarter Horse Association
PO Box 200
Amarillo, TX 79168-0001
806.376.4811 / fax 806.349.6412
www.aqha.com

Federation of International Polo
9663 Santa Monica Boulevard
Beverly Hills, CA 90210
310.472.4312
www.fippolo.com

Masters of Foxhounds Association of America
PO Box 2420
Leesburg, VA 20177-7707
703.771.7442 / fax 703.779.7462
www.mfha.com

National Cutting Horse Association
4704 Hwy. 377 South
Fort Worth, TX 76116-8805
817.244.6188 / fax 817.244.2015
www.nchacutting.com

National Reining Horse Association
3000 NW 10th Street
Oklahoma City, OK 73107-5302
405.946.7400 / fax 580.759.3999
www.nrha.com

National Snaffle Bit Association
4815 S. Sheridan, Suite 109
Tulsa, OK 74145
918.270.1469 / fax 918.270.1471
www.nsba.com

National Steeplechase Association
400 Fair Hill Drive
Elkton, MD 21921-2569
410.392.0700 / fax 410.392.0706
www.nationalsteeplechase.com

Professional Rodeo Cowboys Association, Inc.
101 Pro Rodeo Drive
Colorado Springs, CO 80919-9989
719.593.8840 / fax 719.548.4876
www.prorodeo.com

The Jockey Club
821 Corporate Drive
Lexington, KY 40503
859.224.2700 / fax 859.224.2710
www.jockeyclub.com

United States Dressage Federation
220 Lexington Green Circle, Suite 510
Lexington, KY 40503
859.971.2277 / fax 859.971.7722
www.usdf.org

United States Equestrian Team
PO Box 355, Pottersville Road
Gladstone, NJ 07934
908.234.1251 / fax 908.234.9417
www.uset.com

United States Eventing Association
525 Old Waterford Road, NW
Leesburg, VA 20176
703.779.0440 / fax 703.779.0550
www.eventingusa.com

United States Polo Association
771 Corporate Drive, Suite 505
Lexington, KY 40503
859.219.1000 / fax 859.219.0520
www.us-polo.org

United States Trotting Association
750 Michigan Avenue
Columbus, OH 43215
614.224.2291 / fax 614.224.4575
www.ustrotting.com

USA Equestrian (formerly American Horse Shows Assn.)
4047 Iron Works Parkway
Lexington, KY 40511-8483
859.258.2472 / fax 859.231.6662
www.equestrian.org

FINAL NOTES

*W*hat a journey. I hope you liked the photographs. I included everything I could in this small volume. It is not, nor was it meant to be, the "tell-all" book. It was merely meant to be informative and enjoyable.

I love horses just as much as I know my readers do. I now have an amazing appreciation for the horse as an athlete and a respect for those individuals who have dedicated their lives to caring for, training, riding, and loving the performance horse.

I want to thank all the people who welcomed me into their homes, farms, and ranches and performed for my camera, and shared a small part of themselves with me. I am a better person because of this project.

I also want to thank Jenny Meyer, who worked so hard on the text and did such a great job. Gary and Kelley Custer came up with a beautiful design for the book and made it look incredible. Craig Orison at Express Printing in Hailey, Idaho, who did the separations so expertly, and Cindy Peer at P. Chan & Edwards, who did such a great job with the printing and timely delivery, were instrumental in the completion of this project.

Lastly, Allyn Mann at Bayer Corporation was an amazing source of support and I know we could not have gotten here without him.

Happy Trails,
Dave